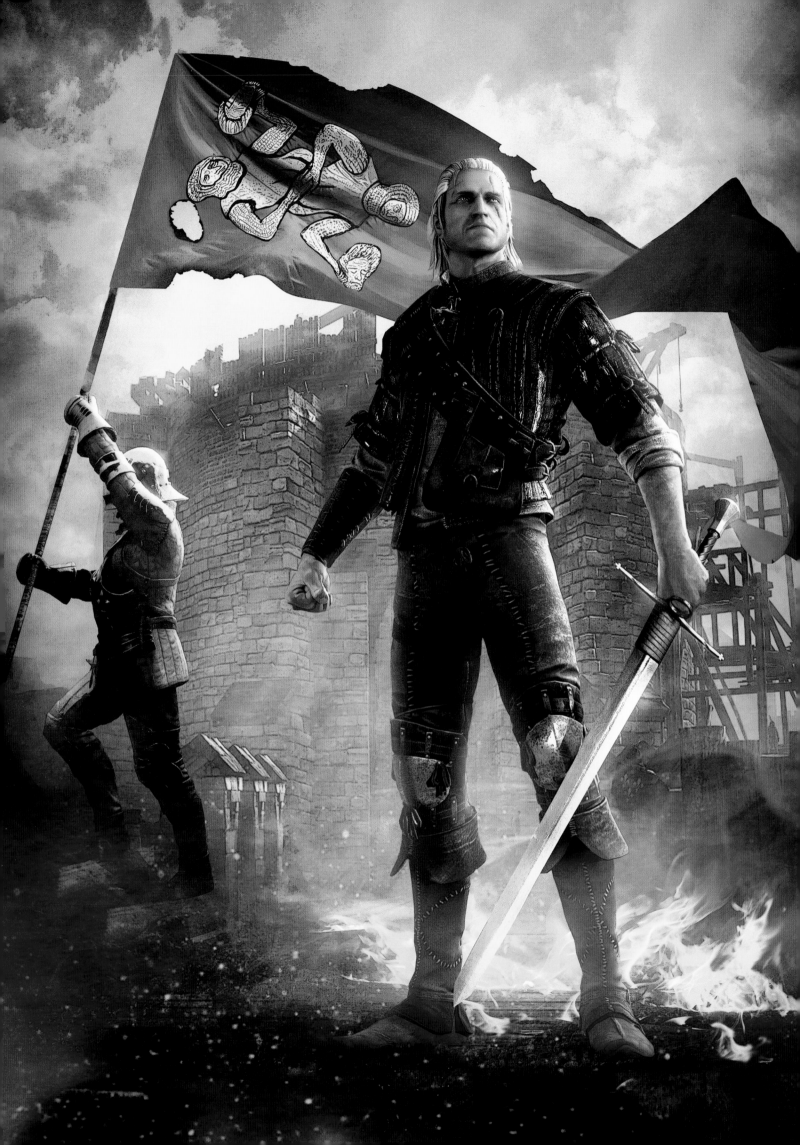

THE WORLD OF THE WITCHER®

VIDEO GAME COMPENDIUM

DARK HORSE BOOKS

CD PROJEKT RED

Head of Studio
ADAM BADOWSKI

Project Managers
KAROLINA LEWANDOWSKA, ASHLEY KARAS

Author
MARCIN BATYLDA

Translator
TRAVIS CURRIT

Proofreaders
ANDREW STONE, TRAVIS CURRIT,
KAROLINA NIEWĘGŁOWSKA,
JAKUB SZAMAŁEK

Editor
MARCIN BLACHA

Artistic Supervisor
PRZEMYSŁAW JUSZCZYK

Art Director
BARTŁOMIEJ GAWEŁ

Business Development Manager
RAFAŁ JAKI

VP of Business Development
MICHAŁ NOWAKOWSKI

DARK HORSE

Publisher
MIKE RICHARDSON

Editor
DANIEL CHABON

Assistant Editor
IAN TUCKER

Designer
DAVID NESTELLE

Digital Production
ALLYSON HALLER

THE WORLD OF THE WITCHER

Published by Dark Horse Books
A division of Dark Horse Comics LLC
10956 SE Main Street
Milwaukie, OR 97222
DarkHorse.com

To find a comics shop in your area, visit comicshoplocator.com
International Licensing: (503) 905-2377
First edition: February 2015
ISBN 978-1-61655-482-8
Limited edition: February 2015
ISBN 978-1-61655-810-9

10 9 8 7 6

Printed in the United States of America

CONTENTS

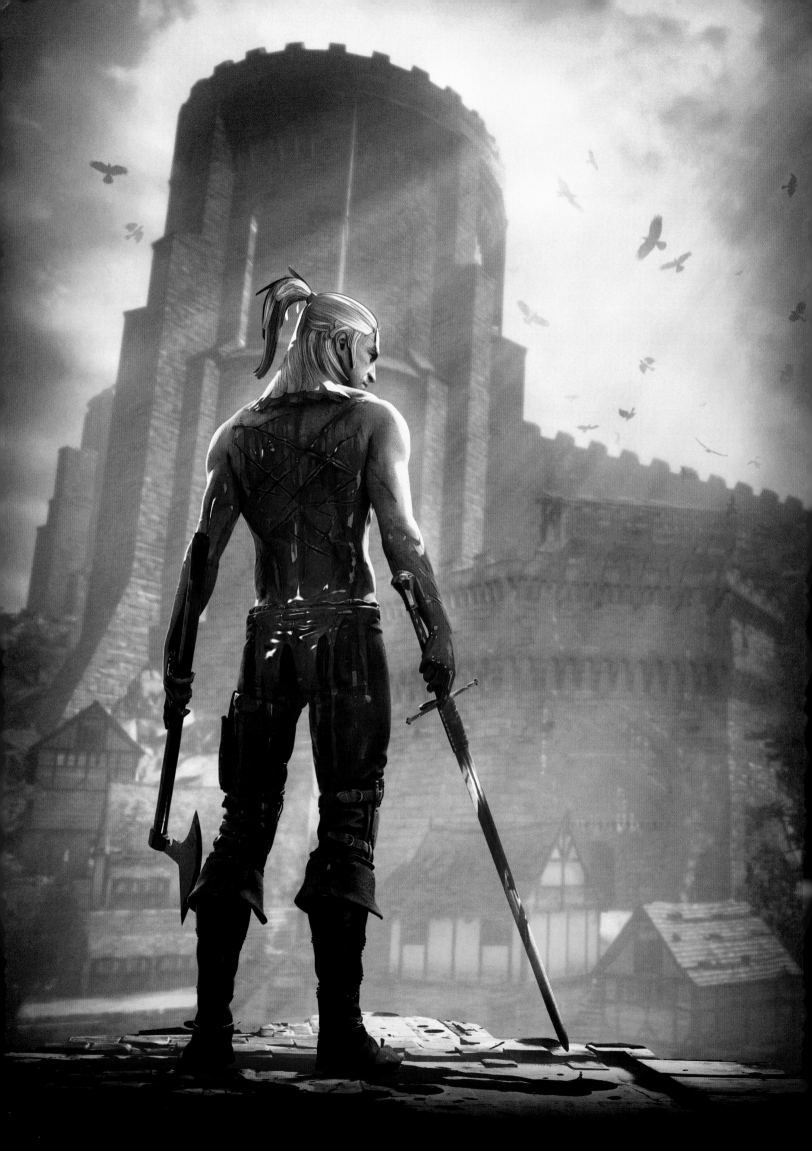

Dear Reader,

The tome you hold in your hands is a compilation of a multitude of notes and drafts, both those authored by myself and those I managed to acquire, copy, or otherwise procure during my many travels. For I have grown fond of collecting observations and information gleaned through lively conversation, so that they might serve posterity as inspiration or cause for reflection.

Most of the notes penned by my hand served as the basis for the creation of my own great work: my memoirs, entitled **Half a Century of Poetry.** *I shall hasten to add, happily spitting in the face of false modesty, that any person who would care for his reputation as an educated and well-read man, and not a simpleton and boor, should acquaint himself with that tome. For those not already familiar with this masterpiece of wit, thrilling adventure, and charming verse, it is undoubtedly available at your nearest purveyor of fine literature, or in the homes of your more cultured and discerning friends.*

Yet a great many of the documents I gathered could not find their way into the aforementioned book. These were, for the most part, texts written by persons other than myself, and therefore, quite understandably, they could not be included in my memoirs. Still, some of these were interesting enough that I decided to make use of them in the present tome—after, obviously, some careful editing and the addition of suitable commentary. I hope, dear reader, that perusing them will bring you much joy. First and foremost, however, I hope that it will grant you a wider perspective on things such as magic, sorcerers, the history of the world in general, the storied past of the witchers, and, in particular, my dear friend Geralt of Rivia.

—Dandelion

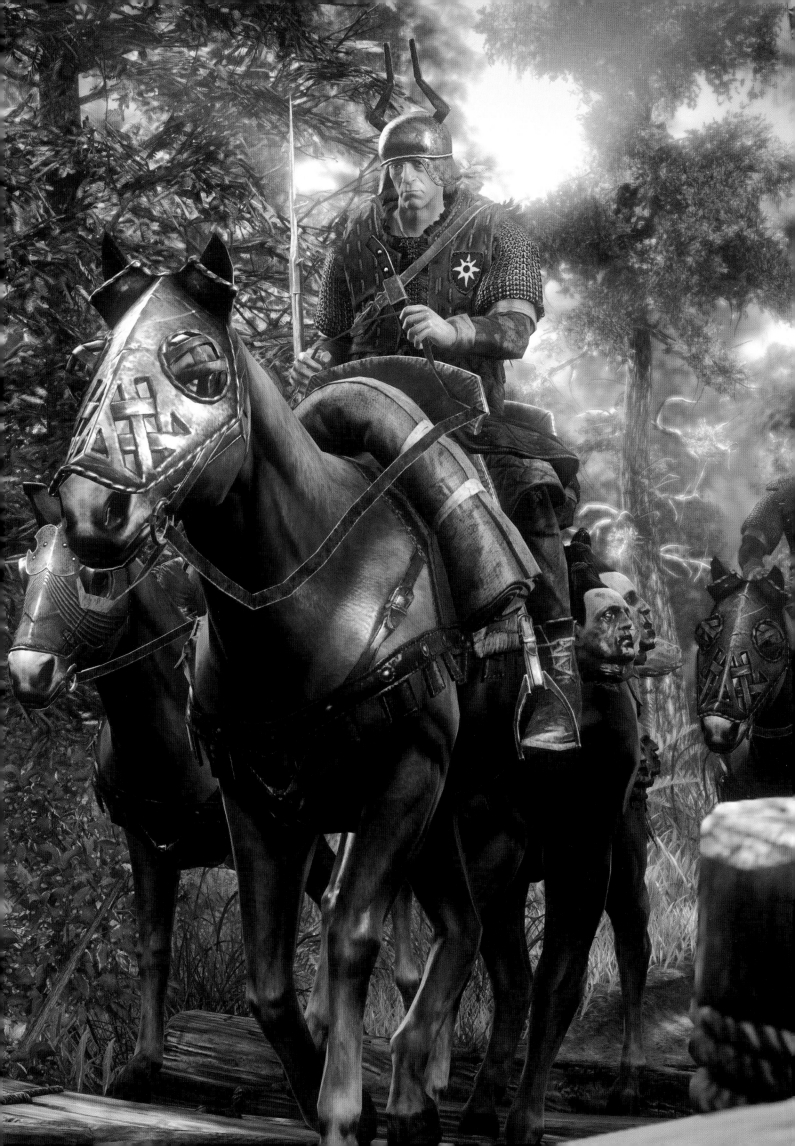

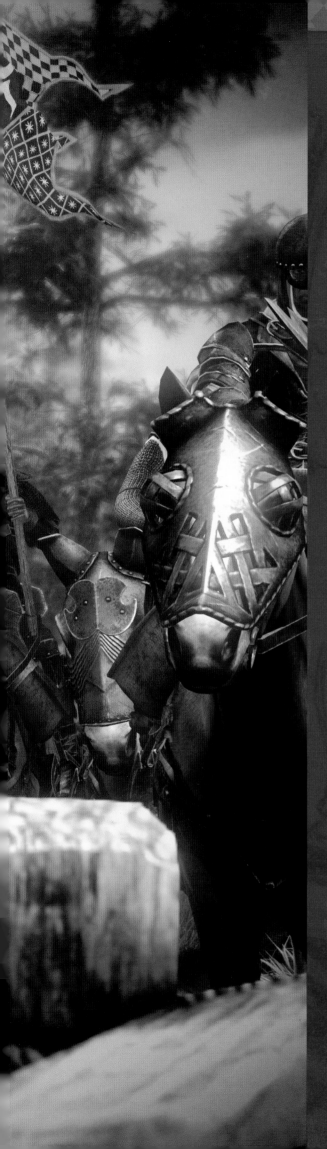

CHAPTER I
THE WORLD AND ITS INHABITANTS

*T*he history of our continent has been described in many voluminous historical treatises and documents. The famous **The History of the World** *by the splendid Roderick de Novembre must be mentioned above all. This was one of the students' favorite readings during my time at the Oxenfurt Academy, though that may have been because it was easy to use the huge tome being passed around the auditorium to conceal a bottle of vodka. I might add that I myself, never one to be swayed by scholarly eminence, always considered the much larger geographical atlas to be better suited toward that purpose.*

As far as the actual content of **The History of the World** *is concerned, many consider it to be somewhat controversial and anachronistic. At the least, the book's presentation of facts is not always free of bias. I hasten to add that by no means do I ascribe any ill will to Roderick de Novembre—for everyone, even the most respected of historians, is the child of his times, his culture, and his nation. It should consequently come as no surprise that a history of the formation of realms, wars, and racial conflicts that is authored by a human will always present the human— that is, the most widely known—point of view.*

Therefore, I highly recommend the following chapter, which contains unique musings on our history and geography by a member of a completely different species. It was penned by Villentretenmerth, a golden dragon, known in his human form as the knight Borch Three Jackdaws. Due to his longevity and his ability to change shape, he has had ample opportunities to observe human society and the passage of many important events. Moreover, he has shown a particularly keen interest in our species, highly atypical for dragons, that is not limited to classifying us as a part of a menu. He has thus proven to be an exceptionally astute commentator on the history of both our species and of the world as a whole.

—Dandelion

THE WORLD AND ITS HISTORY

Your species likes to celebrate history, to put pen to paper, to commemorate, to organize, to systematize. You fill the pages of voluminous tomes with it, you write it down on parchment, you immortalize the deeds of the human race in songs. The roots of this passion are likely found in the distant past, when your species was still young. No matter the time or place or cultural group, once you are past the stage of shattering each other's skulls with a horse's jaw tied to a rod, you eagerly begin to contemplate how best to immortalize this fact, for your greater glory and for the memory of your descendants. Maybe that is why the history of mankind is inevitably the history of war and conquest.

The above statement is not born of prejudice. On the contrary, I am one of the few members of my species who have lived among you and might even be said to be somewhat fond of you. Therefore, I always eagerly observe your accomplishments, though some of your race's deeds and attitudes should, beyond all doubt, be condemned or held in contempt. I would even go so far as to say that said deeds warrant the use of the word *monster*, which you so often use to describe species different from your own.

But let us get back to history, or more precisely, the tales of this world. They too most often tell of a history of war and conquest, but were chronicled long before you arrived.

The First People of These Lands

It is said that ancient dwarven tales hold that the oldest inhabitants of this region of the world were the gnomes. Others claim that there is circumstantial evidence that races such as vrans or the nearly extinct werebbubbs also date back many thousands of years. As you, dear reader,

The World of The Witcher

might correctly surmise, it is therefore difficult to ascertain whether the gnomes truly were the first people to dwell here. It is a known fact, however, that they had small colonies in the mountain reaches of Mahakam and Tir Tochair that existed long before dwarves arrived in these lands, some three to four thousand years ago.

"Taking into account all the evidence at our disposal, an enlightened person must remain open to the possibility that other universes exist. The theory postulating that some of the stars seen in the sky are worlds separated from ours by time and space continues to gain more and more proponents among sorcerers, scholars, and astrologers. Though such deliberations are not viewed kindly by most members of the clergy, the priests' protests should not stop us researchers from trying to discover the truth. For just as the shape of our sphera mundi *has been proven beyond all doubt, despite pressures from the priesthood, so may it be that the correct answer here will be found again not in religion, but in unbiased and unwavering Scholarship."*

—Anonymous

The meeting between gnomes and dwarves was surprisingly peaceful. Truth be told, this may be the only case when the new arrivals did not begin their settlement by waging war on those who dwelled there before them. It is less surprising, however, when one considers that both races have similar preferences and habits, and could therefore coexist within a single society without much tension or infighting. Indeed, their good relations have continued to this day.

Next, elves arrived on the horizon. It seems most likely that they, like yourselves, came here from another world, undoubtedly through magical gates or portals of one kind or other. They appeared more or less two and a half thousand years ago, making landfall from their white ships. They promptly began a gradual colonization of this region which lasted for ten centuries. That expansion was also relatively peaceful, though there were some conflicts. Anyone who has met an elf knows that their nature is not the most amicable, and it is therefore easy to surmise that they clashed with other races—vrans, werebbubbs, and dwarves. These quarrels, however, never turned into a total war or attempts to exterminate one's neighbors. Perhaps that is why, despite all their cultural differences and

Human colonization of the Continent began with an unbroken series of conflicts and bloody wars with other races. Their outcome established mankind's lasting dominance over today's Northern Realms.

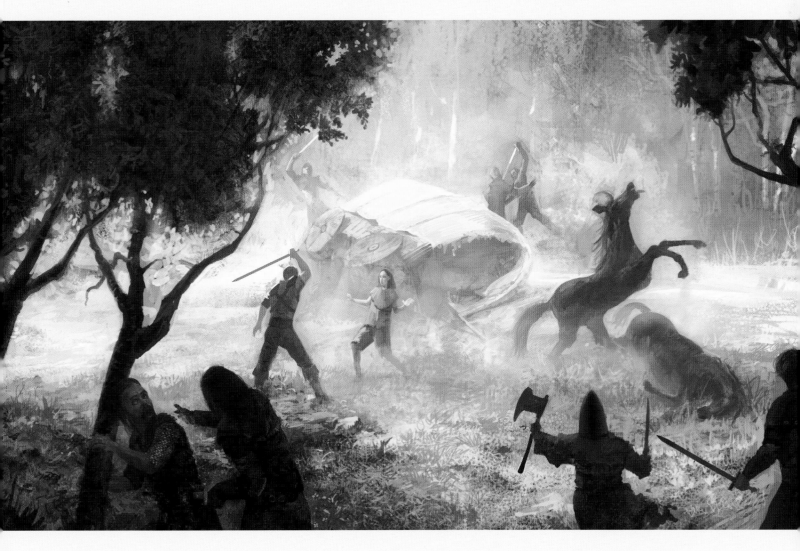

past feuds, relations between elves and dwarves remain fairly amiable.

The Arrival of Humans

It is common knowledge that your race arrived in this world alongside the Conjunction of the Spheres—the great magical cataclysm which remains largely unexplained to this day. That event took place around one and a half thousand years ago, according to human reckoning. It is difficult to determine how long this process lasted, but as a result, a great many other creatures appeared—creatures that without question were not originally born of this world.

The Conjunction of the Spheres also gave birth to another phenomenon—namely magic, which flowed into our

"The elven opinion that humans supposedly came to this world during the Conjunction of the Spheres is another proof of the vile perfidy of that deceitful, gods-forsaken race! For what was brought forth by that terrible event, that monstrous catastrophe cast down upon mankind to doom it? It birthed the foul and filthy magic, and therefore sorcerers, who dare to grasp at the powers and faculties that rightly belong to the gods! It gave life to disgusting beasts that threaten all gods-fearing and just men! To believe that we came to this world in that accursed hour is blasphemy! It is a plot by the so-called Elder Races, to mock the truth and usurp this world, which by divine decree is the inheritance of men!"

—From the sermons of Sigebert, priest during the witch hunt period (1272–1276)

world and became, one could say, its integral part.

Though, as I have said, fifteen centuries have passed since that time, proper human expansion in the region now known as the Northern Kingdoms began relatively recently, around five hundred years ago. It was then that the event now called "the Landing of the Exiles" took place, when ships bearing men who would give rise to the kingdoms of the North made landfall in the Pontar Delta and the mouth of the Yaruga.

It is difficult to say where these "exiles" came from, as on this crucial detail the legends are remarkably silent. If they were indeed exiled, I daresay that it was not because of their gentle and kind natures. After all, over the past few centuries the descendants of these exiles have

Elven ruins bear mute witness to the rise, triumph, and decline of the Aen Seidhe. Few of their buildings have survived in good condition, for as the elves fled the human onslaught they destroyed most of their handiwork, not wanting to see it fall into the hands of the invaders.

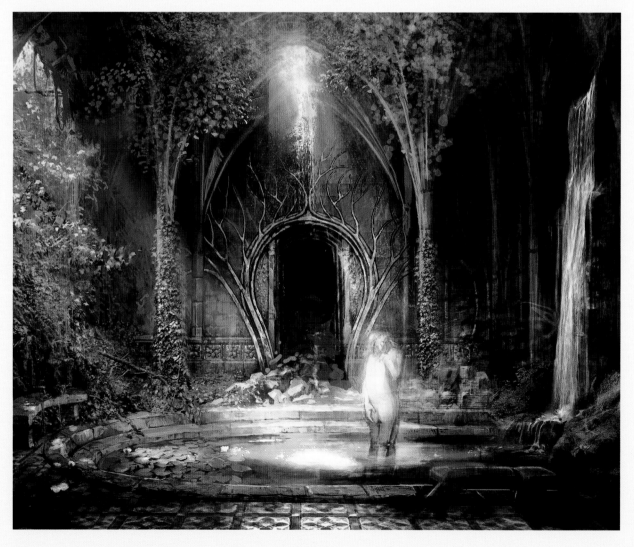

proven themselves to be a determined, bellicose, and intolerant people.

It is also unclear how that First Landing took place, and who were the first to encounter these new arrivals. If the exiles found any other human tribes here, they must have been quickly assimilated by the conquerors, for no trace of them remains in the chronicles. But they quite certainly met elves, who, as one of the already established races, painfully learned of the new settlers' ambitions.

THE WOZGOR AND THE DAUK

"According to Arnelius Grock's classification, the Wozgor and the Dauk are counted among the ancient human cultures that arrived here directly after the Conjunction of the Spheres. They settled the lands between the Dragon Mountains and the Gulf of Praxeda that forms the current territory of the Kingdom of Kovir and Poviss (specifically the duchies of Narok, Velhad, and Talgar) and the principalities of the Hengfors League (the lands of Caingorn, Malleore, Creyden, and Woefield), as well as those of northern Redania (the Gelibol region and the Nimnar Valley). Fragmentary information about these peoples is mainly based on the remains of their material culture.

The surviving writings found on the Dauk menhirs and tombstones found in Wozgor necropolises formed the basis of several prophecies and divinations (vide: 'The Prophecy of the Black Sun'), which remain questionable to this day (vide: 'The Mania of Mad Eltibald'). Some scholars stipulate that the Wozgor and Dauk beliefs remain alive in the form of the religion of Melitele and lesser cults (cf. Coram Agh Tera, Veyopatis). The events which led to the extinction of both peoples remain sharply disputed among scholars."

—Annanias Uldvikel, "Ancient Human Cultures and Their Relicts"

away from the humans, no doubt believing that the new arrivals would at some point finally stop their relentless march to the east. They would later pay dearly for this assumption.

Elves, then, gave way and even abandoned some of their cities. These were promptly taken over by the invaders, who raised their own edifices atop the elven foundations. Thus the elves lost their chance to "push the humans back into the sea," as they like to cry today—too late by a mere half thousand years.

As I've said before, human history is invariably filled with conflict.

The Formation of the Northern Kingdoms and the Wars with Nonhumans

Initially, the elves held a significant advantage over the newcomers, but they unwisely disregarded the threat posed by humans. When the first clashes started to occur, they chose not to take up arms, reasoning that it was preferable to avoid bloodshed that promised to cost countless thousands of lives. Instead, they backed

At the same time as they set out to conquer the lands of other races, the first human colonists began squabbling with each other. Indeed, those early times were once summed up with the caustic witticism that every four arriving ships gave birth to three kingdoms, as nearly everyone wanted not only to be his own master, but also to rule over others.

That is why the chronicles of early human history mainly contain descriptions of internal quarrels

Centuries ago, most inland areas of the Continent were covered in primeval forests. As humans moved out from the mouth of the Yaruga, they cleared more and more woodlands, reducing the wilderness to stumps to make way for fields and farmsteads.

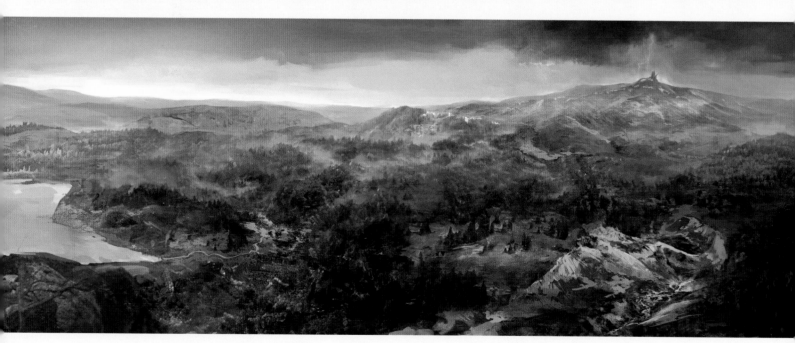

"No less than two dozen cities of the Northern Kingdoms are located on the sites of ancient elven settlements. Among them are the scholarly Oxenfurt and the Free City of Novigrad, as well as Temeria's capital, Vizima, and the cities of Maribor, Tretogor, and Cidaris. As one can clearly discern from its name, the ruins of elven Xin'trea are also the site of present-day Cintra."

—Fragment of second-year dissertation in the Faculty of History at Oxenfurt Academy

and wars, which have been given high-sounding names, such as "Shaping Statehood" or "Strengthening Royal Power." As is typical in such times, the strongest, most ambitious, and shrewdest individuals—for simplicity's sake, called kings (though a list of their myriad self-granted titles could itself fill several pages of this book)—worked tirelessly to incorporate, annex, and make vassals of the lands of their less crafty or more unfortunate neighbors. This was, of course, accomplished through the usual conquests, treaties, marriages, bribery, blackmail, and assassinations. Stronger realms consumed the weaker ones, uniting them under their dynasties. The kingdoms of men expanded, waging war on each other and on the nonhuman races. Step by step, vrans were pushed into the Blue Mountains. Werebbubbs faced a similar fate, with the survivors finding refuge in the remote regions of Mahakam and the Amell Mountains.

The bitter harvest sown during the elven wars is still being reaped to this day. Many Aen Seidhe refused to accept defeat and continue to wage a ruthless guerrilla war against men, one that claims both soldiers and peaceful merchants and villagers as its victims.

Several times, it seemed that humans would at last be content with what they had already conquered. In each case, such hopeful thinking proved a dire mistake. Treaties and nonaggression pacts were signed, agreements were made—only to be broken when they were no longer useful to humans. The most characteristic example was the peace treaty with the elves, shattered just a few years later by the treacherous Redanian attack that led to the slaughter of Loc Muinne. Thus began the second war between men and elves, in which the latter faced the overwhelming enemy forces with all the courage and stubbornness of true heroes—and paid a horrendous price for doing so. The flower of elven youth perished in that terrible conflict, a blow from which their race has never managed to recover.

In this way, some four centuries after their landing, the men whose ships arrived at the mouth of the Yaruga had claimed all the lands between the Great Sea

in the West and the Blue Mountains in the East, between the Dragon Mountains in the North and the Amell Mountains in the South. Thus, the Northern Kingdoms were born.

The Far South

The lands south of the Amell Mountains developed independently of their northern neighbors. It is unclear whether the men who formed the southern kingdoms were members of a different ethnic group, or if they shared ancestors with the so-called "exiles," and their paths diverged ages ago.

To discern the truth, one could examine their legends, the chronicles of their kingdoms, and the genealogies of their kings. But to do so, one would have to travel far to the south and seek the tomes found at the Imperial Academy, for after these lands were conquered by Nilfgaard, most of their writings were deposited there. The peoples brought under the dominion of the empire were also expected to learn its official language and adopt elements of the victors' culture. Therefore, it is difficult to ascertain just how much the people of the South have in common with their relatives from the North.

It can be said with certainty, however, that at least one kingdom, which would later become the Nilfgaardian Empire, was indeed founded by a wholly separate people, likely present in those lands even earlier than five centuries ago. This claim is supported by their completely different language, based

SHAERRAWEDD

"Aelirenn, the White Rose of Shaerrawedd—it was she who led us into battle in that last, desperate clash two hundred springs ago. At that time, after human treachery had left the pavements of our white cities stained with the blood of our kin, we already knew we had no hope of winning the war. Our leaders thought only of preserving our people. They gave the order to leave nothing for the invaders to conquer. We were to destroy our homes, shatter the marble palaces, ruin the shimmering fountains, and bring down the slender towers—including the walls of our pride and joy, the beautiful Shaerrawedd. We were to flee, to fall back into the mountains and build new homes, to wait out the humans, like one endures a severe winter night, awaiting the day which will finally herald spring.

But not Aelirenn. She refused to run without a fight, to destroy our handiwork and all that we held dear. We followed her, though she fed us delusions of victory and in truth promised us only the chance to die with honor. And die we did—with her name on our lips. For her. For white stone and marble. And for our symbol, for Shaerrawedd."

—*Cuannah aep Finavail, comrade of Iorveth and member of the Scoia'tael*

To the south, the small kingdom of Nilfgaard slowly built its power by conquering one smaller neighbor after another. Soon its symbol, the Great Sun, would become the emblem of a newly formed empire, the greatest the world has ever seen.

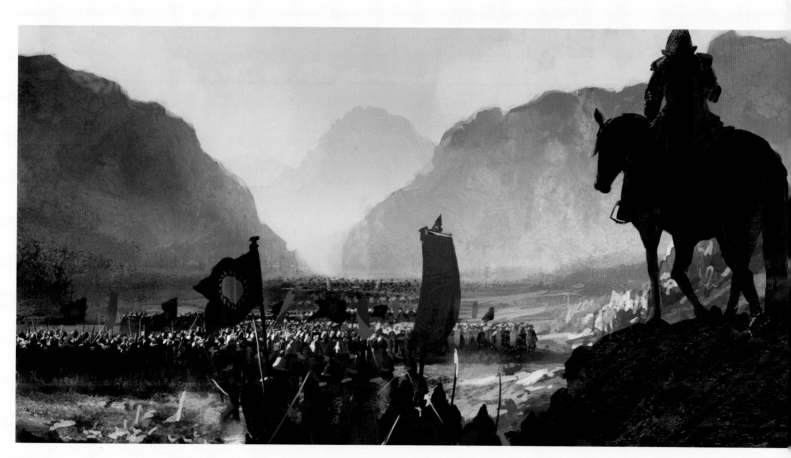

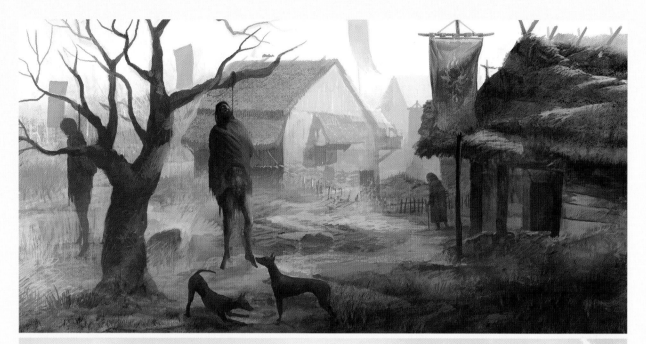

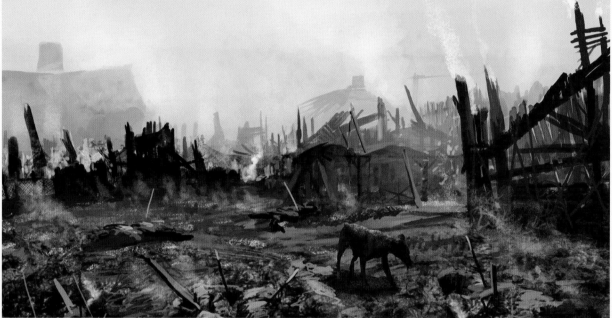

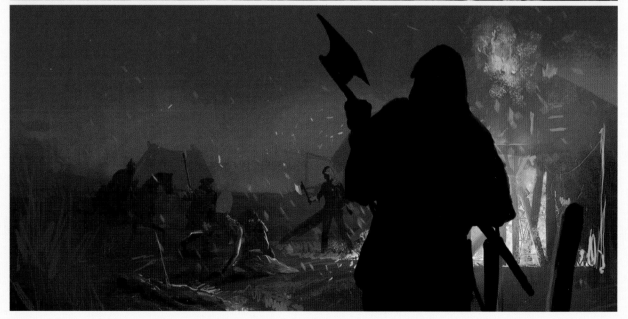

on the Elder Speech, as well as their separate beliefs, customs, and more developed culture.

The history of the South confirms the aforementioned theory that the history of mankind is ultimately a history of conquest. In this case, the rulers of Nilfgaard turned out to outclass all competition in the race to subjugate their neighbors, with the help of, if I may, "the diplomacy of steel." Over several centuries, Nilfgaard grew from a simple kingdom to a true empire, whose power finally reached the foothills of the Amell Mountains, which separated it from the Northern Kingdoms, a few decades ago.

The Conflict with Nilfgaard and the Northern Wars

At that time, it seemed that the empire had reached its final, natural boundaries. Many scholars and specialists hold the opinion that further march to the north was both economically and militarily pointless. Your historians, then, still hotly debate the reasons for the famous Northern Wars. Supposedly, Nilfgaard had no interests that would be served by war. The Nordlings were a warlike and battle-seasoned people, and it was more profitable to trade with them, as the empire needed external markets for its products. The aggression over the Amell

> *"Common Tongue—The language of the Nordling peoples, with the exception of the Skellige Islands (see: 'Elder Speech, Skellige Islands Dialect'). The simple grammar and hoarse pronunciation clearly indicate its barbarous roots. It is likely an amalgamation of languages used by the Nordlings' ancestors in their ancient homeland, which, after their arrival in the North, was supplemented by concepts and phrases from the local tribes and peoples. The final formation of the Common Tongue took place after the first settlement of the Nordlings at the mouth of the Yaruga."*
>
> *—Effenberg and Talbot,* Encyclopaedia Maxima Mundi, *Tome III*

Mountains and the Yaruga River, therefore, promised few if any benefits, while being risky and extremely complicated as far as wartime logistics were concerned. Nevertheless, the ruler of Nilfgaard, Emperor Emhyr var Emreis, gave the order to attack.

His first victim was the Kingdom of Cintra. A little over a dozen years ago, the Nilfgaardian army crossed the Marnadal Stairs and crushed the Cintran army in battle at the mouth of the mountain pass. The imperial armies then descended into the valleys and stormed the kingdom's fortified capital almost on the march, in what became known as the Slaughter of Cintra.

The Nilfgaardians then turned their attention to the Kingdom of Sodden. After crushing its armies in the first battle, the Black Ones conquered the southern part of that land, known as Upper Sodden, before crossing the river Yaruga and attacking the northern region of Sodden. There, the Nilfgaardian might at last met its match, for the empire found itself confronted by the armies of Redania, Temeria, Aedirn, and Kaedwen, united under the leadership of Vizimir, king of Redania, as well as the sorcerers of the Northern Kingdoms. In the famous Second Battle of Sodden, the empire's seemingly unstoppable march was halted, and the Nilfgaardian army pushed back across the Yaruga. The First Nilfgaard War thus ended in a precarious stalemate, as the two sides eyed each other warily across the banks of the great river.

War with Nilfgaard became another opportunity to persecute the elves, who supported the invaders in the hope of gaining back at least some of their lost lands. Tales claiming the Nilfgaardians, who speak a variety of the Elder Speech, were descendants of the Black Seidhe further increased racial prejudice.

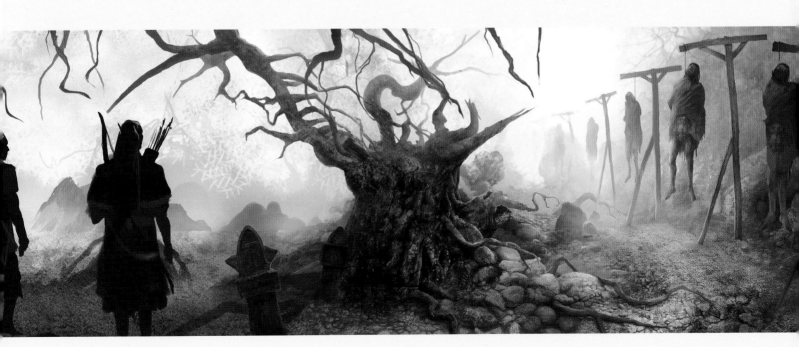

The Escalating Conflict and the Second War

Such a tumultuous peace could not last, and both sides prepared for the inevitable renewal of hostilities. The leaders of the previous coalition—the kings of Redania, Temeria, Kaedwen, and Aedirn, as well as the queen of Lyria, were emboldened by their victory and sought to seize the initiative. They planned to launch a surprise attack that would recapture Upper Sodden and Cintra, and push Nilfgaard back beyond the Marnadal. They even took certain steps to prepare for this operation, but Emperor Emhyr var Emreis, the crafty fox, acted first, having secretly completed his own preparations for war.

Said preparations began with disposing of those responsible for the recent defeat—among Nilfgaard's own military commanders and its enemies in the North. The former quickly found themselves under the executioner's sword, and were replaced with young, ambitious officers

"The Battle of the Marnadal Dale lasted a full day and a night, as the Cintran army never gave way, fighting bravely even in the face of overwhelming odds. When King Eist Tuirseach fell, Queen Calanthe herself took command and prevented the army from fleeing. Gathering the scattered Cintran regiments under her banner, she pierced the enemy encirclement and made for the city. For a fearless heart beat in the chest of the Lioness of Cintra, who proved herself more valiant in that bloody battle than many a man. The brave queen personally covered the retreat, riding at the head of the Cintran knights in a desperate charge against the pursuing Nilfgaardian infantry. In the end, she had to be carried into the city by her loyal retainers, bearing grievous wounds from Nilfgaardian pikes.

The Black Ones then stormed the city on the march, for there were too few Cintran soldiers left to man the walls. Cintra was plundered and her people slaughtered over the course of several days. However, the royal castle itself stood defiant for a time, and when the invaders breached the gate, they found no one alive. For the defenders—a handful of knights, magnates, and their families—preferred to die than to be dishonored by slavery. Queen Calanthe herself asked to be killed, but nobody could bring himself to raise a hand against the beloved monarch. In the end, despite her wounds, she crawled to the battlements and leapt from the wall. So died Calanthe Fiona Riannon, the Lioness of Cintra."

—A tale of the fall of Cintra

enamored with the new strategy of lightning-fast war, or, to quote their own term for it, "blitz." The latter fell victim to a meticulous web of intrigue and conspiracies. King Vizimir of Redania, the leader of the Northern coalition, met his end from an assassin's dagger, plunging his realm into chaos. Meanwhile, Emhyr worked to cultivate internal strife among the sorcerers who'd so greatly contributed to his previous defeat. He promised power, wealth, and position to the greedy or discontented, feeding their ambitions and sowing discord within their ranks.

At almost the exact moment the Nilfgaardian armies suddenly surged across the Yaruga in its upper course, Scoia'tael units, swayed by the devious emperor's promises of elven freedom, fell upon the Nordling rear. The invaders concentrated the bulk of their might on the weaker coalition forces on their right flank, easily smashing the armies of Lyria and Aedirn. While the battles still raged, Kaedwen suddenly changed sides, breaking all previous

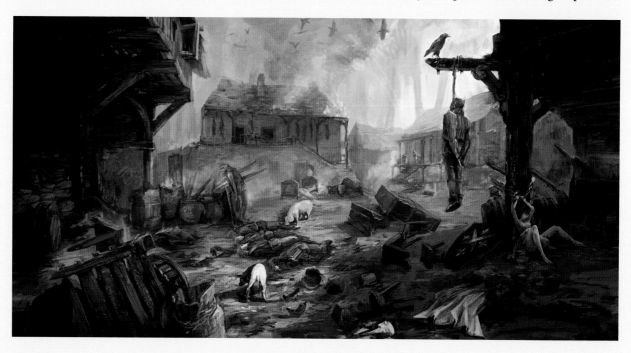

Imperial troops started off the war with a string of impressive victories, quickly breaking through the defenses of Lyria, Rivia, and Aedirn. Two weeks later the Nilfgaardian army crossed into southern Temeria as well, leaving a trail of corpses in its wake.

treaties, agreements, and alliances. Its armies crossed the Pontar, annexing part of its southern neighbor's territories—and thus sealing Aedirn's fate.

Temeria now remained alone on the battlefield. King Foltest, willing or not, had to concede and sign a separate truce with the empire, particularly after his right flank became threatened by King Ervyll of Verden, who also changed sides and paid homage to Emhyr. Said truce, just like so many in the history of warfare, turned out to be worth less than the paper it was written on. A mere sixteen days after it was signed, the Nilfgaardian armies, supported by Verden volunteers and Scoia'tael units, attacked Temeria and her protectorates—Brugge and Lower Sodden. The results were summed up by a colorful, but in all fairness rather accurate, expression that appeared among the common folk: "Emhyr ploughed Foltest without even using tallow."

A Halted Empire

Said ploughing was fortunately interrupted by the coming of winter, and the attempt to resume it once spring

"… And twenty and two sorcerers stood upon Sodden Hill, vowing to stop the Nilfgaardian onslaught with their powers or perish in the attempt. It was a terrible battle, immortalized in song. Fire rained from the skies, lightning flashed time and again, and the very earth groaned, as if tormented by the crackling energies that coursed through it as the heroic sorcerers wielded their magic against the spells of Nilfgaardian warlocks. Thirteen of their number would give their lives to shatter the Black Ones' strength, leaving only nine weary, bloody, but triumphant survivors at the end of the day. The place where they made their stand, once known as Kite Hill, is now called the Hill of Sorcerers or the Hill of the Fourteen. 'Fourteen,' because for some time no one could count the dead, nor recognize all of their corpses, and it was believed that the sorceress Triss Merigold was also among the fallen, when in fact she survived despite her terrible wounds. For that reason her name, next to thirteen others, is etched in the obelisk placed on the hill, and Merigold herself is also known as the Fourteenth of the Hill."

—Marcus Marcellinus, "Sorceresses and Sorcerers"

arrived did not go as well as the emperor desired. Opponents within the empire itself, who did not wish to see Emhyr triumphant in the war, plotted to have the imperial armies crawl onward awkwardly, leaving them open to constant harassment by guerrillas from the defeated kingdoms. Meve, the queen of Lyria, rallied troops which she used to pester and confound the occupying forces, and the vassal state of Verden soon faced its own anti-imperial insurrection. Smaller allies of the Four Kingdoms also joined in the war. The islanders of Skellige launched pirate raids on all Nilfgaardian coastal provinces and, acting together with the fleet of Ethain of Cidaris, blockaded and disrupted marine supply lines.

With these setbacks, the myth of the invincible empire was shattered for good. Volunteers began to flock to the Temerian army, while Redania finally recovered from the shock of losing its king and hastily dispatched an expeditionary corps to aid its southern neighbor. The Kingdom of Kovir and Poviss officially remained neutral, but those in the know maintain that it provided significant financial aid to the coalition. Certainly, the Koviri condottieri of the Free Company fought on the side of the Northern Kingdoms.

After the death of Eist Tuirseach, the Skellige-born king of Cintra, the islanders became Nilfgaard's most implacable foes. During the war their longships played a key role: acting as privateers, they carried out dozens of raids that almost completely paralyzed the empire's sea routes.

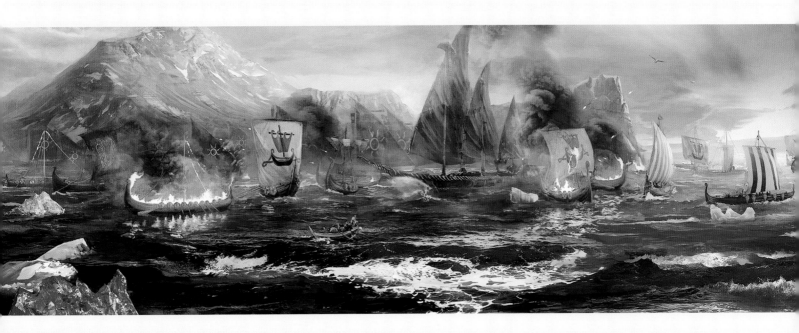

The decisive battle took place at Brenna, where the combined Redanian-Temerian forces were commanded by John Natalis, Constable of Temeria, and supported by mercenary troops and dwarven volunteers from Mahakam. After an entire day of heated battle, the Northern allies finally crushed the Nilfgaardian field marshal Menno Coehoorn's army, proving once again how effective the Nordlings could be when not fighting each other. Brenna became a turning point, for soon after, the feuding kingdoms of Aedirn and Kaedwen signed a truce and together routed the Nilfgaardian forces at Aldersberg, thus bringing the Second Northern War to a close.

". . . Squirrels, or Scoia'tael in elven speech. The name supposedly comes from the squirrel tails they pin to their caps as their insignia. Others say that, since they live in the woods, they survive on nuts, just like squirrels . . . They call themselves elven freedom fighters. I for one don't begrudge them freedom, but take issue with the idea of slaughtering all humans that seems to go with it. They appeared right after the First Nilfgaard War, taking advantage of the fact that our soldier lads marched to the south to fight the Black Ones . . . Most are elves, but there's no shortage of dwarves among them, and even some halflings.

The Scoia'tael prowl the forests, preparing ambushes for settlers, merchant caravans, military couriers, or smaller detachments alike. They're cruel and vicious, and have no regard for prisoners, since they can expect no clemency either. Their leaders are ruthless, and mothers still scare their children using names such as Faoiltiarna, Iorveth, or Yaevinn."

—Hardal Ygvenn, Temerian woodsman

Calm before Yet Another Storm

Nilfgaard was defeated once more, seemingly (again) for the last time. The emperor turned his attention to rooting out opposition at home, while the Northern Kingdoms went back to their internal affairs and quarrels. Henselt of Kaedwen and Demavend of Aedirn almost instantly rekindled their dispute over Lormark, or maybe Upper Aedirn, as each side had its own name for the land in question. In Redania, after the Regency Council's reign, the young King Radovid V took power, with his deeds soon earning him the moniker "the Stern." Foltest also had quite a bit of turmoil to deal with back home, beginning with Scoia'tael uprisings and Jacques de Aldersberg, head of the power-grabbing Order of the Flaming Rose, and ending with rebellious nobles and succession troubles.

A few years after the conflict's end, Temeria was riven by an internal conflict in which oppressed nonhumans faced off against the Order of the Flaming Rose.

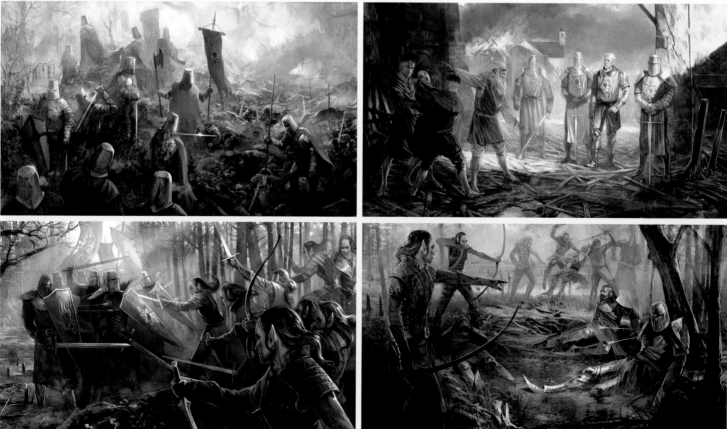

"Historical hindsight makes it clear that the inefficiency with which Prince Joachim de Wett carried out his command at the Temerian front was not born solely of his ineptitude, but apparently in even greater measure of his ill will. For Prince Joachim was a member of a conspiracy formed by several Nilfgaardian magnates who felt slighted by the emperor's refusal to consider marriage to their daughters. For his part, Emhyr var Emreis at the time sought to consolidate his hold on his newly conquered territories by finding Princess Cirilla, the missing heiress to the throne of Cintra and the granddaughter of Queen Calanthe.

The conspirators plotted to ultimately remove the emperor and place the then-underage Morvran Voorhis on the throne, ruling in his name as a regency council. Despite his extensive spy network, Emhyr var Emreis was aware only that there was a faction that harbored some resentment toward him, so he decided to send its influential members and troops loyal to them far away from the throne and the capital. He thus assigned Prince Joachim and Duke Ardal aep Dahy to command positions in the ongoing Northern War.

This gambit worked only in part, as the emperor did not consider that both aristocrats hated him so deeply that they were even willing to risk the success of Nilfgaard's military campaign to undermine him. They had hoped that a prolonged dearth of victories would turn the simple folk and the military against the emperor, and that many would support their revolt once they decided to strike. Neither man, however, lived to see his plans come to fruition. Prince Joachim was beheaded for his ineptitude, and Duke Ardal died of a sudden illness just before his army suffered a crushing defeat at Aldersberg. Many believe that this was no common disease, but poison taken by the duke to avoid disgrace and the punishment meted out to traitors. Others whisper that the emperor himself was responsible, preferring, for his own reasons, to avoid revealing aep Dahy's treachery through a public prosecution."

—Fragments of a master's dissertation in the Faculty of History at the Imperial Academy at Castel Graupian

And then, when it seemed the crises had at last reached an end, kings began to die.

The first victim of an assassin's blade was King Demavend of Aedirn. His death unleashed a flood of chaos that threatened to drown the realm, as burghers, knights, and peasants all tore at each others' throats in a bloody civil war. Soon Foltest of Temeria met a similar fate on the eve of his victory over the rebellious nobles of House La Valette. The unresolved issues surrounding the departed king's succession proved to be, if you'll permit me one of my favorite human idioms, a real kick in Temeria's bollocks, bringing this rich and powerful realm to its knees.

Obviously, everyone suspected that the Nilfgaardian Empire was behind both acts—and, as it later turned out, they were at least partially correct. Emperor Emhyr var Emreis deceived and manipulated the secretive Lodge of Sorceresses by having his agents first offer their services to the Lodge and then, while seemingly acting under its orders, carry out the assassinations of Demavend and Foltest. During the summit of kings at Loc Muinne, the cunning emperor suddenly revealed the Lodge's alleged role, providing the attending

Before the Third Northern War there was a short period of relative peace. How fragile this peace truly was, however, soon became apparent.

rulers with a convenient scapegoat and at the same time preventing the kind of collaboration between sorcerers and kings that had cost him so dearly during the First Northern War. The way was open once again for Nilfgaardian conquest, and soon imperial armies again crossed the Yaruga, biting deeply into their enemies' lands. Thus began the Third Northern War, the outcome of which will decide the fate of this region of the world.

GEOGRAPHY

The Boundaries of the Known World

What you humans believe to be the whole world is in truth but a small fraction. Both your existing civilizations—the Northern Kingdoms and the Nilfgaardian Empire—have, for the moment, reached natural barriers that the current state of human technology does not allow you to cross. I believe that this will change over the course of the next few centuries, as your enterprising race has never proven very tolerant of blank spots on your maps.

The cool waters of the Great Sea bathe the western shores of the Continent and the coasts of nearby isles. Past them lies only an endless expanse of unexplored, frothy blue.

West—The Great Sea

The waters of the Great Sea mark the frontier of your exploration of the West. By my reckoning, it will remain a *mare incognitum* for you for several more centuries, until you sufficiently master the arts of the navigator and the shipwright to overcome the perils of sailing on the high seas. For now, your marine trade routes still cling to the coasts, connecting a string of ports from distant Pont Vanis in the North to warm Baccala at the very southern tip of the Nilfgaardian Empire.

North—Dragon Mountains

The northern border of the human lands is formed by the massive range of the Dragon Mountains. No man to this day has managed to see what is on the other side, due to both the region's extreme remoteness and the dragon population that gives the range its name. The kingdoms located in the mountains' foothills are mostly content to mine the vast mineral reserves found throughout the valleys and peaks. Perhaps when the local lodes of precious metals (including gold, silver, and platinum) run out, humans will decide it is time to expand the known world further to the north. For now, that time still seems quite far away.

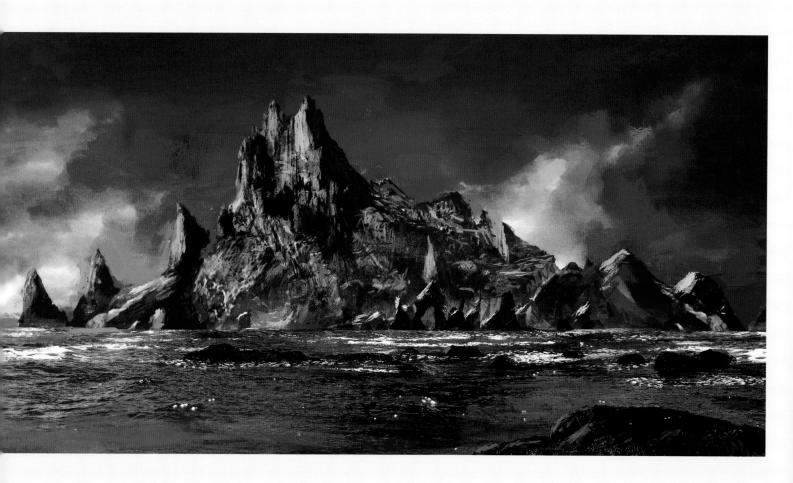

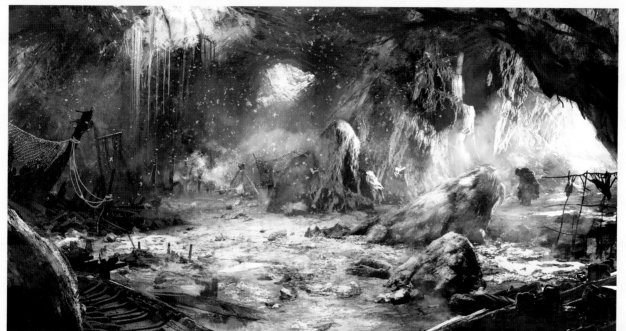

Though men have conquered most of the Continent, their expansion was stopped by natural barriers: the steep mountain ranges that to this day mark the northern and eastern edges of the known world.

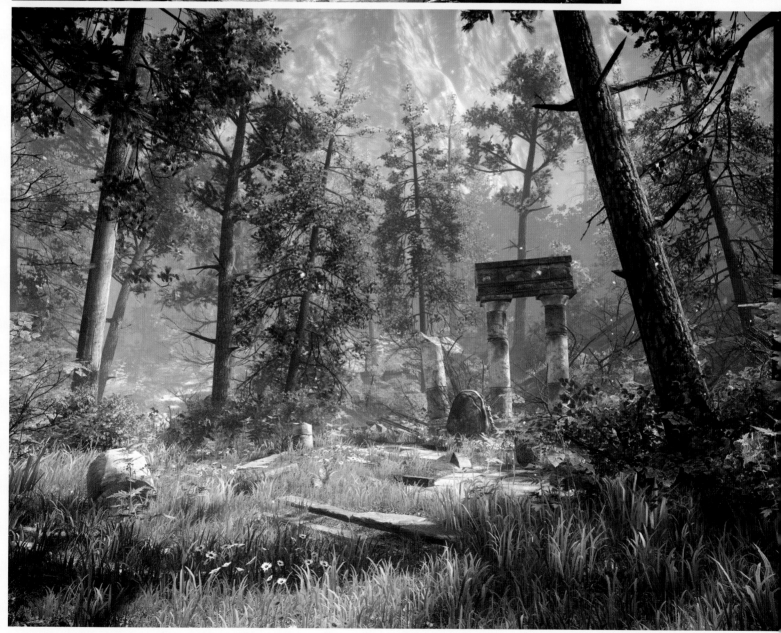

The World and Its Inhabitants

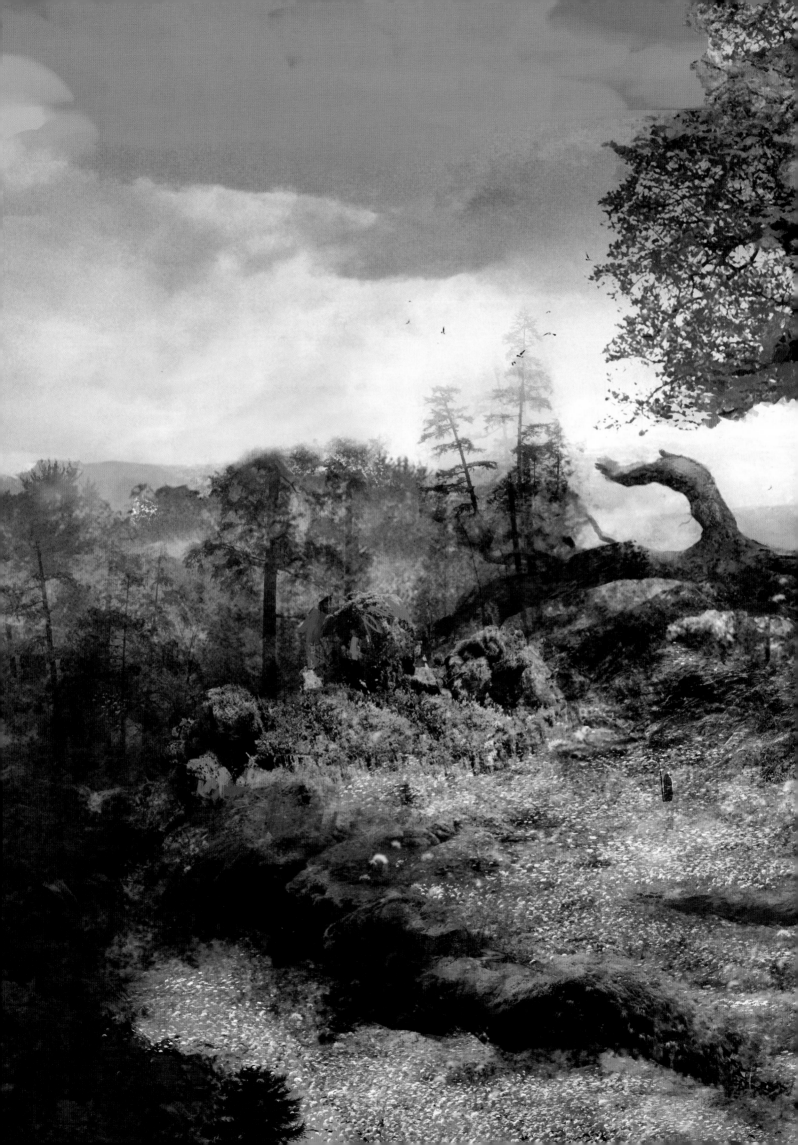

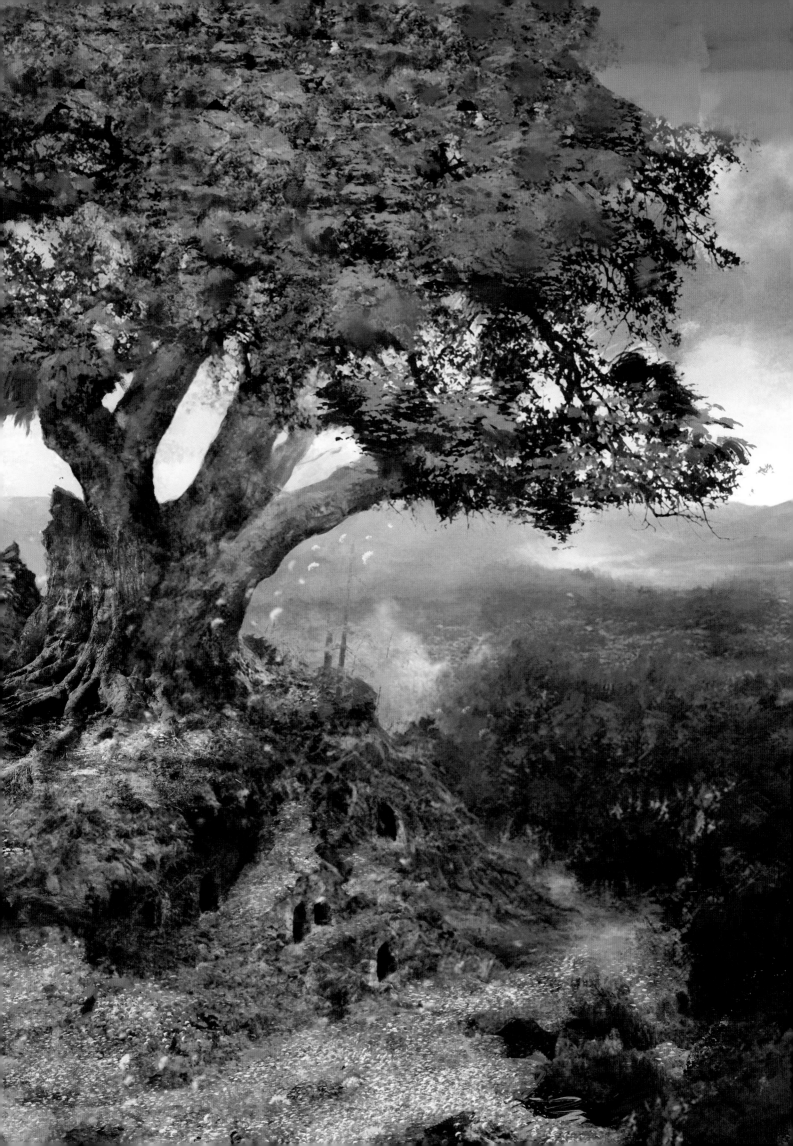

East—Blue Mountains, Fiery Mountains, Tir Tochair Massif, and Korath Desert

The eastern border is delineated by three mountain ranges. They run north to south, forming a tight barrier that is impassable save for a handful of saddle passes.

The northernmost are the Blue Mountains. That range contains the source of the Pontar River, as well as the ruins of once splendid elven cities—Loc Muinne and Est Haemlet. The Blue Mountains are also home for the Free Elves, who, though pushed into this inhospitable land, never laid down their arms and never submitted to your race.

Further south the Blue Mountains give way to the Fiery Mountains, from which originates another mighty river of the North, the Yaruga. The Fiery Mountains separate the region of the world inhabited by your culture, the one you tend to call "civilized," from the "barbaric" and "wild" lands of the East. Seeing mankind's history of bloody wars, intrigues, killings, and mass exterminations, I find it hard to agree with how these labels are assigned, though intellectually I understand that it stems

The caves dotting the Skellige coast hide both beauty and danger, which lie in wait for any adventurer brave enough to explore them.

THE ORDER OF THE FLAMING ROSE

". . . Originally arising from a secular ordo, the Order of the White Rose, which initially emerged in the Kingdom of Temeria. Instead of remaining true to its ideals, the Order of the White Rose became more concerned with land grants from local nobles and temporal wealth. Attaining membership required only the donation of one thousand Novigrad crowns to the order's treasury . . .

The order underwent a reformation after the Nilfgaard Wars. Upon the death of Grand Master Rudolf Valaris, the mantle passed to Jacques de Aldersberg. Under his leadership the order was renamed the Order of the Flaming Rose, and its rules were adopted from the tenets of the faith of the Eternal Fire . . .

Not long after the infamous events in Vizima, the Order of the Flaming Rose relocated to Redania, where, under the protection of King Radovid, it received grants of land in the vicinity of Roggeveen. In return, it began to serve as the king's armored fist."

—Reverend Hugo Balde, "The History of the Illustrious and Noble Order of the Flaming Rose"

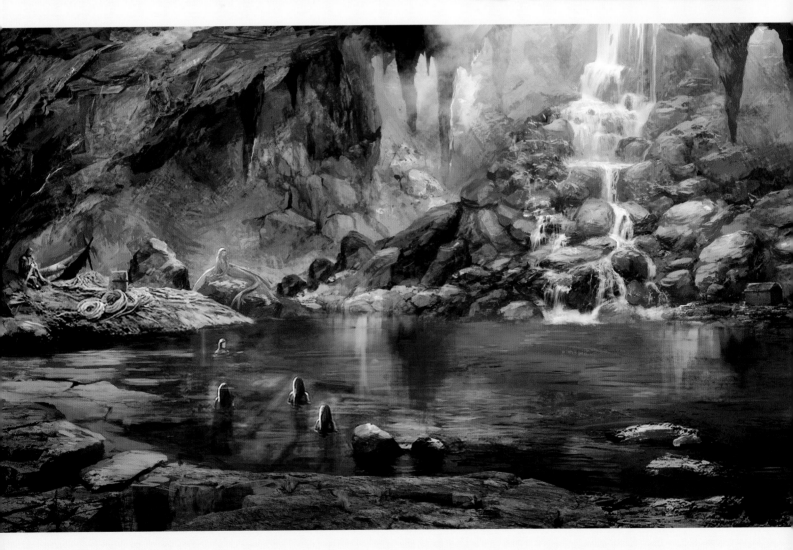

from the conviction of superiority characteristic to all cultures. To maintain the honesty and "neutrality" demanded of a scholar and chronicler, I should add that the peoples living there have an equally low knowledge and opinion of you.

The southernmost of the mountain ranges that make up the eastern boundary of the "known world" is Tir Tochair, which also forms the eastern frontier of the Nilfgaardian Empire. Tir Tochair is also one of the few remaining gnomish enclaves. To the east of the mountains lies an expanse of rock and sand known variously as the Korath Desert or, by those who live on its edge, the "Frying Pan." It is a wild and hostile place, perilous for any creature not adapted to lack of water and ex

"We crossed the Solveiga Gate six days ago, finally leaving civilized lands behind. Presently we are at least three hundred miles from the nearest human settlement of any decent size. Before us is the steep massif of the Fiery Mountains and Elskerdeg Pass, beyond which lies our goal—the exotic Zerrikania and the distant, mysterious Haakland. Before we reach them, however, we will need to cross dangerous, ill-famed lands, for beasts, wraiths, and tribes hostile to humans prowl the surroundings of Elskerdeg. Only yesterday we discovered the horrifying evidence of a cannibalistic feast among the remains of an encampment. The terrible sight chilled the blood in my veins, but we travel in a fully armed company, and surely will be able to defend ourselves from any assault."

—*Fragments of a diary found among the wreckage of a plundered caravan near the Elskerdeg Pass*

treme heat. Legends have it that the sands cover the necropolises and catacombs of a long-forgotten race or extinct human civilization. How and why they declined and disappeared from the pages of recorded history remains unknown.

The Far South

I would like to be able to say more about the regions forming the southern boundary of the lands of men, but veracity demands that I admit my own ignorance. I personally have no solid knowledge of what lies south of Nilfgaard, and any available answers to that question can only be found in the distant empire itself. Supposedly, the marine trade route to the exotic Ofir and Zanguebar leads that way, allowing merchants to

Trolls build their bridges even in such untamed areas as the Kestrel Mountains, hoping to extort tolls from passing travelers.

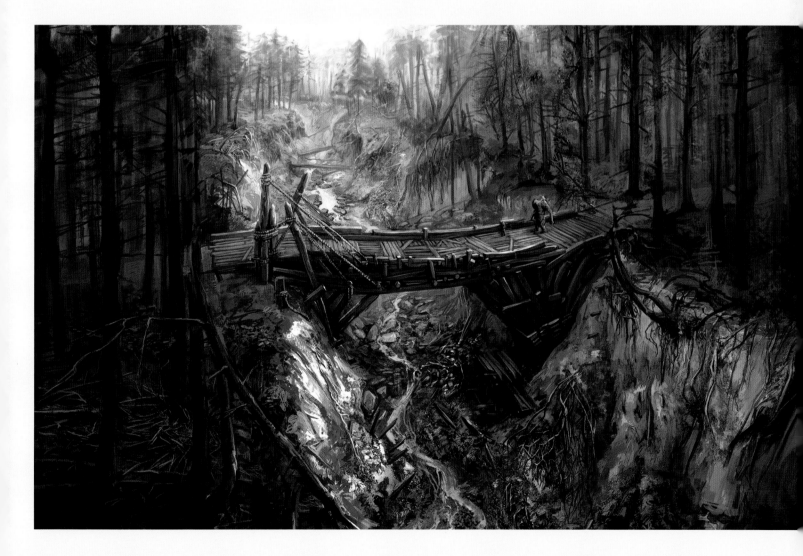

bring back all manner of spices and tales of white horses covered in black stripes. Some place half-mythical lands such as exotic Hannu or the land of Barsa there, where they say local custom demands all girls guard their virginity until they wed. But I truly cannot say with any confidence if these lands can be found in the far South, or indeed if they are anything more than rumors and drunken travelers' tales.

HUMAN LANDS

The Northern Kingdoms are a colorful collection of larger and smaller realms, shifting from time to time as one kingdom annexes some of its neighbor's lands or, on the contrary, shatters into several smaller domains during a civil war or other feudal fragmentation. I have always enjoyed observing these changes, since they are, in my opinion, one of the quintessential features of your race's history. The descriptions provided below are by no means intended to be exhaustive. Rather, they are a cursory sketch by an interested outsider, one (thankfully) not involved in the recent political events.

Kovir and Poviss

Let us begin by discussing the far North. Here, on the Gulf of Praxeda, are the rich lands of Kovir and Poviss, and their vassal duchies of Talgar, Velhad, and Narok. Considering the wealth of the realm, its mighty merchant marine, and its prosperous mines, one cannot help but marvel that a few centuries ago it still constituted a remote province of Redania. So remote, in fact, that King Radovid I simply handed it over to his hated brother, absolving him of any vassal obligations, just to keep him out of sight. Four generations later, after it turned out that the local mountains contain immeasurable lodes of gold, silver, copper, platinum, and iron ores of the highest quality, as well as the extremely rare ferroaurum and dimeritium, isolated Kovir had begun to turn quite a tidy, and noticeable, profit. Needless to say, Radovid I's great-grandson, Radovid III, known as "the Red," took an interest in renegotiating the arrangement. When the answer he received from Gedovius, the self-styled King of Kovir, was not to his liking, he marched north with an army, arranging for assistance from Benda of Kaedwen. A few months later the remnants of the combined Redanian-Kaedweni armies slogged back home, battered and groaning softly. Wealthy Kovir, as the invaders had discovered to their detriment, had the means to hire the best mercenary armies available to protect its borders and

The growth of manufactures, trade, and seafaring were the direct factors leading to the rise of great port cities such as Novigrad or Pont Vanis.

business. As the power of coin has not diminished in the least since that time, the kingdom has never again been assaulted by its neighbors and has remained staunchly neutral, allowing it to profit from trade in peace. This story never ceases to amuse me, for it is indisputable proof that it pays to be resourceful and diligent, and that appearances can be deceiving.

The Hengfors League

Not far to the southeast are the lands of the small principalities of Creyden, Malleore, Caingorn, and Woefield. They once formed the East March of the Kingdom of Kovir and Poviss, but during the latter's temporary secession and accompanying coup, these small principalities obtained lasting independence. After a picturesque period of chaos and internal wars that lasted no less than two centuries, the young, ambitious King Niedamir of Caingorn rose above his rivals and began forging a coalition. In other words, he hanged, beheaded, and quartered all opposition for as long as it took the local nobility to officially recognize him as the leader of an alliance which, from the name of his principality's capital, became known as the Hengfors League.

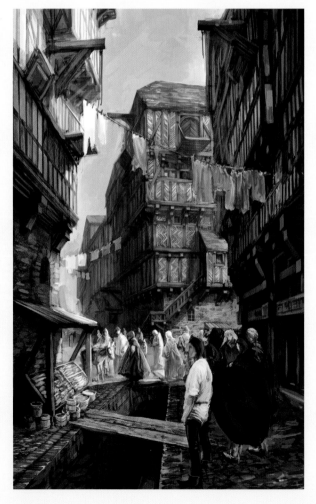

The Great Kingdoms

The hub of the lands of the North is composed of the four largest, most ambitious kingdoms—Redania, Kaedwen, Temeria, and Aedirn. Until recently, they were the prime players in the great game of politics and war that decides the fate of kingdoms and dynasties. With such high stakes, however, one can never be certain that the game is truly won. For it turned out that the Nilfgaardian Empire, far from being busted out, in reality never left the table—indeed, while the others were still counting their winnings from the previous hand, the emperor took over the deal and changed all the rules.

Redania

Located between the Buina and the Pontar Rivers, Redania has always had the highest ambitions, and has never failed to remind its neighbors of its lofty aspirations. Its dynasty can trace its roots directly back to the First Landing in the Yaruga delta. It was founded by the semilegendary King Sambuk, whose name

remains synonymous with archaism in current Nordling folk sayings. The Redanians treat the whole affair with excessive seriousness, and are rather pompously proud of their heritage. The realm's capital is Tretogor, but its true pride and joy is Oxenfurt and the world-famous university located there. Redania's army was always one of the largest in the North, and its Royal Corps fought valiantly in both wars against Nilfgaard.

Redania is also sovereign over the lands of the Arc Coast, the Nimnar Valley, and Gelibol. It is also said that some time ago the realm of Jamurlak, which for a long time was ruled by a psychopathic gaffer named Abrad, was also subject to Redanian rule. That geezer's cruelty was as legendary as his lustfulness, but the last I heard, the disgusting old lecher had finally left this vale of tears—much to the relief of his long-suffering subjects.

Kaedwen

To the east of Redania lies wooded Kaedwen. It is the youngest of the Northern Kingdoms, taking its final form only two centuries ago during the second war

The Pontar is one of two great rivers in the North. Flowing east to west, it acts as a natural boundary between the kingdoms of Redania and Kaedwen and those of Temeria and Aedirn.

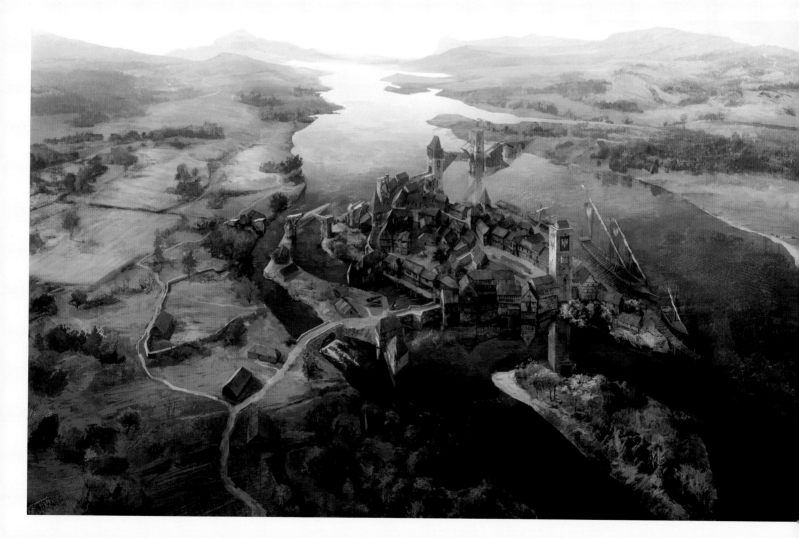

against the elves. For this reason, the Kaedweni disdain for that race is still quite fresh, and the feeling is mutual. Kaedwen has also frequently clashed with its neighbors, especially Aedirn to the south. Ard Carraigh is the realm's capital, but its most famous city is Ban Ard and its sorcerers' school.

Due to Kaedwen's quarrelsome nature and history of conflict, as well as its forested landscape, the surrounding realms see its people as backward provincials, no better than the descendants of outlaws and brigands. Nevertheless, if one glosses over their aversion to elves, the Kaedweni are a hospitable and friendly people. A man on the road will never be denied aid, and each hamlet is wide open to the weary traveler. The Kaedweni are also known for their ribald sense of humor, and their folk sayings, such as "a bitch will never bite another bitch," are not bereft of a certain simple wisdom.

Temeria

The northern border of Temeria is delineated by the Pontar. To the west, the realm borders seaside Cidaris. To the east, by means of the Mahakam Massif, it shares borders with Kaedwen, Aedirn, and Lyria. For a long time, the Yaruga formed its southern border—apart from the borders with Brugge and Sodden, of course—but during its long history Temeria also came to rule over the lands found on that river's southern bank as well.

That history, much like Redania's, dates back to the First Landing. Both kingdoms share a storied history of neighborly rivalry, border disputes, and local wars. The Temerian kings hold court at the city of Vizima, located on the shores of a beautiful lake. The realm's other important cities include Maribor, heavily fortified Mayena, and the bustling port city of Gors Velen, famous for its proximity to the sorceresses' school at Aretuza.

Before the onset of the crisis which now plagues that realm, Temeria was one of the most powerful of the Northern Kingdoms, and its cruelly assassinated King Foltest also held the titles of Duke of Sodden, Sovereign of Pontar and Mahakam, and Senior Protector of Ellander, Brugge, Riverdell, and Angren.

Aedirn

Much like Kaedwen, Aedirn was formed later than its western neighbors. Despite that, it developed faster than its neighbor to the north, a fact many Kaedweni deeply envy. Aedirn enjoys its prosperity thanks to both fertile lands and the mineral wealth found in the surrounding mountains. The cities of Gulet and Eysenlaan are large centers of metallurgy, and Aldersberg, along with the realm's capital of Vengerberg, houses huge textile workshops, dyeworks, and distilleries.

Aedirn has suffered greatly during the last two years, as a result of the dispute with Kaedwen and the resulting war over its northern provinces, and from the imperial invasion during the Second Nilfgaard War. The empire not only plundered and burned, but also disassembled entire production centers and shipped the machinery

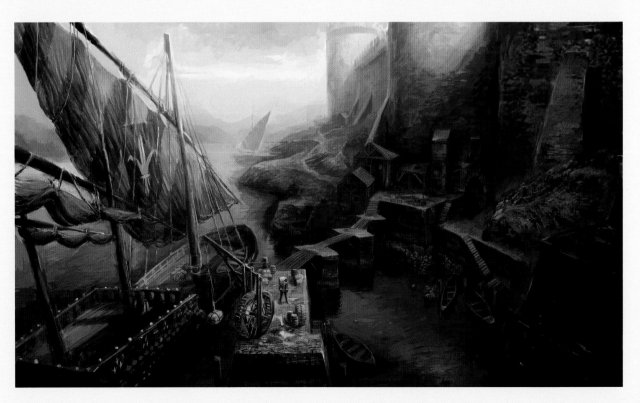

Navigating the North's great rivers by boat is a fast and relatively safe way to travel or transport goods.

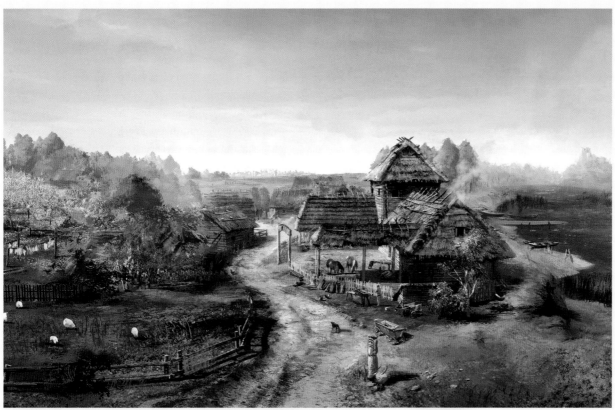

Thatch-roofed wooden huts are typical of Temerian village architecture. The lack of palisades or other fortifications indicates this is a peaceful area.

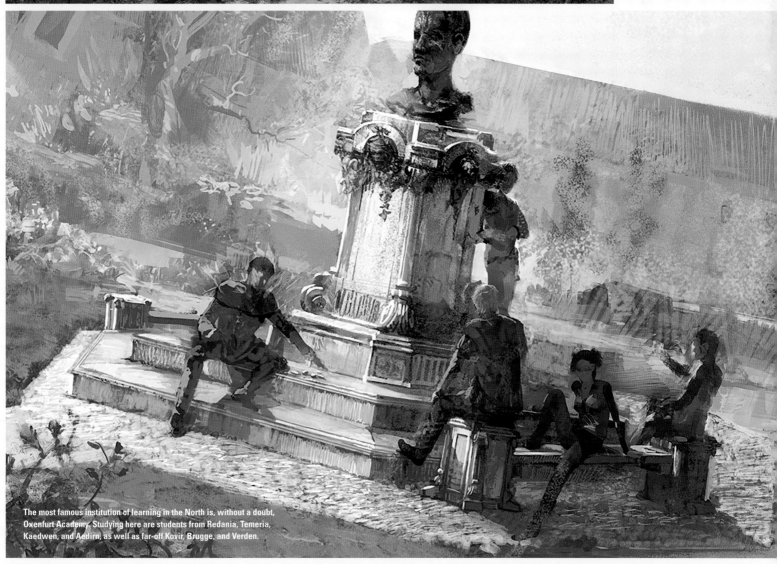

The most famous institution of learning in the North is, without a doubt, Oxenfurt Academy. Studying here are students from Redania, Temeria, Kaedwen, and Aedirn, as well as far-off Kovir, Brugge, and Verden.

The World and Its Inhabitants

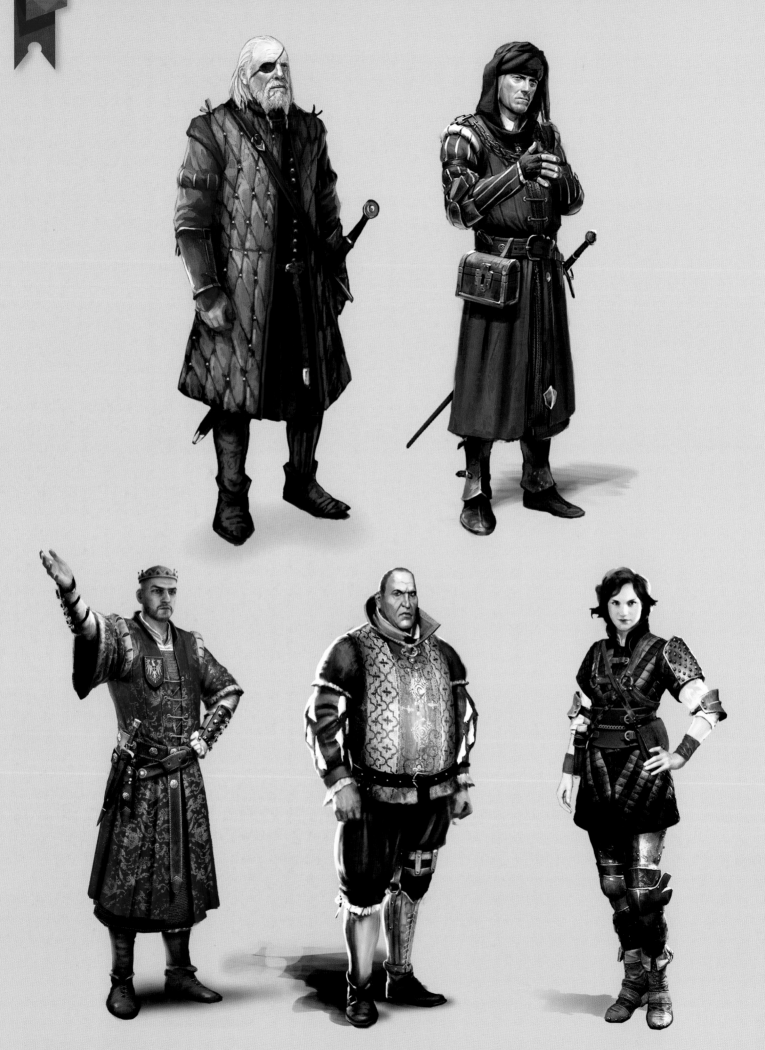

south. I hear they call this "the modern art of managing military conflict." Moreover, the peace accords forced Aedirn to give up a portion of its territory, the Valley of the Flowers, to the elves. The stories that reached me after King Demavend's death spoke of social disturbances, peasant revolts, yet another conflict with Kaedwen, and a growing separatist movement in the Pontar Valley. Needless to say, I am not inclined to pay a visit there anytime soon.

"During the greatly indolent rule of Vestibor the Proud, defiant Redania lost the fertile valleys of the Buina and the Nimnar to a coalition of northern principalities. The most ignoble loss, however, came during the so-called Seven Years' War, when Temeria conquered Novigrad, then capital of the realm, and the surrounding lands at the mouth of the Pontar. This forced the kings of Redania to relocate the capital to Tretogor, where it has remained.

Only Vestibor's grandson, Radovid III, known as 'the Bold' or 'the Red,' managed to win back the lost lands and settle the feud with Temeria. It was then agreed that Novigrad would be made a Free City, and it holds that status to this day."

—Roderick de Novembre, The History of the World

surprising, since the hierarch, Cyrus Engelkind Hemmelfart, though known for his racism, is an old, slothful geezer who doesn't care for oppressing nonhumans nearly as much as he cares for arriving at the privy in time. Perhaps the new steward of state security, who I hear replaced his predecessor by burning him at the stake after a public trial, is the one truly responsible for this state of affairs.

The Lesser Kingdoms

When describing the lands of the Four Kingdoms, one cannot omit their smaller neighbors. These domains, though not as grand, usually have an equally rich and interesting history, and during their existence played host to many important events that shaped the fate of this part of the world.

The Free City of Novigrad

If any city in the North deserves the lofty title of Capital of the World, it is definitely Novigrad. Perched on the mouth of the Pontar like a fat merchant in an inn's alcove, it is surrounded by the similarly familiar smell of sweat and money. Like our archetypal merchant, it is loud, foppish, covetous of profit above all else, and allows no one to disregard it. That is because the Free City of Novigrad is undoubtedly the greatest port on the Great Sea, and over a dozen of the most influential merchant companies make it their home. It also boasts four huge water mills, a mint producing its own coin, eight banks, nineteen pawnshops, almost forty inns, a dozen whorehouses, and nearly two dozen temples, most dedicated to the Eternal Fire. Recently, that cult's influence has reportedly grown considerably, allowing it to begin to wield real power among the city's faithful. This is somewhat

The Kingdom of Lyria and Rivia

This small kingdom has been Aedirn's staunchest ally for quite some time, forming a bulwark against the threat of Nilfgaard and defending the strategic border formed by the Yaruga River. Lyria contains one of the only two locations suitable for mass crossings of that great river, in the region known as Dol Angra. This crossing is defended by the Lyrian-built fortresses of Spalla and Scalla.

Queen Meve rules the kingdom. During the recent conflict with Nilfgaard, she came to be known as a strong, resourceful woman—almost a second Calanthe. Indeed, the monarch, commonly referred to as "the White Queen" or, less officially, "the Virile Widow," personally organized a resistance movement against the imperial occupation. Leading a motley force culled from knights, peasants, and common bandits, she harassed and ambushed Nilfgaardian troops without rest or mercy, winning the undying love and admiration of her subjects. It is said that they would willingly ride through hellfire, if the queen so commanded.

Skellige

The rocky, inhospitable Skellige Archipelago is one of the earliest lands settled by humans. Its people are valiant and skilled sailors—merchants, as well as robbers and pirates—who in addition to the Common Tongue also speak a native dialect based on the Elder Speech. Also in contrast to the

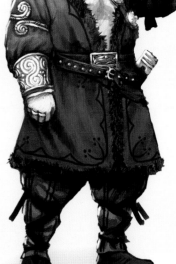

Unlike the homogeneity of Nilfgaardian fashion, noted for its dark and subdued colors, the apparel worn in the Northern Realms is very diverse, made up of a colorful mixture of styles that differ depending on social status and place of birth.

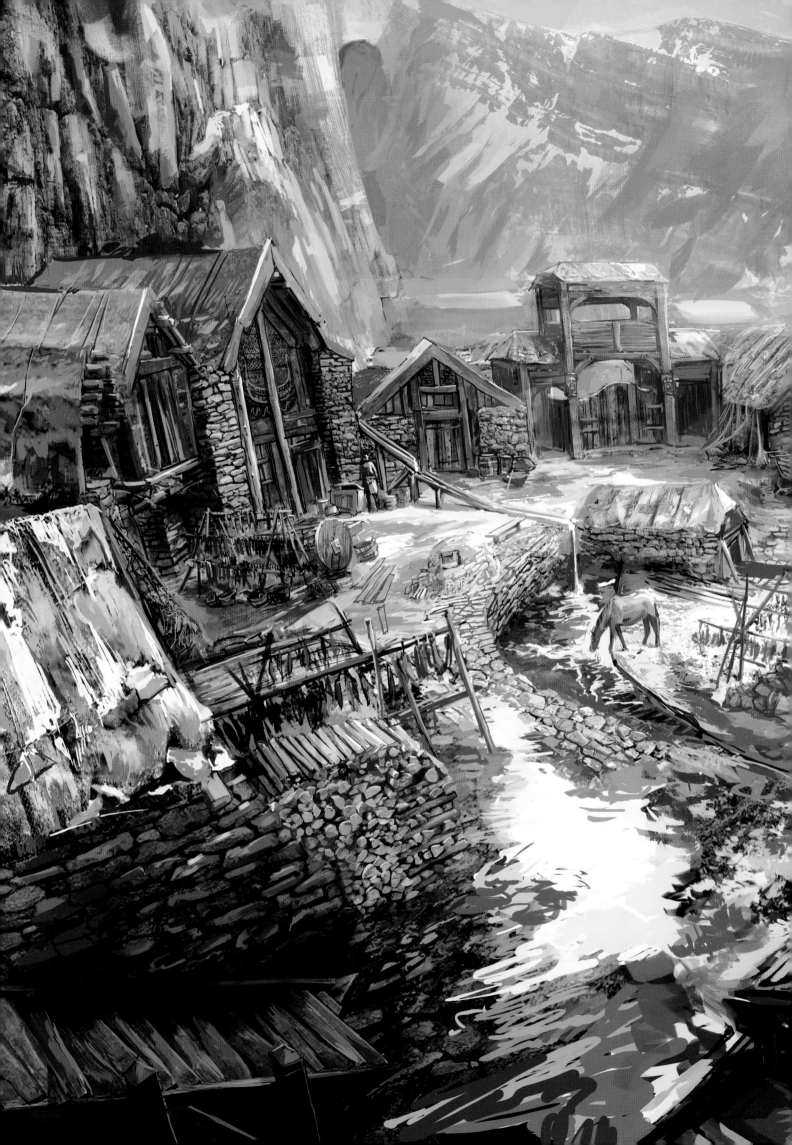

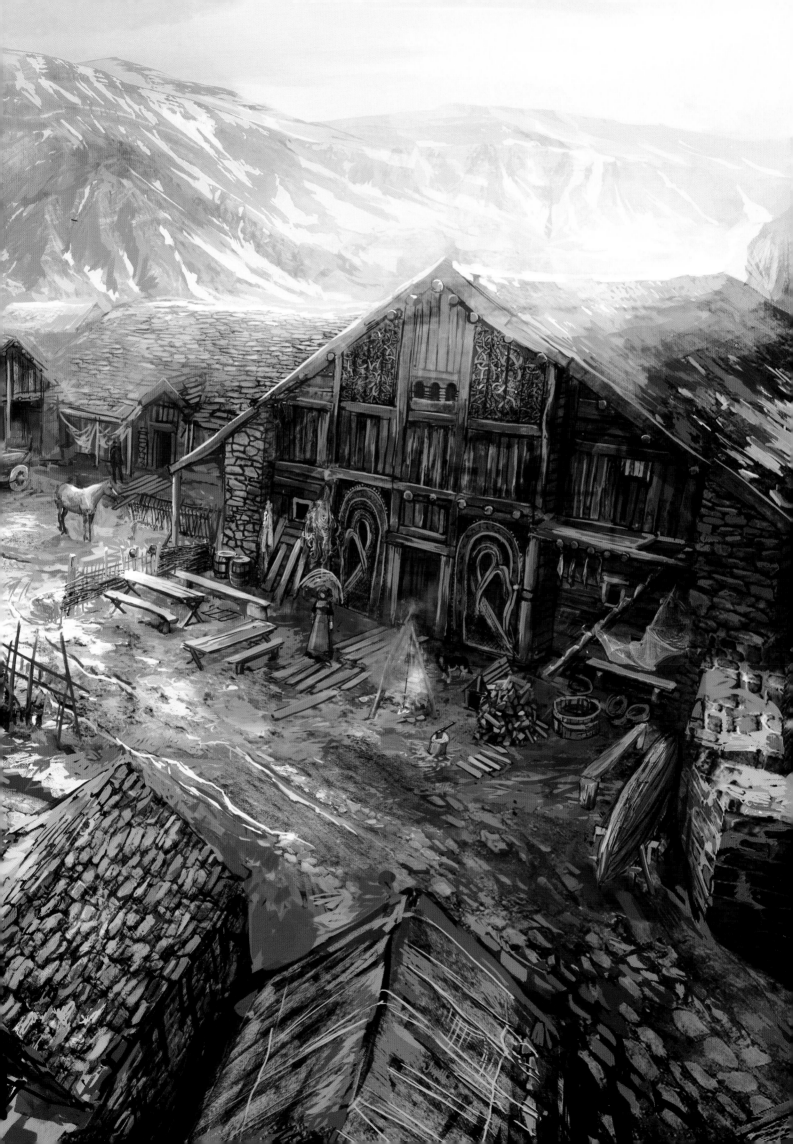

continental North, the Skellige Islanders are predominantly freemen, possessing rights nearly equal to those of the jarls who lead them.

The islands are united under a king chosen from one of the major clans, who is elected during traditional moots. His subordinate jarl is the commander of the military forces, leading, among others, the marine kingdom's powerful fleets.

The Skellige Islands are longtime allies of the Kingdom of Cintra, having been connected to it through marriage—the king of Cintra, Eist Tuirseach, was also the brother of Skellige's King Bran and the uncle of Jarl Crach an Craite. After King Eist's death in the Battle of the Marnadal Dale, the islanders swore bloody vengeance on the Nilfgaardians, becoming their implacable foes.

Cidaris

Though its territory is many times smaller, Cidaris's history is as long and as rich as those of Temeria and Redania. This small, beautiful realm owes its wealth and prosperity to marine trade and rational exploitation of the ocean's wealth—through fishing, pearl hunting, and

> *"Sodden—A no-longer-extant kingdom that straddled the Yaruga River in its lower course. After the First Nordling War (see entry) and the death of its King Ekkehard (see entry), it was divided. The part on the river's northern bank became the Lower Sodden (see entry) region of the Kingdom of Temeria (see entry), while the part on the Yaruga's southern bank became the Upper Sodden (see entry) region of the Nilfgaardian Empire's (see entry) Province of Cintra (see entry).*
>
> *After the Second Nordling War (see entry), according to the Peace of Cintra (see entry), Upper Sodden was also incorporated into the Kingdom of Temeria."*
>
> —*Effenberg and Talbot,* Encyclopaedia Maxima Mundi, Tome XII

amber mining—as well as its famous vineyards. Goods from all the four corners of the world can be found at the famous Sea Bazaar of Cidaris, and the city's shipyards launch and overhaul several hundred ships per year.

King Ethain of Cidaris is widely considered an enlightened, just ruler, as well as a wise politician who does not meddle in his neighbors' affairs, and expects the same in return. The last war against Nilfgaard was an exception, as Cidaris supported the Northern coalition with its fleet.

Verden, Brugge, and Kerack

These small kingdoms lie in the shadow of Brokilon, the enclave of the dryads, who restlessly and violently guard against any humans trespassing on their lands. This largely defines the everyday lives of the kingdoms' inhabitants.

Located between Cidaris and Verden, the small Kingdom of Kerack contains little beside the port city of the same name. Its king, Viraxas, is descended from a former pirate who two or three generations ago

Each of the isles scattered across the Great Sea to form the Skellige Archipelago is ruled by a jarl belonging to one of six powerful clans.

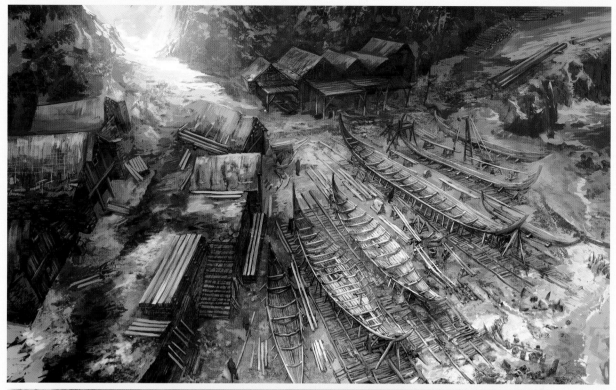

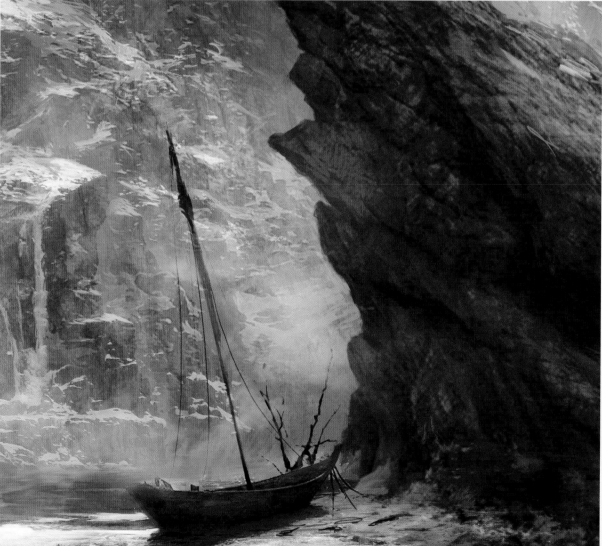

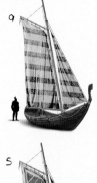

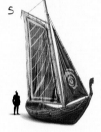

Seafaring has deep roots in the Skellige Isles. The isles' shipyards cannot compare to those of Cidaris in terms of the number of completed units a year, but the islanders' longships are considered some of the world's best vessels.

declared himself the ruler of that dry, mostly unwanted strip of land. The realm is not known for much beyond its rampant corruption, and the only thing truly worth mentioning about it is the inn Natura Rerum, which I heartily recommend.

Verden was at one time a vassal of the Kingdom of Cintra, which is now occupied by the Nilfgaardian Empire. It holds a strategic location at the mouth of the Yaruga, and its three fortresses of Nastrog, Rozrog, and Bodrog command the river's northern shore. During the last war against Nilfgaard, Verden betrayed its former allies, paying homage to the empire and assaulting its neighbor, Brugge. Prince Kistrin then led a successful rebellion against his treacherous father, bringing Verden back into the Northern coalition. Despite this return to the Northern fold—or perhaps in part because of how quickly it followed Verden's first defection—the young King Kistrin and Verden as a whole continue to be viewed with suspicion by their neighbors.

"Far beyond the reaches of the Blue Mountains lie the legendary lands of Zerrikania and Haakland. The former is inhabited by warlike clans led, if the tales are true, by women. Though such things may seem unbelievable, companies of Zerrikanian mercenaries do sometimes include Free Warriors—women with tattoos covering their faces, clad in the furs of wild beasts, and brandishing their weapon of choice, the curved saberras, which they use with deadly efficiency . . .

We know even less of Haakland, save its location to the northeast of Zerrikania. The people of that land are rumored to be the finest horsemen in the world, learning the art as babes before they even learn to walk. Though not referred to by name, they are also possibly mentioned in one of the apocryphal versions of Ithlinne's prophecy, which speaks of a people that will come from the East like a storm, to burn, slaughter, and feast on the ruins, drinking from the skulls of their fallen foes."

—Bella Jande, *"Tales and Legends of Distant Lands"*

Venzlav, the king of Brugge, was also a vassal of Cintra, but after the fall of his southern neighbor he turned to Temeria for protection, paying homage to his cousin, King Foltest. This is hardly surprising, as on a sunny day he could plainly see the flashes of Nilfgaardian spearheads across the Yaruga. Though Brugge is a small and poor kingdom, its people fought with unforeseen valor during the last war against the empire, both when defending their lands against Verdenian volunteers and the professional Nilfgaardian army, and during the later clashes which led to the victory at Brenna.

The Nilfgaardian Empire

To the south of the Yaruga lies the Nilfgaardian Empire, an expansionist realm which has steadily conquered its smaller and weaker neighbors over the last few centuries, continually increasing its size. It was likely founded by the people of the city of Nilfgaard, which lies far to the

States conquered by the Nilfgaardian Empire must adopt imperial jurisdiction, nomenclature, and symbols. The Great Sun banner now flies above the former capitals of over a dozen one-time kingdoms and duchies that are now Nilfgaardian provinces.

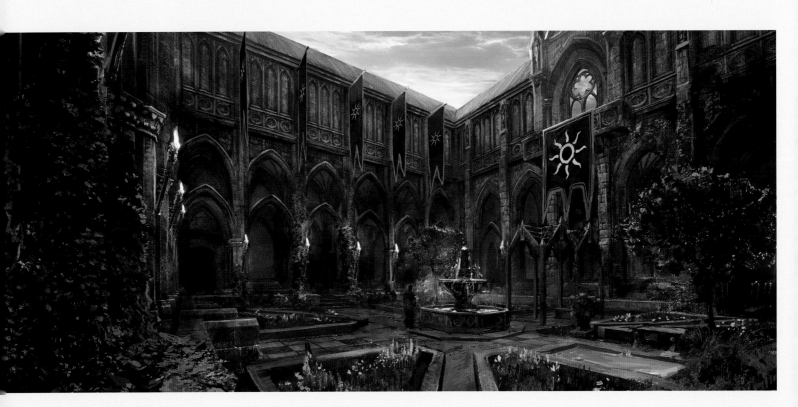

south on the Alba River and now serves as the capital of the entire empire. During their history of ever-expanding conquest, the Nilfgaardians subjugated a multitude of principalities and kingdoms, including Ymlac, Vicovaro, Rowan, Etolia, Gemmera, Maecht, Ebbing, Geso, Mettina, and Nazair. During the recent Northern Wars the empire added Cintra to its possessions, including the Duchy of Attre and, temporarily, Upper Sodden and the vassal state of Verden.

Lands incorporated into the empire typically hold the status of imperial provinces, ruled by appointed governors. Monarchs from lands that willingly paid homage to the emperor were usually allowed to keep their titles and positions, and their realms formally remain kingdoms or principalities. Though all the people of the empire are colloquially known as Nilfgaardians in the North, someone once explained to me at length that within the empire that name is reserved only for the inhabitants of the original region of Nilfgaard proper.

The emperor rules as an absolute sovereign, though a ceremonial senate does exist. The present monarch is Emhyr var Emreis, Deithwen Addan yn Carn aep Morvudd, which in the Elder Speech (which gave birth to the Nilfgaardian language) means, "White Flame Dancing on the Barrows of His Enemies." He is probably the most powerful monarch in this part of the world, though that does not mean his authority is unchallenged. Indeed, a significant, hidden opposition to his rule exists within the empire. Still, the emperor has enormous resources at his command, including the empire's vast professional armies, the corps of garrison troops that maintain internal order, the mysterious secret police, and his fanatical personal guard, the famous "Impera" brigade. Keeping this in mind, it does not seem likely that the current occupant of the imperial throne will be replaced anytime soon. On the other hand, history has shown many times that even the greatest of men can fall, and the accompanying crash tends to be all the more deafening.

NONHUMANS AND THEIR LANDS

Human dominion over the known world is presently an indisputable fact. Over the course of a mere handful of centuries, you have forced other races to acknowledge your supremacy and to coexist—but only on your terms. Those who would not submit were forced to retreat beyond the borders of civilization or perish. The hunger for space displayed by your species is, I must say, at once both enthralling and terrifying.

In wild, unpopulated regions one will at times come across settlements and houses built by primitive races—ogres, trolls, or the half-legendary giants.

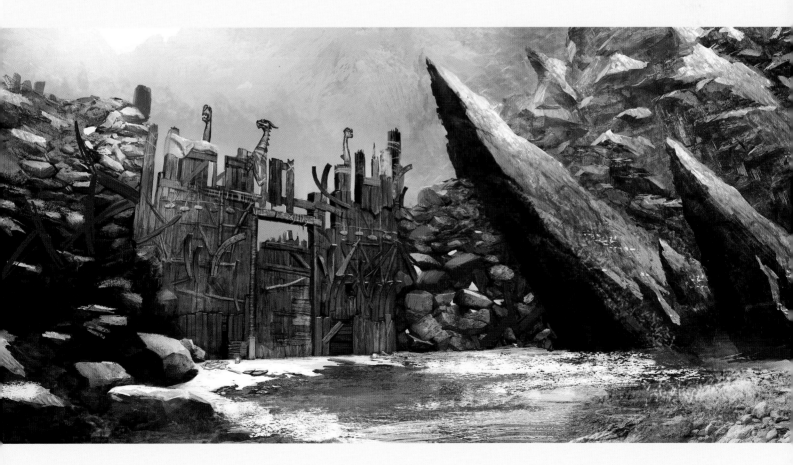

Dwarves

The origins of the dwarves date back to ancient times, even preceding the Conjunction of the Spheres. They are a short, but stout and tough, people accustomed to hard work. Dwarves have a reputation for being dependable and honorable, but are also often seen as endlessly grumbling curmudgeons who care for little except their own kin and gold, which they invariably love to accumulate. In this, it is often said, they are second only to dragons and men. They are also famous for the great jealousy with which they guard their less-than-handsome women, believing that everyone else is eagerly awaiting the chance to seduce them. Very few

have deigned to risk explaining to a dwarf why this belief might be erroneous.

The dwarven ancestral homeland is the mountainous region of Mahakam, though many also live in human cities, where they ply various trades as craftsmen, bankers, or merchants, or find work as bodyguards or mercenaries. For unlike elves, dwarves have taken a pragmatic approach to assimilation, adopting many human customs, practices, and garments as their own, which has significantly reduced the rift between these races. Still, human prejudice against dwarves has not disappeared, and sometimes leads to violence and pogroms. For their part, the more conservative dwarves, or those who sympathize

The expansion of human settlement that took place several hundred years ago forced the dwarves to retreat to a limited area inside the Mahakam mountain range. Nevertheless, outside of this range one can still encounter remnants of their former settlements and mining colonies.

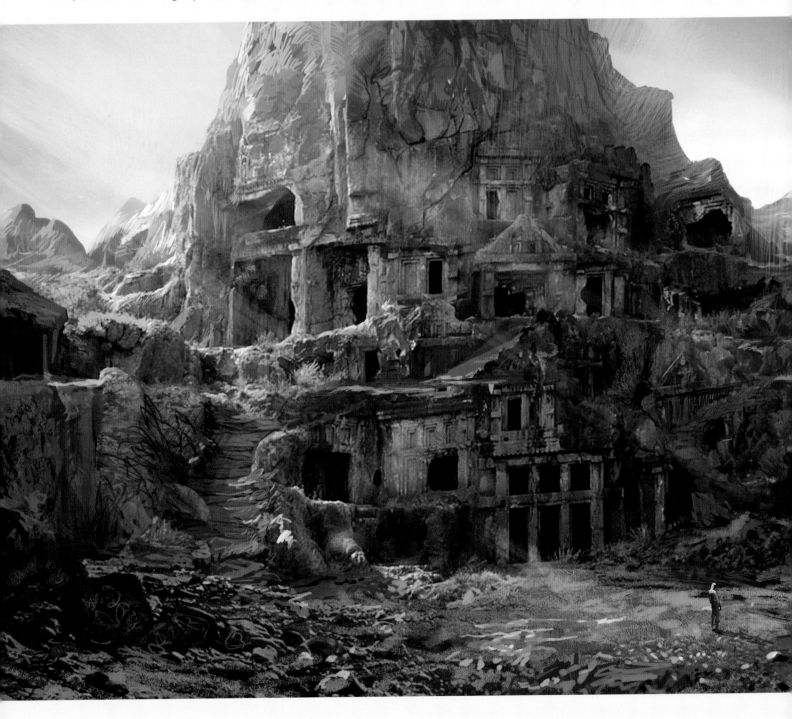

with the Scoia'tael, view dwarves who remain in human employ as traitors and mere dogs on human leashes. As it is often said, straddling the fence is not only uncomfortable for one's arse, but gives both sides a good knee to kick.

> "Gnomes, though shorter than dwarves and not as strong, are equally resistant to hardship and much more agile. This ancient and noble race is characterized by their long, pointy noses, in which they take great pride . . . Like dwarves, they love their handiwork, and are particularly adept at the arts of the metallurgist, the armorer, the jeweler, and the goldsmith. Not many, however, elect to ply their trade beyond their native lands, since their grand mastery, and the profits which it brings, inevitably becomes the object of envy and thus human aversion, which ends in slander at best and pogroms at worst."
>
> —Reverend Jarre of Ellander the Elder, "The Truthful Description of the Elder Races"

herence to tradition and his controversial decrees aimed at upholding it. During the Northern Wars, the dwarves of Mahakam remained officially neutral but tended to support the Northern Kingdoms. The elder spoke out decisively against his kin joining Scoia'tael units, and Mahakam provided much-needed arms to the Northern coalition, even going so far as to form its own volunteer regiment.

Mahakam

The dwarven ancestral homeland contains the great mountain massif of the same name. It rises between the lands of human kingdoms—Temeria to the west and Aedirn and Lyria to the east. Mahakam is famous for its workshops, forges, and ironworks, which are renowned for producing the best steel in the world and, as a result, the finest weapons.

Although the kings of Temeria are the titular lords of Mahakam, in practice the region is largely autonomous, with the local dwarven clans governed by a chosen elder. Currently the position is held by Brouver Hoog, an elderly dwarf famous for his ad-

Elves: The Aen Seidhe

The elven race is past the time of its glory. Once the most populous people in this region of the world, they have been in decline ever since the arrival of humans a few centuries ago, ceding ground to them on nearly every front.

In their own language the elves call themselves the Aen Seidhe—that is, the People of the Hills. They are

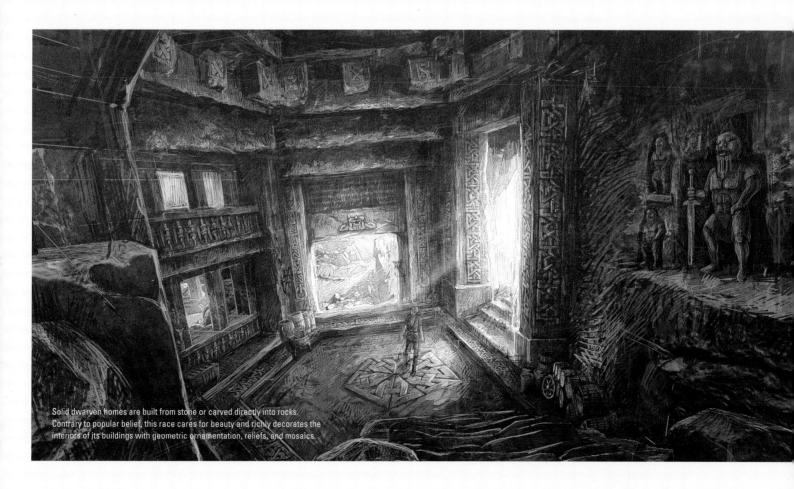

Solid dwarven homes are built from stone or carved directly into rocks. Contrary to popular belief, this race cares for beauty and richly decorates the interiors of its buildings with geometric ornamentation, reliefs, and mosaics.

tall, slim, and of slender build. Their faces are elongated, bearing symmetrical features and large eyes, while their ear conchae are slightly pointed. They further differ from humans in that they lack canines, which leads many to the mistaken assumption that elves do not eat meat and would not hurt any forest animal. This is obviously hogwash. Elves hunt all manner of animals, and most would never pass up a bit of tasty, roasted venison.

They are an extremely long-lived race, with a lifespan that can last hundreds, if not tens of hundreds, of years. What is an eon for you seems but the blink of an eye for them, just another season in the steady cycle of time. Despite their long lifespans, however, elves can only produce offspring while they are young—which is one of the reasons you humans have triumphed in the contest for dominion over this world.

Due to a steady series of losses in conflicts with humans, elves were deprived of most of their ancient lands. Only recently, during the wars between the Northern Kingdoms and the Nilfgaardian Empire, did

> *"The Mahakam Volunteer Detachment served with valor equal to any of the storied regiments of the Northern Wars. Though dispatched many times to the very front line, and thrown into the greatest fray time and again, these brave volunteers never faltered, fighting on even in the face of overwhelming odds with unparalleled dedication. The Detachment won fame during the Battle of Brenna, where it managed to halt the elite Nilfgaardian cavalry division Ard Feainn despite being completely encircled, paying dearly with the blood of many soldiers for this triumph. The Mahakam volunteers also took part in the battles of Mayena and Maribor, where they served with equal valiancy and courage.*
>
> *Unfortunately, this dedication and valor were not properly recognized* post factum, *and historians stubbornly continue to omit the dwarven contribution, giving the laurels of victory solely to the armies of the allied kingdoms. The last act of recognition for the wartime sacrifices of the Mahakam Volunteer Detachment was the victory parade in Novigrad, but even that fact is glossed over by many a historian."*
>
> —Reverend Jarre of Ellander the Elder, addendum to *"Annales seu Cronicae Incliti Regni Temeriae"*

they manage to carve out a new realm of their own—Dol Blathanna. Before that time, elves faced a choice between living beyond human society in deep forests or remote mountains, or attempting to co-exist with you on your own terms, a prospect fraught with difficulty. Their pride and adherence to tradition have always made it impossible for them to assimilate fully into your societies. Elves living among humans still strived to keep their own customs and language, making them forever seen as outsiders—a fact painfully brought home during every pogrom.

Still, despite all their perceived strangeness, they are closer to you than you might think. For elves and men are able to crossbreed, producing fertile offspring. Half elves—the result of such unions—tend to have it rough in life, particularly in human societies, where they are often viewed as being born of miscegenation. Nevertheless, your races have been happily mixing with each other for hundreds of years, and today a surprising number of humans, even those who boisterously

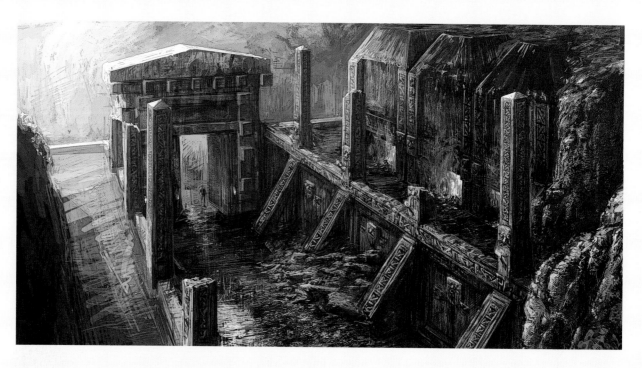

Dwarven fortifications are unparalleled engineering marvels. Thanks to a system of furnaces, boilers, and reinforced gutters, every passageway into the fortress can change into a deadly trap in the blink of an eye.

declare their hatred for elves daily, have at least some elven blood. Such are the paradoxes and ironies of history.

Dol Blathanna

In Elder Speech, the name of this realm means the Valley of the Flowers. Its present ruler is the elven sorceress Enid an Gleanna (the Daisy of the Valley), called Francesca Findabair among humans and widely considered the most beautiful woman in the world. Her chief advisor is Filavandrel aén Fidháil of the Silver Towers, from the House of Feleaorn of the White Ships, the leader of the Free Elves of the Blue Mountains. On account of his long exile to the far reaches of the world, he was for several centuries also

AEN ELLE

"The oldest Aen Seidhe legends speak of another tribe of elves—the Aen Elle, which in Elder Speech means the People of the Alders. Their paths are said to have diverged ages ago, when the Conjunction of the Spheres gave birth to dozens, or perhaps even hundreds, of other worlds. The lord of the Aen Elle was supposedly Auberon Muircetach, known as the King of the Alders, who ruled from the city Tir ná Lia. Several fantastical tales of this king exist, but it is not for me to judge here whether there is a kernel of truth in these legends."

—Hen Gedymdeith, "The Legends of the Elder Races"

"I was abducted on an autumn night. The Wild Hunt passed over our hamlet and took me with them, spiriting me away to their world—a place at the same time indescribably beautiful and terrifying. I was imprisoned, though no chains bound me. Then came endless days of servitude that stretched for an eternity, though they now seem but a moment ago. I accompanied my captors to places I can now hardly recall, and when I finally saw familiar stars in the sky during one such journey, I ran. My lords did not pursue me, as if they had stopped caring for my service. When finally I reached my home village, I found my house empty and ruined, and my childhood friends now wizened old men."

—Anonymous, "Memories from beyond Time"

known as Filavandrel of the World's End.

Dol Blathanna was once part of the Kingdom of Aedirn, but lies on territory seized from elven hands two centuries ago. The return of this territory to provide space for an independent elven realm was one of the conditions of the peace accords signed by Nilfgaard and the Northern Kingdoms after the second war. This new freedom came at a steep cost, purchased with the lives of hundreds of elves from the Scoia'tael units who fought and died on the side of the empire. The same peace treaty that created the Valley of the Flowers had another bitter and contentious condition, as Nilfgaard agreed to hand over roughly three dozen elven officers accused of war crimes to the Northern kings. No wonder, then, that many

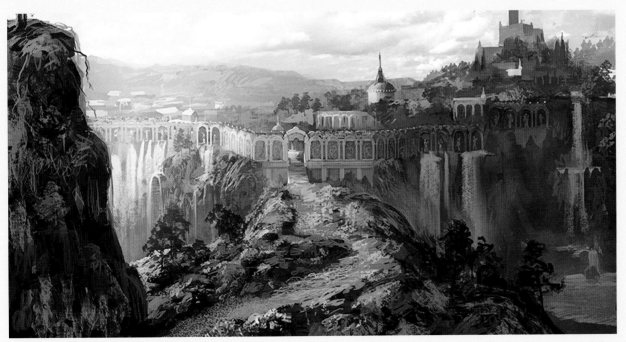

Dol Blathanna is considered by many to be one of the most beautiful spots in the world. Elven-crafted constructions survived the upheavals of war and gardens humans once burned down have grown back thanks to the efforts of their original inhabitants, who have returned here after more than two centuries of exile.

The World and Its Inhabitants

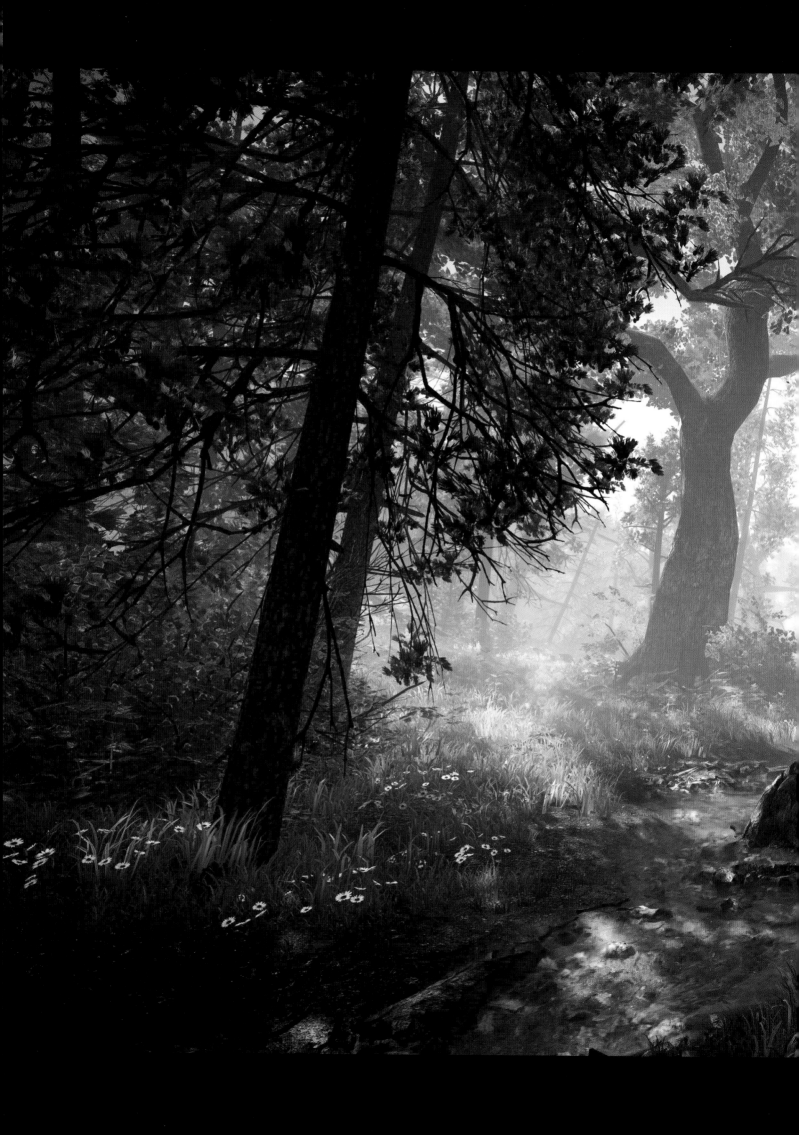

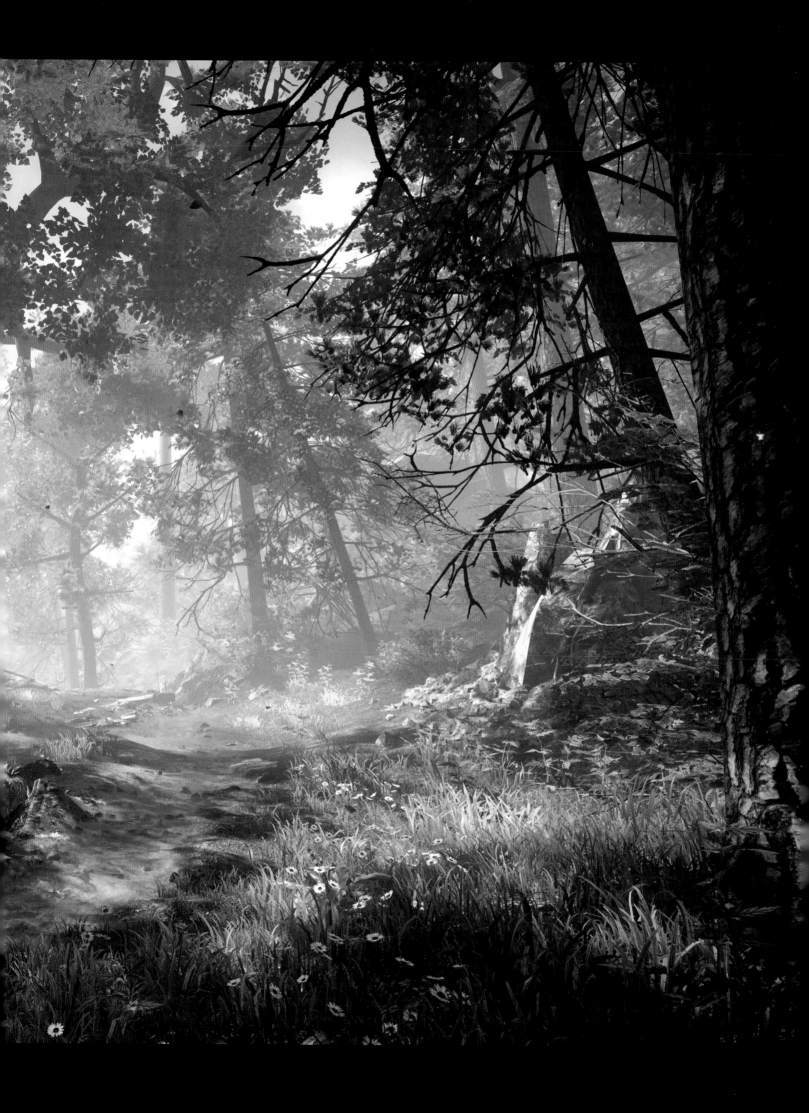

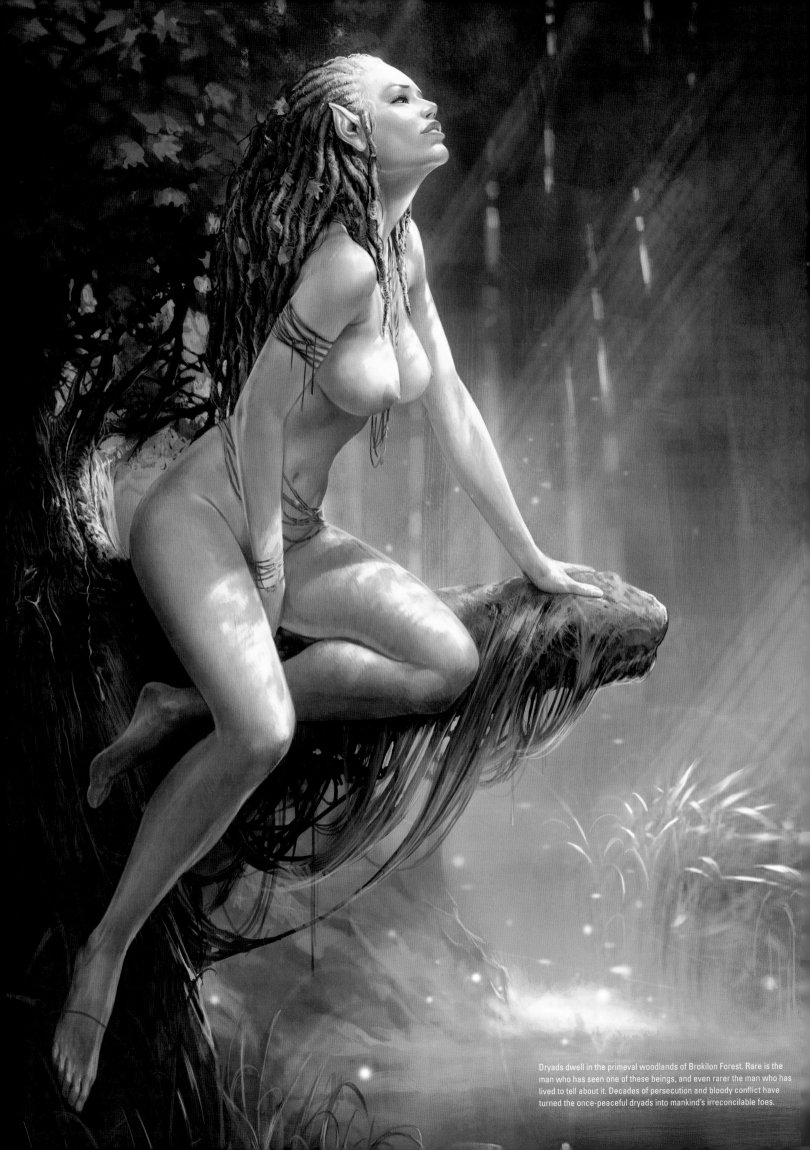

Dryads dwell in the primeval woodlands of Brokilon Forest. Rare is the man who has seen one of these beings, and even rarer the man who has lived to tell about it. Decades of persecution and bloody conflict have turned the once-peaceful dryads into mankind's irreconcilable foes.

elves now feel they have been betrayed and used by Emhyr.

Although the humans who left Dol Blathanna burned and destroyed everything they could, intending to leave only a "Valley of the Ashes" for the elves, the Aen Seidhe hope to rapidly rebuild, and have sworn to defend their new homeland with their very lives.

"Only once have I crossed the border of that beautiful and dangerous land, when I hurried to bring news of great import to my friend Geralt, whom the dryads were healing after he had suffered grievous wounds in battle. I owe my life, and the success of my mission, only to my lucky star, my protector, Art. For only my supreme dedication to my Art allowed me to captivate the dryads with my music, to the point that not only did they spare my life, but also took me to my friend so that I could deliver my crucial message. That is how, after completing my embassy, I was able to leave Brokilon in one piece."

—*Dandelion*, Half a Century of Poetry

Dryads

Like many other beings, apart from elves and a handful of forest creatures, such as leprechauns, pucks, or rusalkas, I have not had many dealings with dryads. These beings, also called "eerie wives" by humans, once inhabited nearly all forests and woods, but presently their sole enclave is Brokilon Forest.

In appearance, they resemble young, lithe maidens. Indeed, the entire race comprises exclusively females, and young dryads are born from relationships with elves or, rarely, humans. As their present contacts with humans are almost exclusively hostile, and more and more dryads have died in defense of their forest, the eerie wives have taken to kidnapping human girls. It is said that these children are given the mysterious Water of Brokilon, which strips all memories of their earlier lives, and that their new caretakers then raise them as their own. It is also said that some of the more unscrupulous humans now leave sick children at the edge of the forest, hoping an epidemic of smallpox, diphtheria, or scarlet fever will decimate the dryads. The dryads, however, seem quite immune to disease, and if the rumors of their healing talents are to be believed, sending infected girls to Brokilon only serves to swell the ranks of the forest's protectors.

The eerie wives greatly revere their forest, and not one of them would ever do anything to harm it. Even their homes are made from living trees, which they are said to be able to shape according to their will. Apart from these talents, dryads are also formidable archers, and would put many an elf to shame with their mastery. They utilize these skills with ruthless efficiency, as any who have tried to intrude upon their woodland realm have discovered.

Brokilon

The ancient Brokilon Forest is the last dryad enclave. It is ruled by Lady Eithné, known as the Silver-Eyed, famous for her knowledge, wisdom, and implacable stance toward humans and their claims.

Brokilon is in a state of perpetual war with its neighbors. The lords of the surrounding lands have always coveted Brokilon's greatest riches—its trees. They would also be pleased to get their hands on the fabulous treasures supposedly hidden in the ruins of the city and necropolis of Craag An, somewhere deep within Brokilon Forest.

That is why for hundreds of years they have attempted to log the forest, inevitably clashing again and again with its defenders. This is a brutal war, without pardon or mercy on either side. Humans cruelly execute any captured dryads, while the forest dwellers give no quarter in return and greet every intruder with whistling arrows. Settlers and men-at-arms, merchants and woodcutters, men and women, old and young—all those who enter Brokilon meet the same end. Such is also the fate of those who try to settle the lands that were once covered by the forest, for the dryads acknowledge no borders drawn by humans. These raids on settlers spark the greatest ire among the surrounding monarchs, especially those of Verden and Kerack, whose hatred of dryads and their leader is legendary. Only the hesitation of the more moderate and gentle king of Brugge, who desires to avoid bloodshed, has stopped the conflict from escalating into an all-out war of extermination.

The thick woods of Brokilon hide many dangers, the greatest of which are the deadly accurate arrows of their dryad guardians.

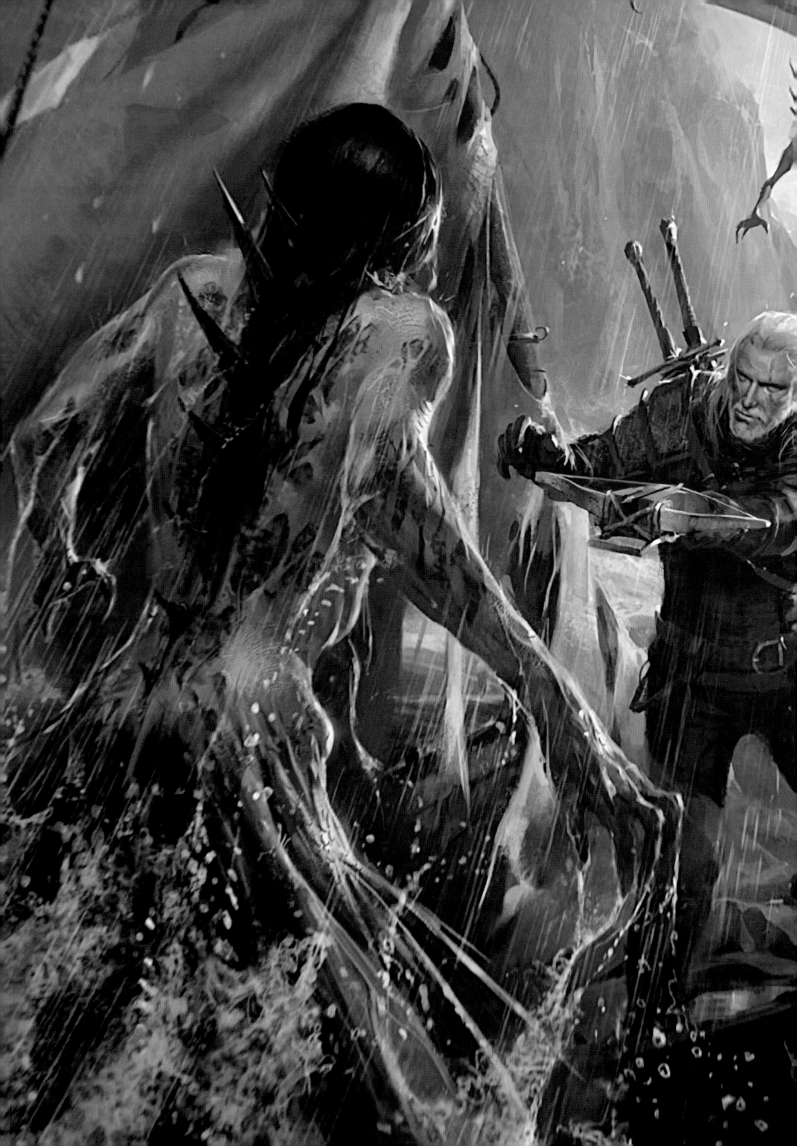

CHAPTER II
THE WITCHERS

No man has ever known more about witchers than Vesemir, who practiced the craft both in its glory days and through the time of its greatest trials and decline. I cannot hope to guess in what year that famed monster slayer first came into the world, but it is known that he watched as the first stones of Kaer Morhen were erected—which took place over two hundred years before I first had the opportunity to meet him. It was there, at the famous Wolf School of witchers, that he taught swordsmanship for untold years, ever eager to school new adepts. It was he who trained my friend Geralt in the art of wielding the sword—an art in which, even in his later years, no man could claim to be Vesemir's equal.

As the years passed, Vesemir became, much like the very monsters he hunted, a relic of a bygone era, someone whose behavior and beliefs—those of an honest and unbendingly just man—grew increasingly rare in the society around him. Candid and straightforward to a fault, Vesemir held deceit and lies—which others trafficked in without a second thought—in utter contempt. For that reason I consider his account of the origins of the witchers which follows to be fully reliable and worthy of your close consideration. I believe any inaccuracies and omissions that might be found therein stem solely from Vesemir's advanced age at the time of writing and his partiality toward a trade so crucial to the core of his being.

—*Dandelion*

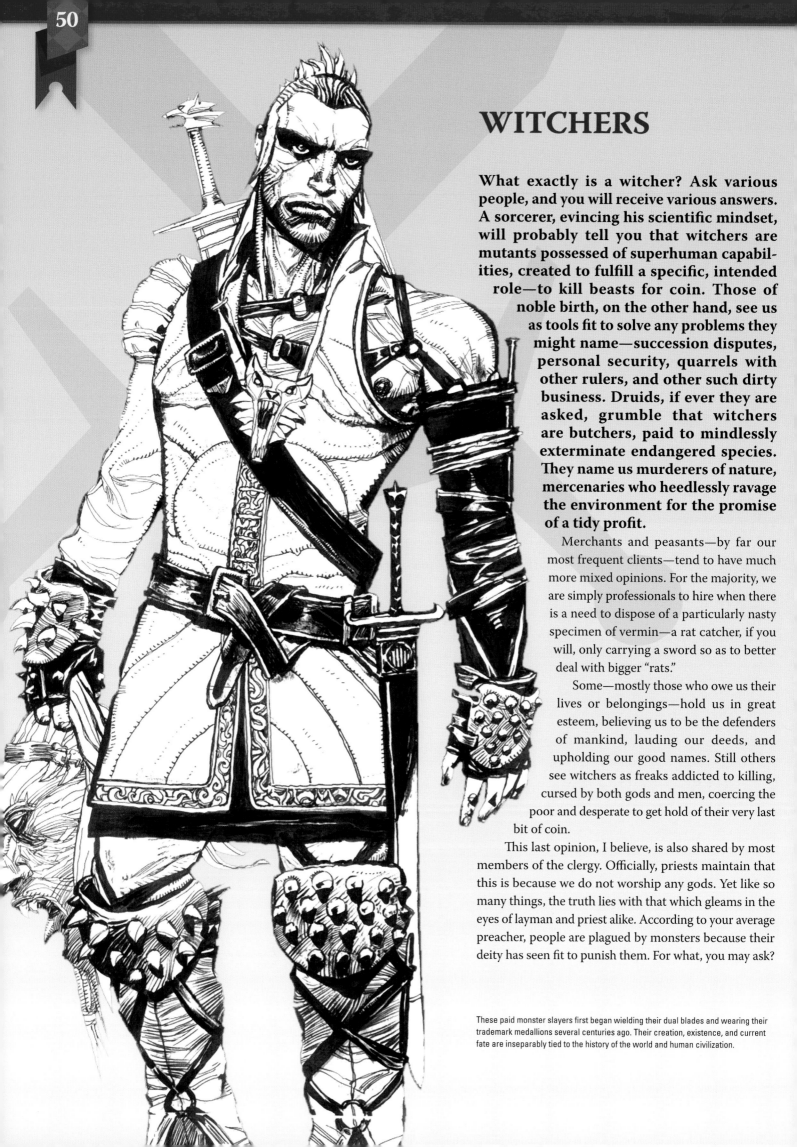

WITCHERS

What exactly is a witcher? Ask various people, and you will receive various answers. A sorcerer, evincing his scientific mindset, will probably tell you that witchers are mutants possessed of superhuman capabilities, created to fulfill a specific, intended role—to kill beasts for coin. Those of noble birth, on the other hand, see us as tools fit to solve any problems they might name—succession disputes, personal security, quarrels with other rulers, and other such dirty business. Druids, if ever they are asked, grumble that witchers are butchers, paid to mindlessly exterminate endangered species. They name us murderers of nature, mercenaries who heedlessly ravage the environment for the promise of a tidy profit.

Merchants and peasants—by far our most frequent clients—tend to have much more mixed opinions. For the majority, we are simply professionals to hire when there is a need to dispose of a particularly nasty specimen of vermin—a rat catcher, if you will, only carrying a sword so as to better deal with bigger "rats."

Some—mostly those who owe us their lives or belongings—hold us in great esteem, believing us to be the defenders of mankind, lauding our deeds, and upholding our good names. Still others see witchers as freaks addicted to killing, cursed by both gods and men, coercing the poor and desperate to get hold of their very last bit of coin.

This last opinion, I believe, is also shared by most members of the clergy. Officially, priests maintain that this is because we do not worship any gods. Yet like so many things, the truth lies with that which gleams in the eyes of layman and priest alike. According to your average preacher, people are plagued by monsters because their deity has seen fit to punish them. For what, you may ask?

These paid monster slayers first began wielding their dual blades and wearing their trademark medallions several centuries ago. Their creation, existence, and current fate are inseparably tied to the history of the world and human civilization.

For insufficiently fervent prayers and not enough temple donations. A witcher, then, is doubly vile, for he kills the beast—the gods' own scourge—and demands coin for the deed, coin that, in the preacher's sanctimonious words, any honest man would give to the church.

Yes, we demand payment for our work. We are professionals, and for services rendered we expect to receive from our employers the previously agreed-upon sum. Such is our trade, a vocation no better and no worse than others. Today there are not many of us left, and soon there will be none. And only when we are gone will people likely remember exactly why they needed witchers.

The Beginnings

Someone might ask: who needs a purpose-bred mutant whose life is dedicated to slaying monsters? It all began ages ago, when humans first came to these lands. The world was different in those days. All of today's fertile fields, meadows, and orchards were once covered in impenetrable woods, which people were only beginning to clear with hatchet and fire. Humans were slowly pushing back the land's ancient inhabitants—vrans, elves, and werebbubbs—into the deep forests and mountains. Still, those races were not the primary threat faced by travelers and inhabitants of these frontier settlements.

The real threat was twofold. First, natural predators living in mountain vales and forest glades soon learned that grazing cattle or draft animals make for easy meals, served on the proverbial silver platter. Of course, they weren't above snacking on a herdsman or a drover either, if the man failed to flee in time. However, these monsters are a natural element of this world. They have their "ecological niche," as the druids eloquently put it. They eat enough to survive and feed themselves and their young, and humans are not the mainstay of their diets.

Though they may differ from one another in age, experience, temperament, preferred fighting style, or equipment, every witcher acts to the same purpose—to fight creatures that threaten human lives.

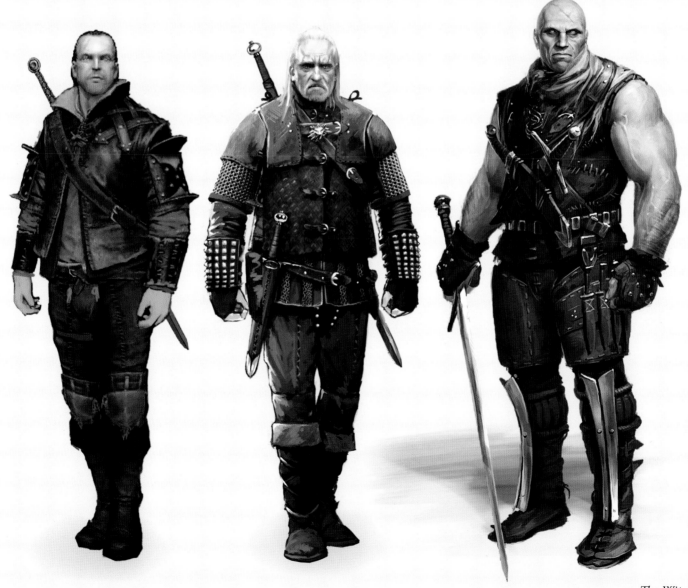

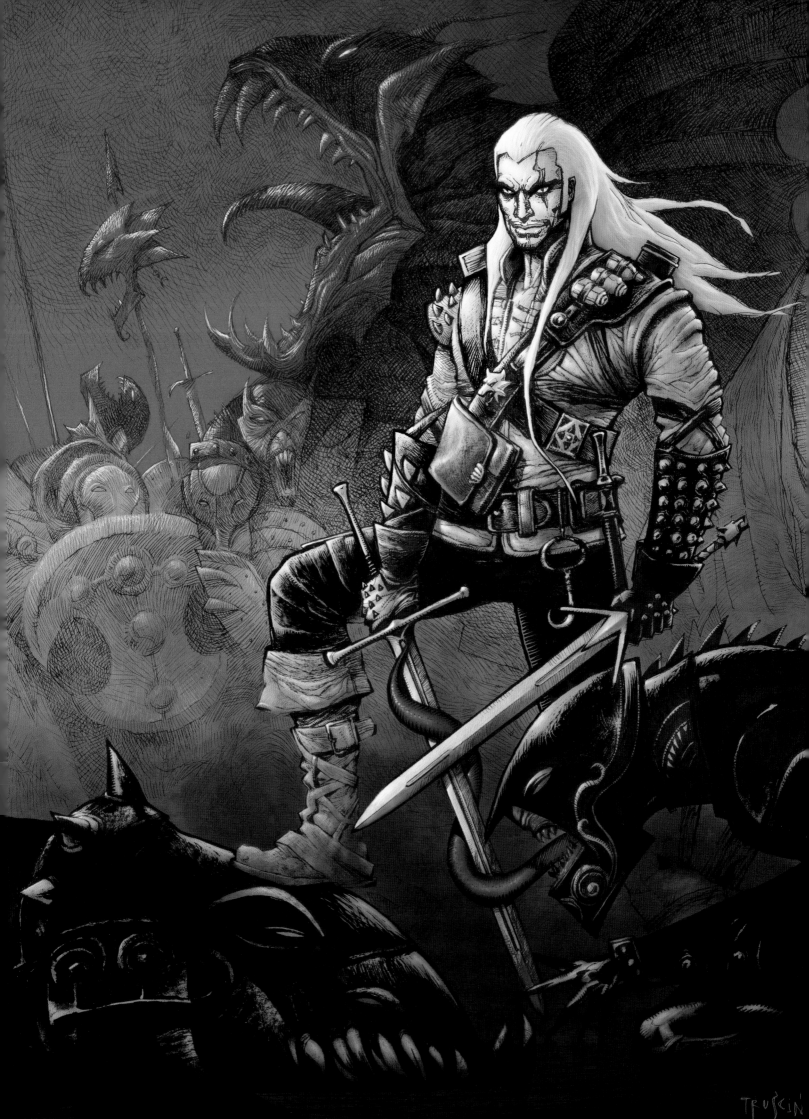

The Conjunction of the Spheres and Unwanted Visitors

But there were also creatures whose tastes soon focused on devouring humans. These monsters came into this world during the blending of the Spheres, just as we did. They adapted very quickly, and found humans—at that time a relatively weak link of the food chain—to be ideal sustenance.

We are not a predatory species. Nature did not provide us with appropriate senses and weapons. After dark, humans are nearly blind, and cannot even make up for this deficiency with an acute nose or keen hearing. In your typical family of three generations, only a few specimens are more or less capable of defending themselves and their kin. The elderly and the children make up the largest part of a homestead's inhabitants. This makes humans easy prey for all the varied carnivores of this world, of which there have been plenty since the Conjunction. Humans delude themselves that they are masters of the world, but when faced with the majority of predators on their terms, in their environments, the average human has just enough time to reconsider such thoughts before turning into a pile of entrails.

Obviously people tried to defend themselves. Heavily armed caravans took to the roads, always attempting to reach the nearest settlement or watchtower before nightfall, or at least to make camp in a familiar location. Villages became surrounded with palisades, and wooden lookout towers were erected to better espy danger during the day. At night torches and bonfires were lit, in the hopes of warding off the things that lurked in the darkness, just beyond the frail circles of light.

Sharpened stakes, closed windows, and barred doors, however, were little obstacle for certain post-Conjunction creatures. Magic, which first appeared at roughly the same time, has birthed monsters as if straight from humanity's worst nightmares: immaterial specters and wraiths that bring madness and death with their mere visage or voice, or beasts capable of changing shape, fiends in human skin, infiltrating villages and preying on their inhabitants.

In search of defense from such terrors, people turned to mysticism and folk magic. Salt was scattered in the frames of windows and doors. A silver coin or an iron horseshoe nailed to the same place also had the reputation of warding off evil forces. Some employed sorcerers, others prayed, still others bought herbs, infusions, and amulets. Some of these practices could indeed help, and are used even today. Some were not worth a hoot. I recall a time when the belief that a red cap or hood would protect a young lass from a werewolf was widespread. Such utter rubbish, also spread by the Dyers' Guild (who saw a chance to increase their profits), took a bloody toll among naive girls.

To sum things up, people were dying day and night. Peasants were cut down by noonwraiths during harvest, huntsmen fell to leshens' claws in the woods, children were snatched by drowners while swimming in ponds,

THE UNEXPECTED CHILD

"The Law of Surprise is a particular magical phenomenon. It usually concerns a person—the Unexpected Child, chosen by destiny, born in the shadow of Fate. It is that Fate that creates the supernatural bond which connects the marked child to the person to whom it was promised—which usually takes place even before the child is born.

For such a situation to occur, the party making the promise must first offer (usually in return for received help) their benefactor anything they might wish. Merely asking what reward they desire is sufficient. At that point the recipient recites the words: "You will grant me whatever unexpected thing you encounter when you return home," or, according to other tales, "You will grant me whatever first greets you at home." The latter case does not necessarily mean a child, making it a more general case of the Law of Surprise.

The offering party must then agree to the arrangement, yet even this does not seal the special bond. Only if the child, or other promised person, subsequently recognizes the recipient's rights when he arrives to claim them is the Law of Surprise finalized.

Children chosen by Fate are always meant for great things. Many heroes known from legends and tales were so marked by destiny. The great hero Zatret Voruta was given over to the dwarves, for his was the first face his father saw upon returning to his keep. The no less well known Supree was also an Unexpected Child, given to the Mad Dei, whom he later saved from a terrible curse.

According to old tales, many a witcher called upon the Law of Surprise when it came to declaring the price for their services. It is commonly thought that such a child would easily pass all the witcher trials or—according to another legend—would not find it necessary to pass them at all. The famous Geralt of Rivia, known also as the White Wolf, was believed to be one such Unexpected Child."

—An Overview of Magical Phenomena (collaborative dissertation)

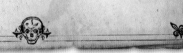

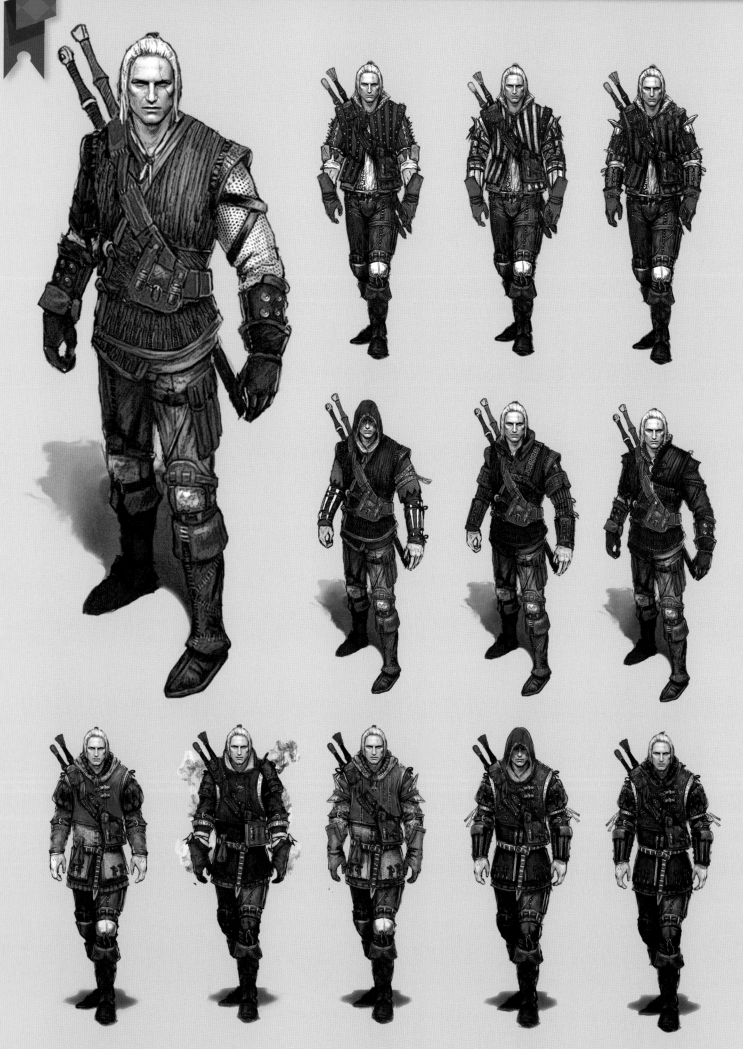

and maidens were preyed upon by vampires in their own beds. The old tale of elderly women who had tired of life going out into the woods alone, without a bear spear, contains not an ounce of fiction.

The need to confront such dangers led to training us, the witchers. We were to be mankind's defenders, who would meet claws and fangs lurking in the darkness with steel, silver, and spell. Mean whoresons who could walk the valley of darkness without fear and face down any beast alive. And, damn it, so we are! We destroy that which threatens people—be it creatures driven by hunger or the joy of killing, directed by their own or by external will. We reverse curses and lift charms, and we defend those who cannot defend themselves. That is why our fraternity was formed, and, though so few remain, that is what we do to this day.

Recruitment

Rumors abound regarding the origins of potential witchers. The simple folk hold a belief, one also associated with drovers and dwarven coppersmiths, that we kidnap children from villages and homesteads. More often than not, when one of our brethren enters a settlement, the women make quite the racket, suddenly clutching their newborns more tightly and shooing their lot of brats back into the house. As if a witcher had the time and inclination to change beshitted diapers, not to mention certain difficulties in providing a suckling baby with the necessary teat . . .

Abducting an older youngster doesn't make much more sense, because it's a terrible pain in the hintersides, and in any case hardly necessary. Highways and city back streets, not to mention temple orphanages or druidic circles, are already filled with refugees, orphans whose parents were taken by war or plague, or striplings who were simply thrown out and left to fend for themselves, castoffs seen by their families as nothing but an extra mouth to feed. To these brats, the chance to become a witcher was a lucky break beyond imagination, for otherwise fate would have them die of hunger or live out their limited days as vagabonds. It was from this bottomless pool of the ill favored and the unwanted that the members of our order were mainly selected.

Most were sought out by the sorcerers who helped to create the foundations of witcher training. Sometimes a witcher returning from the path would arrive with a new recruit in tow. Others were handed over by their own caretakers—mainly bastards, unwanted children from a woman's first marriage, or just fifth sons with no chance to inherit their father's land and no

Facing: Given the nature of a witcher's trade, his armor must provide him with protection, while at the same time allowing him to move freely. Each witcher assembles his own ensemble of protective clothing based on his personal preferences.

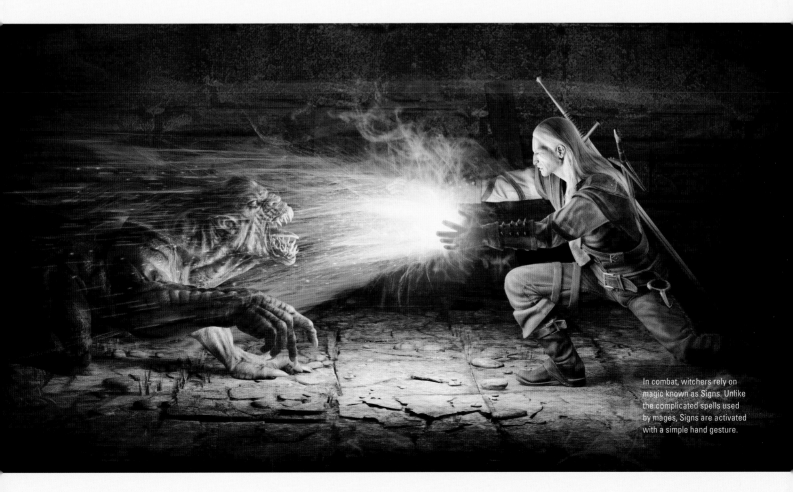

In combat, witchers rely on magic known as Signs. Unlike the complicated spells used by mages, Signs are activated with a simple hand gesture.

The untamed corners of the world are inhabited by countless breeds of monsters. Some arrived mere centuries ago during the Conjunction of the Spheres. Others are older, their origins lost in the mists of time. Still others are created in magical experiments by amoral or renegade mages. All threaten the lives of men; to fight this danger is why witchers were created.

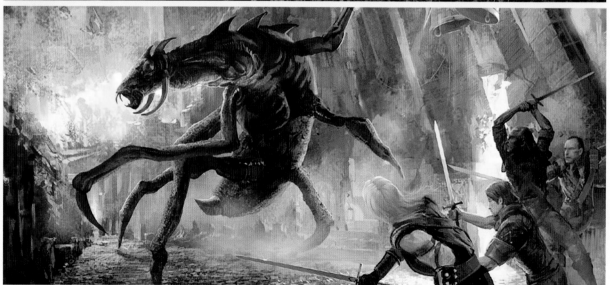

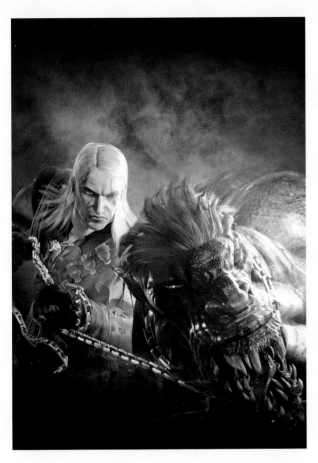

place in a peasant cottage already stuffed full of able-bodied farmhands.

Of course, as the dwarven proverb says, "Shite ain't good for making whips." So only fit lads were chosen, healthy of body and sound of mind—those whose physical and mental constitution showed the promise of surviving the rigors of our training.

Mutations and the Trial of the Grasses

Prospective witchers were trained at Kaer Morhen, also known as the Witchers' Seat. It is here that the Wolf School had its headquarters, and the entire set of alterations, tests, and mutations that would lead to the formation of a witcher was developed. Today nobody can remember their original source or creator. Even those who perfected the process over the years and mastered its intricacies are long dead. Sorcerers must have aided in the whole endeavor, for the final effect is impossible without the use of spells. Yet the initial stages did not require much magic. Mere infusions made from specific herbs were sufficient, combined with a diet of certain species of cave fungi which would regulate the metabolism and enhance one's growth rate. This all was done in preparation for the next phase: the mutation

process or infamous Trial of the Grasses. I personally do not have fond memories of it, not fond at all . . . I think anyone who survived would just as soon forget every moment of that terrible ordeal.

The procedure lasted several days. Over that time we were given magical mutagenic potions that completely altered our metabolism. Then we awaited the effects, which usually were unrelentingly awful. Nonstop fevers, vomiting, hemorrhages . . . Yes, not all rumors about the witcher order are mistaken, and at this point the cull was indeed very severe. The vast majority of those undergoing the trial did not live past this phase.

The few who did moved on to the next part—the Changes. At this stage we were given further infusions and potions, infected with filth of some kind . . . And again came fever, sweat, delusions, shit, and vomit beyond reason. Supposedly the process was "enhanced" from time to time, as a test of new elixirs and mutagens. Typically this meant even more pain, vomit, or worse for those chosen for these "special trials." Geralt emerged from these experiments with a lifetime of foul memories and the loss of pigment in his hair. The other members of that particular test group were not so lucky—not one of them survived.

Aside from Kaer Morhen, there were several other places where witchers were trained. Each had its own training program and slightly different process for the Changes. It has to be said that some of the mutations carried out in these other schools were less than perfect. The effects were sometimes lamentable, as evidenced by the notorious Cat School. I have no idea whether they chose their candidates specifically from young outcasts with a penchant for aggression, or if some unforeseen cruelty was somehow unleashed during the trials, but the final effect was a cadre of psychopaths, madmen, and sadists. Needless to say, the ill fame of their deeds hangs like a dark cloud over our reputation to this day.

The Purge

Perhaps the actions of the Cat School were in part the cause of later events, or perhaps not. The Iello Massacre certainly did not improve our image, but the fact is that dark clouds had

Witchers do not always kill the beasts they hunt. When a monster is born of a curse cast on a human, it must be captured alive—then the unfortunate soul's curse can be lifted.

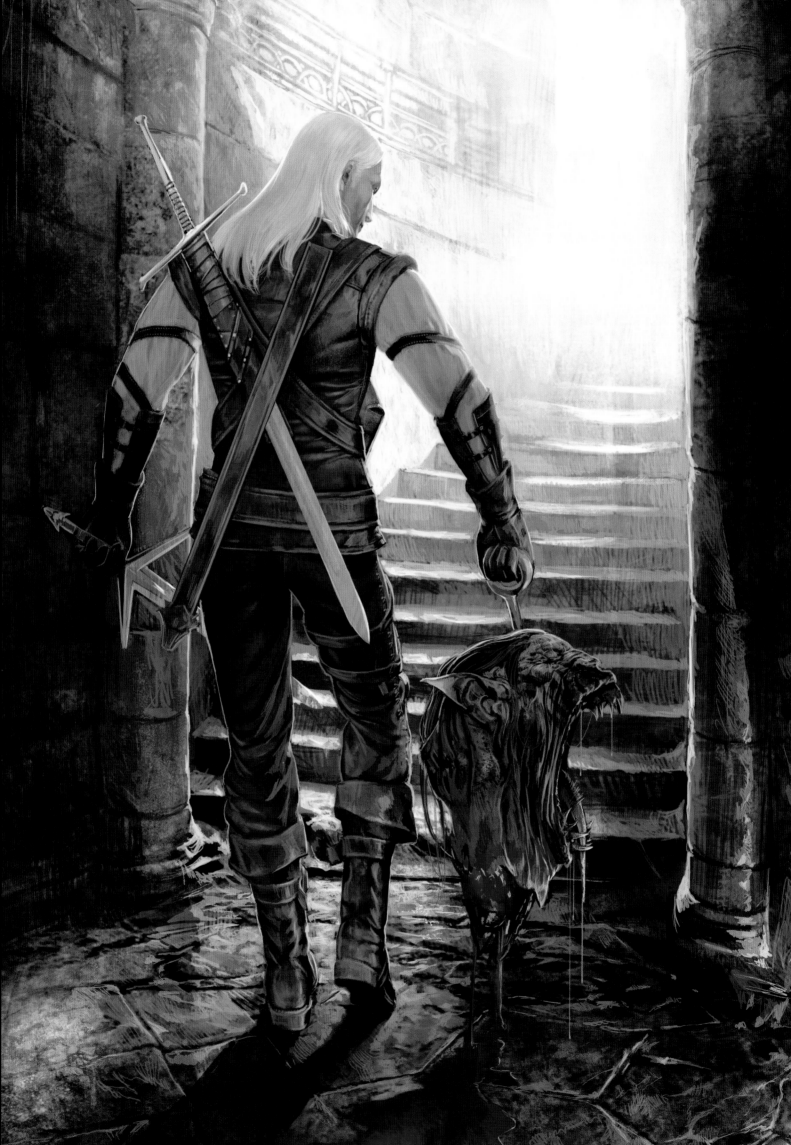

THE WITCHERS' CREATORS

been gathering over our heads for quite some time.

They gathered so slowly that we ceased to pay any attention to them, just like I stop noticing the rain or village dogs barking at my legs when traveling. This lack of caution, however, ended up costing us much more than the occasional bite on the arse. We were never particularly popular, for, just like sorcerers, we tend to remain apart from the common folk, maintaining an aura of cold, steely professionalism. We took on commissions, killed monsters, collected our pay, and traveled on. And so our renown spread—as did our image as silent men and curmudgeons not moved by the fate of others. Worse was our characterization as greedy, nefarious schemers who would deliberately bring monsters upon human abodes so as to later offer to kill them, and in this way extort coin from naive serfs. In some folktales we were likened to demons who delighted in combat and murdered both beasts and men in order to bathe in their blood.

Some of us tried to call out the obvious lies, but most just shrugged. The prevalent thought was, "If the simple folk fear us, they will only respect us more." Only

> *"There is circumstantial evidence that the sorcerers responsible for creating and developing the process of witcher mutations countless years ago were Cosimo Malaspina and his apprentice, Alzur. Their activities, particularly in the field of magical experimentation, remain highly controversial. Some even go so far as to name them renegades. We cannot forget, however, the stupendous role these sorcerers played in the development of magical lore. Spells such as Alzur's Shield and Alzur's Thunder are still remembered by sorcerers today and are likely to be so forever. Nor could any forget the cautionary tale of Alzur's own death—massacred in Maribor by the very viy (a type of giant centipede, for those who do not practice the witcher's trade) he had created. Once free of its master's control, the beast managed to ruin half the city before it fled to Riverdell's forests. Legend has it that the creature prowls them to this day."*
>
> —Master Istredd of Aed Gynvael, draft of *"The Controversies of the Magical Art"*

later did we come to understand how wrong we were.

More and more people were exposed to the tales of mutated freaks, brought to life by vile and godless sorcery. Men started to spit at our very sight, turn away, curse us, and mumble threats behind our backs. It would later become all too apparent that people were intentionally being incited against us. Rumors were put into circulation, and agitation took place on market squares, at highway crossings, and in temples. Even a book was published—*Monstrum; or, A Portrayal of Witchers*. Its author had no qualms about letting his vivid imagination run wild, and wrote such rubbish that it is hard to determine whether we should laugh at or curse the people who believed him.

Many, however, did believe. More and more people turned against us, eagerly gobbling up the shite spewed by these fanatics. When the mob finally crashed against the witcher abodes, it did so with the same shouts of "accursed freaks, godless monsters, unnatural beasts!" on its lips.

Witchers imbue their silver medallions with magic, making them useful tools—and also symbols marking membership in the guild. Men soon learned their meaning, and to this day they arouse strong feelings, whether of respect, revulsion, or fear.

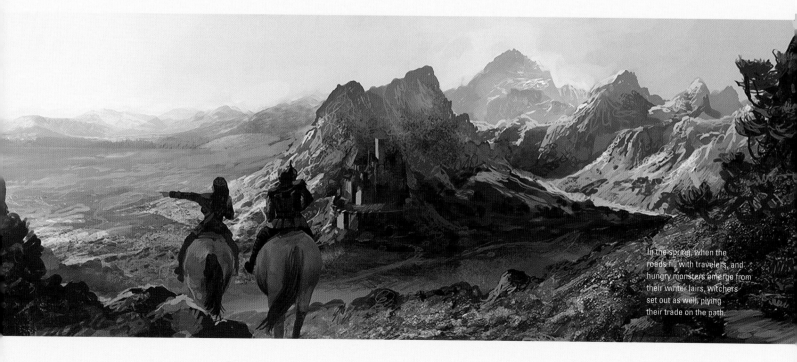

In the spring, when the roads fill with travelers, and hungry monsters emerge from their winter lairs, witchers set out as well, plying their trade on the path.

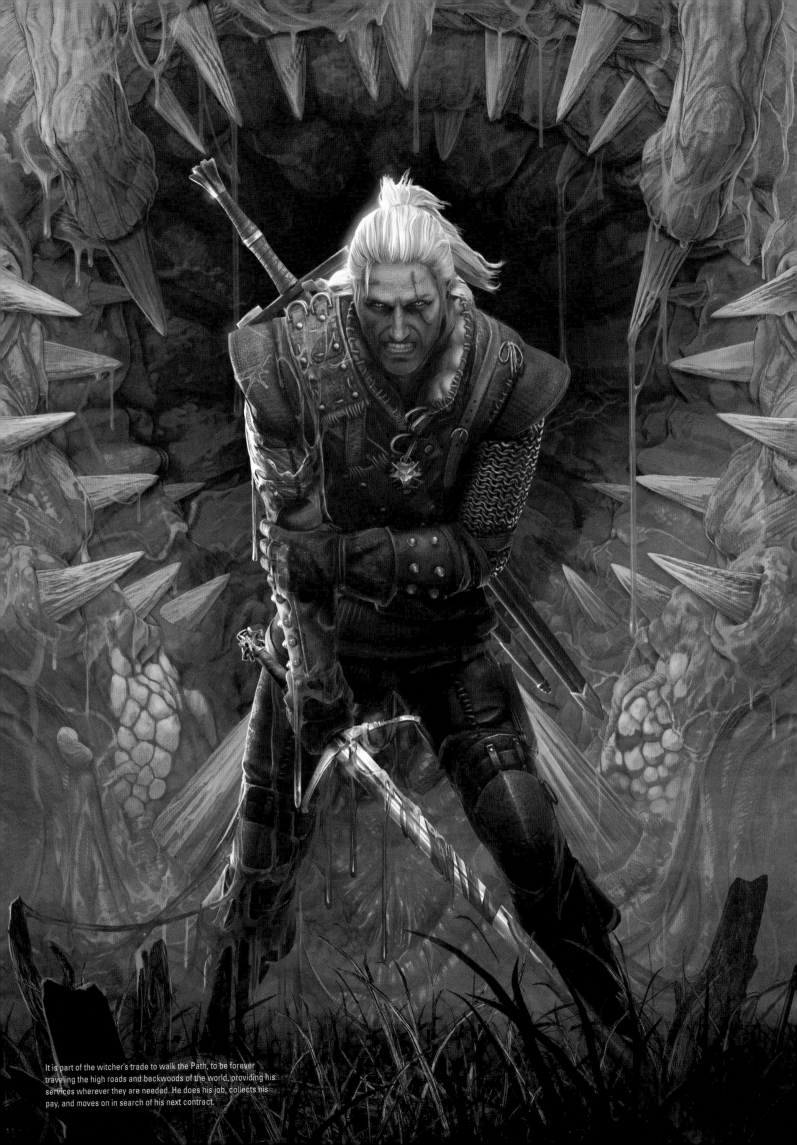

It is part of the witcher's trade to walk the Path, to be forever traveling the high roads and backwoods of the world, providing his services wherever they are needed. He does his job, collects his pay, and moves on in search of his next contract.

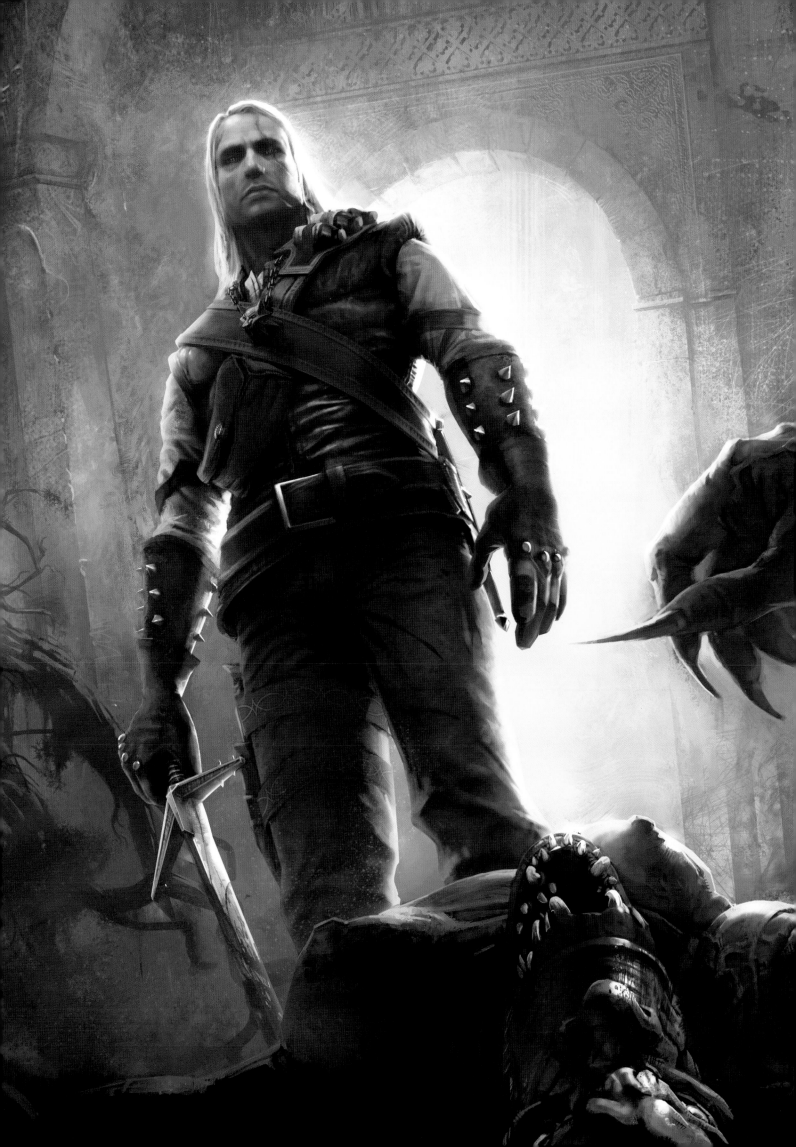

The ancient fortress of Kaer Morhen was for years home to the famous Wolf School, but its glory days are now a distant memory. Empty corridors and ruined halls bear witness to the pogrom that led to the deaths of most who trained or taught there.

KAER MORHEN

Kaer Morhen, the Witchers' Seat, fell that day. Its gates were smashed, destroyed by the magic of the sorcerers who aided the besiegers. The invaders breached the keep, slaughtering anyone they found. None were spared—not the sorcerers overseeing the trials, not the boys in training, and certainly not the witchers present. I and a few others survived by chance alone, by the simple fact that we were away from Kaer Morhen at the time.

That is why I will not go into detail about the defense. I will not say whether it was long and heroic, how many assaults were stopped, or how many foes fell to witcher steel. Later the authorities declared the purges to be isolated incidents. The perpetrators were condemned, with all responsibility heaped solely on their shoulders. Some even expressed regret. Those of us who survived were not pursued. This gave birth to rumors that the witchers themselves were not the true target—the sorcerers responsible for our training were. That may be the truth, or it may not. If it is, those who incited the mob achieved their goals. Though part of the laboratories, some elixirs, and a few notes remained, there is nobody left who might know how to re-create the mutations, trials, and Changes.

> *"Kaer Morhen, also known as the Witchers' Seat, was, according to tales and historical accounts, one of several training centers for witchers. The so-called Wolf School had its roots there. Most authors place it in the inaccessible mountain regions of northeastern Kaedwen, on the upper reaches of the Gwenllech. However, the exact location was never described in detail.*
>
> *The name is a corruption of the Elder Speech* caer a'muirehen, *which means 'old sea keep.' Though the name obviously suggests that the spot was originally occupied by an elven defensive structure, its full meaning remains a mystery.*
>
> *Kaer Morhen was destroyed during an outbreak of purges against the witchers, probably near the end of the twelfth century."*
>
> —Fragment of semester dissertation for the first year in the Faculty of History at the Oxenfurt Academy

This witcher refuge was built amidst the wild peaks of the northern range of the Blue Mountains, in an inaccessible valley far from prying eyes. Few ever knew it existed, and even fewer still remember.

WITCHER ABILITIES AND TRAINING

Physical Changes

The things that happen to a witcher's body and mind during the mutations and the Trial of the Grasses alter him forever. His body acquires new capabilities and functions beyond the reach of ordinary individuals. Firstly, the aging process slows down considerably. This means that a witcher, if not slain, can live several times as long as a normal human. The exact maximum lifespan remains unknown, as sudden violence has been and remains the cause of every death in our profession. Not a single witcher has lived out his days and died peacefully in his own bed.

Another important advantage comes in the form of full immunity to disease—a very useful thing in our trade, considering the places we frequently trudge through and the creatures we fight. Similarly, we sport a certain resistance to venoms and toxins, though not a complete one; exceptionally potent or exotic poisons can still be fatal. That is why the effects of poison are best countered with the use of appropriate potions. Without such elixirs, purging a poison from one's body is damned exhausting, and takes an inordinate amount of time. And yes, increased toxin resistance also means a higher tolerance for alcohol. Many a witcher has bemoaned the extra time (and coin) it takes to get properly drunk—until the next day when they shrug off a hangover that would fell even the toughest of ordinary drunkards.

Eye accommodation is also quite convenient, allowing us to see regardless of the lighting. The ability to narrow and widen our pupils at will enables witchers to see in complete darkness or to avoid being blinded by a sudden flash of light. Add to that a slower pulse that can be regulated under stress, heightened reflexes, acute hearing, and increased resistance to pain—I could go on and on, and I'd likely still forget some detail about witcher physiology which by now I don't even notice myself.

Finally, it must be said that witchers are sterile. It is hard to tell whether this is a side effect of all those mutations, or a deliberate intervention intended to prevent an entirely new species from coming into existence. Either way, after seeing the lifestyle of certain younger witchers, I can only say that someone saved them quite a bit of trouble by making sure that Kaer Morhen would never be besieged by an inevitable horde of swollen-bellied women.

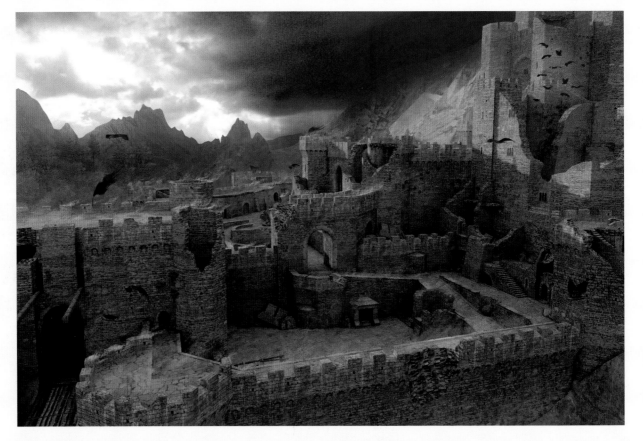

Once these courtyards rang with the clash of training swords and the voices of future monster slayers. Today one only hears the howling of wind and the calls of birds nesting in the ruins.

Psychology

Contrary to popular opinion, we are not soulless. True, witchers are trained and genetically adjusted in order to better control their emotions. Indeed, purging all human feelings would probably be possible. It is said that some witchers even underwent such a process, but either the results were unsatisfactory, or the whole thing ended with some unpleasantness best left unmentioned.

People also claim that witchers fear nothing. This, of course, only enhances our renown, but it is simply not true. We can still feel fear, but we learn to control it. Fear is a useful thing, as it reminds us that we must always keep our limits in mind and proceed cautiously. In the end, foolish bravado, sword rattling, showing off, and starting unnecessary brawls typically all lead to the same destination: the graveyard.

They also say that we do not know compassion. This is also rubbish, although years in this profession can

> ### THE IELLO MASSACRE
>
> *"The massacre at the town of Iello, widely accepted to be the handiwork of the witcher Brehen, forever after known as the Cat of Iello, is but one of many infamous episodes in the history of witchers. Due to its widespread notoriety, it is often compared to the dramatic events which took place a few years later at Blaviken on the Arc Coast. There, in broad daylight, the witcher Geralt strode into the town market and murdered six men and a woman in cold blood, thus earning the enduring sobriquet of the Butcher of Blaviken."*
>
> —H. Jaagen and Y. Deyner, "The Tridam Ultimatum and Other Mass Murders Perpetrated by Nonhumans"

cause a certain desensitization. During training we are already being prepared for the things we will have to face, and these frequently are not pleasant to behold. Tracking monsters means stumbling upon the shredded corpses of victims—women, children, entire families—strewn about, half-eaten, sometimes fresh, sometimes in various stages of decay. The last thing needed at such times is unnecessary emotion. Anger, hopelessness, and desire for revenge or to mete out punishment can all lead to foolish decisions, loss of concentration, and mistakes. In combat, an unhinged swordsman is a dead swordsman.

The same goes for compassion. True, one may pity the victim of a curse, who every full moon transforms into a bloodthirsty beast without a mind of its own. One can, and should, try to help such a person, if it is in one's power. But when all else fails, when one has to actually face the monster, one cannot afford to hesitate.

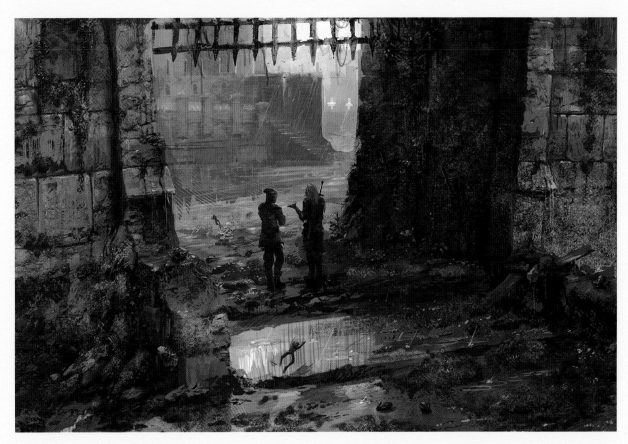

The road to Kaer Morhen is known to a select few—mostly members of the Wolf School or those who are among their nearest and dearest friends and allies.

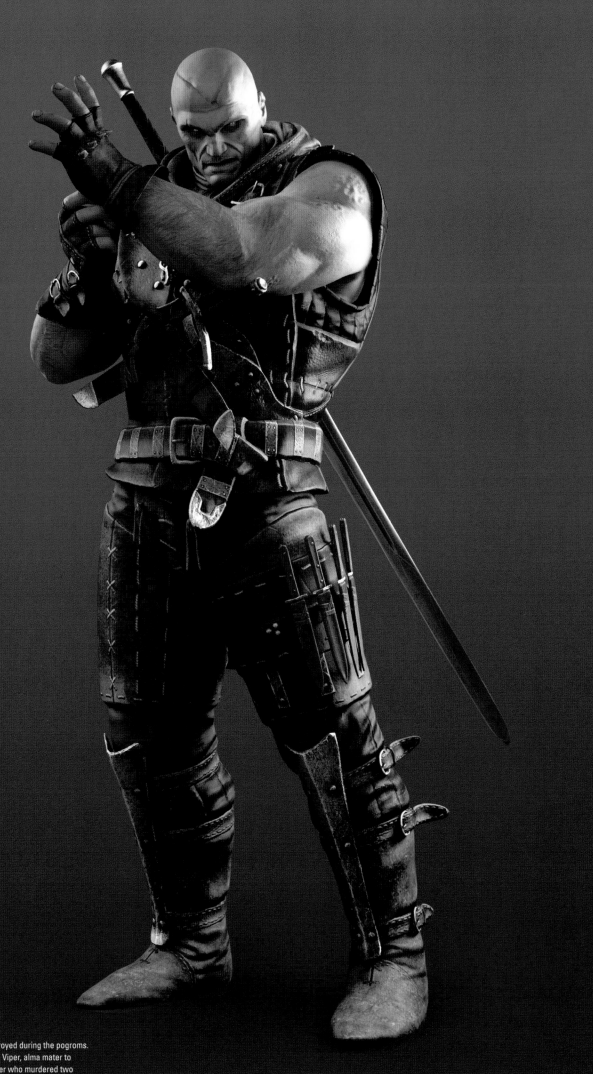

Other witcher schools were also destroyed during the pogroms. Such was the fate of the School of the Viper, alma mater to the infamous Letho, a renegade witcher who murdered two northern kings on the emperor of Nilfgaard's orders.

Physical and Fencing Training

Apart from instruction in swordplay, the basics of magic, and theoretical knowledge, witcher training involves a number of physical regimens that work to enhance a trainee's reflexes, speed, and coordination. Most exercises take part on the so-called Path—a track surrounding Kaer Morhen that forms an obstacle course of sorts. The youngsters have given it their own colorful name—the Gauntlet. Beginners may find the route demanding, but it will build up their stamina, reflexes, and sense of balance. It serves as a good warm-up before fencing exercises on the training machinery within the castle itself.

MONSTRUM; OR, A PORTRAYAL OF WITCHERS

"One cannot forget the role which the anonymous Monstrum; or, A Portrayal of Witchers *played in building up anti-witcher sentiment, nor its de facto role in the purge itself. This biased tale of witcher practices, accusing them expressis verbis of sorcerous, blasphemous deeds, painted an entirely one-sided image of the witcher trade. Calls for hatred and violence against the members of the aforementioned profession are prevalent throughout the pamphlet. Its numerous depictions of religion and piety as the proper way of life and a source of genuine protection from evil forces, and their wholly favorable juxtaposition with witcher practices, suggest that the author of the book was in fact a member of some clergy.* Monstrum; or, A Portrayal of Witchers *was widely circulated right before the anti-witcher purges that took place over a century ago. Despite its obvious biases,* Monstrum *should be recognized for its fiery oratory, and remains one of the mandatory readings discussed at our faculty."*

—Fragment from "The Pen Is Mightier Than the Sword: Literary Works Which Have Changed the Face of the World," a rhetoric lecture at the Oxenfurt Academy

The combat style taught at Kaer Morhen emphasizes speed, mobility, and brutal effectiveness. There are numerous theories about the original fencing style that was used for its base, and the authors of various swordplay treatises have dedicated at least several chapters to the matter. Truth be told, at the time when it was developed it was hard to pinpoint a specific style or school. At first our technique was simply a compilation of the abilities and experiences of battle-hardened cutthroats and mercenaries, no strangers to the sword. It was refined over the years as successive teachers honed their abilities and began to draw on traditional swordplay techniques, which of course

After the pogrom, the keep which once teemed with witchers fell into abandonment and disrepair, with weeds sprouting amidst its ruins. Today the scattered remnants of a battle fought centuries before still speak to the tragic fate of its residents.

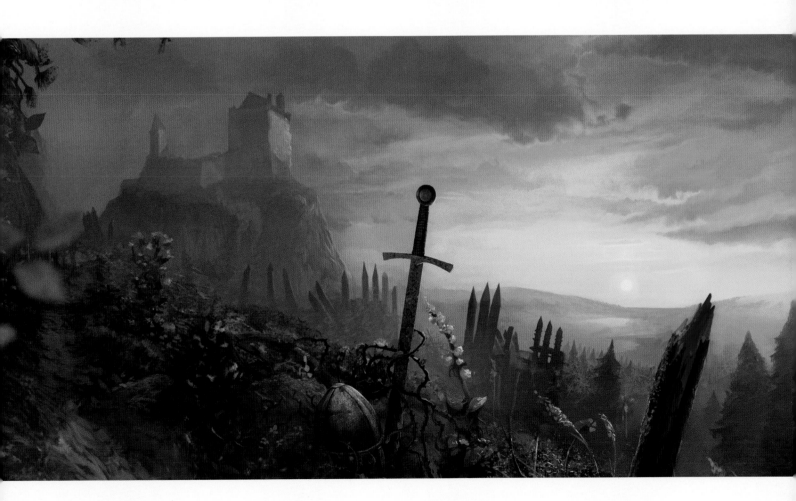

were also in a constant state of evolution. I myself served as a fencing instructor longer than most living men walk this world, and I never passed up a chance to learn something new.

The witchers' techniques were influenced by, among others, elven concepts of swordsmanship, which presumed the use of light armor and relied on numerous dodges and feints. This

In a fortunate twist of fate, a few members of the Wolf School survived the pogrom and dwell in the ruins of Kaer Morhen to this day, using it as their winter shelter and its surroundings as their training grounds.

approach stems from the particulars of our trade. Blocking, guarding, and parrying are mainly useful against an opponent of similar size, weight, and strength, armed with weapons analogous to those made by man. But not even the strongest swordsman can parry the blow of a wyvern's tail or a troll's club. Nor will he block a zeugl's tentacles or a gigascorpion's pincers. In the face of an entire pack of ghouls, drowners, or nekkers, heavy chain

WITCHER SECRETS

"[Illegible] reasons to suspect that some pieces of documentation, formulae, and recipes hidden in Kaer Morhen's secret chambers survived the attack. The witchers likely have access to these, but do not know how to use them. This theory [illegible] events from the previous year, when [illegible] under attack [illegible] organization called the Salamandra. Information acquired by our agents suggests that the attackers' aim was to capture these 'witcher secrets.' Though [illegible] was destroyed, and its leader, the renegade sorcerer Azar Javed, is dead, it is suggested that [illegible] and further monitor the situation."

—Note found near a headless corpse in the sewers of Vizima's trade quarter

mail or even a breastplate does more harm than good, hindering the mobility needed to save you from being knocked to the ground and torn to bits.

Witcher combat training also focuses on the ability to fight in adverse conditions. This practicality is the root of our mastery and is what makes us so effective at our trade. There are few individuals who would be a threat to a witcher one on one—though that does not mean they do not exist. The world does not lack for people who, just like us, make their living through killing. Scarred mercenaries who have survived many a battle, deadly assassins, famous sword masters—to underestimate their abilities would be a lethal mistake. And yet, when fighting a monster in its natural habitat—a dark cave, a fetid bog, or the half-collapsed corridors of

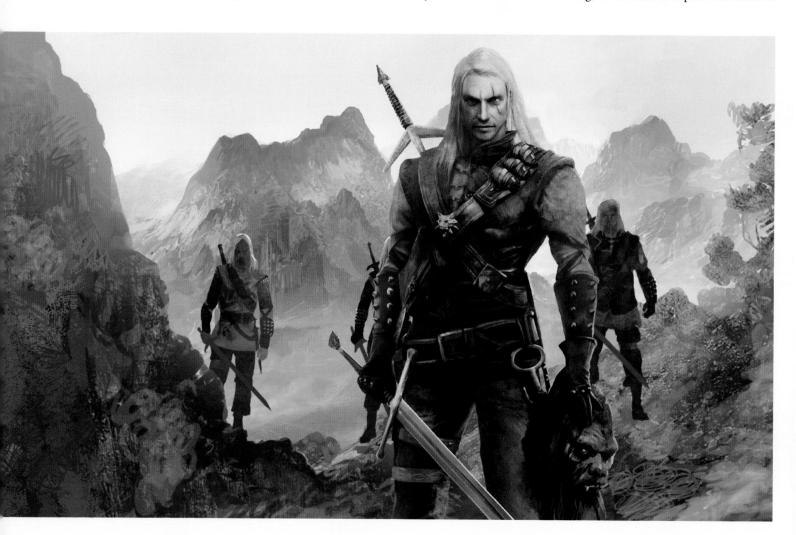

THE GAUNTLET

"You can run through the Path a hundred times, and still break your neck on the hundred-and-first run. Things are always changing, always in motion. The fallen trees that form natural catwalks over stony ravines decay with time, or plummet into the chasm. In spring the snowmelt dislodges stones from narrow mountain paths. Winter ice makes every second step potentially fatal. More seasoned urchins have broken their bones or lost their lives in the Gauntlet than there are whores in Novigrad's brothels. If you've ever been to Novigrad, that statistic speaks for itself."

—Witcher Lambert

an old tomb—all those talented masters would not stand a chance. That is why we train with covered eyes, on wobbly catwalks, waist deep in water, or balancing on stakes planted in the ground. That is why we practice somersaults and tumbling—to be able to bide our time and strike at the critical moment, when our very survival hinges on a single, precise swing of our sword.

Monster Lore

There is more to being a witcher than waving a sword around. Knowledge is just as important, and so we intensely study the creatures we will have to face. We pore through ancient tomes, figures, and both oral and written tales and legends. When facing a beast, a witcher must know exactly what he is up against and what his chances are. He must be familiar with all the ways to fight it effectively. Knowledge of an enemy's natural habitat, daily cycle, habits, diet, and, above all else, weaknesses, is the key to victory.

We are so good at what we do because we have prepared for it. Fighting common monsters, those without any special abilities—such as ghouls or nekkers— is hardly a challenge for an experienced witcher.

This does not mean such an opponent can be treated lightly. When accepting even the simplest commission, one must learn all one can. Talk to witnesses, determine who were the victims, have a look at the scene of the attack, and examine the trails. Appearances can be deceiving, and a wrong appraisal of the situation may cost a witcher his life, if suddenly faced with an unknown or unexpected creature.

Witchers guard secret tools and knowledge that make their keep a tempting target for greedy or power-hungry men. The denizens of Kaer Morhen easily fend off lone treasure hunters, but a band of armed assailants once fought through to the heart of the ruins and stole some of the famous "witcher secrets."

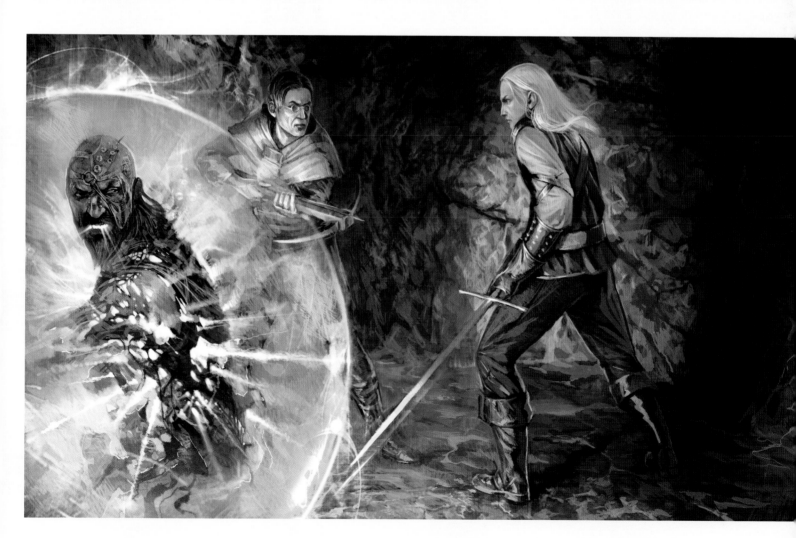

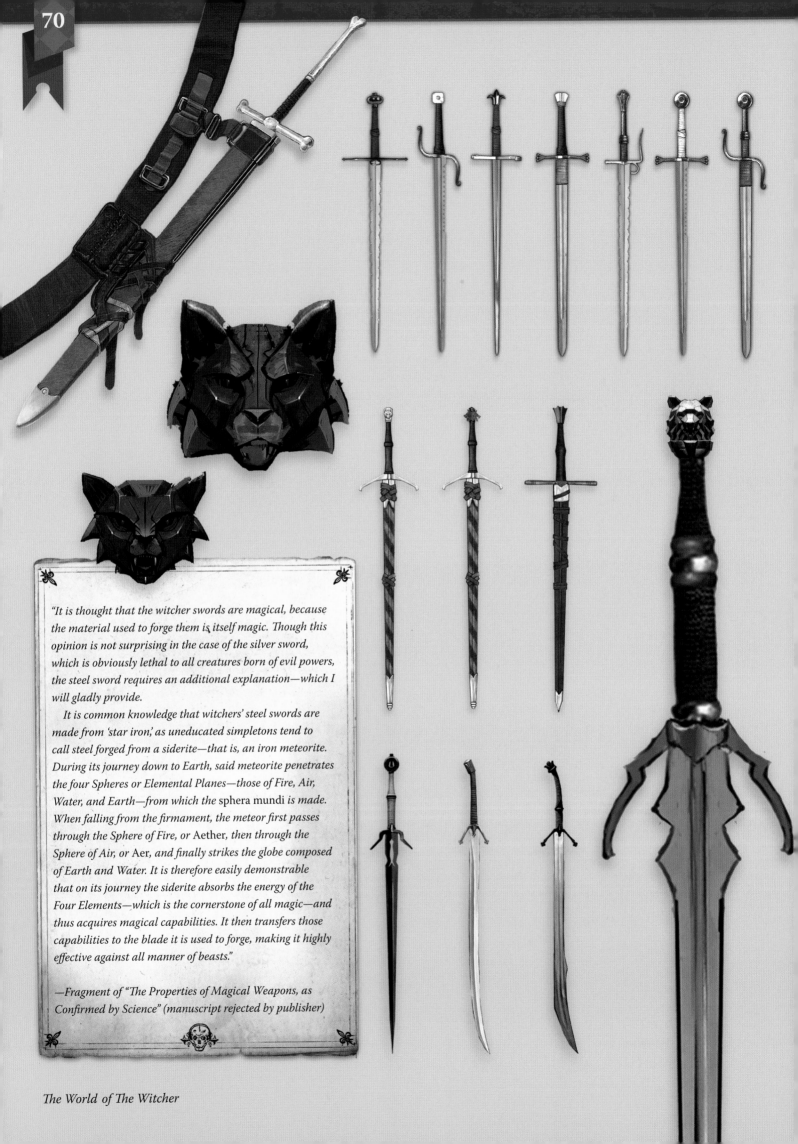

"It is thought that the witcher swords are magical, because the material used to forge them is itself magic. Though this opinion is not surprising in the case of the silver sword, which is obviously lethal to all creatures born of evil powers, the steel sword requires an additional explanation—which I will gladly provide.

It is common knowledge that witchers' steel swords are made from 'star iron,' as uneducated simpletons tend to call steel forged from a siderite—that is, an iron meteorite. During its journey down to Earth, said meteorite penetrates the four Spheres or Elemental Planes—those of Fire, Air, Water, and Earth—from which the sphera mundi is made. When falling from the firmament, the meteor first passes through the Sphere of Fire, or Aether, then through the Sphere of Air, or Aer, and finally strikes the globe composed of Earth and Water. It is therefore easily demonstrable that on its journey the siderite absorbs the energy of the Four Elements—which is the cornerstone of all magic—and thus acquires magical capabilities. It then transfers those capabilities to the blade it is used to forge, making it highly effective against all manner of beasts."

—Fragment of "The Properties of Magical Weapons, as Confirmed by Science" (manuscript rejected by publisher)

Witcher Swords

Swords are the tools of our trade. Every witcher owns two blades, commonly called steel and silver, though as I will soon explain, this terminology is an over-simplification. Both swords are always of the highest quality, manufactured on an individual commission, and their size, weight, and hilt are all tailored to the person who will wield them.

The silver sword's blade, despite popular belief, is not forged from this metal entirely. Silver is a soft metal, and therefore impossible to properly sharpen. Instead, the core of the blade, as well as its edges, is made from steel coated in silver. Still, the weapon remains somewhat delicate, and I would definitely advise against using it to parry another blade. The silver sword is chiefly used against creatures born of magic. This group includes all the beasts that are relics of the Conjunction of the Spheres, as well as monsters created through curses, bred or summoned by magic, or otherwise

> *"The opinion that the dwarven* sihils *are the best swords in the world is both widely prevalent and widely mistaken. It is true that the forging process incorporates ancient gnomish techniques for grinding and sharpening the blade, which to this day have no equal. But the bladesmith's craft reached its true peak only in the ancient gnomish swords known as* gwyhyrs. *Their blades were made from dark steel, hollowed to reduce the weapon's mass. The unique honing process resulted in a flame-bladed sword sporting exceptional sharpness, allowing it to easily cut a batiste shawl floating in the air in half. Original* gwyhyrs *are presently a rarity and command exorbitant prices."*
>
> —Esterhazy of Fano (master swordsmith), *"Tales of Weapons"*

resulting from magical phenomena.

It is not true that all witcher steel swords are made from meteorite ore, which is also called siderite and often associated with magical properties. In truth, the weapons can also be made from steel smelted from magnetite ore, as well as siderite and hematite ores. Personally I prefer the first, though it is damned hard to sharpen properly, on account of its extreme hardness. That is why a core of magnetite steel is usually sheathed in softer steel, which is easier to hone. The best blades currently being made are the *sihil* of the Mahakaman dwarves, though it is said that even they pale in comparison to the swords forged ages ago by the gnomes.

In time, the witchers' steel swords earned the name of "swords for men." A foul moniker, though not one conjured out of thin air. A good steel blade is indeed our first line of defense against mankind's hatred, stupidity, or greed. The world is full of those who would happily kill a witcher—out of resentment toward our

Flying monsters—harpies, wyverns, and griffins—roam far and wide in search of prey, troubling villages which once thought themselves safe from monsters but now see the need for witchers.

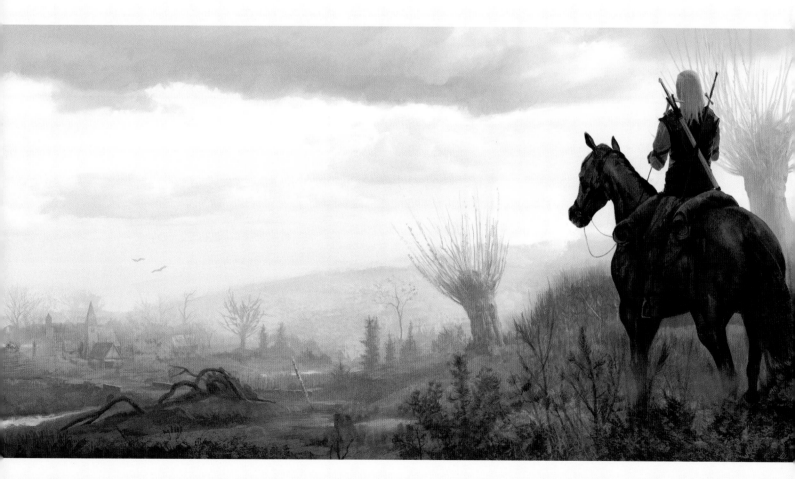

trade, for fame, or simply to profit by snatching up our hard-earned coin. So the witchers, fully aware of the situation, never hesitated to relieve this world of the burden of dolts who were so thick headed as to threaten their lives. For that reason, in my day we called our steel swords "swords for fools." Unfortunately, seeing as how mendacious and two-faced scoundrels of bitches seem to rule this world, a great many fools have been apparently spared this selection process.

THE CODE

"Witcher Code—A precise collection of strict rules and regulations governing the life of the witcher caste (see Witcher Order). Rigorously ingrained during training, it is supposed to be a collection of certain principles and customs of these beast hunters. The code is chiefly concerned with a multitude of imperatives and prohibitions pertaining to witcher contracts. Most of the instructions it contains remain a secret, since the code itself prohibits mentioning them."

—Albert Braas, "Nordling Tribal Customs"

Medallion

The witcher medallion is not only an insignia of our profession—it is also one of its tools. It has numerous useful capabilities that are accessible, of course, only to one who possesses the necessary knowledge and training. First of all, it reacts to the presence of sorcerous auras in the immediate surroundings, making us aware of nearby spell casting, active illusions, or magical creatures. It also warns the owner of sudden dangers, thus providing an additional moment to react. Keep in mind, though, that the medallion is not infallible. A very strong magical aura—such as those found in Places of Power or during the solstices—can provoke aberrant reactions. In large cities, where people widely use simple magical amulets or sorcerous alarm systems to protect their homes, coin, or ruttish wives, the medallion can also behave abnormally.

Most witcher potions are deadly to those whose bodies are not prepared to handle them. Witchers brew these concoctions using alchemical equipment; learning to do so is an important part of their training.

Signs and Potions

A witcher's Signs may be almost childishly simple spells to the average sorcerer, but they are quite sufficient for our needs. One of the merits of the Signs is that they do not require an elaborate magical formula, but merely concentration and a small gesture. This makes them particularly useful for witchers, whose one hand is usually occupied by a sword. Their other merit is that one needs only minimal talent to learn them, or, more precisely, it is merely sufficient not to be an antitalent. I suppose that is why someone decided that it is possible to teach Signs to those who dedicate the majority of their days not to scholarly study but to monster slaying. I must admit that Signs do make our work faster and easier, as even the most skilled swordsman can always benefit from the ability to set the enemy ablaze or knock him to the ground with a simple gesture.

The final component of a witcher's equipment is his potions. Brewing them requires various ingredients both common and scarce, such as organs of certain monster species or rare herbs. In most cases these decoctions are lethal, or at least exceptionally harmful, to a normal human. Witchers, however, are inured to them from youth, though that does not mean the potions have no ill effects on us. They must therefore be administered in very precise doses.

Potions have a multitude of applications. They increase our resistance to toxins, amplify our regenerative abilities, or enhance concentration, allowing

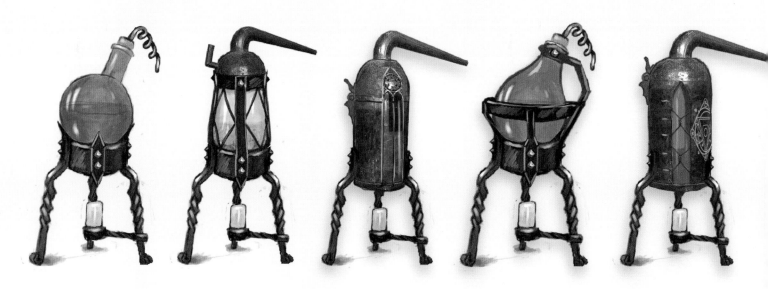

for easier accumulation of the magical energy necessary to cast a Sign. Most are imbibed before combat to speed up our reflexes tenfold, magnify the strength and precision of blows, or take our pain tolerance far beyond normal limits. A witcher on potions is damned fast and murderously effective. No man can match him without the aid of sorcery. Yet as I said, extreme care must be exercised when consuming potions, since they have the potentially disastrous side effect of poisoning you. "Died of an overdose while preparing for battle" would make a rather pitiful epitaph for a witcher's tombstone.

Witcher Work and the Question of Price

Witchers spend their winters in Kaer Morhen. Here we can quietly rest, replenish our stocks of rare potions, repair our equipment, and meet up with friends. Come spring, we venture once more out into the world and search for work. We ask innkeepers, reeves, and village aldermen, and look for proclamations and notices nailed to trees or signs at crossroads. Most of the time, people cast hostile stares our way upon our arrival at a settlement. In the worst cases, they might cast horseshit or even stones, making a hasty departure usually the

best course. But if they leave their cottages, greet you, invite you inside, or offer food, this usually means they have a job for you—or maybe they simply want to hear the latest news from the world at large. It is a good idea to occasionally visit the places where you have already worked. People are less wary and distrustful there, and it is easier to learn what might be going on in the area or to stock up on supplies. Sometimes grateful folk will even spare a room for you to spend the night, or will buy you a few rounds at the local inn, so it pays to cultivate your reputation. In some places, the fourth or fifth generation still recognize me on sight.

Picking jobs comes down to personal preference. No witcher is obliged to accept a contract if it is beneath his dignity, if the money offered is inadequate for the risk involved, or if he simply feels he won't stand a chance of succeeding. The price for our services is negotiable, but you must take care not to damage the market for everyone by working for a pittance. The exact fee depends on how complex the matter is, how much time it will likely take to complete, the foreseeable personal expenses, and any special request made by the client.

The details concerning payment are typically agreed upon before accepting a job. Usually remuneration takes the form of a single sum handed over after the contract is completed. We do not normally take coin up front,

Neutrality is a key witcher principle. They take no sides in the world's many conflicts, and thanks to this can practice their trade no matter the current political or religious situation.

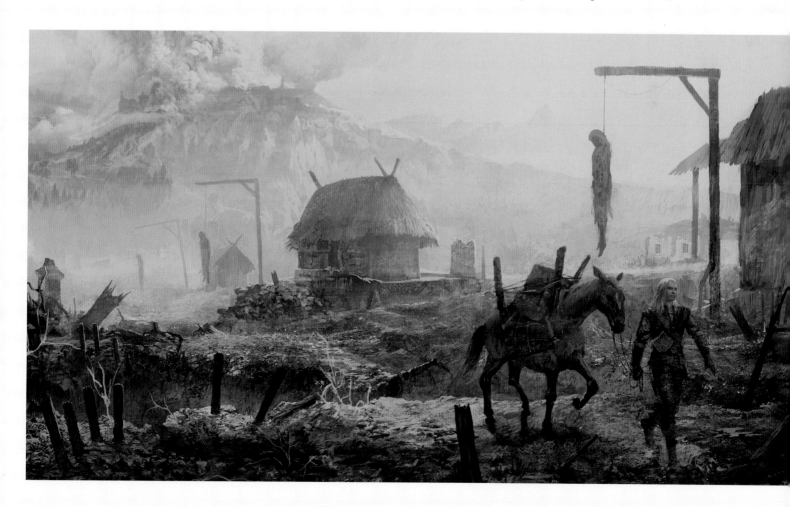

but we will at times ask for an advance, especially if the work is likely to take some time. The form of payment is also always decided beforehand. In most cases, especially when working in villages and receiving small sums, it takes the form of coin. When the client is a wealthy merchant, sorcerer, or lord, we prefer newfangled account transfers or banking checks, which are easily redeemed at any dwarven bank.

Grueling training, years of practice, expert knowledge, and specialized equipment—this is how witchers fulfill their calling and become the most effective monster hunters the world has ever known.

"Yes, we keep saying we are neutral and keep our distance from things that should not concern us. But sometimes a witcher faces ordinary, down-to-earth evil, the type of genuine grievance, injustice, or plain old iniquity so grand that even one of us will find it hard to pass calmly by. At times like these, said witcher should think twice before doing something foolish. But if he concludes that despite his training and principles he has to act, or he will never be able to look in a mirror again without spitting, then he should do it like a professional. And when he is done, he had better not be expecting any praise or thanks, for he won't receive any. He must simply turn, walk away, and never come back."

—Anonymous (ascribed to Vesemir, master of the witcher trade)

Mistakes

At times, people display a shocking ignorance or almost willfully misguided understanding of the nature of our profession. Geralt once mentioned a duke who tried to hire him to find a girl who had rejected his vulgar advances and fled his ball, leaving only a shoe behind. The White Wolf barely managed to convince his would-be employer that the task was more appropriate for a huntsman than a witcher. I even recall being asked to get rid of a rat infestation of supposedly magical origins. The townsfolk, in all seriousness, suggested I try luring the rodents beyond the walls using a magical flute.

Most frequently, though, we are mistaken for assassins or sellswords. Most often this tendency is displayed by various lords, accustomed to buying people's

services with no regard for cost, without ever imagining that they might be turned down. There are usually two ways out. First, you can politely but firmly refuse, citing the Witcher Code. But when the crowned head is particularly thick skulled and stubborn, you should use your first chance to depart, and thus avoid any further troubles that might arise.

Taking on such work would undermine the reputation of our entire profession and make us little better than common thugs.

Since we are on the subject of the Witcher Code, it must be said that there never was one. The term is often invoked by Geralt to identify the set of principles he follows, or rather attempts to follow. The lad has a real talent for getting involved in things he's sworn to avoid . . . but that is a tale for another time. Truth be told, every one of us has some kind of principles. We try to live by them, faring better at some times and worse at others, but you have to be committed to something. You could say that each witcher has his own code. Moreover, it is good for business. You always can avoid an unwanted job by citing the prohibitions of "the code." People respect those who follow certain principles—probably because it's damned rare in these foul times.

If you want to purchase our services, keep in mind that our profession was created with a very specific purpose in mind: Witchers should kill monsters. Not members of sapient races, not harmless creatures or exotic species, but beasts that threaten human life. Beings birthed from magic, relics of the Conjunction of the Spheres, creatures of chaos, and monsters resulting from magical experiments or curses are what witchers were made to combat and destroy.

While keeping in mind who we are and what we do, you should also never forget who we are not, and what we should not do.

We are not knights-errant, fighting for ideals and glory. We work for money and ply a very specific trade. We do not fill in for agents of the law by pursuing bandits or marauders. We do not follow kings, barons, merchants, sorcerers, or priests into their endless wars. We are neutral. If ever we were to break that rule, it might quickly turn out again that the world would no longer be neutral toward us.

CHAPTER III
THE MAGIC AND RELIGIONS OF THE CONTINENT

Yennefer of Vengerberg, the true love of the witcher Geralt, hero of Sodden Hill, and at one point the youngest member of the Council of Sorcerers, is undoubtedly one of the most talented magicians of our time.

Initially, it must be said, we did not get along very well. Would you believe that I once heard the rumor that for years she "despised me like the bubonic plague"? At that time, my own feelings toward her were also less than cordial. This likely stemmed from the fact that, as Geralt's devoted friend in a world often equally hostile to witchers and to true artists like myself, I always felt it my duty to take the witcher's side in the many crises that emerged during his often-tempestuous relationship with the sorceress.

All that changed several years ago, when a band of ruffians abducted and tortured me in the hopes of extracting Geralt's whereabouts. Suddenly, Yennefer entered the scene like an avatar of vengeance, her eyes flashing fire as she meted out justice upon those villains and saved me from a certain death. Later she told me that she had actually held me in high regard for some time, for I was the witcher's ever-faithful friend and had never abandoned him, no matter what dire circumstances befell us. And so, Yennefer and I have been friends ever since. When I asked her to explain matters relating to magic, its history, and the laws that govern it, she agreed, though not without some hesitation.

—*Dandelion*

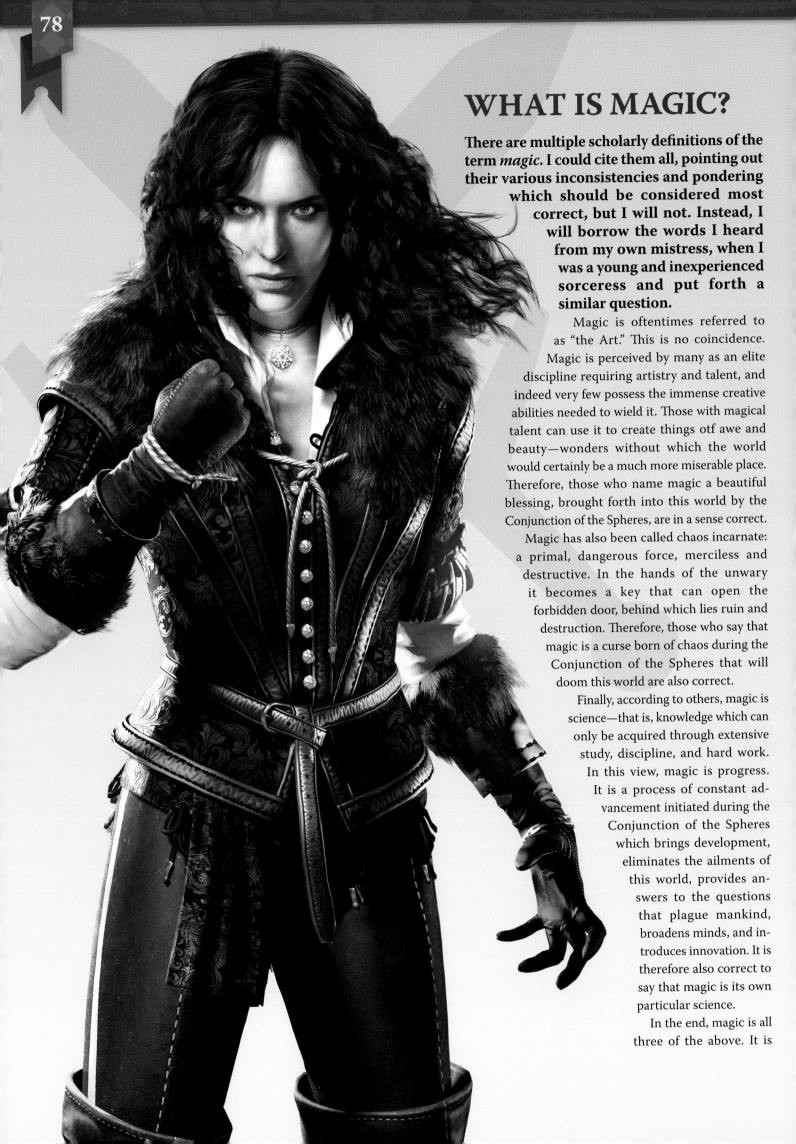

WHAT IS MAGIC?

There are multiple scholarly definitions of the term *magic*. I could cite them all, pointing out their various inconsistencies and pondering which should be considered most correct, but I will not. Instead, I will borrow the words I heard from my own mistress, when I was a young and inexperienced sorceress and put forth a similar question.

Magic is oftentimes referred to as "the Art." This is no coincidence. Magic is perceived by many as an elite discipline requiring artistry and talent, and indeed very few possess the immense creative abilities needed to wield it. Those with magical talent can use it to create things otf awe and beauty—wonders without which the world would certainly be a much more miserable place. Therefore, those who name magic a beautiful blessing, brought forth into this world by the Conjunction of the Spheres, are in a sense correct.

Magic has also been called chaos incarnate: a primal, dangerous force, merciless and destructive. In the hands of the unwary it becomes a key that can open the forbidden door, behind which lies ruin and destruction. Therefore, those who say that magic is a curse born of chaos during the Conjunction of the Spheres that will doom this world are also correct.

Finally, according to others, magic is science—that is, knowledge which can only be acquired through extensive study, discipline, and hard work. In this view, magic is progress. It is a process of constant advancement initiated during the Conjunction of the Spheres which brings development, eliminates the ailments of this world, provides answers to the questions that plague mankind, broadens minds, and introduces innovation. It is therefore also correct to say that magic is its own particular science.

In the end, magic is all three of the above. It is

Art, Chaos, and Science: a blessing, a curse, and progress. It all depends on who calls upon it, and for what purpose.

Magic stems from nature. It is in the earth we walk upon, in the fire burning in its heart, in the air we breathe, and in the water which brings life and which flows within us. If you happen to be gifted with the particular talent, all you need do is reach out your hand and grasp the magic all around you.

> *"And then Jan Bekker raised his hand, surrounded by a bright nimbus, and in a powerful voice spoke, louder than the storm: 'Bend, oh elements, and submit to my will, for henceforth I am your master!' And such power emanated from him that the wind calmed, and the cruel waves became still. And so the ships of the Exiles could safely come ashore, for Jan Bekker had harnessed the Power, so that it would serve mankind for ages to come—thus proving that said force does not have to be malevolent and destructive."*
>
> —*Roderick de Novembre,* The History of the World

dormant and hidden for a very long time. He or she may even seem to be a magical antitalent. Despite effort and concentration, a source will not be able to cast any spell, since she or he connects to magical energy unconsciously and processes it unconsciously as well.

Magical Talent and the Sources

The first individuals with magical talent started to appear not long after the Conjunction of the Spheres. These were mainly children who showed a natural inclination toward magic at a very young age. They could absorb the Power, process it, and use it in a deliberate, purposeful manner. Given time, they showed the potential to further develop and refine these abilities.

There were other individuals who emerged at this time as well, who would later be called sources. A source's talent is wild and untamed—a vast magical power over which the source has no control. He or she is something akin to a medium, and indeed often is possessed of prophetic predispositions. Such a person is a vessel for the Power, an involuntary relay. A source's abilities, though extremely powerful, usually remain

However, his or her talents inevitably reveal themselves sooner or later, and their first manifestation is spontaneous and usually very violent. The Power which uses the source as a relay and a focusing lens is released without any control whatsoever, most often with destructive consequences for anything in the immediate vicinity.

A source's extraordinary abilities can be detected by means of careful observation and certain trials and tests. When properly directed and trained, sources can learn to unlock their unbelievable potential in a controlled manner and become very powerful sorcerers. However, in the ages before it was discovered that the Power could be controlled and utilized, both sources and others touched by magic were ostracized and feared.

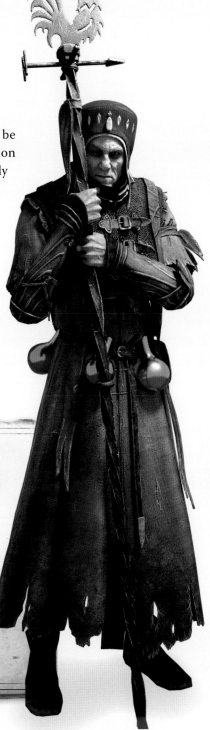

> *"For obvious reasons it is difficult to date the beginnings of magic, since they lie somewhere within the Dark Ages that directly followed the equally poorly documented cataclysm known as the Conjunction of the Spheres. The story that the famous sorcerer Jan Bekker was the first to use the Power, and did so in order to calm the ocean's waves during the First Landing, became prevalent over the ages. This scene is immortalized in countless paintings and sculptures—and yet this seems another case where the truth is more mundane than the legend. All existing evidence suggests that he only harnessed the Power some time after the Landing, and that during it he suffered from the same painful effects of seasickness that afflicted most of the passengers and crew. Undoubtedly Bekker would have dearly liked to calm the ocean that day, for he spent most of the Landing, to use the vulgar but appropriate colloquial expression, 'puking like hell.'"*
>
> —*Fragment of the controversial cycle of lectures* Disproving Myths, *professed at the Oxenfurt Academy*

Channeling the Power

Magically gifted individuals can channel the Power flowing through nature and bound in the four elements that surround us. This talent is indispensable for practicing the magical art. For while it is true that in the short term a sorcerer is capable of casting spells at the expense of his own vitality, the consequences are severe and range from temporary weakness to loss of consciousness and even to death. Therefore, it is critical to be able to channel and process the vast reservoir of energy that encircles us.

Today the ability to draw upon the Power is one of the fundamental elements of a future sorcerer's basic education. Some display a natural, inborn talent, while others need more time and training to hone this ability. The process itself is seemingly simple. It requires above all else a concentration of will and appropriate focus, which allow sorcerers to attune themselves to the available reservoir of energy.

Novice adepts, however, often find the process of channeling the Power to be a long, arduous, and unpleasant affair. Instances of so-called "contraction"—that is, an uncontrolled acquisition of energy—are frequent but usually result in harmless shocks, and only if the appropriate precautions have not been taken. On the other hand, extremely reckless or careless channeling can lead to more dire consequences, including hemorrhage, nerve shock, blindness, coma, temporary or permanent

OF CATS AND DRAGONS

"Among all the creatures of the earth, there are only two which can channel the Power: cats and dragons. Both species instinctively sense the location of magical intersections and often pick these places to rest—which is strange, as all other animals avoid such locations. Multiple theories have offered interpretations of this behavior, but none can explain it fully. As far as dragons are concerned, some scholars maintain that they must surely use the accumulated Power to enable their flight, for science tells us that no creature so large and so massive could lift itself from the ground using only its own wings.

Cats, on the other hand, are commonly thought to use the gathered Power to fuel their ability to perceive the unseen. Others believe that this talent is natural to cats, and that they use the energy drawn from magical intersections for other, unknown purposes. For it is a known fact, proven beyond all doubt, that all species of Felidae are remarkably capable of seeing creatures from other dimensions, invisible beings, and emanations of the Power."

—Fragment of "The Mystery of Mysteries," penned by Mistress Agnes of Glanville

Many mages' laboratories are fitted out with alchemy equipment, though most consider material investigations a mere helpmate to their true focus: research into the nature of magic.

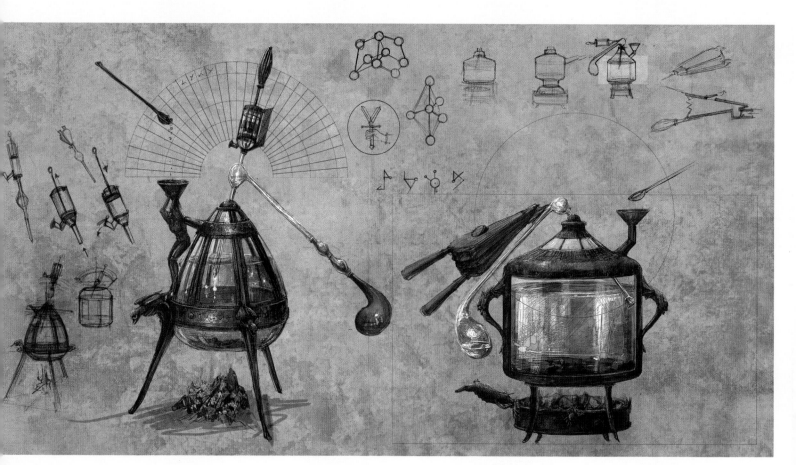

auditory and visual delusions, and finally madness or catatonia.

Each concentration or manifestation of an element is a potential source of energy. The difficulty of using it and the risk involved depend on its nature and form. The greater and more dynamic the source, the easier and more dangerous it is to use. The most powerful of these natural concentrations of energy are known as Places of Power.

> "Places of Power are locations where the modulus of the circulation of magical energy is extremely high. Examples include meeting points between tectonic plates or intersections of water veins. The phenomenon is specific to geological anomalies and locations where the energies of different elements permeate. It is most easily observed in areas of increased seismic or volcanic activity, and can also be found in certain swamps and bogs, or among windswept cliffs and mountaintops.
>
> Because of their capabilities, the Places of Power emit a certain specific aura, easily identified by appropriate senses. Drawing upon magical energy there is much easier than in other places. That is why these locations are oftentimes chosen by sorcerers to build their towers, and in the past many were places of worship, where megaliths and temples were erected."
>
> —An Overview of Magical Phenomena
> (collaborative dissertation)

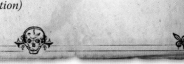

The Power of Elements

As has been mentioned, the Power flows from nature and gushes from the four principles or, in other words, elements. Each element has its own unique character. The compilation that follows is but a cursory outline of this complex matter. For further discussion, see Giambattista's *Elemental Empires*, where a detailed study of the subject can be found.

Water—Due to its moderate dynamics, water is the optimal medium for inexperienced sorcerers to learn to channel the Power. As with the other elements, any concentration or manifestation of water can be used as a source of magical energy. However, it is best to start by drawing from water veins, preferably from their intersections—the most widespread Places of Power. Easily detectable by even the least experienced adepts, and isolated from most external influences, intersections are a relatively safe source of the Power. In time, a sorcerer will be able to learn how to draw energy from the many variable and mercurial manifestations of the element of water—for a calm lake requires a different approach than a rapidly flowing stream. The sea, on account of its dynamism, is a particularly troublesome source. Despite its vast stores of energy, drawing upon it is best left to more experienced sorcerers.

The runes and magic inscriptions adorning mages' robes are meant first and foremost to impress laypeople, be they commoners or kings.

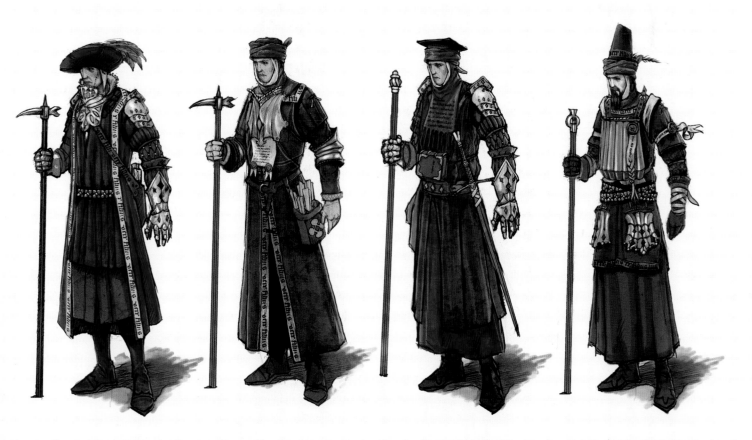

The Magic and Religions of the Continent

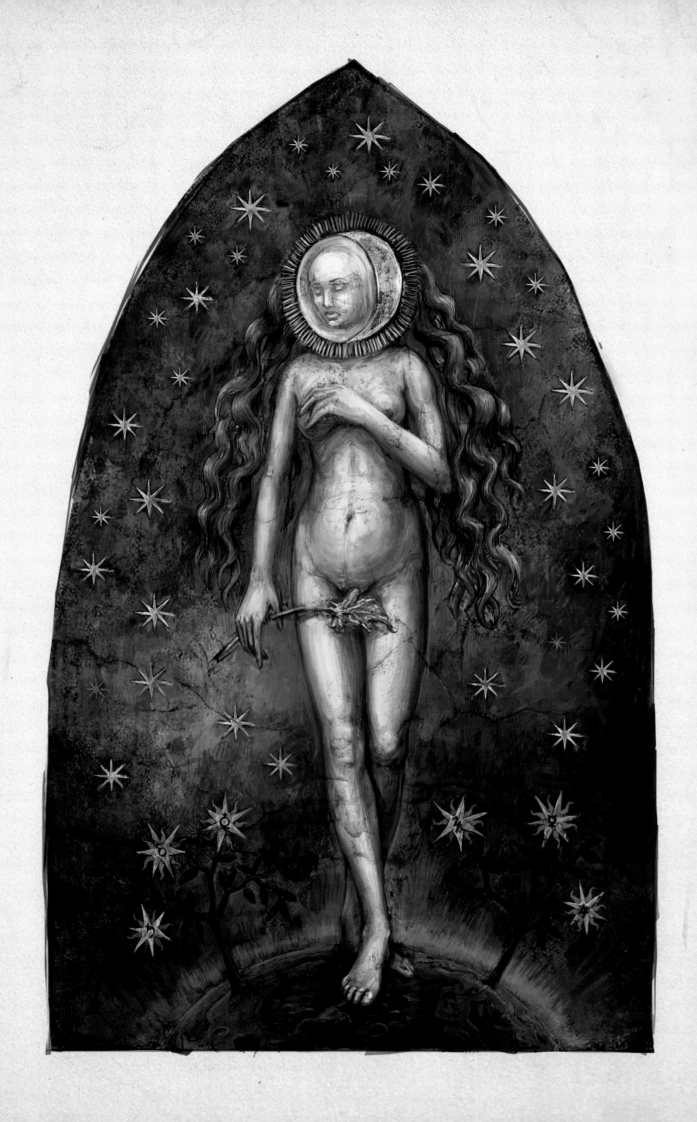

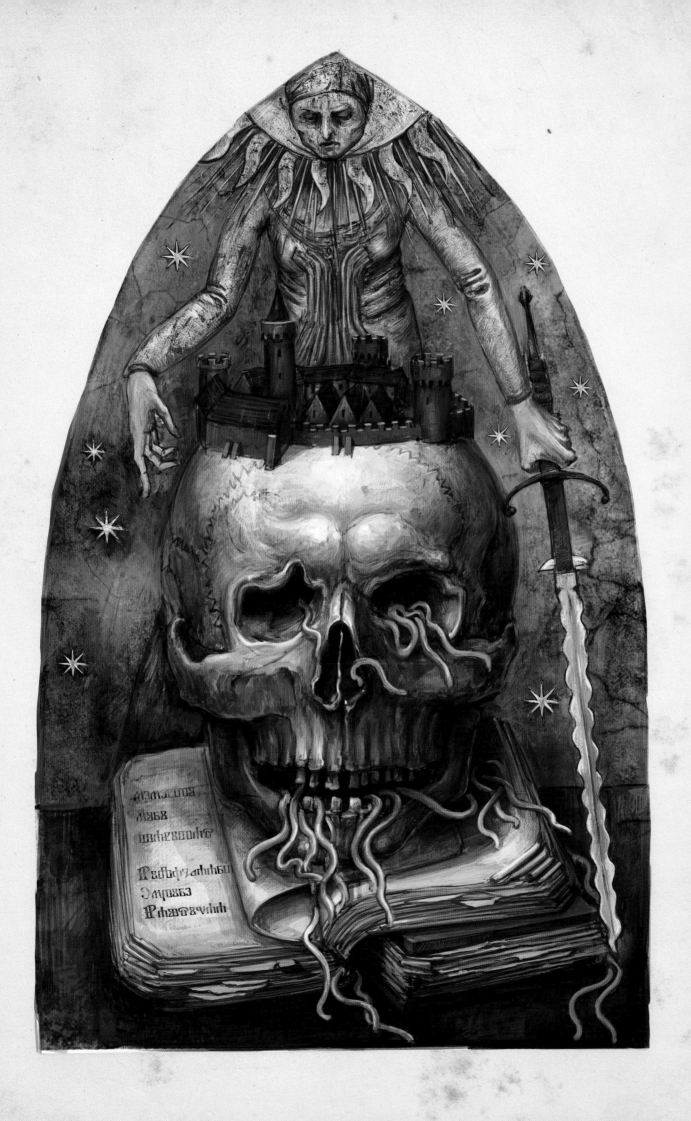

Earth—Though this element is almost universally accessible, earth is not an efficient transmitter of energy. Drawing from it requires a large expenditure of labor, mainly on account of the static nature of the Power held within. Most sorcerers find the effort required to be disproportionate to the gains realized. It cannot be denied, however, that those who have mastered this art have exceptional means at their command, for the Power hidden within earth is tremendous.

Air—This most fickle and dynamic element also holds impressive potential. Unlike the element of earth, it is much easier to draw upon and requires less effort. This does not mean, however, that it is simpler, for air's capricious nature demands great skill and knowledge. A sorcerer who lacks the appropriate proficiency will simply be unable to attune himself sufficiently to the

"None of the four Planes or Dimensions—those of Fire, Water, Earth, and Air—is accessible to mere mortals. They are inhabited, however, by creatures known as geniuses. There are four types, each corresponding to one of the four Elements which comprise their respective essences. Each type of genius also counts its antithesis among the others. Thus, the marides, aligned with the Element of Water, are opposed by the fiery ifrits. The Plane of Earth is inhabited by the d'ao geniuses, and the Dimension of Air which opposes it is home for d'jinni—whose name, incidentally, is the root of the word genie. This last term is often used by simple folk to refer to all creatures that inhabit the Elemental Planes, which is an obvious blunder . . .

Unusually powerful sorcerers can sometimes bind such beings and bend them to their will, thus acquiring tremendous might, to the point of near omnipotence. For a genius, being the living personification of an Element's energies, is akin to an almost boundless reservoir of the Power. Thus, its master can draw energy from the genius for spell casting, without the tiresome need to channel from traditional sources. However, those who are able to bind a genius are few and far between, for the strength of the inhabitants of the four Planes is only matched by the cunning which they employ to avoid such a fate."

—*"Of the Elemental Planes and Their Inhabitants," fragment of Giambattista's Elemental Empires*

element and will not draw a satisfactory amount of the Power. A certain intuition is needed, and that comes only with years of experience and constant practice.

Fire—Many a young adept has met a tragic end when trying to prematurely harness this most unpredictable and chaotic element. The Power flowing through fire is as grand as it is fickle. Drawing upon fire provides energy readily and swiftly—sometimes too swiftly. The Power channeled from fire is easiest to "contract" upon, and an inexperienced adept may not be able to stop drawing energy before it

is too late. Sources in particular must exercise extreme caution, as coming into contact with the Power drawn from fire may suddenly activate their peculiar abilities, usually in a destructive manner.

Magic power derives from a raw, uncontrolled force that also lies at the heart of other phenomena—such as the spontaneous appearance of dangerous wraiths on the field of battle.

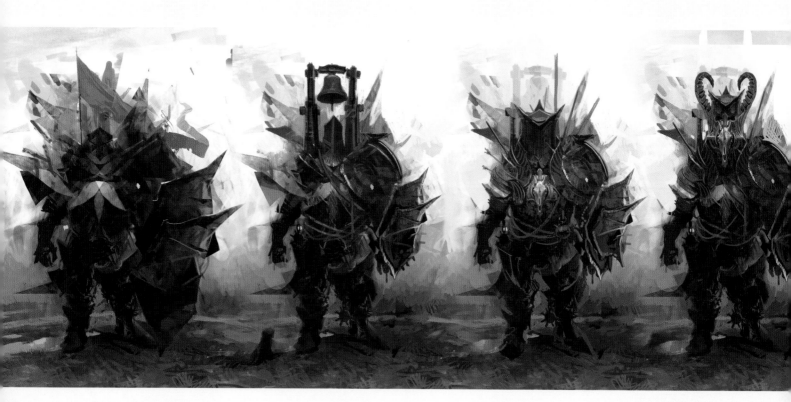

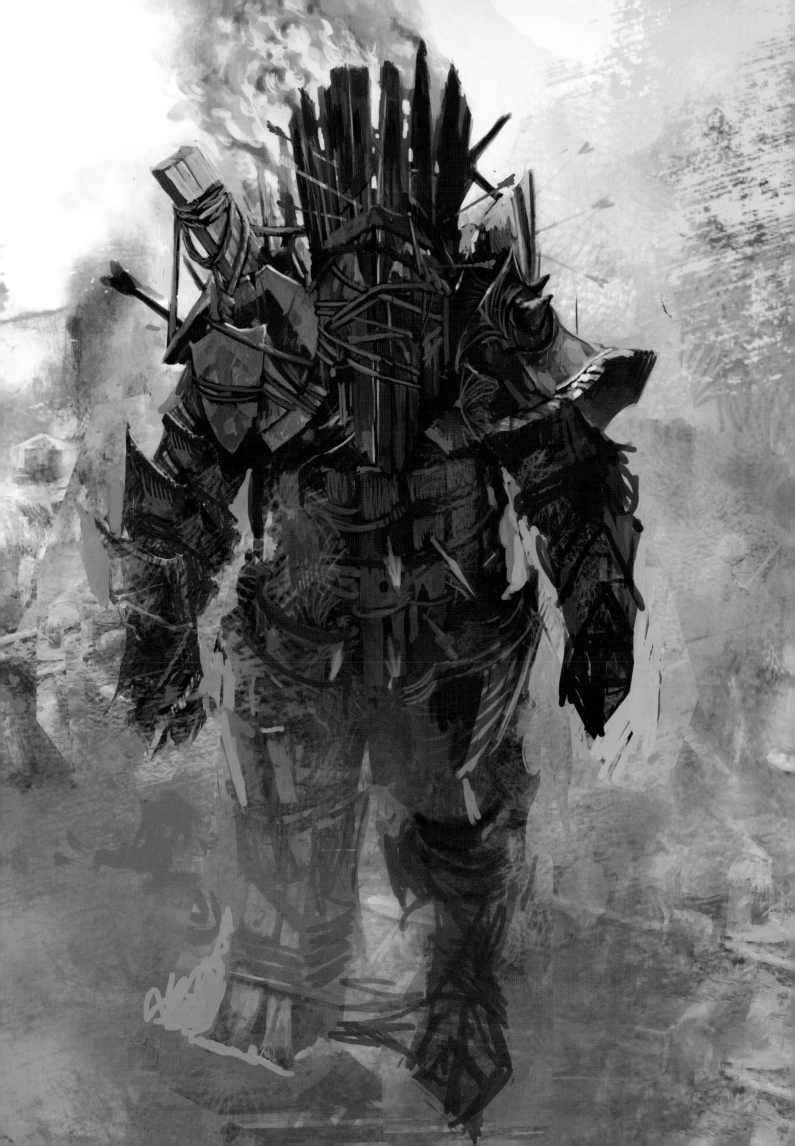

Casting Spells

A skilled sorcerer is able to use the channeled Power to cast a spell. Usually this requires uttering an appropriate magical formula and employing specific gesticulations. In truth, however, the two elements that are absolutely necessary to bend the Power to the spell caster's will in order to form and activate a spell are simply deep concentration and the expenditure of an adequate amount of accumulated energy.

The required amount of Power varies, depending on the result one aims to achieve. Uncomplicated spells do not need much, while more advanced spells are fueled by proportionately larger amounts. Attaining an extremely powerful effect may be well outside a sorcerer's reach, if his knowledge and experience are inadequate to draw enough Power or to utilize it prudently.

When casting spells, an adept of the magical art ought to keep in mind the following:

First, as has been mentioned, one can only use as much of the Power as one has channeled. Attempts to

> *"Among the many substances possessed of strange and wondrous qualities, it would be unthinkable to omit dimeritium. This extremely rare, bluish-hued metal can block magic by severely limiting the flow of the Power in its immediate surroundings. On account of this attribute, an alloy of dimeritium and iron is used to forge shackles intended to chain those who can command the Power. A sorcerer thus ensnared cannot cast even the simplest spells, and the metal's mere touch is enough to cause nausea and vertigo. The most powerful mages, however, have demonstrated an ability to overcome this weakness, immunizing themselves to dimeritium's effects over time or even neutralizing its aura for a short period."*
>
> —An Overview of Magical Phenomena
> *(collaborative dissertation)*

utilize more have a host of ill effects on one's own organism. These consequences have already been mentioned, so I do not consider it necessary to do so again here.

Second, one must exercise restraint when expending the Power. Here I do not mean limiting the frequency of one's spells, though I do believe that certain sorcerers should think twice about using spells to solve such trivial problems as lacing one's shoes, mending clothes, or preparing a warm bath. Rather, I mean appropriate expenditure of the Power within the context of a specific spell. One should always use only the precise amount necessary for the desired effect. Squandering an amount of the Power suitable to light a campfire while attempting to conjure a spark for a candle wick is a common mistake among novice adepts.

Third, one's gestures should be concise and one's incantation articulate and firm. My own mistress used to say that one should command the Power, and not sputter out pitiful supplications. A stammering or stuttering sorcerer will at best lose face, and at worst may tragically

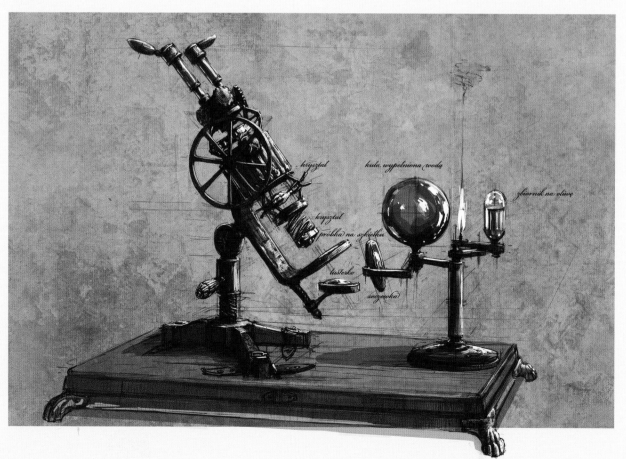

end his own magical career, usually in a spectacular manner. The fact that his dramatic exit from this world will be less than pleasant for bystanders as well provides little consolation.

On the other hand, a flawless pronunciation and talent for oratory can be a real asset in our trade, and make spell casting much easier. The sorcerer Alzur remains the best example to this day—his mighty voice and superior diction allowed him to cast even the most complex spells with ease. Despite its ability to kill half a dozen men at once, the spell Alzur's Thunder is not widespread precisely because the required incantation is so complex. To master the great sorcerer's signature creation is exceptionally difficult, and in itself is a testament to one's magical skill.

As far as the aforementioned gesticulation is concerned, though it is indispensable in many cases, it does not necessarily have to be performed using one's hands. Wands and magical staves are the most common substitute, but there is a single known case of a leg being used to cast a spell—though this feat has not yet been reproduced or officially analyzed.

Types of Spells

The end result of these actions is called a spell or, very rarely, a hex. Most existing spells were developed during the last few centuries, and the method for casting them has not been altered. From time to time, however, new incantations are created. These incantations can

"To the Chancellor of the Ban Ard Sorcerer's School,

The latest drunken excesses of the third-year students, which took place during the Belleteyn celebration, have exceeded all acceptable norms. The impetus for these shameful events stemmed from a discussion of Master Dorregaray's visiting lecture from several weeks ago, in which he mentioned how the sorceress Yennefer of Vengerberg managed to cast a spell while 'gesticulating' with her leg. The event itself took place some years ago in the Kestrel Mountains, and Master Dorregaray witnessed it, as we well know, personally.

The hypothetical contemplation of how this feat could be re-created later became the root of a spontaneous contest organized by the adepts. Said 'contest,' when combined with alcohol smuggled into the dormitory, quickly escalated into more-obscene revelry. The finale took place beyond the school's walls, in the city itself. There, at the Three Spruces inn, the students Vidar Holgersson, Hoster Wythcliff, and Cammle Torrel the Younger scandalized the patrons by appearing without their underclothes and, according to the more delicate reports, 'trying to cast spells without using their hands.' To add insult to injury, when arrested by the city guards, the students claimed they did it all 'in the name of progress and the further development of magic.'

A multitude of complaints continue to be registered on account of the incident, and the city's burgomeister has announced that he will visit us to discuss the matter. I need not remind you of the complications this visit promises to bring, as adept Hoster Wythcliff is his nephew. I suggest resolving the issue as soon as possible by undertaking the necessary disciplinary action and intensifying our academic rigor, since events such as these do not help in upholding our institution's good name.

Kind Regards,

Archmaster Mardin of Rakvelerin, Vice-Chancellor for Student Affairs"

"If any of them managed the feat, he should visit me with his registration book."

—The chancellor's alleged response, according to gossip among students

be the result of studies and experiments that took years to complete, or of pure chance—such as when a daring or foolhardy sorcerer simply attempts a new formula or, just as likely, makes a mistake when casting another spell and happens to live through the results.

There are several formal typologies of spells. The need to memorize and recall these magical taxonomies is the bane of all second-year sorcery students. Most of the classical divisions mention no less than five and sometimes more than a dozen groups of spells, including psychokinetic spells, illusions, divination, transformations, and finally creation magic, considered by many to be the apex of the sorcerous art.

Many powerful spells require certain objects in order to be cast, which must meet strict requirements in terms of shape, size, and the materials and tools used in their construction.

Forbidden Magic

There are, however, certain kinds of magic which are still prohibited under the edicts of the old Conclave. These include necromancy and demonology, also known as goetia. Both fields were considered to be far too dangerous and unethical to allow their unrestricted study, much less practice. Before these restrictions were handed down, there were of course a few unfortunate incidents which led to the deaths of several sorcerers and many bystanders. Considering how long those specializations were not restricted, we are speaking of hundreds of more-or-less accidental victims at a minimum. I doubt, however, that it was the fate of these bystanders that provided the Conclave's motivation for issuing the appropriate edicts. The instinct for self-preservation is no less strong among sorcerers than among ordinary humans.

As far as necromancy is concerned, the ban is limited only to practical use, and does not extend to theoretical or purely academic knowledge. In some cases, backed by applications with sufficiently positive opinions, the Conclave can grant special dispensation to study this specialization. That is why, although it is not mentioned openly, many sorcerers have at least a theoretical grasp of the field and even the rudimentary skills necessary for the most basic of necromantic practices, such as acquiring simple information from the recently departed.

Goetia, or plainly speaking, demonology, is a different matter altogether. It focuses on summoning creatures from other dimensions and realities, often from strange and alien corners of time and space, usually with the hope of bargaining with them for information or services. Contrary to popular opinion, summoning a demon does not require great abilities or knowledge, but merely access to the appropriate magical formulae. This makes goetia a very tempting path for novice adepts. However, since such adepts obviously lack skill and knowledge, and since summoned beings are uniformly, exceptionally dangerous, a successful summoning usually results in the would-be goet's death. Officially, this is the reason given for all the prohibitions and punishments aimed at those who would attempt to summon any creatures from other planes.

> "Merigold's Ravaging Hailstorm—the informal name of a spell which called down a savage hail during the pogrom in Rivia in the year 1268, ending the massacre and the riots in the city. The name comes from its creator, the sorceress Triss Merigold, who cast it inadvertently while attempting to cast Alzur's Thunder. The spell is not formally recognized and listed among registered spells, as it has never been reproduced. The commission investigating the events in Rivia concluded that the unexpected spell was likely due to the fact that Sorceress Merigold suffered injuries to her mouth during the riots, which caused her to unintentionally distort Alzur's original formula.
>
> There is also another theory that claims the Ravaging Hailstorm was an effect of casting the spell in cooperation with the sorceress Yennefer of Vengerberg. That version, however, was rejected by the commission, on account of the complete lack of evidence that Yennefer of Vengerberg was anywhere near Rivia at the time."
>
> —Felicia Cori, "The Spells That Changed History"

The Basics of Magical Education

The current educational system is the result of significant transformations over the last few centuries. Over that time my brethren have labored hard to rehabilitate (some might say whitewash) the reputation of sorcerers, but the beginnings of the Brotherhood were not nearly as praiseworthy as we would like to present them.

Both young sources and magically talented children have always made the best prospective sorcerers. That is why in ages past members of our brotherhood were continually on the lookout for such individuals. Upon locating a suitable child, the sorcerers tried to obtain custody, utilizing various, often unethical, means. To not mince words, children were taken from their families. Usually this was done by means of persuasion and appeals to reason, by presenting the parents with predictions of the young talent's glorious future. However, subterfuge was frequently used as well, with sorcerers manipulating the parents' fear and misgivings about their child's hidden talents. There were also cases of abducting children by force. This was all done for the betterment of mankind, of course, and therefore seen as excused by a higher purpose.

> "The sorcerers' first seat, and the site of training young adepts, was Mirthe, known today as the city of Mirt in Redania. Here, those who would later form the first Conclave were educated, among them Agnes of Glanville—the first woman to become a sorceress.
>
> The school at Mirthe was destroyed during Falka's Rebellion, when the whole city was burnt to the ground and its inhabitants brutally murdered. One of the fathers of the magical tradition, Master Radmir of Tor Carnedd, died a martyr at that time, condemned to be skinned alive on the orders of Falka herself."
>
> —Fragment of semester dissertation for the second year in the Faculty of History at the Oxenfurt Academy

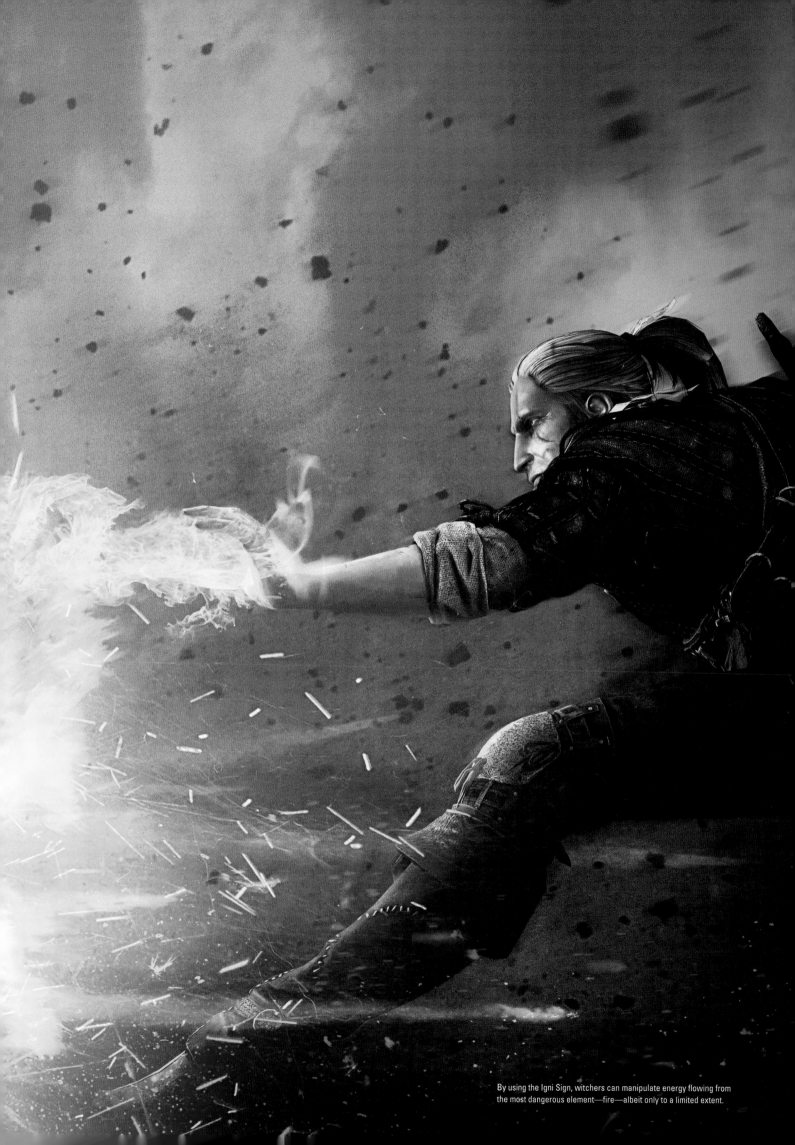

By using the Igni Sign, witchers can manipulate energy flowing from the most dangerous element—fire—albeit only to a limited extent.

Today such practices have been long abandoned, but the folktales of mages demanding children as payment for their services are an echo of those terrible times. Still, even in recent times, every sorcerer had the sworn obligation to inform the Conclave about any sources he encountered, so that they might be placed under observation and, at an appropriate moment, awed by magic, so as to be more easily convinced to study it.

When our profession was still young, we eagerly utilized the assistance and experiences of elves in the field of magical education. Archmaster Geoffrey Monck became famous for his bold journey to Loc Muinne, where he managed to negotiate an agreement allowing a group of young sources to learn from elven mages—perhaps the Aen Saevherne themselves. Said agreement was ruined a few short years later, when the army of Marshall Raupenneck of Tretogor massacred the elven populace of Est Haemlet and Loc Muinne without regard for gender or age, leading to another bloody war. Despite

THE AEN SAEVHERNE

"Despite popular opinion, the term Aen Saevherne is not simply the equivalent of 'elven sorcerer,' but has a much deeper meaning. The closest possible translation would be 'sages.' Indeed, if rumor is to be believed, the Aen Saevherne command not only an impressive knowledge of magic, but also—as implausible as it seems—a comprehension of other worlds, time, and space. These Sages form a separate caste among elven sorcerers, mysterious even to their brethren and greatly respected by all, including the most powerful among them."

—*Geoffrey Monck, "The Magic of the Elder Folk"*

this renewed conflict between humans and elves, the boy Gerhart of Aelle, who was at that time given to the care of elves, grew up to become one of the greatest sorcerers in history, now known as Hen Gedymdeith.

Training

In the Northern Kingdoms there are presently two sites where young adepts of both genders are trained to become sorcerers. The girls' school is located in the palace of Aretuza on the small island of Thanedd on the shores of Temeria. Only sorceresses and trainees are allowed there, and any petitioners and guests are limited to the palace of Loxia that guards the bridge to shore and the city of Gors Velen.

Girls from all corners of the world are taught there, and admission to the school leads to both great prestige and high fees, which guarantee an appropriately high educational standard. In fact, the academy's renown is so great that sorceresses who have graduated from Aretuza have little problem continuing their education—either staying

Places of Power are used both for magic rituals and for the religious rites practiced by certain ancient faiths.

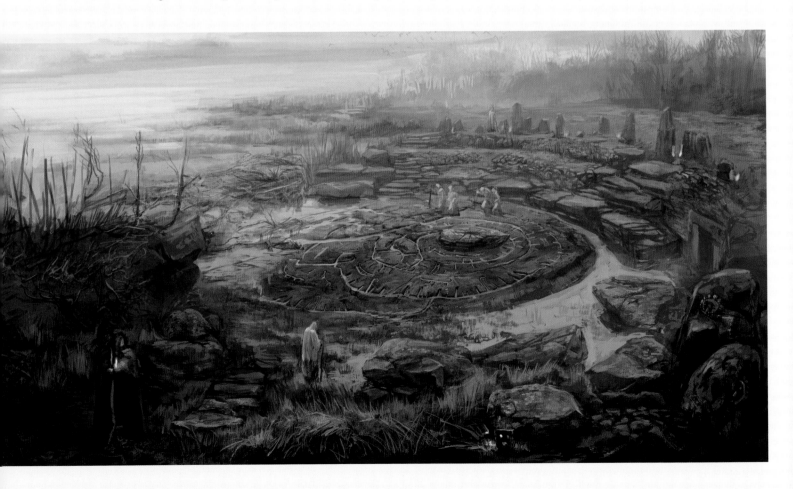

on as assistant professors, or gaining a full-time apprenticeship with one of the mistresses. Even those who choose to become dwimveandras can count on the support of the academy's special stipend fund.

The boys' equivalent of Aretuza, though not as highly esteemed, is the academy at the city of Ban Ard in Kaedwen. Here, future adepts undergo an education similar to that provided at Aretuza, finally becoming full-fledged sorcerers. Unfortunately, though the school's educational standard is quite high, it is not as prestigious as Aretuza. Some even sneer that Ban Ard is rightly better known for its banner of heavy cavalry than for the achievements of the academy's alumni.

It is entirely possible that military traditions, which have always been widespread and provided career paths for young men, are indeed the source of this disparity in prestige and academic achievement. In our society the opportunity to learn is a real chance for change in a girl's life. For those not fortunate enough to be descended from noble houses, education provides an avenue to other ac-complishments in life beyond doing laundry, cooking, and wiping the noses of a host of sniveling brats. Even those girls who lack real talent, and whose limited abilities preclude them from finishing their education at Aretuza, often go on to become lawyers—in most cases, still an impressive social advancement that opens doors to a much wider world.

Young men, however, are not as keenly motivated to study hard, as evidenced by comparing the results from both academies. Those who do not finish their studies still have many career avenues available to them, and in most cases even an incomplete magical education is a valuable asset. The most cunning and talented among those expelled from the academy are always approached by agents of this or that secret service, eager to offer them the honor and excitement of life as a clandestine agent. Others may apply for commissions as army or naval officers. Those with the dullest intellects, as is well documented, always go into politics or pursue a career at one of the courts. Once the motivation and aspirations

> "A dwimveandra is a young sorceress who practices on the road, much like a journeyman artisan. After finishing their education at Aretuza, some girls decide not to become apprenticed to a specific mistress, but instead embark on a journey, allowing them to train with various sorcerers. After spending several years on this atypical internship, a dwimveandra may apply for an exam which will verify the abilities she has gained. Passing the exam grants her the title of Mistress of Magic."
>
> —Anabelle Radfind, An Invitation to Magic (handbook for students in the first year at Aretuza)

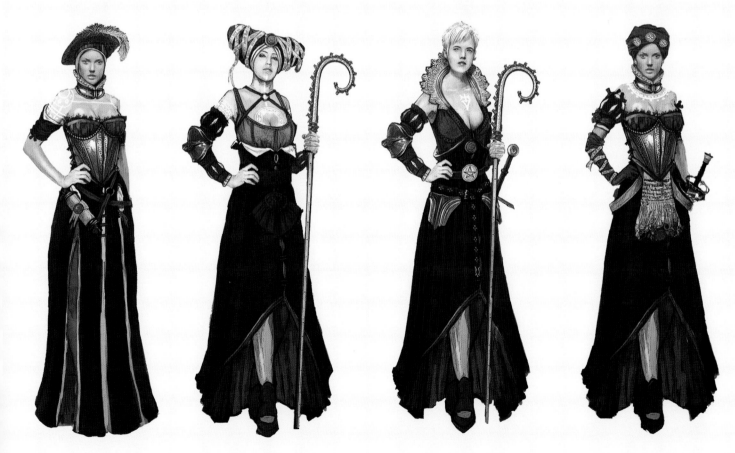

The fashionable, eye-catching clothing female mages wear is meant both to signify their profession and to highlight their ageless, unchanging beauty.

The Magic and Religions of the Continent

91

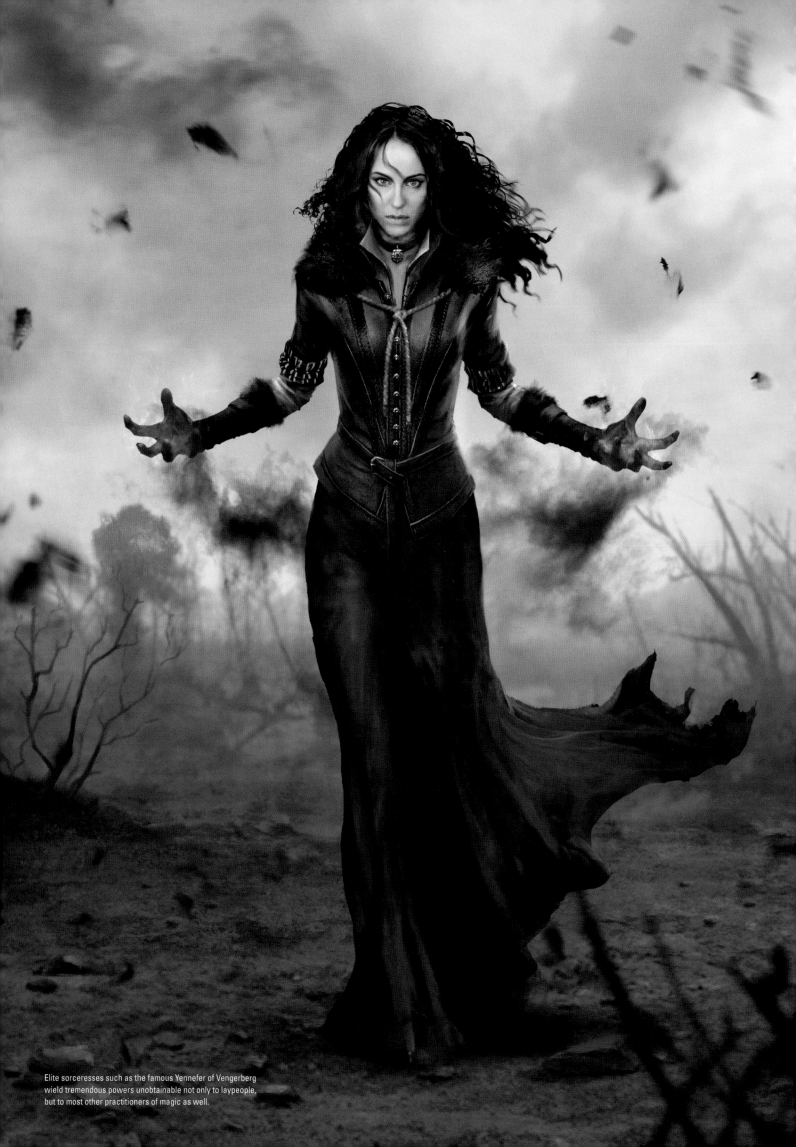

Elite sorceresses such as the famous Yennefer of Vengerberg wield tremendous powers unobtainable not only to laypeople, but to most other practitioners of magic as well.

of both groups have been taken into account, the generally higher achievements of Aretuza's adepts should not be a surprise.

Sorcerers and Society

At the dawn of its history, our Brotherhood remained neutral, at least in comparison to the present day. This neutrality was guaranteed by the so-called Novigrad Union, an agreement between sorcerers, priests, and the various crowned rulers that sanctioned the separation of magic and state for many ages. On the one hand, this agreement obviously limited our influence in the wider world, but on the other, it provided us with complete autonomy to create and maintain our own hierarchy, pursue our magical research, and deal with our internal conflicts without outside interference.

Sorcerers, therefore, did not dabble in politics and, moreover, did not seek to rule. Instead, they often played a role as mediators. Ages ago, Raffard the White, to name one of many examples, famously arranged a peace between kings during the Six Years' War. Adhering to the principle of separation between mages and rulers, he even refused the crown offered to him at the time. True, he later did agree to become a royal advisor—rumor has it the king in question was such a complete idiot that even Raffard admitted he could not be left to rule on his own—but his interventions in politics always remained rather delicate.

This autonomy allowed for the creation of the first Conclave, formed from the most distinguished practitioners of the magical art, and the establishment of our internal rules, commonly known as the Law. The first result of this step toward greater organization among sorcerers, however, was a brief civil war in which those who would not submit to the new hierarchy were eliminated—among them Raffard the White. This fact, of course, is not mentioned often in historical chronicles,

"Adept's name: Yennefer
Former name: Jenny

After initial testing confirmed her magical talent, the adept was admitted to Aretuza's first class. The girl comes from a pathological family—her father abused her psychically and physically, and her mother failed to support her. This rejection and abuse were likely precipitated by the deformation of the girl's spinal column and scapula (she was a hunchback), or possibly by her mixed human-elven bloodline (she is a quarter elvish, and her mother a half blood).

It was undoubtedly the lingering effects of these traumatic childhood experiences that drove her to attempt suicide soon after admission to our academy. The girl tried to cut open her forearm veins and ended up inflicting serious tendon damage (healer documentation attached for reference).

Despite the above, the adept was personally recommended and very highly graded by the Chancellor of our Academy, Archmistress Tissaia de Vries. Her deformities and tendon trauma were corrected with the use of higher magic during her first year, and her further education has fully vindicated the Chancellor's high opinion.

Adept Yennefer is a highly talented and determined student. Her results on subsequent exams have remained excellent."

—*Fragment of the records of the sorceress school in Aretuza on Thanedd Island*

most likely to preserve the allure of his legend.

Later, another governing body was formed—the Supreme Council of Sorcerers, which was intended to aid the Conclave in administering and regulating practitioners of magic. Although we were becoming a more and more hierarchical organization, the members of the Brotherhood of Sorcerers largely remained interested only in magical experiments, research, and expanding their knowledge.

From the time of the Novigrad Union, these separate spheres of influence were generally respected by both rulers and sorcerers. That is to say, each side habitually infringed on the other's domain, but never in a blatant or genuinely significant way. This balance of power changed during the First Nilfgaard War—more precisely, during the Second Battle of Sodden, which was won in part due to the valor and self-sacrifice of sorcerers. That day we stood to defend the kingdoms of our birth, and that day, in the eyes of many, we became heroes. We won the respect and gratitude of burghers, farmers, and soldiers alike. We also won the good will of the kings whose realms we had saved that day from Nilfgaardian fire and steel. And then, instead of stopping at that, instead of being content to bask in the adoration of the common folk, we demanded pay.

Not literal pay, of course. Rather, some of our brethren came to the conclusion that we were indispensable and decided to take advantage of this fact. And behold: the kings of the North's greatest realms, the same kings who until now had kept sorcerers at a distance, now started to invite us to their tables, shower us with favors, and accept us

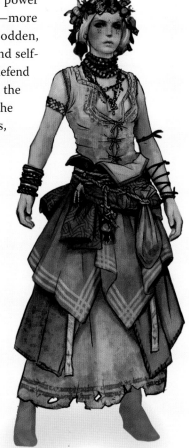

as advisors. It would have been better if we had been satisfied with receiving homage and sharing our opinion when asked, but a taste of power really does tend to go to your head.

Of course, it would be an exaggeration to say that all sorcerers started to dabble in politics. The absolute majority did not care about it at all, instead serving as healers or court diviners, or just continuing with their research and educating young adepts. But there were some who allowed the idea to enter into their heads that they could manipulate and control kings, or even overrule their decisions for the betterment of the state. Some managed to do so; some did not. With each intervention in politics, each revelation that mages had manipulated events behind the scenes, each rumor that the real power behind the throne was the "neutral advisor," conflict between sorcerers and rulers grew. The notorious debacle on Thanedd served as the last straw, after it was discovered that the most ambitious sorcerers had committed treason and sided with the same Nilfgaardian Empire they'd fought against but a few short years earlier.

That day changed everything. Sorcerers, even those who served their kings loyally and took no part in the Thanedd Coup, lost the confidence of their respective rulers, while the Conclave and the Supreme Council of Sorcerers were dissolved.

Contemporary Magic

People are widely convinced that magic is essentially all powerful, its capabilities endless and its power limitless. This is not entirely correct. It is true that no definable limits of the Power have been discovered to date. However, there are practical limits on its use, born of each sorcerer's personal abilities and the spells at his or her command. The research every member of our profession carries out is obviously supposed to stretch and even breach these limits. Still, opinions vary about where our understanding of magic currently stands and how far it can still be advanced.

Some maintain we are but a step from uncovering that mystical "mystery of mysteries," from reaching the stars, from commanding time and reality. Seeing the progress made since the first attempts at harnessing the Power, it is easy to understand this sentiment. Compared to the present day, the list of spells known a few centuries ago was pitifully short. Teleportation at that time was still in its infancy—and truth be told, I myself would be loath to use a magical portal of the early type, even if it was created by Geoffrey Monck himself. Crystal balls stood as the pinnacle of communication between sorcerers, rapidly displacing

A magic megascope is a complicated artifact which allows mages to communicate with each other at great distance or spy on people and places of interest.

"Thanedd Coup—The events that took place on the first of July during the Year of the Great War in the Garstang Palace on Thanedd Island. Roughly two hundred practitioners of the magical art from every corner of the Northern Kingdoms, including the greatest and most influential ones—royal advisors, as well as members of the Conclave and the Supreme Council of Sorcerers—had gathered for a great summit, during which a bloody and fateful confrontation transpired. Sorcerers loyal to the Northern Kingdoms, including Philippa Eilhart of Redania, Triss Merigold and Keira Metz of Temeria, Radcliffe of Oxenfurt, advisor to the king of Aedirn, and Sabrina Glevissig of Kaedwen, attempted to arrest some of their brethren with the help of the Redanian Secret Service. The traitors who collaborated with the Nilfgaardian Empire were, among others, Vilgefortz of Roggeveen, Artaud Terranova, and Fercart of Cidaris.

Despite some initial success born of surprise, the attempted arrest was a fiasco. In a bid to maintain neutrality, Tissaia de Vries, chancellor of the academy of Aretuza, liquidated the barrier spell which prevented both sides from using magic. This action allowed the conspirators to free themselves and summon help, leading to an all-out battle between Northern loyalists and the Nilfgaardian-aligned traitors. As later investigation revealed, the traitorous plotters were indeed preparing a coup of their own, which they hoped to enact with the help of a unit of Scoia'tael hidden in Garstang's cellars. They also sought to capture Cirilla of Cintra, who at that time was also present at Thanedd.

The end result was a massacre in which many sorcerers died, including several who had no idea of either the loyalists' or the traitors' respective plots. In the end, only a handful of traitors managed to flee, but the events at Thanedd have shaken the reputation of sorcerers in the Northern Kingdoms ever since."

—Marcus Marcellinus, "Sorceresses and Sorcerers"

homing pigeons. Today they are themselves considered a relic of the past, long since overtaken by the versatile megascope, which allows for both communication and localization. Few could have imagined the changes brought about by the longevity-granting alraunum decoction or the discovery of magical medicaments for a multitude of ailments

"The sorcerers serving the Empire ought to remember that I am the Empire. And the Empire expects two things from them: obedience and results. If one of them should forget about obedience, he should be reminded, preferably in a manner exemplary to others. If one fails to provide results, he would do best to convince me, preferably curtly, that this is not a result of lack of obedience."

—*Words ascribed to Emhyr var Emreis, emperor of Nilfgaard*

which, until recently, quite literally plagued the world.

Yet some sorcerers, and there are several quite prominent ones among them, hold more critical opinions. They claim that we have reached a deadlock in our expansion of arcane knowledge. In effect, the field of magic is at a standstill, and is doomed to remain so for some time. While they admit that much was achieved over the past centuries, they believe we are currently rushing ever nearer to a dead end. They point out the lack of ethical standards concerning experimentation, the veneration of fossilized opinions, and the tendency to wallow in old, often outdated theories. They stigmatize the excessive interest in politics and power that leads too many sorcerers to abandon their research, instead cajoling for royal favor. They rail in particular against those who would seek to control dynasties and direct the fate of entire nations from behind the scenes. Considering the recent history of our brethren, it is hard not to sympathize with this critique, and I wonder whether we will be able to take it to heart and avoid similar mistakes in the future.

RELIGION

The following section was also authored by Yennefer of Vengerberg. Readers may possibly be surprised that the person analyzing religion has no personal connection to any of the numerous religious cults discussed here. I initially intended to ask the honorable priestess of Melitele, Mother Nenneke, to contribute, but after having thought it over I decided that the opinion of a person who is educated but not directly involved in spiritual matters will allow the whole section to remain more objective with regards to this delicate and often contentious subject.

—*Dandelion*

To begin, I must say that I do not believe I am the most qualified individual to discuss anything more than very basic precepts of religions and existing cults. Moreover, I do not feel entitled to speak of creeds I know little or nothing about. For example, I know as little as anyone in the North about the cult of the Great Sun that worships in the Nilfgaardian Empire. I also have never held much interest in matters relating to early religions, such as the now nearly completely forgotten cults of Coram Agh Tera, Veyopatis, or the mysterious Water Lords. Those interested in these subjects would do well to seek out specialized literature.

With these caveats out of the way, let us turn our discussion to the subject at hand: religion and its practitioners. My own approach to matters of faith is notably lacking in any significant dose of mysticism, and my opinion of most members of the clergies is bereft of due reverence. This might be due to my academic training

"Lodge of Sorceresses—A secret organization formed after the fall of the Conclave and the Supreme Council of Sorcerers. It was founded by sorceresses who served the kings of the North, as well as those from the Nilfgaardian Empire. At its founding, the Lodge declared its mission to be the preservation and guidance of the future of Magic. The Lodge also played an instrumental role in the negotiations that led to the Peace of Cintra, which ended the so-called 'Second Nilfgaard War.'

In time, the Lodge came to be accused of considerably less-praiseworthy deeds. Among other things, its members were supposedly involved in the so-called 'Assassinations of Kings,' the victims of which included Demavend of Aedirn and Foltest of Temeria. This led to a series of purges, and for a time the organization itself was outlawed.

Various sources indicate that the following sorceresses were members of the Lodge: Philippa Eilhart, Síle de Tansarville, Sabrina Glevissig, Triss Merigold, Keira Metz, Margarita Laux-Antille, and Yennefer of Vengerberg, the elves Francesca Findabair and Ida Emean aep Sivney, and at least two sorceresses from the Nilfgaardian Empire—Assire var Anahid and Fringilla Vigo."

—*Marcus Marcellinus, "Sorceresses and Sorcerers"*

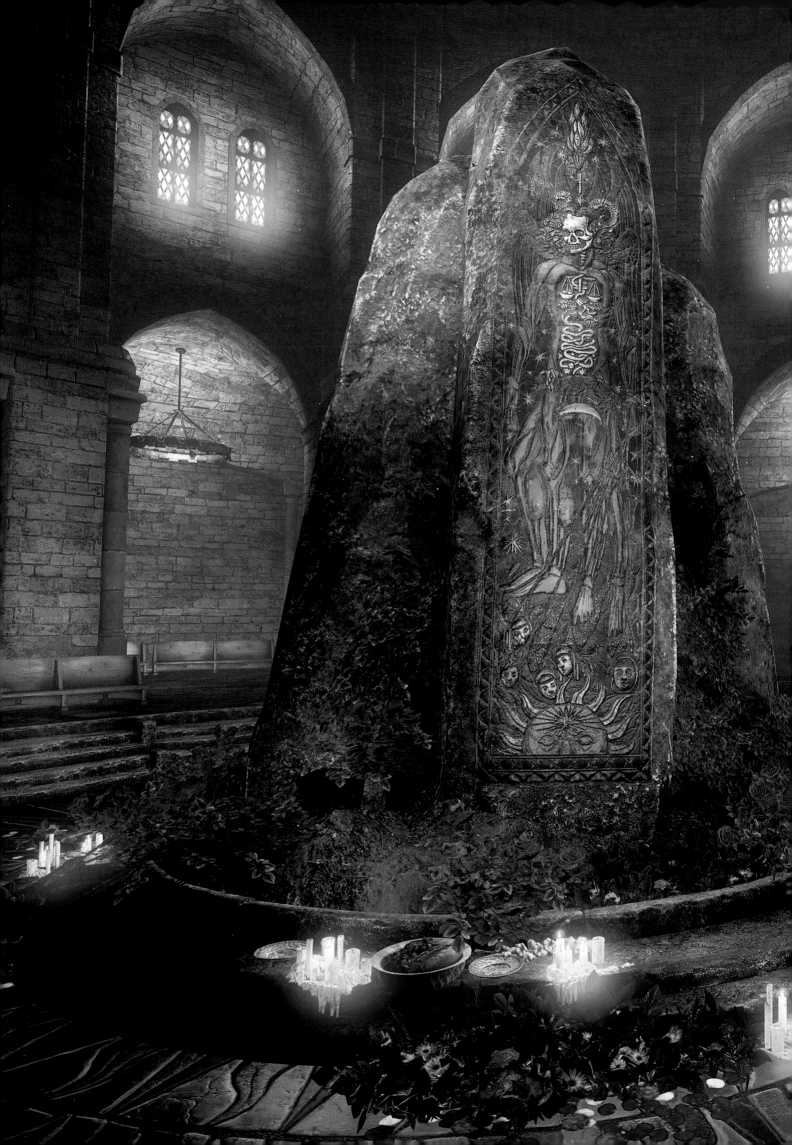

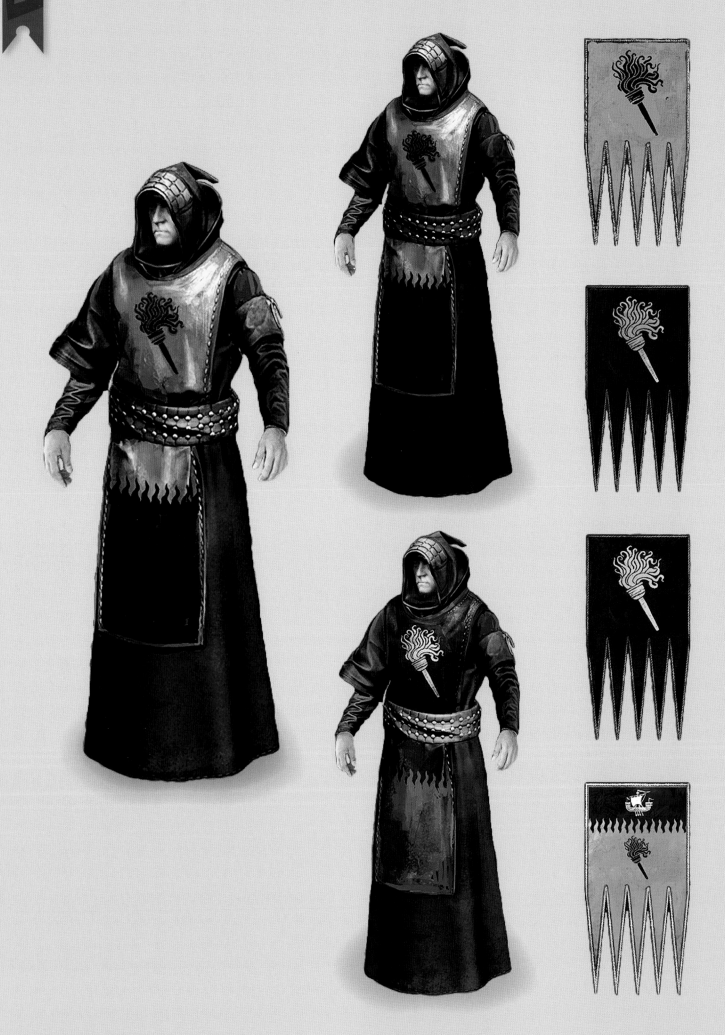

and its emphasis on the rational understanding of a seemingly fantastical phenomenon (namely, magic), but it is just as likely because we sorcerers are simply not very fond of priests—and the feeling is mutual. In the minds of most sorcerers, priests are considered to be obsessed demagogues or simpletons, who mistake the fact that one in ten priests can actually somehow command the Power for a sign of divine protection and favor. The priests, in turn, see most of us as blasphemers who brazenly usurp divine powers, rights, and prerogatives. Both attitudes ensure that the relations between our two castes are somewhat complicated at best.

That does not mean, however, that all priests are blind fanatics. I have met several whose convictions and attitude have earned my utmost respect. In such cases, any differences of opinion we might have possessed regarding religious matters were never an obstacle to reasonable discourse.

> *"The Nordling places of worship vary among the different religions. Deities such as Melitele or Kreve are revered at temples, usually erected in the local architectural style and adorned with frescoes and stained-glass windows. Druids worship Nature under the open sky, in sacred groves or megalithic circles of giant stones. The oldest centers of worship were installed at Places of Power and are known for their strong magical auras."*
>
> —Hevelius Reijksvaard,
> *"Nordling Religions and Places of Worship"*

Religion and Magic

Most sorcerers consider magic and the results of prayers to be fundamentally the same manifestation of the Power, though the exact means utilized in the case of prayer remain an unresolved mystery. It is an undisputed fact that some priests can manipulate the Power as well as any sorcerer, and moreover can do so without any formal training, studies, or preparations.

There are many theories to explain the above phenomenon. My own mistress, Tissaia de Vries, concluded that prayer allows priests to enter a sort of trance, or to autohypnotize themselves, and thereby gain an ability to subconsciously channel and process the Power in a manner analogous to our spells. For their part, priests consider that processed energy, or more precisely its effects, to be a manifestation of the grace of their gods. I have accepted this theory for a long time, though I will admit that the events which I witnessed at the Temple

This Skellige henge is dedicated to the deity known as Svalblod. This cult's bloody rites led to its marginalization and then its nearly complete banishment from the isles.

In ancient times men worshiped the gods by raising henges, obelisks, and cromlechs. In the centuries that followed they then built massive temples directly on top of these ancient monuments.

of Freya on Hindarsfjall several years ago have somewhat shaken my skepticism regarding the existence of gods. While I am not prepared to devote myself to the service of the Mother, I now hold the opinion that there are undoubtedly more things in heaven and earth than are dreamt of by sorcerers.

MAJOR CULTS

Melitele

The cult of Melitele is certainly one of the oldest religions in existence, having its roots in the far-distant past. It is an amalgam of ancient, prehuman beliefs dedicated to various goddesses of the harvest, fertility, and love, as well as the protectors of farmers, crops, hearths, and pregnant women. All these religions, in time, merged into the cult of the Allmother, Melitele. Unlike other ancient religions, which have generally lost influence over time before finally becoming limited to a few local temples and forgotten shrines, the cult of Melitele has no shortage of worshipers, and remains ever popular and respected. This may be the result of the religion's exceptional tolerance and open-mindedness, and the fact that its teachings incorporate a great deal of useful and practical knowledge. The cult of Melitele is also notable for its genuine dedication to helping others,

" 'Em mistletoe cutters, that is, druids, m'lord, always set up shop in oak glades. Everyone knows that oak, next to mistletoe, is th' most holy plant to 'em. But they bow to all nature and love every livin' thing, even those harmful to men. If a mosquito started to feast on a druid's blood, th' mistletoe cutter would cheer 'im on. Truth be told, they help people too, treating ailments and such, and in olden times one could ask fer their help with no fear. But they say now 'em druids have changed, all because of the war. In olden times nobody would think to raise 'is hand against a druid, but when brigands and marauders heard that 'em druids is peaceful and carry no arms, 'ey heaved at 'em. But 'em cutthroats had a nasty surprise coming, cause 'em mistletoe cutters have ways o' dealing with their kind. I heard they can command trees, making 'em walk like men, and that 'em tree monsters catch 'em brigands for druids. Then 'em mistletoe cutters stuff 'em bandits in a huge wicker man and burn 'em alive as a kind o' sacrifice to th' spirits o' nature, o' some such. Well, when that rumor got around, people started to fear 'em druids a bit, chiefly 'em woodcutters, 'cause everyone knows 'em mistletoe cutters never cheered when forests is cut down. But I never heard about 'em druids harming an innocent man."

—Brushwood, beekeeper ealdorman

rather than the focus on indoctrination and enriching the church and its priests that characterizes so many other religions.

The goddess is worshiped in three forms: the maiden, the mother, and the crone, and is depicted in these various guises in sculpture and painting. One of the most widely known centers of the cult of Melitele is the temple-cloister complex located near the city of Ellander, the capital of the duchy of the same name in northeastern Temeria. That complex, administered by the priestess Nenneke, is renowned for its highly regarded temple school. Those sent to learn there—mostly children and youths—are not required to enter ordination, but some indeed do become novices. The school curriculum teaches reading, writing, and simple arithmetic, with the brighter students also being instructed in the basics of philosophy, ethics, history, and the art of healing.

Kreve

The cult of Kreve is quite popular in some of the Northern Kingdoms, especially in Kaedwen, Redania, and Woefield, though I have little to say about the

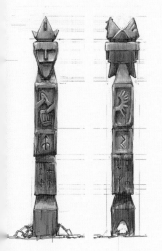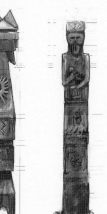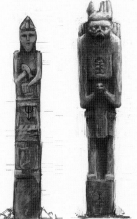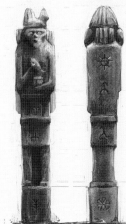

Statues and steles depicting local gods date back centuries—to the very beginning of human habitation on the Continent.

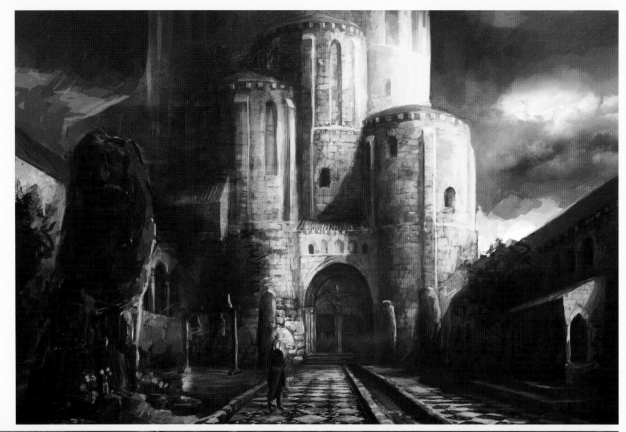

As religion grew more sophisticated, so did sacral architecture. Small shrines and chapels were replaced by monumental cathedrals erected using cutting-edge engineering and architectural techniques.

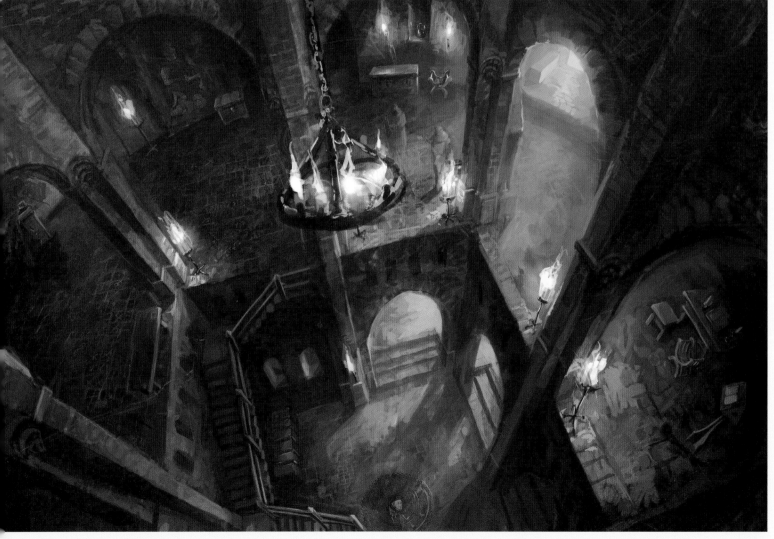

deity itself. The cult's priests hold no disdain for political influence and worldly concerns, and therefore can often be found at the courts of various nobles and magnates. They usually spend their time droning on with platitudes about the divine origins of rulers and reminding any and all that the gods look favorably upon those who contribute donations to their temples. They also have a penchant for emphatic moralizing, a habit I had the dubious honor of experiencing personally. A certain priest of Kreve in the city of Rinde once chose to besmirch me in his sermons, referring to me with all manner of epithets, among which "harlot" was one of the milder ones. To be fair to the irate clergyman, I do have to grant that his hostility and the whole "moral crusade" upon which he embarked stemmed from his genuine convictions and mores, and not from mere spite, prejudice, or the desire to be applauded, as is usually the case.

"The Isle of Hindarsfjall's the goddess Freya's home in Skellige. Here her priestesses dwell, and here's where she's got her chief temple, sat in the midst of the sacred grove called Hindar. We trek to that grove to perform rituals in the Great Modron's honor, and to gather the holy mistletoe we islanders use to decorate nearabouts everything—from cradles to coffins."

—Asle Thorfinsson, Skellige sailor

Druids

Druidism's origins are almost as ancient as those of the cult of Melitele. Druids do not worship any particular deity, instead proclaiming the divinity of nature itself. They also espouse the principle of maintaining balance, which they believe reflects nature's innate order and harmony. This makes their faith both a religious and a philosophical system. Their cult is centered around local communities known as circles, which serve as assemblies of all druids from a given region. Every circle is chiefly concerned with taking care of the natural environment of its surrounding locale, maintaining places of worship and, whenever possible, providing aid to local inhabitants. A circle's chief druid is formally known as a hierophant or, if the position is held by a woman, a flaminika.

Druids are particularly known for their commitment to defending endangered species, often writing petitions or supplications to local lords. Due to their good

Carved stone pillars, like the one shown here from the woods near Flotsam, are some of the few remaining testaments to the existence of the cult of Vejopatis in these lands. Today only a handful still revere this deity.

"He who intends to walk the valley of darkness ought to bring a lantern with him. For he who sprains his ankle in the darkness will not walk far."

—The Good Book; or,
The Teachings of the Prophet Lebioda

relations with the local populace, which usually holds them in great respect, their actions are frequently successful. For not many magnates, or even kings, would risk the social unrest that might result from openly opposing the druids.

Freya and the Beliefs of the Skellige Islanders

The goddess Freya is worshiped chiefly in the Skellige Isles, though supposedly her cult has recently spread to coastal regions of the North as well. I was not able, however, to verify that information. Undoubtedly, the Skellige Islanders revere Freya above all other deities, and she is a central figure in their belief system. They grant her the venerable title of *modron*, which means "mother," for the goddess is the patron of hearth, love, fertility, and the harvest. These aspects cause many to consider her to be one and the same with the continental Melitele. Modron Freya is also the patron of prophetesses, seers, telepaths, and others who seek to glimpse the

unknown, as represented by her symbolic attributes: the necklace of foresight Brisingamen, the cat, which hears and sees the invisible, and the falcon, which looks from above.

Apart from Freya, the Skellige Islanders worship a number of sea gods and practice a type of ancestor cult (the "cult of heroes"), as well as a local branch of druidism. All these beliefs are interwoven into a colorful, though perhaps a bit chaotic, pantheon. For most outsiders, the islands' approach to religion appears to be an idiosyncratic mess, and only the islanders themselves do not get lost in the various intricacies of their faith.

The Prophet Lebioda and the Good Book

The cult of the prophet Lebioda flourished about one and a half centuries ago, during the lifetime of its founder. The prophet himself was, as far as I know, a simple shepherd, who preached sermons and told parables about life, gods, and men. He managed to accumu-

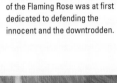

Born of lofty ideals, the Order of the Flaming Rose was at first dedicated to defending the innocent and the downtrodden.

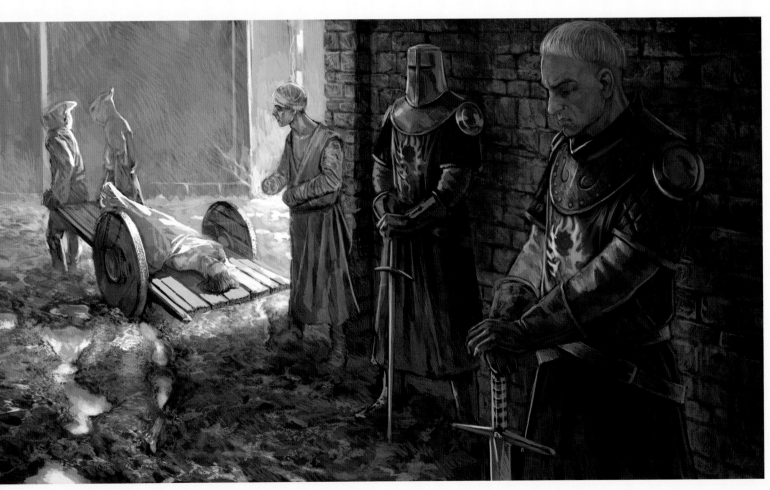

late a surprisingly large group of followers, who strived to live in accordance with his precepts. The prophet met his end when he was already advanced in age, being set on fire and then devoured by a dragon which he was attempting to exorcise. Supposedly, this exorcism was intended to keep the reptile from preying on some Kaedweni villagers' sheep. In any case, his death was proclaimed to be martyrdom, and his recovered bones were placed in a sarcophagus in Novigrad. Though the cult itself largely ceased to exist after Lebioda's death, his teachings survived, having been compiled and written down in the so-called *Good Book*, a collection of enlightening anecdotes and quite droll allegories.

> *"The story of how the Prophet Lebioda's bones were recovered is quite amusing, especially when you consider that they are supposedly taken out of his sarcophagus on certain festivities, and the pious given the honor of kissing them. I will for the moment refrain from repeating the story, as tales of combing through dung, even dragon dung, are not very well suited for mealtime conversation."*
>
> —Addario Bach, dwarven musician from the Copperette mine's Miners' Brass Band

The Eternal Fire

The cult of the Eternal Fire was initially a local affair, limited to Novigrad and its immediate surroundings. Today it has spread to nearly all of Redania, slowly pushing out the cult of Kreve. It has also gained a militant arm in the form of the Order of the Flaming Rose, known for its implacably hostile stance toward nonhumans and magic.

Despite its contemporary appearance, a mere century ago the Eternal Fire was nothing more than a stern but still quite tolerant faith. The flame that served as the focus of its worship was, according to its priests' creed, the symbol of progress, the light that dispels darkness, and the hope for a brighter future. The religious beliefs of other faiths were generally tolerated in Novigrad, with the exception of outright blasphemy against the Eternal Fire or attempts to undermine the authority of its cult. Those declared to be blasphemers, as well as those who would use sorcery to harm others, were condemned to be burned at the stake, and a special temple guard was charged with investigating and carrying out sentences for these crimes.

The order turned into an extremist group devoted to racial persecution and witch hunts. The innocent humans and nonhumans they once swore to protect later became their primary victims.

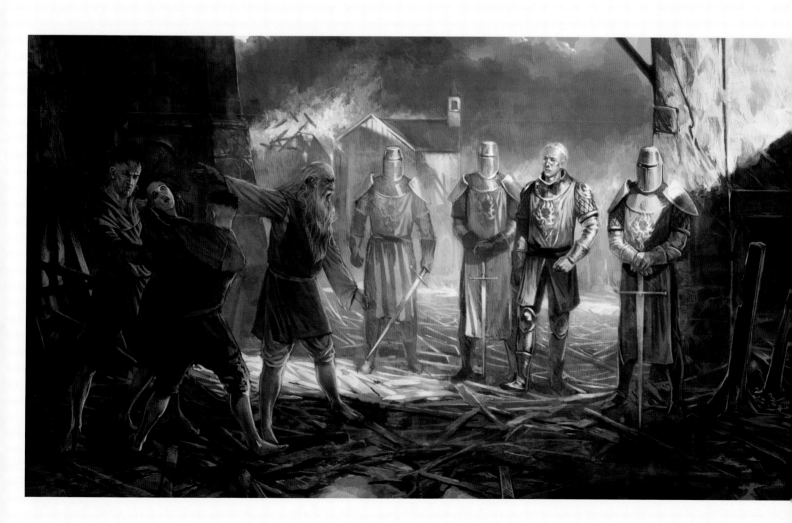

The priestesses of the Lionheaded Spider, or Coram Agh Tera, are able to call down powerful curses on their enemies. The faith itself, which first arose in the Gelibol and Nimnar Valley region of northern Redania, is today considered a dangerous cult.

As the cult's influence grew over time, the situation began to change. The hierarch of the cult of the Eternal Fire, elected by an electoral college, became Novigrad's de facto ruler. The temple guard in turn became an agency of state security, with its powers unchecked by any secular authority. Cases of blatantly false accusations and show trials ending in executions and the confiscation of property by the cult became ever more prevalent. Fear of "black magic" gradually evolved into an aversion toward all forms of sorcery, nonhumans, and finally, sorcerers themselves. The result was an escalating climate of persecution for nonhumans and suspected magic users, which culminated in the famous "witch hunts" and the execution of hundreds of innocent people. The history of the cult of the Eternal Fire thus stands as a clear example of how a religion can become warped when fanatics take control and strive to force all others to follow their creed.

> *"For women are sinful and maleficent creatures, by their very nature! The accomplices of Chaos, who stand against the Order created and ordained by the gods! They are the eager lackeys of dark forces, forever seeking to satiate their unnatural lust. Therefore, to remind them of the appropriate reverence and fear owed to the gods, and to maintain the just strictness that is the mark of a responsible father and husband, it is proper to dispense precautionary lashings often and with a steady hand. One also cannot permit women to dress licentiously, which unleashes unhealthy prurience, or to use any finery, as this is the obvious mark of pride and promiscuity. Instead, they should be made to dress in simple, modest robes of dun color, cut in such a way as to prevent any and all sights that the eye might find covetous."*
>
> —*Fragment of a Eternal Fire priest's sermon*

New Religious Movements

Lately, the number of deities has been growing at an increasing pace, serving to confuse even persons with a much greater interest in religious matters than I. Here, I do not mean good old polytheism, or cults of ancestors or local protector spirits, which were so widespread just a few centuries ago. Rather, the majority of these new religions claim a monopoly on truth, stating that only their faith has discovered absolute wisdom and that following any others is sin and apostasy, and will bring eternal damnation. It is telling that they seem to care little for providing spiritual help, counsel, or support to any worshipers in need. Instead, most of their time appears to be spent in competition to invent the newest commandments demanding intolerance of adherents of other faiths or regulating the most private and intimate affairs of their followers. This tendency is a sad example of how religion, instead of bringing hope and support to those in need, too often turns to animosity and fear, becoming yet another tool for unscrupulous politicians and demagogues.

In some far-off corners of the world people still worship the old gods and mysterious beings of great power. An example of this is the cult of the Ladies of the Wood in Velen, whose shrines are scattered throughout that region's woods and isolated villages.

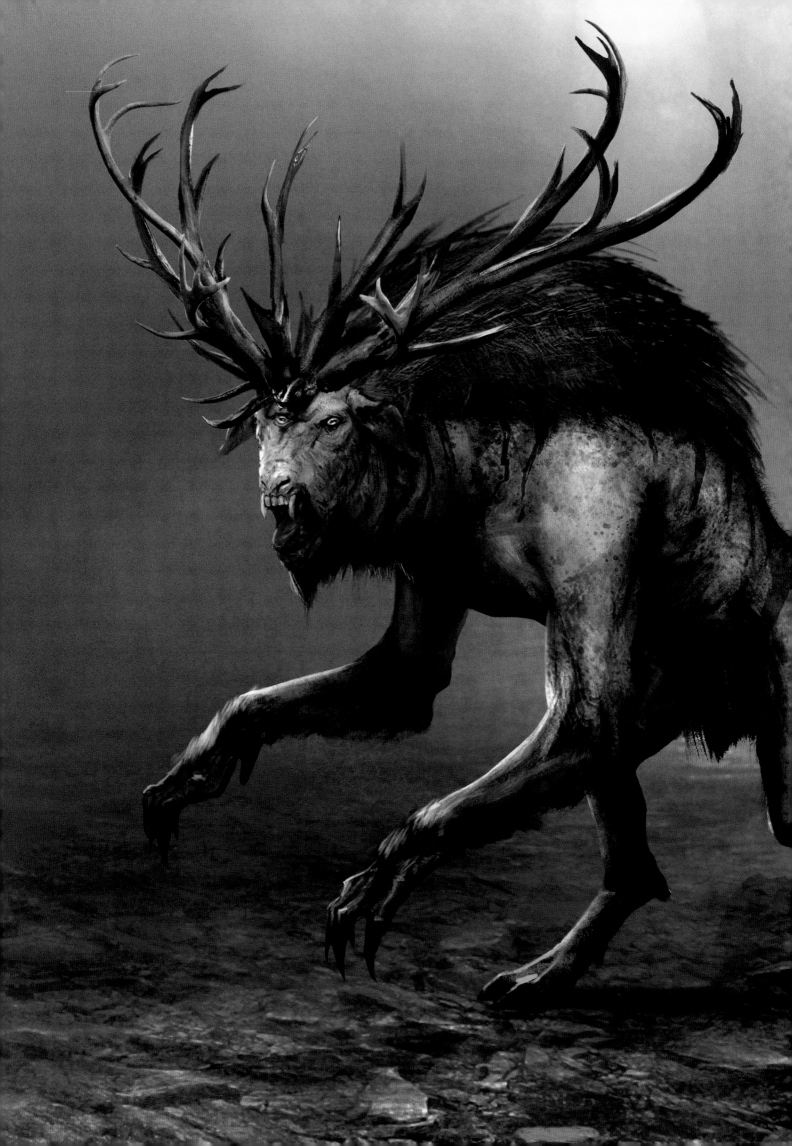

THE BEASTS OF THE NORTHERN KINGDOMS

There are many ballads depicting the adventures of Geralt of Rivia, known as the White Wolf, yet none beside my own get close to even half-truths about him. He was supposedly a famous Child of Surprise, yet that is only true as far as his mother, a sorceress, surely was greatly surprised at becoming pregnant, since, as is widely known, almost all sorceresses cannot conceive children.

My own great-grandfather had yet to be born when Geralt learned swordplay at Kaer Morhen and when he vanquished his first monster. Fate would have us meet only a quarter of a century ago, yet that meeting was the beginning of our longtime friendship, which affords me unrivaled knowledge of the witcher. We have faced many a peril together, and escaped with our lives unscathed. We have saved each other's lives innumerable times. Therefore I can confidently say that Geralt of Rivia is an exceptional person in all regards, save for his knowledge of arts and the characters of men, as these matters are, sadly, completely beyond him.

If there is one field in which nobody can question Geralt's expertise, it is the knowledge of all kinds of monsters, which he has been successfully exterminating for over half a century. His knowledge in the matter never ceases to amaze me, and I have spent many an evening hearing the witcher's tales of the habits of various beasts and monsters, as well as his denunciations of spurious, clearly fabricated myths, which captivate the mind of the common man. Here you will find those of his words that I managed to put to paper, both as a warning and as a reminder.

—Dandelion

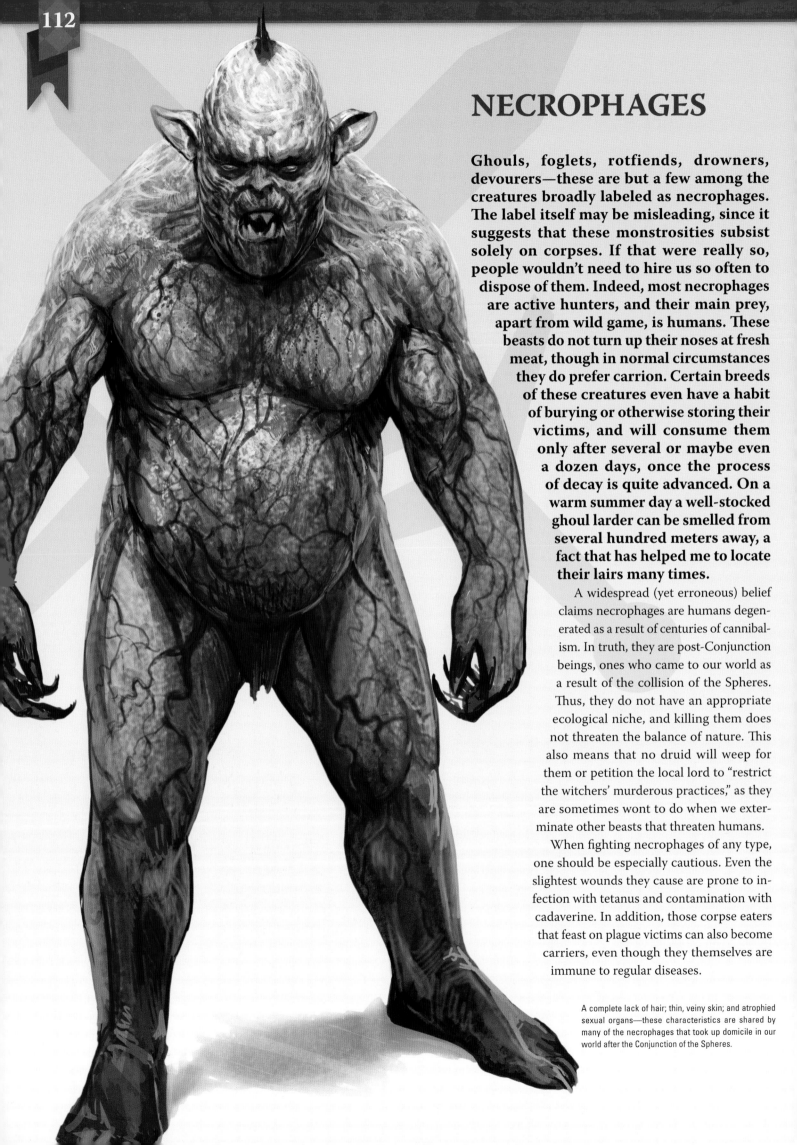

NECROPHAGES

Ghouls, foglets, rotfiends, drowners, devourers—these are but a few among the creatures broadly labeled as necrophages. The label itself may be misleading, since it suggests that these monstrosities subsist solely on corpses. If that were really so, people wouldn't need to hire us so often to dispose of them. Indeed, most necrophages are active hunters, and their main prey, apart from wild game, is humans. These beasts do not turn up their noses at fresh meat, though in normal circumstances they do prefer carrion. Certain breeds of these creatures even have a habit of burying or otherwise storing their victims, and will consume them only after several or maybe even a dozen days, once the process of decay is quite advanced. On a warm summer day a well-stocked ghoul larder can be smelled from several hundred meters away, a fact that has helped me to locate their lairs many times.

A widespread (yet erroneous) belief claims necrophages are humans degenerated as a result of centuries of cannibalism. In truth, they are post-Conjunction beings, ones who came to our world as a result of the collision of the Spheres. Thus, they do not have an appropriate ecological niche, and killing them does not threaten the balance of nature. This also means that no druid will weep for them or petition the local lord to "restrict the witchers' murderous practices," as they are sometimes wont to do when we exterminate other beasts that threaten humans.

When fighting necrophages of any type, one should be especially cautious. Even the slightest wounds they cause are prone to infection with tetanus and contamination with cadaverine. In addition, those corpse eaters that feast on plague victims can also become carriers, even though they themselves are immune to regular diseases.

A complete lack of hair; thin, veiny skin; and atrophied sexual organs—these characteristics are shared by many of the necrophages that took up domicile in our world after the Conjunction of the Spheres.

Ghouls and Their Strains

Ghouls make up the main body of post-Conjunction relics classified as necrophages, and this includes the larger, more dangerous breeds: alghouls, graveirs, and cemetaurs. They are all similar in appearance and have multiple traits in common. These, for example, include stooped posture (some of the more deformed subspecies move about on all fours), hypertrophied pectoral girdles and front limbs, and hands with opposing thumbs and fingers ending in short, blunt claws ideal for burrowing. Their strong jaws and long tongues enable the beasts to easily shatter thick bones and lick them clean of their favorite delicacy, marrow.

Rotfiends and Greater Rotfiends

The ghouls' distant relatives are the rotfiends and their larger cousins, the greater rotfiends. These species were long thought to be a deformed variation of ghouls, but after years of research this or that group of wizened scholars decreed that the beasts are in fact a separate species of necrophages. Thus science triumphed, though the rotfiends themselves likely did not particularly care.

Rotfiends remain upright most of the time, and their limb proportions are not that far off from human ones. Their jaws are also less developed than those of other necrophage breeds, likely due to the fact that these creatures prefer decomposed corpses several months old, and especially prize the runny contents of the abdominal cavity. Rotfiend heads are also different from those of their "cousins"—and by "different," I mean a messy, bloated, and deformed lump, almost devoid of eyes. This doesn't seem to impair the monsters, since, like most necrophages, they rely primarily on their highly developed sense of smell to locate their victims.

Drowners and the Drowned Dead

These inhabit both natural and artificial bodies of water, from rivers and lakes to mill ponds and city sewers. It is commonly thought that these creatures are drowned men, somehow arisen from the dead to prey on the living. This opinion is as widespread as it is false, for the beasts are in fact another post-Conjunction relic.

The common traits shared by most of the necrophages suggest these post-Conjunction species originate from the same world. Many have similarly proportioned skulls and limbs and display other characteristic features in common, such as long tongues and strong jaws adapted to crushing bones.

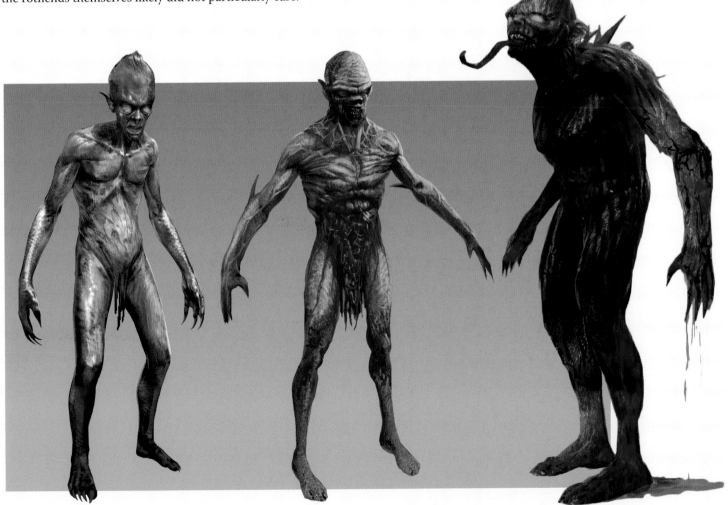

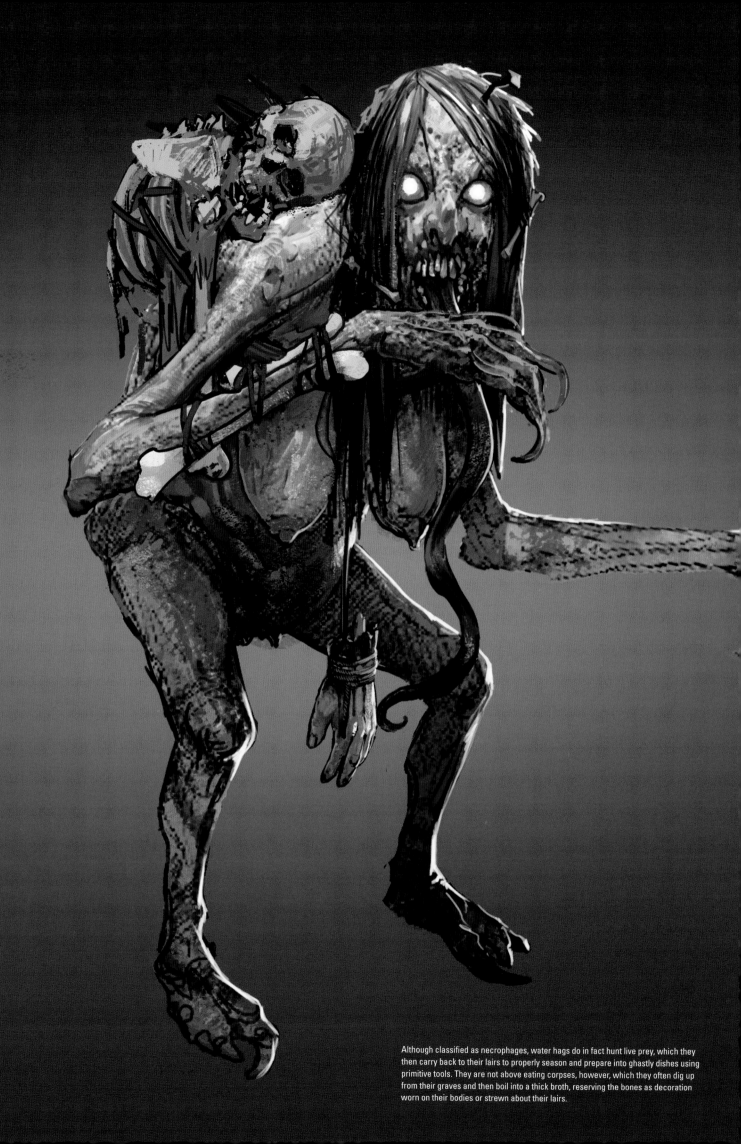

Although classified as necrophages, water hags do in fact hunt live prey, which they then carry back to their lairs to properly season and prepare into ghastly dishes using primitive tools. They are not above eating corpses, however, which they often dig up from their graves and then boil into a thick broth, reserving the bones as decoration worn on their bodies or strewn about their lairs.

Both drowners and the drowned dead, despite their misshapen appearance, are excellent swimmers. They are adept at sensing vibrations in the water, and their huge, bulging eyes give them excellent sight in star- and moonlight. They subsist on fish and amphibians, as well as on any warm-blooded creatures (primarily small game and humans) they manage to catch and drown. When in their natural element, they prefer ambushes, attempting to pull the victim underwater before throttling it with their strong hands and clawed fingers. If they are not immediately hungry, they may keep corpses underwater for several days, waiting for the meal to become properly seasoned.

Grave Hags and Water Hags

These beings are also usually counted among necrophages, though some experts on the matter do not agree with this classification and maintain that they should be considered an entirely separate group of monsters. For indeed, while both species devour the bodies of the dead, the hags also actively hunt their victims or lure them into cunning traps. Those they catch are first skinned with the use of appropriate tools, and then made into ghastly dishes. The hags prefer to boil, roast, or smoke the flesh of their victims in their abodes, which are similar to human dwellings.

Grave hags resemble tall, wizened old women, though their disproportionately large heads, bulging eyes, and long arms with huge, clawed hands clearly reveal their inhuman origins. They frequently visit burial grounds, which has led to the absurd notion that they are some sort of female ghouls. It is true that they dig up graves in search of skulls and other bones of the dead. These are used to adorn the hags' lairs or carried as amulets, although it

"Therefore, to save their own lives, those men committed the vilest of deeds and started to dine on the corpses of their deceased kin. And so voracious were they, that after consuming the flesh, they shattered femurs to get to the marrow. Once the corpses in the hamlet ran out, they began to dig up old bones from the graveyard and use them to make soup, which lasted them through the long winter until spring. However, the peasants grew so fond of human flesh that they could no longer live without it, and even the tastiest dish was like dust and ash to them. Thus they began to raid the cemeteries of neighboring villages, and if a battle took place nearby they would scour the battlefield for corpses to bring home, to the great joy of the whole hamlet. Greatly emboldened in their hideous practices, they even broke the sacred rites of hospitality, and began murdering travelers they had invited under their roofs.

Justice and retribution, however, were not far away, for when the folk of the surrounding area learned of these deeds, they fell upon the man eaters in great strength. And when they discovered the travelers' belongings and an abundance of human remains hidden in the village, they wrought great vengeance upon the murderous cannibals, killing many and burning their houses to the ground. But some of the degenerates fled justice and hid in deep forests, giving birth to the tribe which even today haunts graveyards and battlefields, seeking to sate their perverse hunger for human flesh."

—*Silvester Bugardio*, Liber Tenebrarum; or, The Book of Events Terrible but True, Yet Never Elucidated by Science

is difficult to say if they have any practical uses. The withered bodies of these creatures conceal great strength, but their truly formidable assets are their supernatural powers, as well as their guile in hunting prey.

The withered bodies of these creatures are covered in slime and sludge, and stink beyond comprehension. Their hair resembles seaweed, their maws are filled with crooked teeth (however many they have left), their claws could fit a werewolf, and in battle they sling balls of mud at their foes. Whoever thought water hags had something in common with naiads must have had a truly poetical soul, and most certainly never saw one in daylight.

Water hags inhabit all forms of wetlands in the vicinity of rivers and lakes, as well as swamps and bogs. They construct hovels made of wood, mud, and reed, or make their lairs in watery hollows they excavate in riverbanks and shoreline scarps. When hunting in their natural habitat, they typically attack from ambush, catching swimming children or pulling fishermen from their boats or jetties. At night they sneak into waterside villages and abduct livestock or late-night travelers, whom they take back to their abodes to devour.

VAMPIRES

Most of the traits commonly ascribed to these creatures are bollocks, nothing but the confabulations of superstitious serfs. Despite popular opinion, vampires are not undead, or the damned arisen

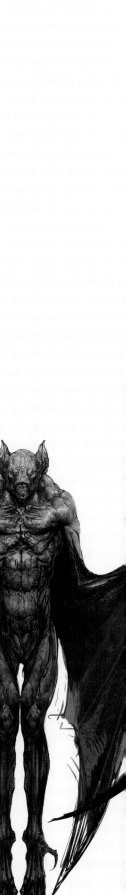

Vampires' physical traits make them ideal nocturnal predators, hunting noiselessly on membranous wings. The heightened senses of certain species of this genus enable them to smell the scent of fresh blood from over two miles away.

The Beasts of the Northern Kingdoms

from their graves, but beings which came to our world during the Conjunction of the Spheres.

The vast majority of other myths about them are not true either. Though vampires avoid the sun, its rays are not in fact lethal to most. Their bite does not turn others into vampires, and they are not repelled by garlic or holy water. Holy symbols are equally useless—as Vesemir used to say, at most they will insult the vampire's religious feelings, if it has any. Stabbing a vampire with a wooden stake can certainly ruin its day—but wouldn't a sharpened stake in your chest ruin yours as well? On the oth-

"Water hags are naiads who fell in love with mortal men, and thus lost their eternal youth. It does not happen often, for water nymphs are fickle creatures that rarely have any concern for the young men they seduce. Still, sometimes a nymph will truly feel for a man and then, in accordance with the ancient, mystical laws of her people, she becomes subject to the flow of time. Because she is a magical being, she cannot die—but she does age, growing more and more decrepit until she finally becomes a water hag. Then, on moonlit nights, she comes to the lakeside and weeps for her lost youth. Though her body is wizened and ancient, she still likes to dance naked in the moonlight and make immoral proposals to any passing youth she meets."

—A folktale

er hand, given vampires' natural resilience and regenerative capabilities, said stake would either have to be quite large or pierce a vital organ of some sort to truly hurt the creature—hence the not entirely useless legend of vampires' vulnerability to stakes through their hearts. Given the choice, however, a smart witcher will prefer a silver sword every time.

Vampires are traditionally divided into two groups: higher vampires and lesser vampires. It is difficult to say who was originally responsible for the classification, but it is now so widespread that it is considered valid, despite its limitations.

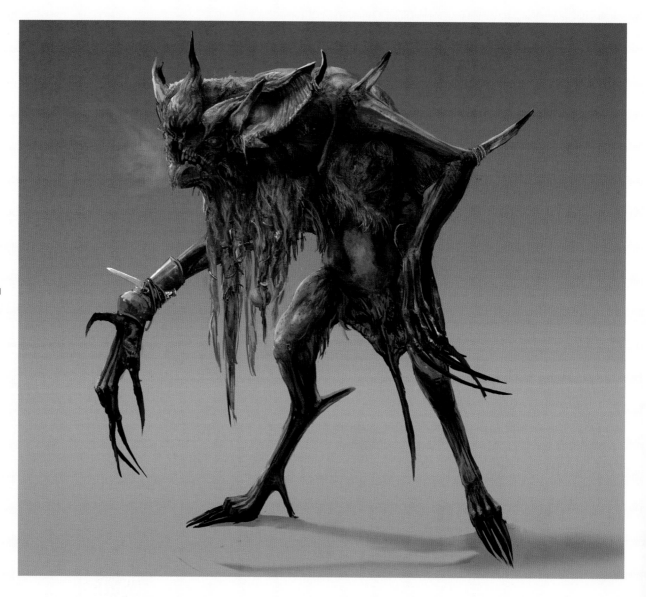

Some higher vampires transform into giant, eyeless bats. Others, such as the katakan and the ekimmara, already display many batlike characteristics in their natural form. Despite their misshapen appearance, these vampires present a mortal danger to even experienced monster hunters.

Higher Vampires

Many experts include alps, mulas, katakans, bruxae, and nekurats as members of this group. These species indeed possess several unique traits not shared by their lesser cousins, and thus are commonly called higher vampires. They are resistant to sunlight, and most can mask their true natures and pretend to be human, which aids them in hunting or evading pursuit. Many are also capable of transformation and possess telepathic powers, making them formidable foes. Despite all these abilities, however, they are not true higher vampires.

Genuine higher vampires are a separate, extremely powerful breed, commanding great powers which are sometimes unique to particular specimens. They are masters of the art of camouflage and in most cases appear nearly identical to humans. Only their teeth, and the fact that they cast no shadows and have no reflections in mirrors, can reveal their true nature. I have even met one higher vampire whose presence did not trigger a reaction from my witcher medallion. Besides being supernaturally fast and agile, higher vampires can also assume the form of a giant bat, become invisible, and use their gaze to mesmerize their victims or put them to sleep. They are invulnerable to sunlight, fire, and silver, and have unbelievable regenerative powers which allow them to return to life even after beheading, dismemberment, or incineration—though in such cases the process may take many decades.

Lesser Vampires

This term, as I have already said, is technically incorrect, but is commonly used to describe three species: fleders, ekimmaras, and garkains. The first two are not native to our climate, but over the last dozen or so years the range of their habitat has expanded over the Yaruga and further north.

When compared to the species mentioned before, the lesser vampires are indeed primitive and cruel, guided more by instinct than by intelligence. They are vulnera-

"Two men-at-arms surprised the bloodsucker, but their weapons merely pierced the air, for the monster was already gone from the spot where it stood mere moments ago! A heartbeat later both fell, blood spurting from throats torn asunder by the demon's claws . . . By the life of my mother, I swear I saw it with my own eyes! It was then that the priest brandished his amulet, emblazoned with the symbol of the Eternal Fire, at the blood-soaked dead'un, and called upon divine power to strike terror into the beast's cold heart. We all believed that the demon would flee . . . until it began cackling hideously, as if it could barely contain its amusement. It said that the priest's faith was not worth a wooden penny, for he had shown no respect for divine laws—ploughing young wenches and stealing donations—and, in any case, he was holding the divine amulet upside down. Then the vampire transformed into a bat and fled, giggling all the while. That was the last we saw of him."

—Part of a tale heard in a Novigrad inn

ble to sunlight and hunt exclusively at night. They also do not stop at draining blood, but will brutally rend their victims asunder to feast on their warm flesh. Fleders even go so far as to drink the blood and consume the bodies of the sick—something other species tend to avoid. When hungry, they will not pass up a fresh corpse either, making them only marginally better than necrophages.

ETHEREAL EMANATIONS

The great number of tales about ghosts and specters stems from the simple fact that people have a habit of inventing phantoms for themselves, imagining all kinds of immaterial and invisible wraiths which only make their presence known through mysterious sounds, such as rattling chains, moaning, and screaming. More often than not, it turns out that these sounds are caused either by the ealdorman's indigestion or by a pair of lovers who decided to sneak away to a remote, secluded location. Still, sometimes we do face a genuine spiritual manifestation, which emerges as a kind of traumatic echo from someone's violent death.

Most of the creatures born in this way are invisible to mere mortals and do not influence the material world, but some, driven by wrath and hatred of all life, go out of their way to harm humans.

Wraiths

Wraiths are the most common of ethereal emanations. They are the vengeful ghosts of people who died violently or suddenly, usually as a result of some injustice—the betrayal of a trusted friend, an unjust

Fleders, migrants from another world, have adapted to our urban habitats. During the colder months they hibernate in crypts and abandoned buildings, only emerging to hunt during the first warm nights of spring.

The Beasts of the Northern Kingdoms

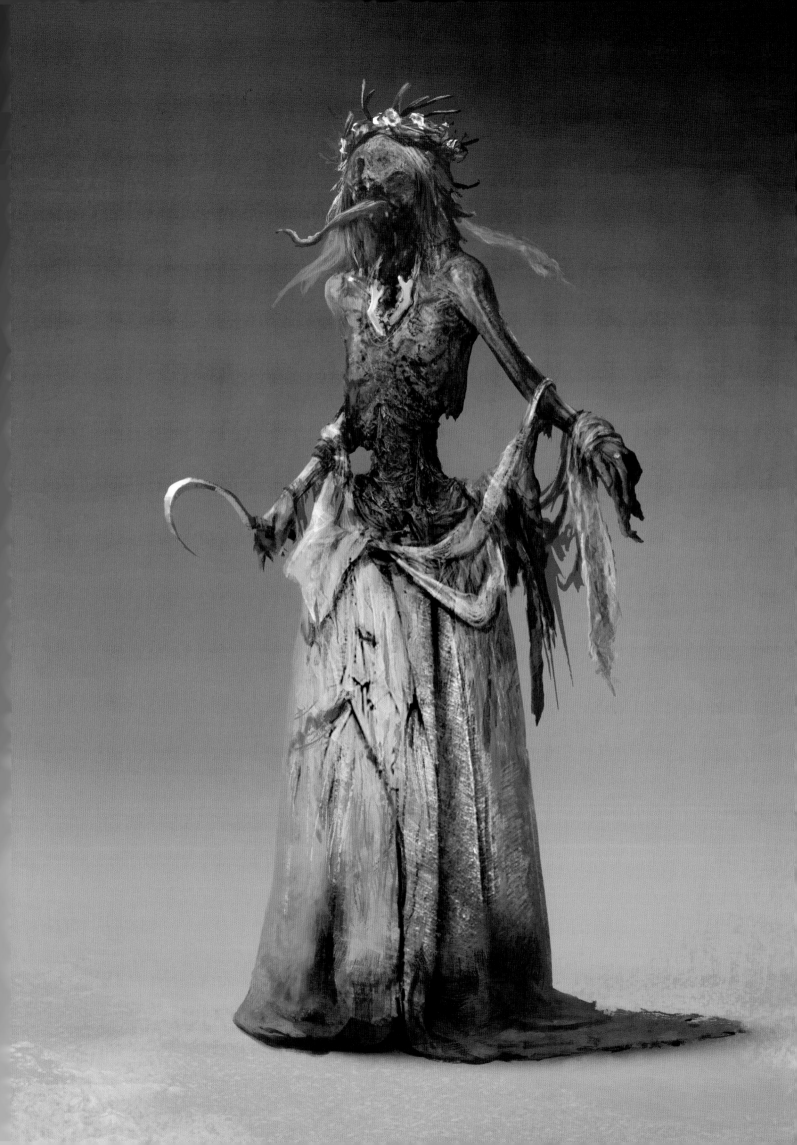

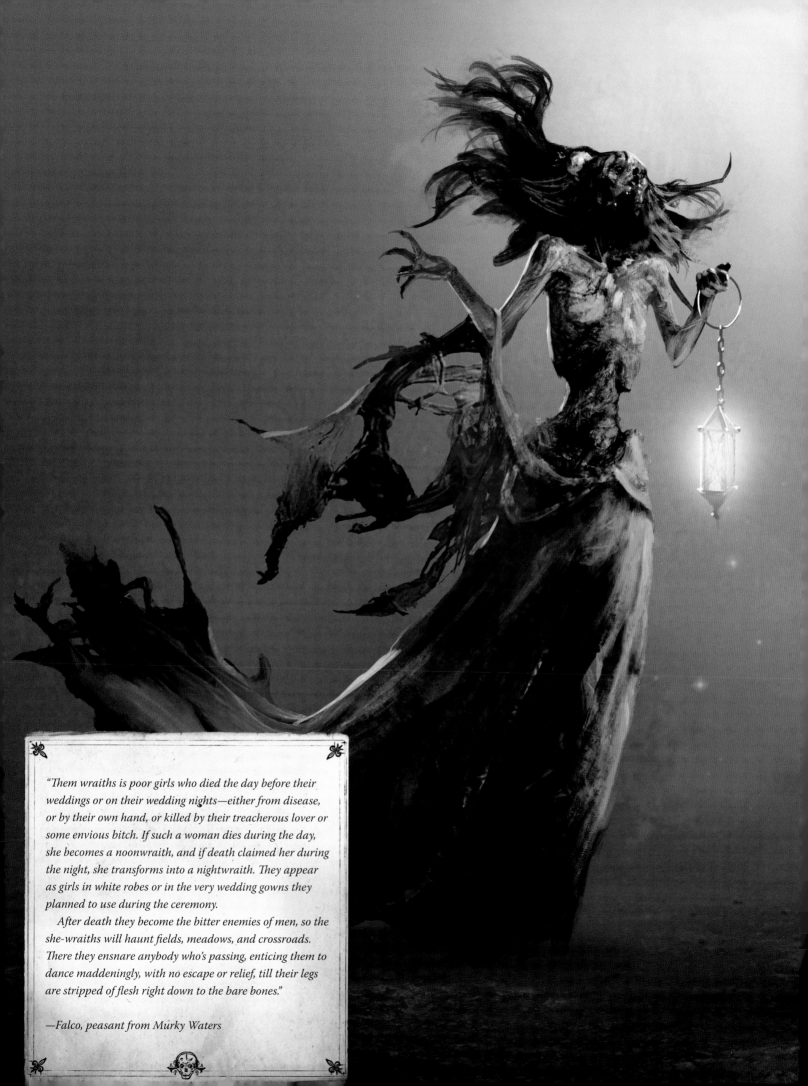

"Them wraiths is poor girls who died the day before their weddings or on their wedding nights—either from disease, or by their own hand, or killed by their treacherous lover or some envious bitch. If such a woman dies during the day, she becomes a noonwraith, and if death claimed her during the night, she transforms into a nightwraith. They appear as girls in white robes or in the very wedding gowns they planned to use during the ceremony.

After death they become the bitter enemies of men, so the she-wraiths will haunt fields, meadows, and crossroads. There they ensnare anybody who's passing, enticing them to dance maddeningly, with no escape or relief, till their legs are stripped of flesh right down to the bare bones."

—*Falco, peasant from Murky Waters*

accusation, or a murder born of greed or envy. Nor is it only the victims who may become wraiths. Such is also the fate of those who commit such grave transgressions, meaning murderers, oath breakers, and kin slayers.

The ghosts of madmen or people who were exceedingly cruel during their lives often immediately return as angry and violent specters. For most, however, the process of transforming into a wraith usually takes some time. The ghosts of the mur-

"There are many ways to deal with wraiths and restless ghosts. When you want to get rid of one, take a barrel of moonshine, a thin rod of thornapple two ells long, three nails from a harrow used to turn over the earth, and a handful of poppy seeds. Go to the graveyard by day and find the grave of the restless dead who disturbs the living. Drink the moonshine for courage—but only three mouthfuls, no more. Then dig up the grave of the damned and pull the corpse out. Take the thornapple rod and wrap it around the cadaver's neck, and pierce its heart with the nails. Place the corpse back in the coffin, open the deceased's mouth, and pour in the poppy seeds. Close the coffin and rebury it. Drink the rest of the moonshine and go home. When the night comes, the wraith won't be able to arise, for the iron nails and the thornapple rod will pull it toward the earth. And the poppy seeds will stop it from moaning and disturbing your rest. Finally, bored, he'll start counting the seeds in his head, wasting time until the morning. And so it will be every night thereafter."

—*Unknown author,* The Booke of Remediums for Beasts and Monsters of All Kinds

dered or the murderers begin by seeking the aid of the living, either to avenge them or to make up for their wrongs. Over time, the emotions fettering them to this world fade, and the spirits of the dead disappear into nothingness. Yet those whose deaths gave birth to sufficiently powerful emotions strive to avoid this fate at all costs. Because they can find no rest and cannot bear to give themselves

over to oblivion, they begin to draw strength from their growing hatred, becoming ever more bitter and aggressive. Gradually madness consumes them entirely, and only slaying every being they meet gives them a moment of respite from their torment.

Noonwraiths and Nightwraiths

In this case, a few minor details aside, the folk legend is surprisingly close to the truth. These creatures are a breed of wraiths, the ghosts of women and girls who indeed died violent deaths just before or just after their weddings. A woman who, spurred on by jealousy, has killed her betrothed or recently wed rival will also become one. Their names, as you might have guessed, reflect the time of day when they are active. And they do exclusively haunt rural areas, mainly mead-

One of the more interesting theories about wraiths claims that for some of them, their grotesque appearance is a reflection of madness deforming both the inner and outer self. Trapped for dozens or even hundreds of years in the world of the living, these phantoms lose all memory of their past and their physical forms, becoming warped shades of what they once were.

ows and farming fields, usually near the place of their death.

Noonwraiths appear on bright, warm days, when the sun reaches its zenith. They take the forms of girls or hags whose skin is tanned from the sun, wearing white robes and, sometimes, wedding wreaths. They prey on peasants working their fields or children playing nearby. Nightwraiths, in turn, are active only during the night, particularly when the moon is full. They usually waylay late travelers, but cases of sneaking into homes and attacking sleeping victims are not unknown. Both nightwraiths and noonwraiths can drain the life from their victims, swirling about them in something like a parody of the wedding dance they were doomed never to enjoy.

"This terrible beast, this cockatrice, is a grotesque terror resembling both a winged reptile and a cock. This is because it hatches from an egg warmed by a hundred snakes, an egg laid by an immoral cock which, like a hen, gave its buttocks over to other cocks. When the cockatrice hatches, it devours all the snakes, gorging itself on their venom so greatly that a mere gaze of its terrible eyes is enough to kill. Curiously, only witchers can withstand it. Some say that their magical amulets and sorcerous potions protect them, while others claim that witchers themselves are so full of hatred, and so used to the hostile stares of men, that the cockatrice's gaze can do them no harm."

—*Fr. Adalbert of Tretogor*, A Plague on This World, Being a Description of Monsters Vile and Unnatural

HYBRIDS

This is the popular but unprofessional name given to a wide variety of monsters that possess the traits of two or more creatures. Some believe they appeared during the Conjunction of the Spheres, while others think they are native to this world and existed here long before the Conjunction. Since sources dating back that far are scarce, to say the least, both theories are difficult to verify.

Griffins

The griffin resembles a crossbreed of a huge cat and a predatory bird. It mainly inhabits wild, mountainous regions, building its nests on inaccessible peaks. Large, hoofed mammals are its usual prey, but, being highly territorial, a griffin will also passionately defend the area surrounding its nest. With the expansion of human settlements and trade routes, griffins have become more and more of a threat to humans, attacking travelers and merchant caravans, as well as settlers and, particularly, shepherds and their flocks.

The archgriffin is a rare subspecies of griffin, distinguished by its extreme aggressiveness and a unique mutation allowing it to spit balls of vicious acid that cause severe burns.

Harpies

Harpies combine the traits of birds and humanoids, their bodies being those of old women, but with avian wings, talons, and beaks. They are social creatures, constructing colonies on rocky cliffs and other areas which are difficult to access. Harpies are omnivores and readily adjust their diet to the locally available flora and fauna. They are

Griffins' very size and strength make them dangerous predators. Their sharp beaks rend flesh with ease, but even a blow from their wings is enough to knock down a horse or crush the bones of smaller prey.

The Beasts of the Northern Kingdoms

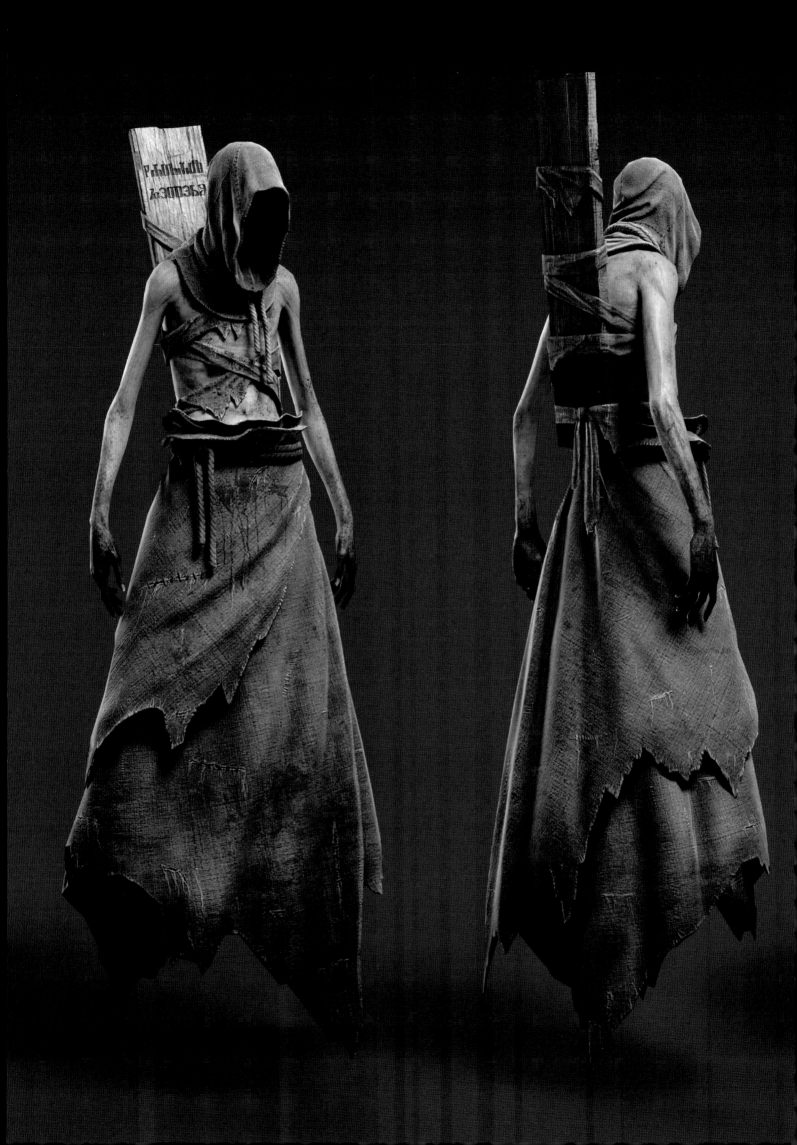

not above eating carrion but prefer live prey. Harpies will typically attack creatures smaller than themselves, suddenly striking from above and killing with their talons and wings. However, when numbers are on their side, harpies have been known to take on larger prey and even armed humans.

> *"No spell or curse can cast itself—thus, the tales of curses sent by the gods are obviously mistaken. A true curse requires a human to formulate and utter it. The ability to command the Power is, of course, highly useful here, but there are many documented cases of curses being cast by persons without any magical training, whether formal or informal.*
>
> *The place and time are also of import, but the main element needed for a curse to manifest is a sufficiently concentrated will. Without this, no effects will take place. Powerful emotional baggage, accompanied by appropriate words, can cause a particular sort of magical phenomenon, similar in some ways to the process which priests call prayer. As a result, the person casting the curse is able to subconsciously concentrate the Power and unleash it at the object of their hatred. The final effect is usually delayed, and almost never reflects the uttered curse verbatim."*
>
> —An Overview of Magical Phenomena *(collaborative dissertation)*

Cockatrices

Also known as the scoffin, the cockatrice is a member of the rare ornithosaur order—that is, creatures with traits of both birds and reptiles. The idiotic superstitions about it maintain that, just like a basilisk, it can cause death or petrification with its mere gaze. Speaking from experience, this is complete bollocks. The cockatrice's gaze is no more dangerous to life than that of an enraged turkey. One should be more wary of its beak and long, sharpened tail, which the beast uses to deadly effect. Even young specimens can be mortally dangerous, as they prefer ambush attacks from behind, aiming at the base of the neck or the left kidney, near the aorta. A mature cockatrice is not afraid of direct confrontation, and will strike with both tail and wings, attempting to wear its foe out before making the final blow—one aimed at the victim's neck or eyes.

THE DAMNED

As confirmed by my many years of practice in these matters, the theory that curses require human casters is broadly correct. However, it is not always possible to identify the person who cast the curse, and precisely these situations sometimes give birth to creatures that then plague a region for years or even generations, paying the price for their own or their relative's crimes. Such creatures include both monsters created as a direct result of a curse, such as strigas or botchlings, as well as humans who became cursed due to contact with the initial victim, as occasionally happens in cases of acquired lycanthropy.

We witchers are sometimes hired to attempt to break the spell on such creatures by lifting the original curse. If the monster has killed people, however, revenge can be another motive, and our employers may expect that we will simply kill the creature without further ado. Each case should therefore be approached individually, for sometimes lifting the curse is simpler and less risky than trying to combat the monster.

Werewolfism is a common curse and is often passed from generation to generation. Those stricken with it lose their human impulses during their transformations, and over time sink deeper and deeper into the abyss of madness.

Werewolves

The werewolf is a type of terianthrope—that is, a man capable of assuming the form of an animal. Though it is commonly thought that lycanthropy is the result of a curse, the matter is in fact much more complicated and has never been fully explained.

Some cases of lycanthropy do indeed stem from a curse, which results in those afflicted transforming uncontrollably into a wolf or half-wolf/half-human hybrid, usually during the full moon. Some are aware of

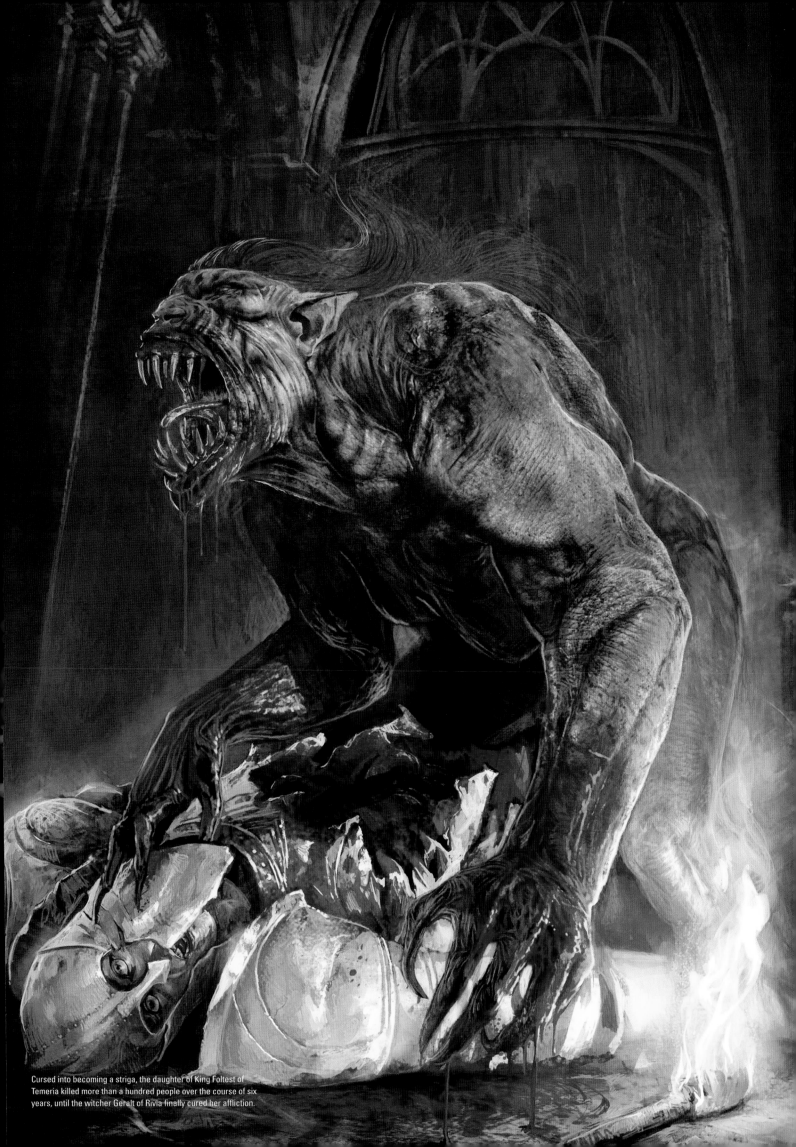

Cursed into becoming a striga, the daughter of King Foltest of Temeria killed more than a hundred people over the course of six years, until the witcher Geralt of Rivia finally cured her affliction.

their condition and retain control over their instincts even when transformed—such individuals usually seek to avoid other humans and simply wait for the night to end. Most people, however, either eagerly embrace the blood lust or remain unaware of their transformation, awakening with blood on their hands and its taste in their mouths.

On the other hand, the numerous cases of children being born with this affliction have led some to theorize that lycanthropy is a hereditary disease. This theory postulates that werewolves are a separate, magical species, and that those cases considered to be the outcome of a curse are simply the result of a dormant transformation gene becoming inadvertently activated by an evil spell. This theory of hereditary lycanthropy is somewhat supported by the fact that people who are born as werewolves can fully control their transformation. Removing the affliction is nearly impossible in such cases, and every attempt requires the goodwill and cooperation of the werewolf. There are also confirmed cases of terianthropes forming pairs and giving birth to offspring who are also capable of controlled transformation.

> *"Newborns with two hearts and two souls—newborns which have teeth—turn into strigas. These should be driven away or killed. If killed, they need to be buried in haste and immobilized, lest the striga should later rise from the dead. This is done by pinning the monster's palms and feet to the ground with sharpened stakes, and driving such stakes through both hearts. If this is not done, the striga will arise during the night to attack both men and cattle, draining their blood and devouring their entrails."*
>
> —Folk wisdom

Botchlings

These beasts are created when a child, often an unwanted one, dies and is not properly buried. The monster is about one and a half feet tall and creeps into bedchambers at night, preying on pregnant women. Hidden beneath the bed, a botchling will absorb the vitality of the mother and her unborn child, causing fever and weakness. Once its victim is enfeebled and unable to defend herself, the beast attacks directly, latching onto her and drinking her blood, which ultimately leads to her death and that of her unborn child. The botchling is rarely aggressive toward other people, though when threatened it can transform, assuming the shape of a deformed humanoid crawling on all fours. This form is much more dangerous, as the botchling will suddenly leap into close range, attempting to bite its foes or rend them with its razor-sharp claws.

Providing the botchling with a proper burial lifts the curse, turning the creature into a lubberkin—a protective household spirit.

Though small and misshapen, botchlings can spell doom for the pregnant. Victims first think they suffer from ordinary fatigue or infection; when the creature strikes directly, it is already too late.

Strigas

The striga is the result of a curse placed upon a pregnant woman. The child of a woman cursed in this way never survives, and instead becomes a monster, rising from the grave years later to prowl the vicinity of its burial ground. Although small, thickset, and hunched, the striga is supernaturally fast, agile, and strong, and thus extremely dangerous even to experienced warriors. It usually hunts at night, though certain specimens have been observed attacking during daytime, and is noticeably more aggressive during the full moon. Strigas subsist on the flesh and blood of the humans and animals they kill, preferring internal organs, especially the liver and the heart, which are a valuable source of necessary sustenance for their periods of lethargy between activity cycles.

It is possible to lift the curse from a striga, but this is very dangerous. Typically, one needs to spend one or more nights at the site of the beast's burial, waiting each night for dawn to break. The third crowing of a rooster should return the beast to its human form, if it catches the monster outside its coffin or sarcophagus. Of course, should the monster decide to return home before dawn . . . Well, in these cases, let us hope you paid close attention during Master Vesemir's fencing classes.

DRACONIDS

The draconids are a quite numerous order—even proper dragons alone number at least half a dozen species. Both they and the lesser draconids have inhabited these lands from time immemorial, forming an important branch of our ecosystem. As human cities and villages grew, and grazing and farming lands expanded, collisions between territories inhabited by draconids and those inhabited by humans became increasingly frequent. These predators

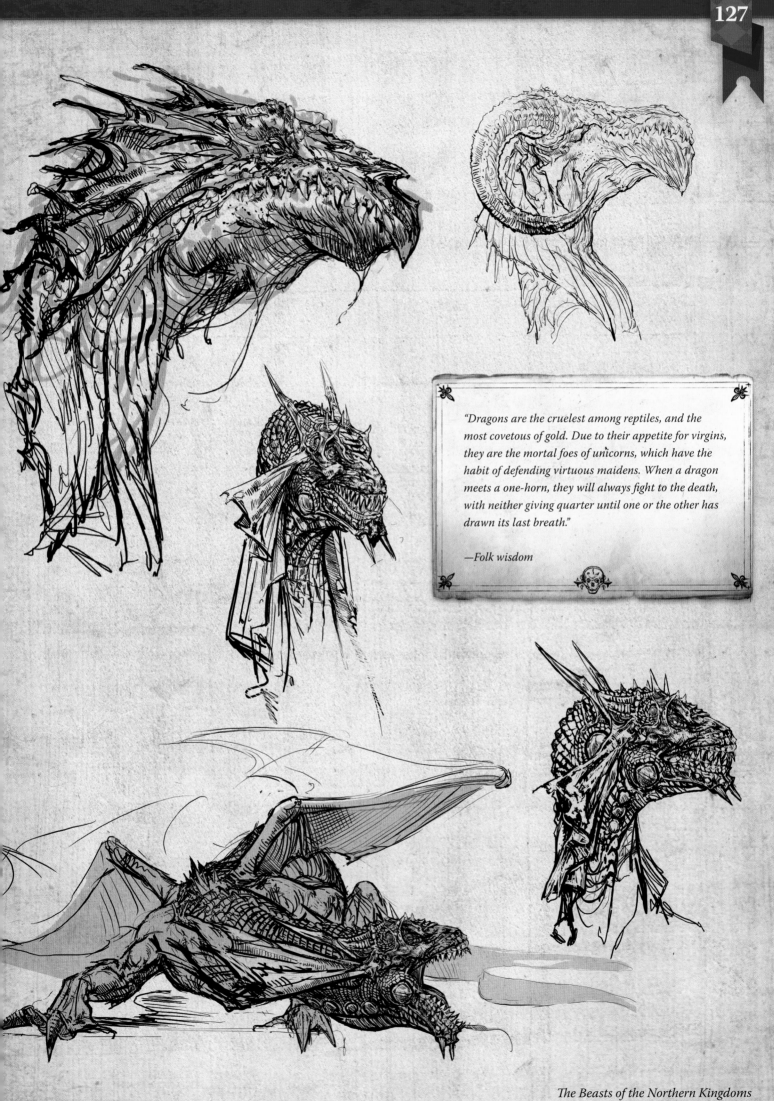

"Dragons are the cruelest among reptiles, and the most covetous of gold. Due to their appetite for virgins, they are the mortal foes of unicorns, which have the habit of defending virtuous maidens. When a dragon meets a one-horn, they will always fight to the death, with neither giving quarter until one or the other has drawn its last breath."

—Folk wisdom

The Beasts of the Northern Kingdoms

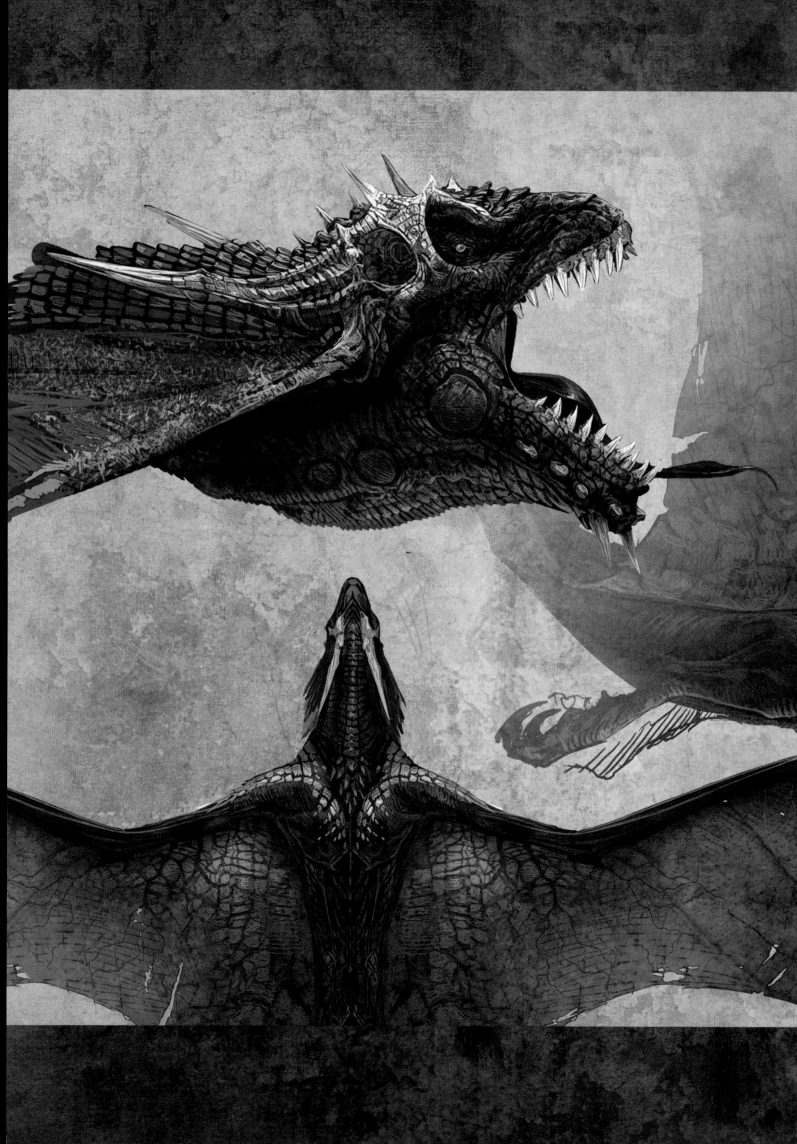

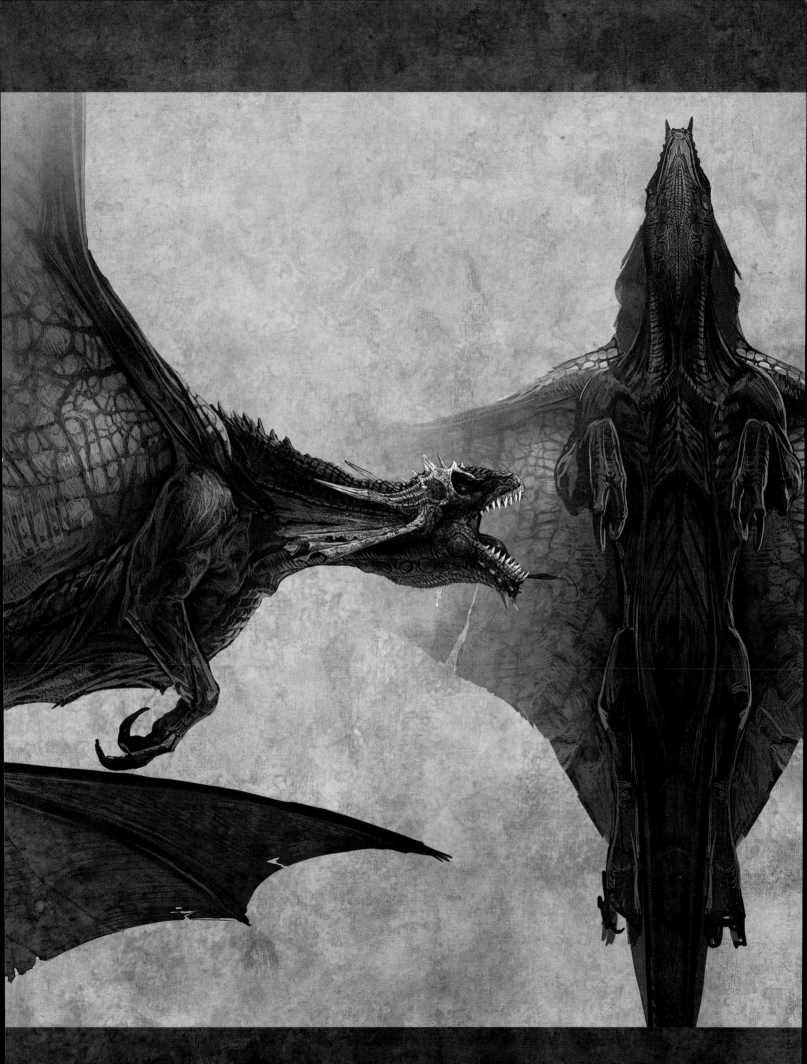

quickly learned that herds of cattle and swine are a readily accessible source of food, which, in turn, led to attempts to exterminate them by any means available.

Lesser Draconids

The most populous members of this order are the so-called lesser draconids, which include slyzards, forktails, and wyverns. A layman will easily confuse any of these species with dragons, as they share scaly skin or armor made up of bony plates, bat wings, and reptilian maws, legs, and tails. The main difference between them and their cousins is simply one of size. It is also worth noting that lesser draconids possess atrophied forelegs, to the point that the aforementioned wyverns and forktails have none at all. Most species make up for this with their long, slender necks, which allow them to move their heads faster and more gracefully than dragons can. With their flexible necks, they can attack like a striking snake, suddenly darting forward to snatch prey. Apart from their fanged maws, their armament includes sharp talons on their hind legs. Some species, especially forktails and wyverns, also utilize their tails in combat. These often come equipped with one or more bony spikes.

It is the arachas's gift for mimicry and its capacity for extraordinary feats of camouflage that make it a dangerous predator. Its victims only discern its presence once it is well within striking range.

"For dragons, forktails, and other adder kin which plague cattle there is but one remedy. Take a sheep of two years old and slaughter it, pull out the guts from its belly, but do not skin it. Pick a dozen handfuls of fool's parsley and hellebore, gather five quarts of deadly nightshade, and buy three pints of sulfur. Stuff all this into the sheep, sealing the carcass with cobbler's tar and good twine.

At dawn, take the stuffed sheep to the meadow where you graze the rest of the herd. Use stakes to prop it up, and leave it be. When the hungry reptile flies over, in its stupidity it will devour the sheep whole, paying no heed to the living ones. Then you don't have to wait long till terrible pains overwhelm it. The monster will start to roar awfully and spout fire from its maw and arse alike, twitching and flailing like a drunk peasant the day after harvest. Wait a dozen hours for the beast to finally lie still, and then take pitchforks, flails, or even stanchions and heave at it.

One should not let the sheep's guts go to waste. Rinse the maw, fill it with chopped heart, liver, and lungs mixed with minced onion, oat flour, and field herbs. Add lard, seal tightly, put in a pot of boiling water, and stew for three hours, then serve."

—*Unknown author,* The Booke of Remediums for Beasts and Monsters of All Kinds

Dragons

Dragons are a separate family of draconids, characterized by their large size, two pairs of well-developed legs, and huge wings and tail. They are also much more advanced than their smaller cousins, possessing not only greater strength, but also cunning and intelligence. Though the reasons for this behavior remain unknown, dragons universally love to collect gold, gemstones, and other treasures—a trait which has already made its way into countless legends. Despite what tales of noble dragon slayers rescuing innocent maidens might have you believe, the people organizing expeditions to hunt down dragons are invariably motivated not by the desire to put an end to the local threat, or even to win fame, but by simple greed.

In the same way, the tales painting dragons as terrible foes of the human race, which are used to justify half of all hunts, are just fables. If dragons had no treasure hoards, nobody would even give a damn, except maybe the serfs whose sheep they devour. It is worth noting that almost every dragon hunt is closely scrutinized by someone connected to the Jewelers' Guild. Not coincidentally, despite the fantastic size of some dragon hoards, no hunt has ever led to the market being suddenly flooded with gemstones, with the corresponding drop in prices.

INSECTOIDS

This group contains a wide variety of huge, usually carnivorous, and extremely dangerous insects. Most of these creatures are the products of evolution—predators native to our environment and thus important elements of our ecosystem. But some specimens are the side effects of the magical experiments so eagerly performed by sorcerers a few centuries ago. For sorcerers, despite their extensive education, can be surprisingly shortsighted, seemingly unable to imagine that a centipede or spider enlarged with a few spells here and there might at some point decide to tear their benefactor's head off and flee into the wild, becoming a hunter of men and beasts instead of crickets and flies.

Arachases

Once native to the far South, this invasive species has needed only a few decades to wander north, adjusting to our climate and temperatures. It leads a solitary life, preferring humid forests and swamps. As the product of warmer climates, it survives the northern winter by hibernating, burying itself in mud or the forest bed.

Similar to most insectoids, the arachas's trunk and appendages are covered in a chitinous carapace. The creature's abdomen is vulnerable, but it typically uses large shells or hollow tree trunks to cover it with a sort of makeshift armor. The beast prefers to ambush its prey, pulling them toward itself with a long tendril it launches from its maw. Some subspecies are capable of mimicry as well, allowing them to surprise their victims all the more easily.

Endregas

These insectoids in the order of arachnomorphs mainly inhabit wooded areas. Much like many species of ordinary insects, endregas live in colonies, with the members divided into different castes with specific roles. Endrega workers construct cocoons and take care of larvae and eggs. Warriors compose another caste, less numerous but more specialized. Their duty is to defend endrega nests and to hunt for food. Endregas are highly territorial and will attack any being that ventures too close to their nests. A rapidly growing endrega colony can therefore cause terrible damage to local flora and fauna, and become a real threat to nearby human settlements.

Koshchey

This monster fortunately does not occur naturally, and is born exclusively as a result of magical experiments. It takes the form of a large arachnid, several meters long and covered in a hard, chitinous carapace, armed with a pair of powerful pincers with sharp spines. The exact process of creating one remains a closely guarded

The renegade druid Ferengal created a koshchey to aid his band of robbers. With it at his command, he waylaid merchant caravans crossing Klamat Pass, halting all commerce over that important trade route.

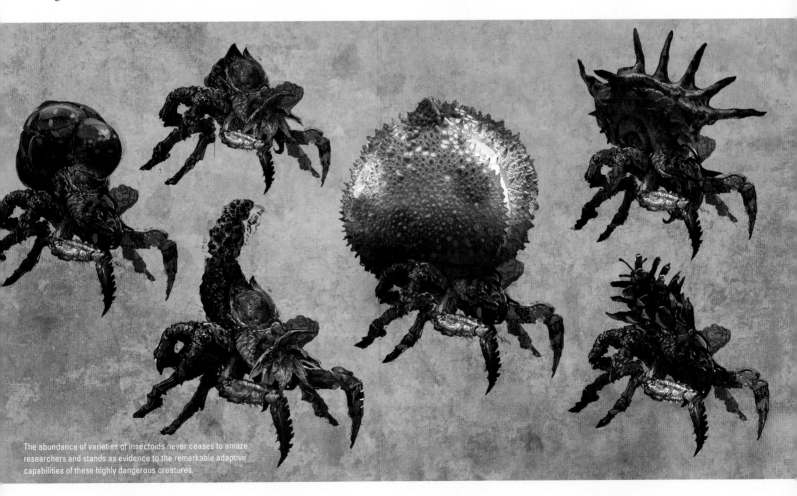

The abundance of varieties of insectoids never ceases to amaze researchers and stands as evidence to the remarkable adaptive capabilities of these highly dangerous creatures.

"Several subspecies of dragons çan be identified. These are commonly known as rock dragons, green dragons, red dragons, black dragons, white dragons, and golden dragons. This simplified classification was created based on their hue and, in the case of rock dragons, the area they most commonly inhabit.

Rock dragons are the smallest of the subspecies, and in the present day they have been hunted to near extinction. Their skin is gray-brown in color, and they indeed used to primarily live in rocky areas, though the same can be said about other dragon breeds.

Green dragons are the most widespread subspecies, though in truth they are more gray than green, much like slyzards. The red dragon's scales range from dark maroon to brick red. The black dragons, which are the largest breed, are in fact a very dark brown. The rare white dragons are not found in our climate, but instead inhabit the far North. They are only known from the tales of a few daring explorers, who describe their scales as light gray or even light blue.

Unquestionably, the rarest subspecies is the golden dragon, draconis aurum nobilis*—a semimythical creature supposedly possessed of multiple magical abilities and keen intellect. It is said they can communicate with other races using telepathy, and that they can change shape, even assuming human form. Though golden dragons are commonly considered to be legends, sightings have been reported by trustworthy witnesses, making it impossible to completely rule out their existence. One such case took place near Woefield several years ago. The region had become flooded with dragon slayers due to rumors that one of the beasts was haunting the area. These rumors turned out to be true, as a mighty golden dragon using the name Villentretenmerth confronted the retinue of King Niedamir of Caingorn and his accompanying dragon hunters, forcing them to retreat. These events were confirmed by multiple eyewitnesses, including two sorcerers and a witcher."*

—Fragments of a lecture from the Faculty of Natural History of the Oxenfurt Academy

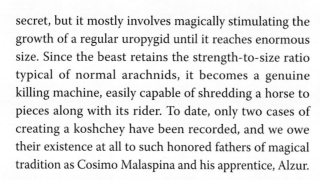

secret, but it mostly involves magically stimulating the growth of a regular uropygid until it reaches enormous size. Since the beast retains the strength-to-size ratio typical of normal arachnids, it becomes a genuine killing machine, easily capable of shredding a horse to pieces along with its rider. To date, only two cases of creating a koshchey have been recorded, and we owe their existence at all to such honored fathers of magical tradition as Cosimo Malaspina and his apprentice, Alzur.

MAGICAL CREATURES AND CONSTRUCTS

The list of monsters which our comprehensive bestiary owes to sorcerers is not limited to mutants and magically bred beasts. Mages also have the unfortunate habit of creating their own magical servants or summoning beings from other dimensions. We cannot omit these creatures from consideration, as accidents do happen from time to time, allowing them to break free of their magical bonds and run amuck. Such events usually have dire consequences for the entire region—but can represent a job opportunity for a well-prepared witcher.

Golems

Golems are constructs made by sorcerers to carry out specific designated tasks, from carrying great loads to dealing with unwanted visitors. They are assembled from various materials, with stone being the most common, though clay or wood can also be used. These beings have no will of their own and cannot think—they can only carry out the simple instructions of their master. A golem is usually animated by a magical stone known as a golem heart which is, obviously, placed in its chest.

Golems used as guardians are likely to continue carrying out their duties even after their creator's death. In battle, they make up for their limited creativity with their supernatural resilience and great physical strength. Given their unquestioning loyalty, lack of family life and thus no related vacations or distractions, and the fact that they have no desire for pay and no thirst for strong drink, you could indeed say that they are the ideal servants, and certainly understand why a sorcerer might prefer a golem over the average drunken, lazy lout.

Genies

This name is often used to describe powerful, but in fact lesser, elemental creatures summoned by sorcerers from one of the four elemental planes—earth, fire, water, and air. In truth, it is usually employed erroneously, since a true genie is a being of unbelievable power, one that steel or silver cannot hope to harm. To even confront such a being requires powerful magic, and such magic can still fail, leading to results as spectacular as they are tragic for both the sorcerer and the entire surrounding area. Luckily, only the most powerful masters of magical knowledge can even attempt to summon such a creature,

Stone golems have all that it takes to become weapons of great destruction. Woe to the mage who lets such a minion slip out of his control or, worse, turn against its master.

Bojowski

and thus these beings are extremely rare.

Unlike true genies, the lesser magical servants from the elemental planes can be defeated, but that does not mean they are anything less than mortally dangerous. Their direct connection to an element allows them enough power to crush nearly anyone their master wishes, meaning that those who dare confront such beings must be either supremely skilled, or supremely foolish.

> *"On that day a terrible fate befell the Redanian city of Rinde, as the greedy and treacherous sorceress Jennifer tried to ensnare a genie in a magical net. For the magician believed that if she managed to control the genie, she would have a powerful servant, whom she could set loose upon the burgomaster, the high priest, and the city council, who had greatly and justly reprimanded her for her promiscuous lifestyle and many foul deeds.*
>
> *Yet the witch did not have her way, and though their struggle lasted for quite some time, she could not contain the genie using her spells. And the creature, while trying to escape, destroyed no less than a dozen buildings, including an inn, a wine store, and a barber-surgeon's shop, which led to people being sober, moody, and unshaven for several days after. There is no telling how the whole thing would have ended, if not for the witcher Gerhard, who used a secret exorcism to drive away the monstrous genie to the far reaches of the world."*
>
> —*A folktale*

A typical nekker is as tall as a child of several winters, though some specimens can be taller again by a whole head. The creatures hunt in packs, with several members to each. They ambush their prey from their underground tunnels, trying to cut off the victim's avenues of retreat. Nekkers will then rush a cornered man or animal in a large mob, biting and slashing with their sharp claws. Their attacks are usually disorganized, as nekkers are not extraordinarily courageous, and individual specimens will frequently hesitate for a moment before overcoming their fear and moving to attack. This pattern can be altered, however, by the presence of larger specimens, which are easy to identify because

Skilled mages construct wood and clay golems with relative ease. They animate them with magic seals and formulas carved directly on their bodies or written on ribbons draped around them.

OGROIDS

Supposedly, the scholars who created this classification followed some sort of taxonomical rules, but their selection of species never ceases to amaze me. For not only ogres and all troll subspecies are counted among ogroids, which is somewhat logical, but also giants and nekkers—which are as different as a striga is to a leshen. Despite this, those learned men, after much discussion, and likely nodding sagely, came to the conclusion that the number of common traits in bone structure, habits, and hell knows what else, is sufficient enough to assign all these species to a single, common group.

Nekkers

Nekkers are small, misshapen creatures that inhabit remote areas. They make their abodes in dark woods, damp gullies, and shadowy dales, where they live in colonies composed of anywhere from a dozen to several dozen individuals. Their lairs take the form of dugout hollows, interconnected by narrow underground tunnels. Nekkers use these pathways to quickly travel around their colony and its immediate surroundings, disappearing into the earth and then seeming to instantaneously pop up elsewhere.

The monsters communicate through a series of screeches, grunts, and moans. The wide variety of these sounds has led a group of scholars to theorize that these are not mere verbal cues, but actually a type of primitive language.

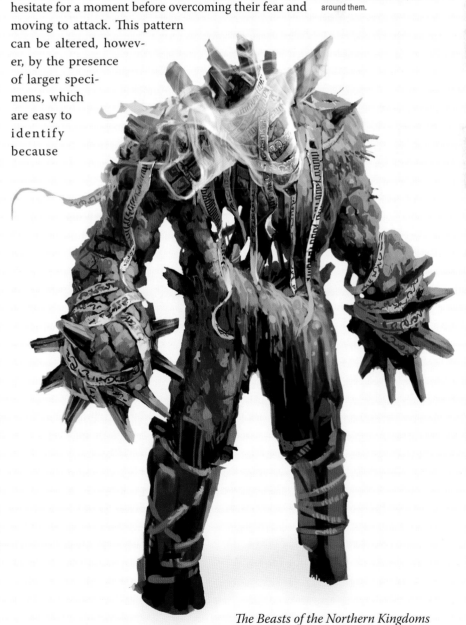

The Beasts of the Northern Kingdoms

of their habit of spreading colorful clay over their snouts. These larger and more dangerous individuals, commonly known as "nekker warriors," specialize in hunting and fighting. They are also frequently found leading groups of their smaller brethren, and their presence alone is enough to spur other nekkers to fight more ferociously.

Trolls

Trolls are huge and strong, but not particularly sharp. Surprisingly for such large and seemingly clumsy creatures, they are quite skilled at carpentry and stonemasonry. The structures they build are astonishingly resilient, though maybe not the most aesthetically pleasing. Trolls make their dwellings near bridges, whether built by themselves or by other races, and live off collecting tolls from travelers. They usually demand provisions, livestock, or horses. If the traveler has nothing to offer, he has to find another route—though if times are lean, he might end up as a hungry troll's main course.

Presently, it is unreasonable to still classify trolls as monsters. That is because over years of coexistence with more intelligent races they have at least partly adjusted their customs, and now should properly be considered an intelligent, though primitive, race. Incidents in which trolls attack villages and hamlets are now rare, for they have largely abandoned their man-eating habits and usually limit themselves to stealing cattle and livestock from time to time. They even began using primitive clothing, though in their case these are usually scrounged together from fragments of rags, old bags, and various junk worn as ornaments.

"When ya think about it fer a while, 'tis easy to see trolls is not really monsters. Yeah, they ain't pretty, but cooper Sulibor's wife ain't either, and nobody's hired a witcher to get her, right?

They's also smart. Not really smart like our innkeeper, for he's a worldly man who learned at the temple school and can count w'out using fingers, and even goes to fairs at the town. Boy, he's really seen the world. But a troll sure is smarter than Dreslav the shepherd boy—ya know, the one that was kicked in the 'ead by a horse when he was still a kid, and now he's all weak minded, always talking to 'imself and 'is pigs.

Trolls is also hard working, more so than most humans. The ones in the mountains beyond the village built a bridge in five days—how many carpenters could do that?! Truth be told, they'd gripe until they got an advance payment, and then be off to get wasted, the bloody drunks. Prob'ly botch the construction in the end too! I knows their kind! Yeah, trolls now wants a toll for crossing the bridge, and if someone don't pay, they break 'is leg, sometimes both legs, but that's still a sight cheaper and safer than going through the Old Clearing and the Frog Mire. And ya can make a deal with a troll, bargain a'out payment, since trolls speaks Common and ya can understand 'em, unlike, say, yer royal tax collector. One used to come 'ere and fleece us for everything we had: poll tax, chimney tax, plow tax, tail tax, and gods know what else. And 'e didn't bloody care that winter was harsh and harvest poor, 'is 'qu-otoa' had to be met, and if someone asked why should we pay so much, 'e started babbling about dutifactual service, obligations, royal prerogativations, and other such bullcrap. Luckily, when 'e was leaving last year, 'e used the Troll Bridge. And since trolls was mighty hungry a'er winter . . . Well, a new one ain't come yet, so we's got peace for a while . . ."

—Miwocht, village blacksmith

The most intelligent of trolls even understand the concept of exchanging goods and services. These more intelligent specimens make deals with surrounding villages, usually building and maintaining local bridges, and even protecting the peasants from predators or bandits.

That does not mean, however, that these creatures are completely harmless or subsist on veggies. Attacks on humans still happen occasionally, particularly in early spring when hungry trolls begin to run out of winter stores. Some specimens, especially of the wilder mountain subspecies, don't see a real difference between a human and a cow. These trolls still attack travelers and harass local hamlets, becoming a real terror for the area and a legitimate source of witcher work.

RELICTS

Finally, there are creatures that elude all categorization and do not fit into any kind of scholarly taxonomy. Many are quite rare or even completely unique, while others are commonplace. The one thing they all have in common is that they originated in ancient times, well before the coming of men and elves or even dwarves and gnomes into this world. That is why scholars label such species "relicts." Many of these creatures have different names in different parts of the continent, making the creation of a complete list all the more difficult. Over dozens of centuries some of these species went completely extinct, yet others can still be found, especially in remote and wild places, where they have become ingrained in the local folklore so deeply that they are treated as lesser deities or demons.

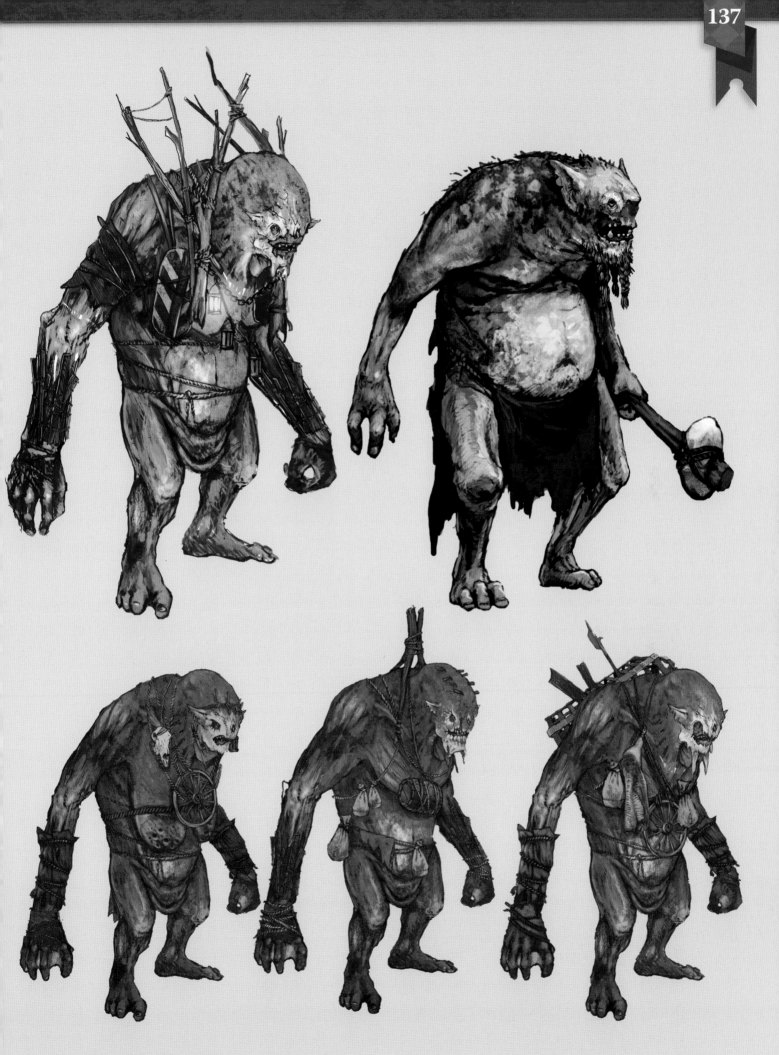

Though undeniably intelligent, forest trolls struggle with the finer points of concepts such as "clothing." As a result, they wear everything from animal hides and tree branches to rags, bits of armor, and whatever else they find or steal.

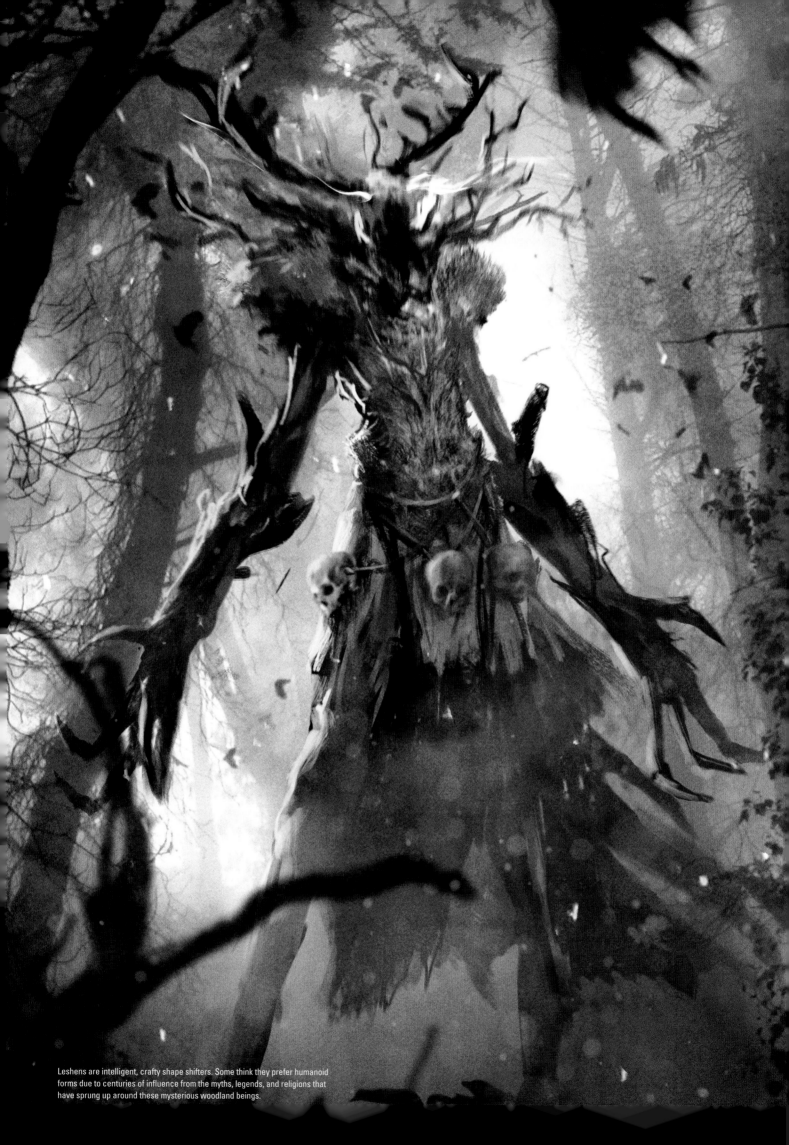

Leshens are intelligent, crafty shape shifters. Some think they prefer humanoid forms due to centuries of influence from the myths, legends, and religions that have sprung up around these mysterious woodland beings.

Leshens

Also known as the Forest One or the Wood One, the leshen is a shape shifter that inhabits ancient forests. According to some legends, it can assume many forms, from a hunched old man with skin the color of bark and hair of moss, leaves, and twigs, to a tall, clawed beast crowned with a horned deer skull, to any manner of forest predator, including a wolf, wildcat, bear, or even a flock of birds. A leshen is very dangerous in battle, as it can call upon the forest itself and all its inhabitants for aid. This command over both animals and plants causes many to consider it the lord of the forest.

In some regions of the world these creatures were the subject of worship and a type of nature cult, and such practices are still alive in many isolated woodland communities. Even today, the inhabitants of certain hamlets sacrifice small game or birds to a leshen, and worship it under the name Kerun or Kernos. These cultural relics gave birth to many legends of helpful leshens that will drive prey toward hunters, help lost pilgrims find their way in the forest, or rescue travelers from brigands. This last myth is not entirely baseless—the leshen is a highly territorial creature, and treats the forest it inhabits as its personal domain. It will often consider the appearance of armed men—whether bandits or hunters—as a challenge or outright threat. It will then use any available means to drive the intruders off or eliminate them. This fierce territorialism is the basis for the widespread opinion that only the most valiant of huntsmen can traverse a leshen's hunting grounds and remain among the living.

Fiends and Chorts

These mighty beasts have wide, bulging torsos covered in fur or short bristles, and move about on hind legs not unlike those of a goat. They also use their longer forelegs to support themselves, making for a characteristic profile. The beast's nearly neckless, animal-like head appears

"Yet there are also such beasts that cannot be overpowered, and must be appeased with sacrifice instead. If a Wood One is angered and drives game away, take a lamb or piglet into the forest and tie it to an oak in the middle of a clearing on a moonlit night. If the Wood One accepts the gift, he will stay his wrath and the forest will be full of game once more. . . .

. . . If a fiend or chort is causing plagues and decimating your cattle, your only hope is to prepare a meal of bread, honey, and meat, and leave it on the edge of the forest or bog. You can also play a soothing tune on the fiddle, to lull the beasts to sleep and calm their ire. . . .

. . . Yet if all else fails and you cannot appease the spirits of the forest, go and make a racket near another village, shouting and cursing the spirits as long as you can. Then the creatures will direct their wrath at that other hamlet, and will leave yours in peace. Truth be told, it might be better to start with this stratagem, so as to not waste livestock and foodstuffs. And if that does not help, the only thing that can be done is to pay silver to a witcher, who will surely slay the vile creatures."

—*Unknown author,* The Booke of Remediums for Beasts and Monsters of All Kinds

to sprout directly from its massive shoulders. A fiend will sport extensive antlers not unlike those of a deer, while a chort will have a pair of curved horns similar to a ram's.

Some time ago, scholars attempted to assign the beasts to one of the known orders of monsters and to give them proper names, but neither attempt was successful for long, and certainly this was never adopted among the common people. To this day the beasts known in folktales as fiends and chorts inhabit forest lairs, marshes, and mires, which they sometimes leave to attack humans, destroy farmland, and devour livestock. On this account, they are sometimes believed to be able to cause various calamities, from crop failure and hailstorms to murrain.

Fiends rarely venture from the shelter of their deep-woods lairs, but, due to their size and aggressiveness, each time they do spells catastrophe for the surrounding region. An enraged fiend will not relent until it has spent all its fury and satiated its enormous appetite, usually with fatal consequences for the inhabitants of nearby villages and settlements.

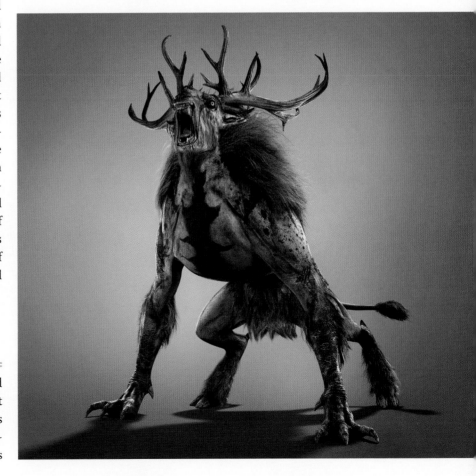

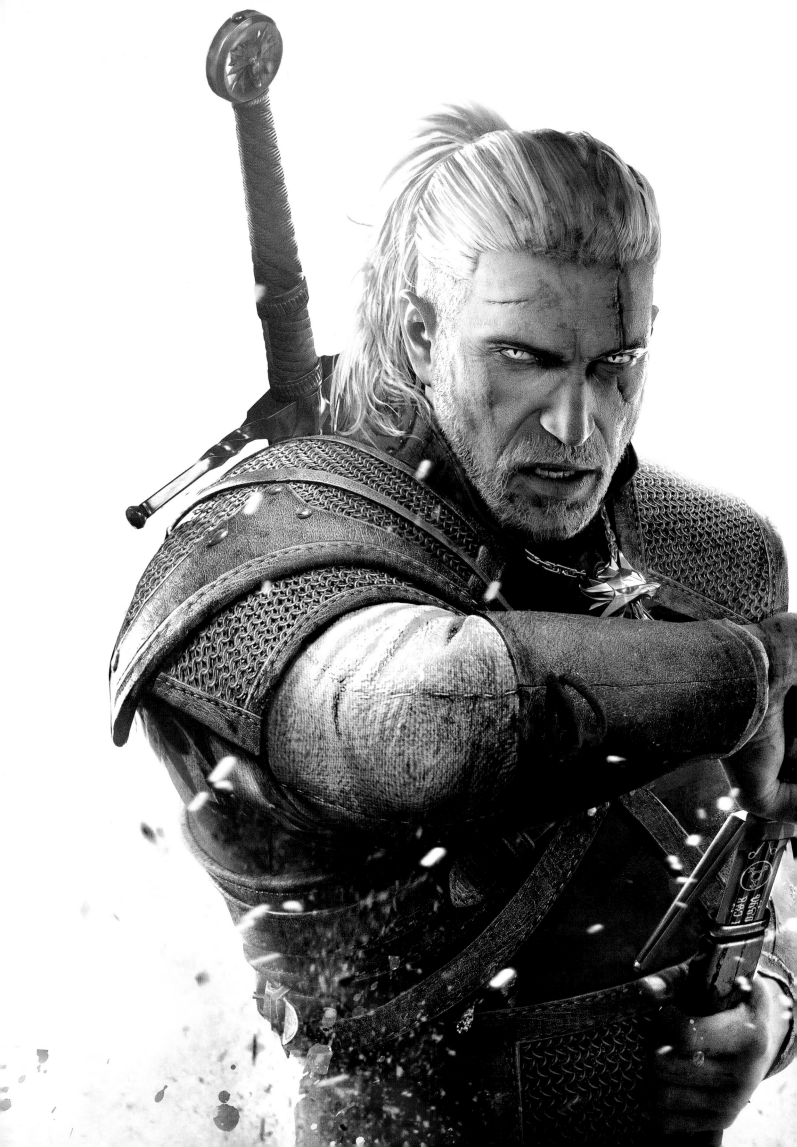

THE STORY OF GERALT OF RIVIA

Geralt of Rivia is a truly exceptional individual. Admittedly, a brief encounter might tempt one to label him a mere swinger of swords, a simple monster catcher, a rough-and-tumble practitioner of a dirty trade—but peer closer and you will soon discover he is a man of unplumbed depths, unique views, and vast, world-spanning experience. On the surface, he is introverted, tight lipped, one might even say gruff, but underneath lies an overflowing sea of goodwill, good humor, and an honest readiness to help his friends, be it with a bit of sound advice or the masterful application of his blade. He is a man of rugged and sometimes ragged appearance and manners who nevertheless enjoys a great deal of esteem from the fairer sex. He is, in a word, a walking contradiction. And this is precisely why he makes the perfect hero for poems both epic and lyric. I predict that, sooner rather than later, someone will write down his story and make of it a ballad that will be on the lips of every bard in the North for centuries—and I hope, dear reader, that someone will be me.

Geralt and I have been friends for years, ever since the moment we met nearly a quarter century ago. Throughout this time we have shared each other's company more often than not. Thus, allow me to shed any cumbersome false modesty—always a particularly onerous burden for one such as myself—and say that I know his story better than any man alive. This being so, it is my duty to put down in writing, even if only in the form of a rough sketch, the more important events of our acquaintanceship.

—Dandelion

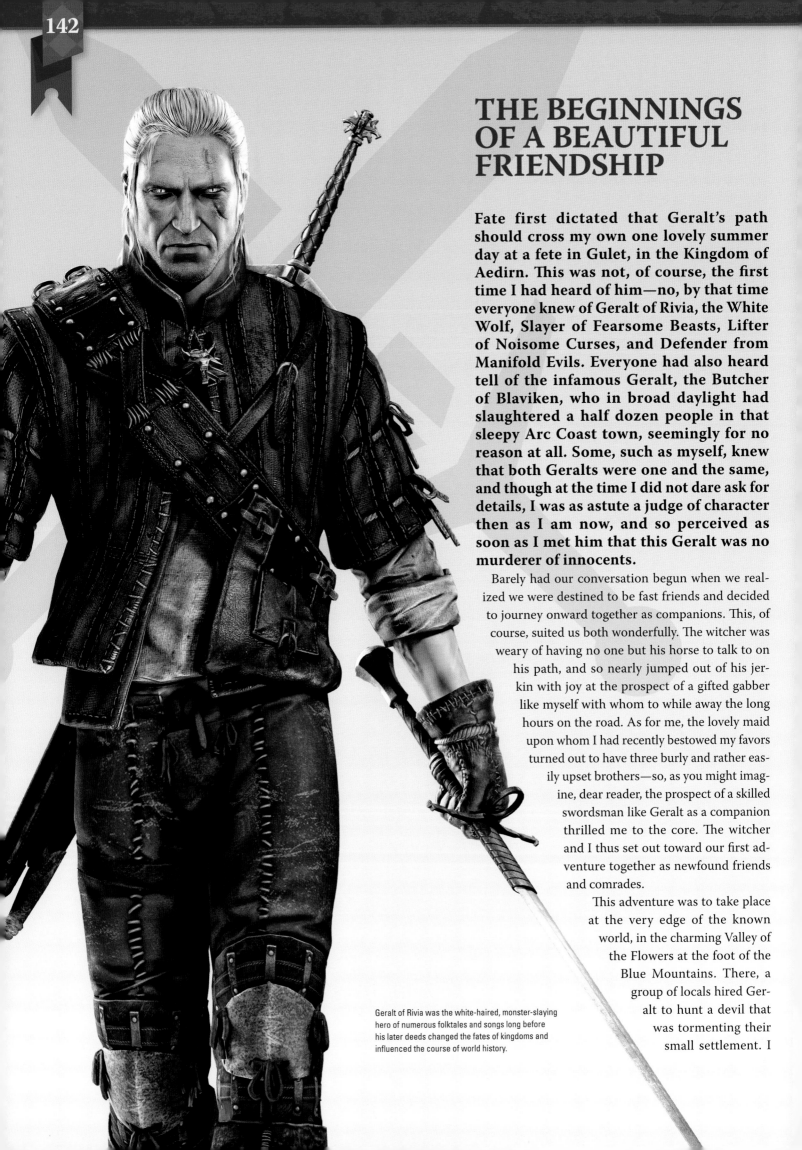

THE BEGINNINGS OF A BEAUTIFUL FRIENDSHIP

Fate first dictated that Geralt's path should cross my own one lovely summer day at a fete in Gulet, in the Kingdom of Aedirn. This was not, of course, the first time I had heard of him—no, by that time everyone knew of Geralt of Rivia, the White Wolf, Slayer of Fearsome Beasts, Lifter of Noisome Curses, and Defender from Manifold Evils. Everyone had also heard tell of the infamous Geralt, the Butcher of Blaviken, who in broad daylight had slaughtered a half dozen people in that sleepy Arc Coast town, seemingly for no reason at all. Some, such as myself, knew that both Geralts were one and the same, and though at the time I did not dare ask for details, I was as astute a judge of character then as I am now, and so perceived as soon as I met him that this Geralt was no murderer of innocents.

Barely had our conversation begun when we realized we were destined to be fast friends and decided to journey onward together as companions. This, of course, suited us both wonderfully. The witcher was weary of having no one but his horse to talk to on his path, and so nearly jumped out of his jerkin with joy at the prospect of a gifted gabber like myself with whom to while away the long hours on the road. As for me, the lovely maid upon whom I had recently bestowed my favors turned out to have three burly and rather easily upset brothers—so, as you might imagine, dear reader, the prospect of a skilled swordsman like Geralt as a companion thrilled me to the core. The witcher and I thus set out toward our first adventure together as newfound friends and comrades.

This adventure was to take place at the very edge of the known world, in the charming Valley of the Flowers at the foot of the Blue Mountains. There, a group of locals hired Geralt to hunt a devil that was tormenting their small settlement. I

Geralt of Rivia was the white-haired, monster-slaying hero of numerous folktales and songs long before his later deeds changed the fates of kingdoms and influenced the course of world history.

won't bore you by delving into the details of this contract, but suffice it to say that the witcher proved he was not the kind of monster exterminator who slaughters first and asks questions later. This "deovel," as the locals called it in their charming dialect, turned out to be a thinking creature, a sylvan in fact. Geralt did not kill it but instead strove to drive it off peacefully. Before he could complete his task, however, a band of elven guerrillas surrounded us—and Geralt's first reflex was to negotiate for my life, to save me, an artist he had met but a few weeks prior, before thinking to save himself. Having proven himself a man of great discernment and magnanimity, from that time forward Geralt had my complete trust and no ill word about him would ever leave my lips.

"I'd known Geralt for a long while, and considered him a friend. He happened to be sojourning in Blaviken when they showed up. Seven of them, a pugnacious lot, all full of cold menace and armed to the teeth. Left quite the impression—even remember their names. Short, stocky, swarthy fellow was called Tavik. Nohorn and Fifteen, they were once mercenaries with the Angren Free Company. Then there were these twins, Vyr and Nimir, devils from gods-know-where. The half elf, Civril, was a bandit and murderer who had wet his daggers in the Tridam massacre, where he and his band had taken a particularly unlucky group of pilgrims hostage and butchered them one by one till the local baron met their demands. And then there was Renfri, better known as Shrike because of her penchant for impaling her victims. She'd been wandering the world for some time, first with a band of seven gnomes, and then with her own gang of assorted toughs from all the more unsavory corners of this land. She had some papers claiming they were on royal business, but in truth they'd come to our town for vengeance, to fix this mage who'd supposedly done her some terrible wrong.

Geralt, well, he sensed trouble brewing and went to have a chat with Renfri. She apparently swore to him that, if the mage left on his own, she'd offer him the 'Tridam Ultimatum.' The witcher was no fool and knew this meant they were planning a repeat of what happened in Tridam. I told him we had no proof, that they hadn't done a thing wrong as of yet, and if he attacked them the law wouldn't and couldn't be on his side . . . He didn't listen. He didn't wait. And so on that day, a market day it was, seven people were cut down in the town square—a bloodbath if ever there was one."

—Caldemeyn, ealdorman of Blaviken

Geralt and Yennefer

Geralt and the sorceress Yennefer, his greatest love, first met during our next adventure—one that began with a sequence of events so unlikely, so unbelievable, that you will no doubt accuse me of overindulging in poetic license, or perhaps strong drink. Yet it is the unadorned truth that on one particularly fine morning the witcher and I cast our lines into a river hoping for a breakfast of fish, but instead pulled out a magic amphora with a genie imprisoned inside. Once freed, the ungrateful being not only failed to grant us three wishes, but in an instant flew at my throat! The result was a severe injury that came close to permanently depriving me, and the world, of the instrument of my trade—my voice. Geralt went in search of help and, catching word of a sorceress staying in the nearby town of Rinde, set off to see her without delay. That is where he first met Yennefer, and though

the beginning of their relationship did not seem to portend great passion, anyone familiar with matters of the heart and the fairer sex would have recognized at once that something would come to pass between these two. Yennefer at first treated Geralt as just another useful instrument, flirting with him and agreeing to restore my voice, only to then cast a spell on Geralt that put him into a strange trance, during which he publicly flogged several people and then fainted and was hauled off to the dungeons. The sorceress, it turned out, had plans to use us both to help capture the genie, seeking to tame this being and bind its great magical power to her will. Why mages think it wise to attempt to enslave creatures of near-limitless power and equally irascible temperaments, I will never understand. But that is neither here nor there, for I have promised you, dear reader, a tale of the love between Geralt and Yennefer, and so you shall have one. As you know, many are the loves that start with a quarrel, and this one soon fit that pattern perfectly. When things began to spin out of control and the sorceress's life was endangered, Geralt ran to her rescue. Of course, before the danger passed, Geralt and Yennefer managed to get into a vicious fight and the genie succeeded in destroying a quarter of the city, but all ended well. Geralt used one of his wishes to win the sorceress's heart and save the rest of the city from the furious genie's vengeance, putting a permanent seal on the affection between the two and binding their fates together, forever and for always.

Yet while love is one matter, a man's need to be independent is an entirely different one. One year into their relationship, Geralt flew the proverbial coop, disappearing from Yennefer's house in Vengerberg with

While on his path, Geralt relies on his swords both as the tools of his trade and as symbols proclaiming "witcher" to all who see them. He thus rarely parts with them willingly.

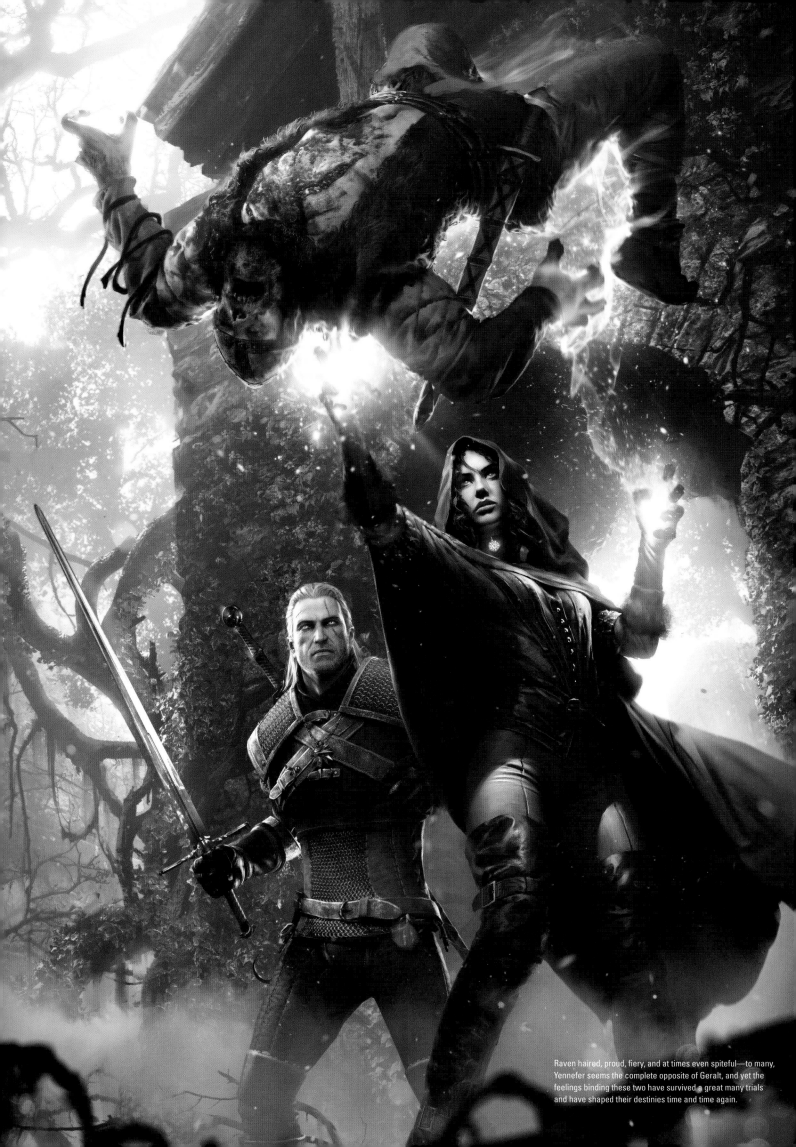

Raven haired, proud, fiery, and at times even spiteful—to many, Yennefer seems the complete opposite of Geralt, and yet the feelings binding these two have survived a great many trials and have shaped their destinies time and time again.

only a letter and a bouquet of violets on the table by way of explanation. I hardly need say that this type of farewell so enraged Yennefer that for the next four years any mention of the man would set her teeth to grinding. The witcher might be a grizzled veteran when it comes to monster fighting, but in his relations with women he has always behaved like an immature schoolboy. By this I do not mean his impulse to flee when he felt a woman was growing overly possessive or trying to change his habits by force—this he shared with all his brothers of the male sex. In such a situation flight is a natural reaction, but maturity and common courtesy demand that the act of parting be conducted in a way so as to break the news as delicately as possible. Acting any differently is not only cruel, but also risks prompting the woman in question, and possibly her friends, to seek revenge. It also eliminates any chance of ever spending tender and pleasurable moments in her company again in the future. I hope, dear reader, that you will not find it vulgar of me to say that I have had to break a few hearts in my many travels, and have learned from experiences both delightful and tragic that it never pays to burn one's bridges prematurely.

The Feast in Cintra

At least Geralt had the good sense to try to stay out of the enraged sorceress's way for a while. It was during this period of separation that he traveled to the Kingdom of Cintra, carrying out a witcher contract that would prove to be the most important of his life. He arrived in Cintra at the behest of the queen of the kingdom, Calanthe, who feared a disruption at her daughter's birthday feast. Rightly so, it turned out, for before the lavish feast had concluded a monster appeared and invoked the Law of Surprise, an ancient and extremely powerful magical contract, to claim the right to Calanthe's daughter, Pavetta. This monster, known as the Urcheon of Erlenwald, had the appearance of an armor-clad knight but with the head of an enormous

Geralt and Dandelion have known each other for over twenty years. The adventures and dangers they lived through together have forged a deep friendship that survives to this day.

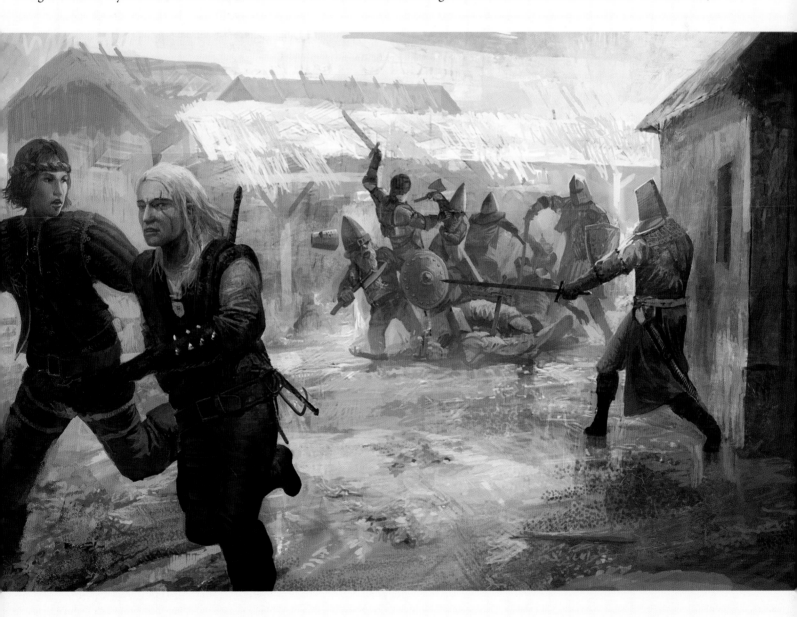

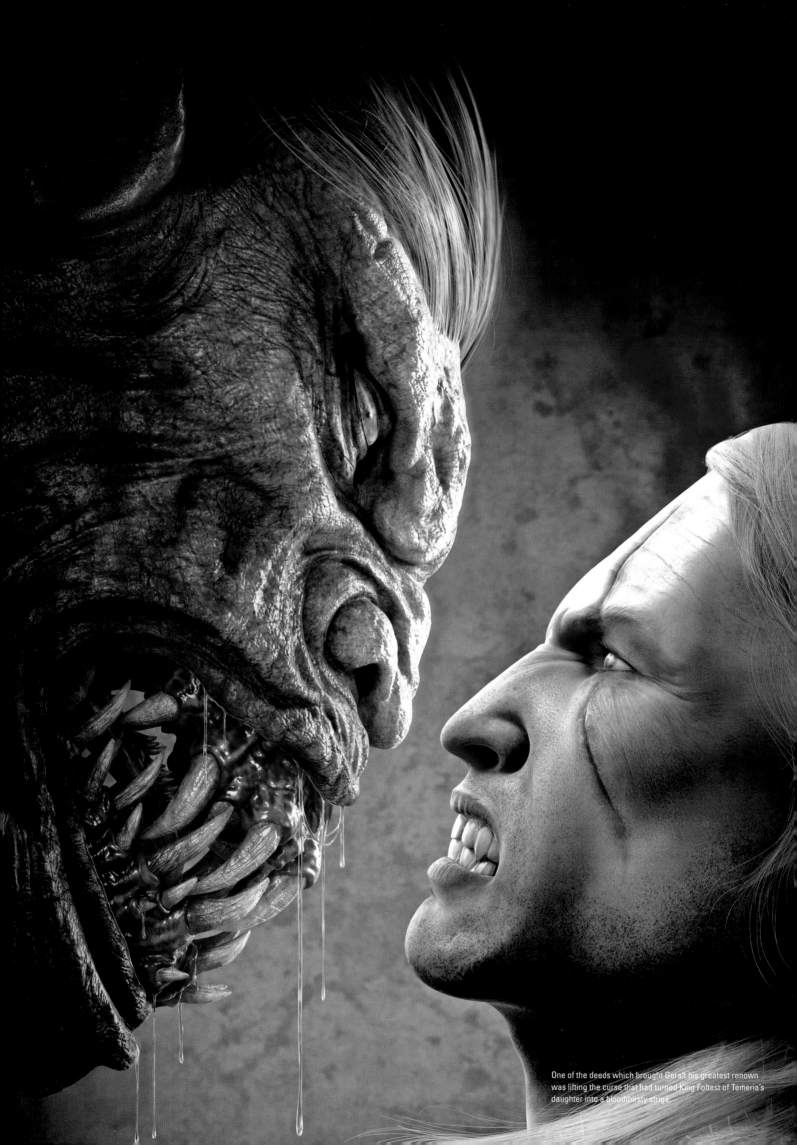

One of the deeds which brought Geralt his greatest renown was lifting the curse that had turned King Foltest of Temeria's daughter into a bloodthirsty striga.

hedgehog. Needless to say, a curious beast—suspiciously curious, in fact, for Geralt had a hunch this was no monster but a cursed man, and so stopped it from being killed until the truth could be discovered. True enough, the Urcheon proved to be a duke from the south named Duny, and eventually Queen Calanthe overcame her initial reservations and agreed to give Pavetta away as his bride, thus lifting his curse.

What happened next, dear reader, entangled Geralt inextricably in Fate's net and changed the course of his life forever. Duny, moved to tears with gratitude, offered to give Geralt anything he desired. The witcher then repeated the age-old formula of the Law of Surprise: "Give me that which you already have, though you do not know it." What Duny did not know was that his new bride, Pavetta, was pregnant, and so Geralt had secured the right to their child—the future Cirilla of Cintra.

Geralt's fate, however, would wait ten long years before again knocking on his door. In the meantime, he left Cintra and resumed wandering the world, notching up further adventures, romances with sorceresses, and run-of-the-mill witcher contracts along the way. Some of these successful contracts brought him great fame, such as lifting the curse on King Foltest's daughter, who had transformed into a striga and was terrorizing Vizima. For handling this task with skill and discretion, Geralt earned the ruler's gratitude and entrenched his already considerable renown.

It was my great pleasure to be a firsthand witness to a portion of his deeds during this time. More than once we plummeted together into steaming pots of trouble, only to carve a path out via the sharpness of his sword or my wit. In the course of such escapades, we encountered many old friends and made many new ones. Such was the case during the trouble with the golden dragon in Holopole, when we happened across Yennefer, who was still just as furious as ever with Geralt after their break-

> *"The death of Duny and Pavetta—'twas great mourning after that here in the isles. Pavetta, she were Calanthe's daughter, cub of the Lionors aep Xintra—the Lioness of Cintra, as you Continentals called her. She had for her second man Eist Tuirseach, a son of the isles. And so the passing of her daughter and her daughter's man, why, 'twas like a death in our family too, and a death of the worst kind, for it brought no glory nor enemies to take our vengeance on. We sat together in the king's keep, every man a grizzled sea salt who'd lost many an oarsmate or sword brother, and drank together in a silence darker and more somber than any I've known before or since. We whispered at the time that the Geas Muire had killed the princess and her husband—the Curse of the Sea, a storm none could predict . . .*
>
> *And 'tis true that a tempest broke out o'er the isles on that tarnished day, one that struck with force enough to shake the very bedrock of Ard Skellig—but the sky always weeps with fury when the royal blood of Cintra is spilt. It poured out bitter tears after the death of Calanthe's mother, old Adalia, and trembled with despair when the Lioness of Cintra herself died. So 'twas not the storm killed Pavetta and Duny. Sea only started its wailing after the worst had already happened. The Sedna Abyss, that cursed place of every sailor's nightmares, where many a ship has disappeared on a clear day leaving nary a plank behind, had worked its foul magic once more . . ."*
>
> —Hallbjorn, son of Guthlaf, Skellige seaman

up. At this time, we also met Yarpen Zigrin and his gang of dragon hunters, the Crinfrid Reapers. Quite the tumultuous tussle broke out when Geralt—stubborn, principled Geralt—put his foot down and refused to kill the dragon. Given their professional dedication to the hunting *and slaying* of dragons, this pleased Yarpen's gang none too well, and more than a few hands were reaching for concealed daggers before tempers fortunately cooled.

As for Yennefer and Geralt, they reunited and lived as one again for some time. Not a long time, of course—soon it was revealed that Yennefer had feelings for one of her fellow mages, Istredd, and could not choose between him and Geralt. Torn by her conflicted emotions, she decided to leave them both and disappeared, only to return again some time later. In fact, that the witcher and the sorceress would part, only to reunite and then part again, eventually became as natural a rhythm as the tides, and so there was no point in keeping close track—try as one might (and dear reader, I did try!), it is impossible to compose an interesting ballad about "Six Breakups and Six Getting-Back-Together-Agains."

And so the years passed. Geralt and I hunted a doppler in Novigrad, arranged a union between Duke Agloval of Bemervoord and a siren, and had many other such adventures not worth mentioning here, but which you can read about in full, gory detail in my other works. And then, ten years after that memorable feast in Cintra, fate once again fell like a gull dropping out of the clear sky and onto Geralt's head.

Playing with Fate

Geralt had visited Cintra only once in all this time, and then only to inform Queen Calanthe that he would not hold her to the Law of Surprise and wanted to "disavow all rights to Pavetta's son." Why forego his rightful

privileges, guaranteed by an age-old and unbreakable magical law? Geralt had pondered this matter for some time, and decided he did not want to expose the child to the risks of witcher training and, more importantly, take him away from his family. Yet unbeknownst to Geralt, Pavetta had borne a girl. He only learned of this fact years later, in an entirely unexpected place—the middle of Brokilon Forest—when he purely by accident happened to rescue his Unexpected Child from the clutches of a monster.

This child was Ciri, who even at a tender age was as exceptional an individual as Geralt. I won't delve into how she came to be in the dryads' wood—itself a tale worthy of an entire ballad—nor how she overcame the myriad dangers of that wilderness, including the memory-depleting Water of Brokilon, save to say she proved herself a heroine on par with any life or art has ever produced.

The iron ties of fate linking the two were well evidenced throughout all of this, yet the witcher stubbornly refused to accept fortune's verdict. He decided against taking the girl with him, though that was his right and his destiny—and despite the fact that, to the best of his knowledge, Ciri was now an orphan, as Duny and Pavetta had died in a mysterious maritime accident some years before. Instead, Geralt sent the young child back to her grandmother, Calanthe, to be raised under the care of his friend, the druid Ermion. Just think—had he decided otherwise, the history of Cintra and possibly all the North would have unfolded quite differently indeed.

Shortly thereafter the First Nilfgaard War broke out. I will not outline the course of the conflict in detail here—for those readers not already familiar with this world-shaking event, I have provided a short history in the first chapter of the present work. I shall only state that after the Cintra massacre and the death of Calanthe, it was widely assumed that her granddaughter had also perished during the widespread slaughter of the capital's citizens. I told Geralt as much when I stumbled upon him some time later in Sodden, while the war was still raging. Upon hearing this news,

> *"Behold! The Time of the Sword and Axe approaches, the Time of the Wolf's Blizzard, the Time of the White Frost and White Light. Nigh is the Time of Madness and Disdain, Tedd Deireadh, the Final Age. The world shall perish amidst ice and be reborn with the new sun. Reborn of the Elder Blood, of Hen Ichaer, of a planted seed. A seed that will not sprout but burst into flames!*
>
> *Ess'tuath esse! So shall it be! Watch for the signs! What signs these shall be, I now say unto you: First the earth will flow with the blood of the Aen Seidhe, the Blood of Elves . . ."*
>
> —*"Aen Ithlinnespeath," the prophecy of Ithlinne Aegli aep Aevenien*

the witcher first turned as pale as a corpse, and then insisted on riding to Cintra immediately, the entire Nilfgaardian army be damned. Later, his emotions gave way to more rational thinking and he abandoned that suicidal plan. Though he kept his mouth shut tight in a somber frown and did not bring up the topic again, I could see in his eyes that he felt as though his heart had been torn from his chest.

Yet fate once again would show how strong the fetters linking Geralt and Ciri were—stronger even than the blood lust of armies or the brutal calculus of the Slaughter of Cintra. For though the population of Cintra was decimated, the girl had somehow survived the turmoil of war and found shelter, first with nearby druids and then with a kindhearted family of peasants from Riverdell. That is where Geralt found her, in one of those happy accidents that act as fate's signature on the frontispiece of the ballad of our lives. Geralt saved the life of a farmer, who then invited the witcher back to his hut, hoping to worm his way out of fair payment through hospitality and homemade hooch. Oh, how I regret that I was not present when Geralt entered that humble cottage, expecting to find only moldy straw and an even moldier matron, and instead saw his destiny. To put in words the surprise and joy mingling on his face—that would have been the artistic challenge of a lifetime, one that even my talents might not have been able to meet.

From then on, Geralt had no more doubts that Ciri was indeed his destiny, and took to this new role of caregiver and adoptive father with gusto. Rightly supposing that Ciri, heir to the throne of Cintra, was a person of great interest to Nilfgaard and the myriad schemers of the North, he decided to conceal her from all prying eyes. He thus took her to the best possible place to hide anyone—the isolated and nigh-unreachable witcher fortress, Kaer Morhen. There the girl grew in strength and skill as she trained with the sword under the watchful eyes of Vesemir and the other witchers, the memory of the horrors she had witnessed slowly forgotten, or at least buried under a new and happier life.

Ciri spent roughly a year and a half at Kaer Morhen. During this time Geralt taught her what he knew best, namely sword play, and one must admit that the girl proved herself a very adept pupil. Geralt realized, however, that professional monster slayers, even the most dedicated

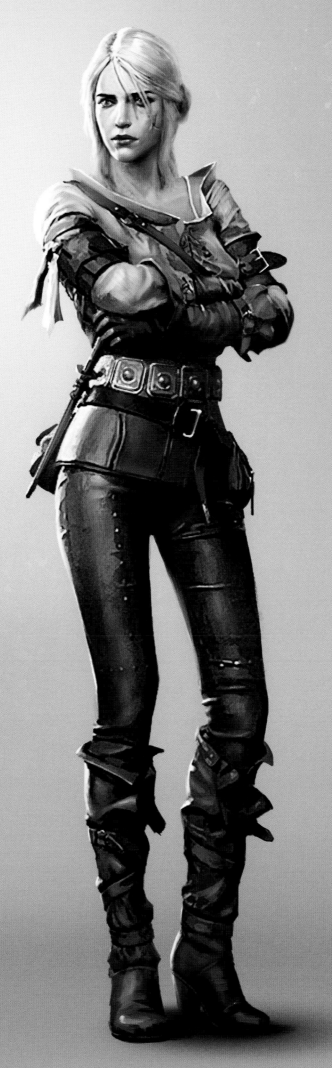

Fate and the Law of Surprise bound Cirilla to Geralt from the moment of her birth. When tragedy stripped her of her family, Geralt found her and took her to Kaer Morhen, where he and his fellow witchers taught her the ways of their craft.

and well intentioned, did not make ideal companions for a budding young woman. His fellow witchers agreed, and so he decided to send Ciri to Melitele's temple, where she would be given a more well-rounded education touching on things beyond the brewing of potions and the weaknesses of ghouls. This decision was spurred on by the fact that the child was discovered to be a source—a person gifted with dormant magical talents and powerful prophetic abilities. And so it came to pass that the witcher took the young girl to Ellander, where for over a year she studied history, geography, Elder Speech, and proper runic calligraphy under the tutelage of Mother Nenneke. Care for the newly discovered source's magical talents, on the other hand, was provided by none other than Yennefer, whom Geralt had asked to guide Ciri's instruction in the ways of sorcery. At first, Ciri was not at all fond of the sorceress, but their relations quickly grew warmer—confirming my theory that Yennefer grows on one with exposure, like a pungent cheese or an atonal melody. After that year at Ellander, the sorceress was supposed to take Ciri to Aretuza, the sorceress academy on the Isle of Thanedd,

The fact that Cirilla's true father is the ruler of Nilfgaard, Emperor Emhyr var Emreis, remained a closely guarded secret for quite some time, unknown to both the emperor's closest confidants and Geralt.

where she would complete her studies. Unfortunately history, as it so frustratingly tends to do, had made other plans.

Hunters on the Trail

Throughout this entire period, Geralt had kept Ciri's very existence tightly under wraps. Only his closest friends, such as myself, even knew that she was still alive, much less about her stay at Kaer Morhen. Events later proved this was not a case of excessive precaution. A great many people were searching for Ciri after her disappearance during the Cintra massacre—and none had her best interests at heart. Chief among them was Ciri's father, the emperor of Nilfgaard, Emhyr var Emreis, known also as Deithwen Addan yn Carn aep Morvudd—the White Flame Dancing on the Graves of His Enemies.

Oh, dear reader, what I wouldn't give to see the befuddled expression on your face at this moment! You are surely scratching your head as you read these words,

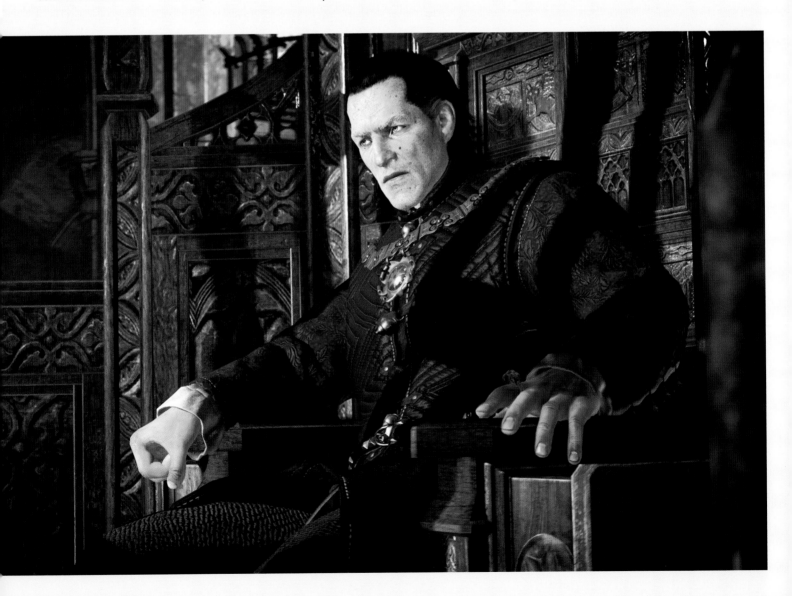

wondering if they are not by chance the product of some typographical error or honest mistake on my part, or perhaps even a clumsy attempt at misguided humor. "Why, Ciri's father, dear Dandelion, was he not Duny, the one-time knight-errant and enchanted Urcheon of Erlenwald whose curse Geralt so memorably

> *"When the criminal's stake had been lit and the flames reached up for her, she began insulting all the knights, barons, mages, and councilors gathered in the square in such foul language that they became filled with dread. 'An avenger will be born of my blood,' she yelled. 'From the defiled Elder Blood, a destroyer of nations and worlds will rise! He shall avenge my torment! Death, death and revenge upon you and your offspring!' That was all she managed to articulate before she perished. Such was the death of Falka, her punishment for the innocent blood she had spilled."*
>
> —Roderick de Novembre, The History of the World

lifted a few pages ago?!" Believe me, I hear your cry, dear reader, and though I may permit myself a chuckle at your predicament, I am not so cruel an author as to keep you imprisoned in ignorance.

For now the time has come to reveal a great secret known to but a handful of chosen individuals. Though it might astound you to hear it, Duny was and always had been Emhyr var Emreis, heir to the throne of Nilfgaard. When he was a young teenager, the man who had usurped and then murdered his father—the rightful emperor—ordered his mages to dispose of Emhyr. They botched the job, instead only turning him into a hideous half man, half hedgehog. He fled the empire and headed north, to Cintra, where prophecy had promised he might find a cure for his condition. His salvation came in the form of the Law of Surprise, which with Geralt's help led him to wed Pavetta, heir to the Cintran throne. His life as Duny, husband to Pavetta, was one of peace and harmony, though if the rumors are to be believed, Calanthe never fully trusted her son-in-law—although to be fair, rare is the mother-in-law who does.

You will surely now ask, "But, Dandelion! How did Duny, a.k.a. Emhyr, survive the watery catastrophe that drowned his wife?" Why, what an attentive reader you are! Alas, I am afraid you shall have to remain vigilant a bit longer, for that story is tied to a part of Geralt's fate I will recount at another time . . .

On second thought, I shall recount it now. After he successfully lifted Duny's curse, Geralt returned to his normal witcherly activities, though they were now accompanied by a tumultuous inner debate about whether to exercise his rights under the Law of Surprise. Meanwhile, the newlywed couple continued their lives. Pavetta gave birth to Cirilla and Duny/Emhyr plotted to retake the imperial throne with the help of the Cintran army. Then, as sudden and unwanted as a lover's unexpected pregnancy, a mysterious mage appeared. This sorcerer, whose identity I will guard

for the time being as a dramatic secret, familiarized Emhyr with an ancient prophecy that in short order became the future emperor's dominating obsession. The prophecy stated that the entire world would be consumed by a White Frost, and only Cirilla's son could save it, after which he would become its undisputed ruler.

Wanting to rebuild the empire's might with himself at its helm, Emhyr hatched a plan to spirit Pavetta and Ciri away from his mother-in-law Calanthe's mistrustful eye. The still-as-yet-unnamed mage was to help him fake the family's death in a shipwreck, while in truth teleporting them all to safety in Nilfgaard, where an uprising meant to place Emhyr on the throne was nearing its successful completion. Ciri, however, did not board the ship with her parents. Most likely Pavetta, a powerful source in her own right, and so perhaps a prophetess as well, saw through Emhyr's plans and acted to protect her daughter. When Emhyr realized his daughter was not with them, he flew into a violent rage. In the heated argument and scuffle that followed, his wife fell overboard—and only then, moments too late, did the mage teleport the ship to dry land inside the empire. Emhyr's plans had come to naught, but he was not about to give up after the first setback. Once secure on the Nilfgaardian throne, he declared war against Cintra, both to strengthen his position with a glorious military victory and to pursue another route to recovering his control over Cirilla. Once again, however, his efforts failed. Before her own valiant death, Calanthe was able to whisk Ciri out of the capital, and thus Emhyr's daughter slipped through his fingers for a second time.

Yet the emperor persisted in his efforts to get his hands on Ciri, and Geralt knew hiding her at Kaer Morhen had most certainly staved off this threat for only a short while. The emperor had spies and informers everywhere, and every day they narrowed their search and drew the net tighter around the witcher fortress.

Sorcerers' Ambitions and Political Schemes

Meanwhile, someone else was searching for Ciri. Someone with the wherewithal to hire the best manhunters, spies, and assassins, all with one task: to

eliminate Geralt of Rivia and capture his ward. This mysterious opponent was revealed to be a Northern mage who had collaborated with Emhyr var Emreis in secret for years—the very same mage who had told him of Ithlinne's prophecy years before, and whose name I will at last reveal: Vilgefortz of Roggeveen.

No one suspected his treason—after all, he was a renowned hero of Sodden Hill, a prominent member of the Chapter of Mages, and a much-decorated veteran of the First Nilfgaard War. Young, handsome, and highly talented, Vilgefortz was unfortunately also sick with ambition, and his all-consuming lust for power pushed him forward on the path to betrayal. The Nilfgaardian emperor, recognizing that such ambitions could be turned to his advantage, had promised the young sorcerer control over the provinces to be established in what were once the Northern Realms once the empire was victorious. Yet even cunning Emhyr did not comprehend the true extent of Vilgefortz's ambitions. For all the while he helped Emhyr search for Ciri, Vilgefortz planned to betray the emperor and use the girl for his own vile purposes. He secretly began experiments that were intended to bring him nothing less than power over all

of time and space. How did he mean to accomplish this? The horrid depravity of his plan defies all words—so much so that I will not dare speak of it in detail here, lest my readers recoil in such shock and revulsion that they refuse to finish the rest of our tale.

The activities of the Nilfgaardian spy corps and the agents of the as-yet-unknown mage (unknown, that is, to Geralt—but not to you, dear reader!) in Brugge, Riverdell, Temeria, and Redania had not escaped the notice of Northern intelligence. They did not know Emhyr was the father of Calanthe's granddaughter, yet the political reasons why he might want her were clear. Ciri was, after all, by right of her birth an important figure on the complicated and ever-shifting chessboard of dynastic unions and alliances. Her marriage to the emperor would seal his right to occupied Cintra's throne, and it was this possibility that the kings of the North wanted to prevent at all costs. The North, for its part, aimed to use Ciri as a pretense for waging war against the empire to reclaim her homeland. The Peace of Sodden between the North and Nilfgaard had never looked more fragile, with each side lying in wait for just the right moment to pounce on the other.

Protecting his ward often pitted Geralt against both common bandits and merciless, well-trained assassins sent by unknown powers with mysterious motives.

Though he had always sought to distance himself from the affairs of kings and petty rulers, the witcher was no political naif. He did not know the exact nature of the forces threatening Ciri, but he recognized the danger was grave. With coin, connections, and a few skirmishes with hired assassins, he managed to learn what the Northern Realms' spies had managed to establish about Nilfgaard's and the mage's hunt for Ciri. The plan to place Ciri in the sorceresses' academy under Yennefer's care now seemed all the wiser. Aretuza was better defended than almost any other place on the Continent, and its de facto extraterritorial status and the presence of dozens of the world's most talented magic wielders hindered the operations of spies and soldiers of all stripes.

Alas, Geralt, Ciri, and Yennefer's stay on Thanedd coincided with an extremely ill-fated summit of mages. The summit, called to unite and strengthen the influence of magic users, ended in an attempted coup and a fratricidal civil war, with Scoia'tael guerrillas in the empire's service aiding one faction and Redanian special forces siding with the other. Naturally, the witcher found himself in the stickiest part of the whole chaotic mess, fighting against anyone and everyone who came between him and Ciri. During this general melee he killed a few elves and a traitorous mage, roughed up some Redanian special agents, and broke the leg of their boss, Dijkstra. Next on Geralt's list was the mage Vilgefortz, who had at last revealed his true, traitorous face. Quite to everyone's surprise—not the least Geralt's—the showdown between these two demonstrated that the witcher had finally met his match.

After some preliminary pleasantries and attempts at luring the witcher over to his side, Vilgefortz reached for a more convincing argument in the form of a magical steel club. Then he did with it what no man had ever done before: he beat the witcher to a bloody pulp, crushing him so utterly that Geralt was left in a broken heap, unable to move a single bone or muscle. With Geralt thus indisposed, Vilgefortz was free to chase after Ciri. Fate had once more parted the witcher and his ward—temporarily, of course, though given Geralt's state this seemed far from certain at the time.

The maimed, half-dead witcher was rescued from his plight by Triss Merigold, who teleported him to safety in Brokilon. There, Geralt underwent a long recovery, treated by the magic of the dryads dwelling in the forest. That is also where I, following Triss's instructions, found him and delivered news of his loved ones and world events.

The news I brought was not the happy kind. Ciri's fate was unknown, and Yennefer had also disappeared during the coup, for which her colleagues condemned her as a traitor and coconspirator with Vilgefortz. Nilfgaardian troops, meanwhile, had crossed the Yaruga and were

defeating the Northern allies on all fronts, slowly gobbling up their lands one mouthful at a time.

Geralt, in typical Geralt fashion, grew sulky and standoffish at hearing this, but as soon as he had regained his health he decided to ride off in search of Cirilla—to Nilfgaard itself, in fact, reasoning that if she had been captured, she would have been taken there. I need not tell you that this idea seemed to me the epitome of suicidal stupidity, but anyone who knows Geralt knows that once an idea takes root in his head, nothing less than a hurricane force can tear it out.

In Search of Ciri

And so we hit the road once more, planning to cross the central branch of the Yaruga and then continue south. I say "we" because as the witcher's friend, I did not think for a moment to abandon him in this hour of need. It was a good thing too, for his journey would have been a short one indeed without my assistance. Our party grew

This portrait, which presents young Princess Cirilla Fiona Elen Riannon in a manner befitting the heiress to the throne of Cintra, was one of the few clues the hired assassins working for the mage Vilgefortz had to go on in their search.

Geralt first met Zoltan Chivay during his search for Cirilla and soon found him to be an excellent travel companion. The affable, bawdy dwarf gave ample proof that Geralt and his associates could always count on his unconditional friendship and help.

along the way, adding various characters more colorful than any bard could invent. Joining us as we left Brokilon was Mary "Milva" Barring, an accomplished archeress and huntress, and a poacher and outlaw to boot. Somewhat further in our travels we happened upon a company of wandering dwarves led by Zoltan Chivay, who joined us and soon became our fast friend. Next to join was Emiel Regis Rohellec Terzieff-Godefroy, the best blood-abstaining vampire apothecary I've ever known. Last was another man with an obscenely long name, Cahir Mawr Dyffryn aep Ceallach, a young Nilfgaardian whom the emperor had dispatched in search of Ciri, but who, moved by the events he had seen unfold, abandoned his mission and decided to help us get her back.

Together we marched, led onward by a slender thread of hope, enormous determination, and trail after faint trail. We left Brokilon, crossed war-stricken Brugge, Sodden, and Riverdell, and then made our way to Angren—for the druids dwelling there would, according to our new friend Regis, help Geralt and provide some guidance on where to direct our search next.

There is not ink enough in the world to write about all the adventures we encountered along this route, so I will just say that, though there was many a close call, we survived our baptism by fire, fighting side by side against the vagaries of fate. At one point we had to part ways with Zoltan and his band, whose road led to their homeland in Mahakam. Shortly afterward, we crossed the Yaruga, entering territory annexed by the Nilfgaardian Empire several years earlier. Here we picked up the trail of Vilgefortz's lackey, aided by a teenage adventuress, Angoulême, who had decided to join our merry company. It was also here that Geralt, following the druids' instructions, met a mysterious elf named Avallac'h, who told him the secrets of Ciri's ancestry and, though we would never have guessed it at the time, would play an enormous role in her future.

Through her mother Pavetta, her grandmother Calanthe, and their ancestor Riannon, Cirilla was a direct descendant of the elven Sage Lara Dorren aep Shiadhal. She was also an heir to Hen Ichaer, the mysterious Elder Blood mentioned in the famous prophecy proclaimed by

"Lara Dorren aep Shiadhal was an elven sorceress, a member of the elite circle of Aen Saevherne, the Knowing Ones, or Sages, as humans sometimes call them. She was heir to an unusually strong line of Hen Ichaer—in your language, the Elder Blood—and so was to marry a specially chosen elf and bear him a child—a child who would possess the power to control the Gates of Time and who would save our kind from the White Frost.

Lara, however, rebelled against this fate and chose from among you humans a young mage named Cregennan of Lod. She bound her life to his and gave birth to his child some time later. Though both parents died—he by the hands of your race, she from cold and exhaustion while fleeing her pursuers—the child survived, starting a long bloodline whose heiress is Cirilla Fiona Elen Riannon of Cintra."

—Avallac'h, Aen Saevherne

Ithlinne, the elven seer. To the elves, she was something else as well—Zireael, the Swallow, a harbinger of rebirth and the spring to come after the White Frost, nothing less than she who would save their entire kind. What is more, Avallac'h, in a manner reminiscent of a village schoolmaster lecturing his most dunderheaded pupil, tried to make the witcher understand that his search was in vain. Ciri did not need protection; in fact, further meddling in the path fate had plotted for her would bring unforeseeable and most likely horrendous consequences.

Geralt is rarely one to take advice, even from his closest friends, as I have discovered myself on many occasions. It should thus come as no surprise that he ignored the directives and mysterious warnings of an unknown and rather arrogant elf. Unfortunately, he did not know what to do next, for all the trails we had heretofore been following suddenly broke off a short time later near the border of the small, autonomous duchy of Toussaint, ruled by my one-time great love, the duchess Anna Henrietta. We decided to rest there for a time so that our band could replenish its depleted reserves of strength and good humor while we determined our next move. This turned out to be a much wiser decision than we ever could have known. The local inhabitants welcomed us with very open arms, and even such a quiet and reserved fellow as Geralt was able to make a few close friends. The closest? Fringilla Vigo, a Nilfgaardian sorceress and a relative of Anna Henrietta's who was a guest at the palace. Of course, it was later revealed that she had lured Geralt into her bed only to make her job of spying on him easier—though not, surprisingly enough, on the emperor's orders, but on behalf of the secret Lodge of Sorceresses. This band of powerful female magic wielders, founded after the coup on Thanedd, wanted to take their own revenge on Vilgefortz and locate Ciri in order to educate her properly, induct her into the Lodge, and wed her to a Koviri duke. Their stated justification was that a sorceress on the throne of a strong, stable state would be a cure for the wars and conflicts rending our world apart (like many ambitious women before and since, they felt the need to disguise their drive for power and prestige under a pretext of motherly concern for world peace).

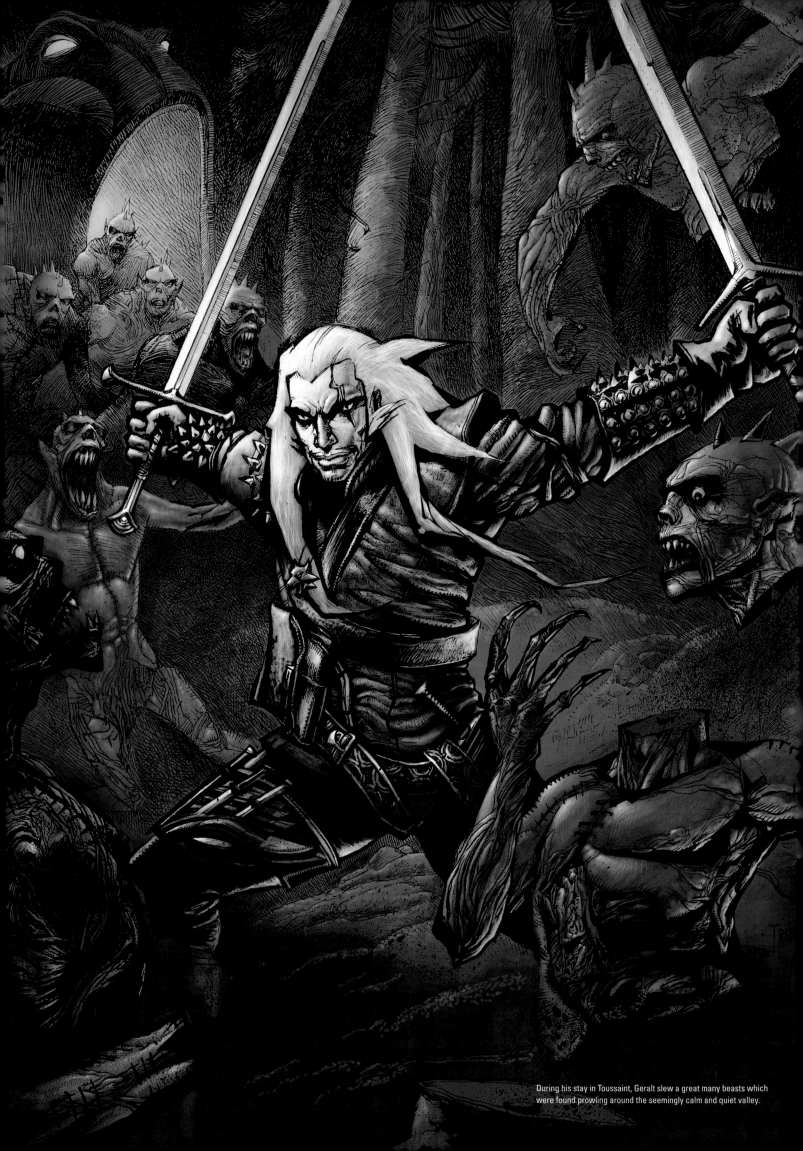

During his stay in Toussaint, Geralt slew a great many beasts which were found prowling around the seemingly calm and quiet valley.

All signs indicated that Geralt, discouraged by the lack of any hints, clues, or leads whatsoever, and bewitched by Fringilla's charms, would stay in Toussaint indefinitely. Yet fate again intervened, this time in the form of a fortunate accident. Toussaint, it seems, had been terrorized by a hideous and, more importantly, elusive beast for some time—just the kind of problem that demanded a witcher's attention. While hunting for this monster, Geralt happened to overhear a conversation which laid out in explicit terms exactly where the dastardly Vilgefortz was hiding. Not tarrying a moment longer, Geralt gathered his company and rushed off for his date with destiny.

"Lara's Teleport—also called, after its discoverer, Benavent's Portal. Location: Thanedd Island, top floor of Gull Tower. Fixed in place, active only at certain times. Principles of operation: unknown. Destination: unknown; entering most likely results in immediate and gory disintegration, though the possibility of various diversions and dispersions prior to this cannot be excluded. Caution: Lara's Teleport is chaotic and mortally dangerous. Experiments categorically forbidden. Use of magic in Gull Tower and its immediate surroundings is prohibited, teleportation magic in particular. The Conclave will consider applications for permission to enter Tor Lara and examine the teleport only in very select circumstances. Any such application must be part of an ongoing research program, subject to Conclave scrutiny and approval, and the applicant must be a specialist in the applicable field."

—*Prohibita* (list of forbidden artifacts),
Ars Magica, Ed. LVIII

Bibliography: Geoffrey Monck, "The Magic of the Elder Folk"; Immanuel Benavent, "Tor Lara Portal"; Nina Fioravanti, "Teleportation: Theory and Practice"; Ransant Alvaro, "The Gate of Secrets"

The Fate of Cirilla, Princess of Cintra

Here I must say a few words about what had become of Ciri during all this time. While fleeing Vilgefortz during the chaos of the Thanedd Coup, she stepped into the ancient magic portal known as Tor Lara . . . and stepped out into an unknown and hostile landscape. In fact, the portal had taken her to the very edge of the Korath Desert, far, far to the south, near the eastern edge of the Nilfgaardian Empire. There she overcame countless obstacles that, had she been made of meeker stuff, or had fate not destined her for greater things, would surely have been the end of her. She avoided death by thirst and starvation in the desert only to nearly wind up in Nilfgaardian captivity, before being saved from this fate at the last minute by a band of outlaws known as the Border Rats. Alone and far from home, Ciri joined this predatory gang of misfits, composed of teenage strays and orphans like herself, who prowled the empire's southern bounds living off tribute, plunder, and the fruits of the land. She traveled with them for several months, earning their respect as she fought and robbed under the assumed name of Falka. This wild-oats-sowing idyll ended when the gang had the misfortune to draw the attention of a ruthless bounty hunter by the name of Leo Bonhart. He slaughtered the band, sparing only Ciri—though not at all out of charity. For Bonhart was an amoral and cruel man who, having recognized "Falka" for who she really was, took her captive hoping to collect the fat price on her head. In the meantime, for his own twisted amusement, he forced Ciri to fight in the arena at Claremont, reveling in the thrill of the crowd as this seemingly waifish young maiden cut down men twice her size again and again. When he at last grew tired of sending hordes of thugs at her and watching her carve them into fine ribbons, he decided to collect on his bounty by handing her over to the mage Vilgefortz and his imperial double agent ally, Stefan Skellen, known also as the Tawny Owl. Fortunately, Ciri managed to escape before he could do so, sustaining a heavy wound in the process that left a jagged scar on her face. On the run once more and hounded on all sides, she finally found shelter with an old hermit. This kind man helped her tend her wounds and recover from the horrors she had faced. Later he revealed he was a wise historian, philosopher, and scholar named Vysogota of Corvo. Persecuted for his outspoken views, which were far too progressive for the stodgy halls of academia—indeed, for most anywhere—he had chosen a life of exile far from human settlement rather than give in to his tormentors.

From Vysogota, Ciri learned about the mysterious Tor Zireael, or Tower of the Swallow, which housed a teleport said to be magically linked to Tor Lara on the Isle of Thanedd. As soon as she had regained her strength, she set off in search of this tower, counting on using the magic portal to return home. Fighting with Vilgefortz and Tawny Owl's agents and fleeing Bonhart as she went, Ciri at last found the legendary Tor Zireael and came face to face with her heritage. The Elder Blood she had inherited from the elf Lara Dorren was awakened and granted her a tremendous power:

The Story of Geralt of Rivia

the mastery over space and time. Though she as yet hardly understood or knew how to control this great power, Ciri had become the Lady of Time and Space, able to transition between worlds as easily as you or I might pop in on our neighbor for a friendly drink or a bit of gossip.

Ciri stepped into the portal in the Tower of the Swallow, yet it did not take her to Thanedd as she had hoped. Instead, she found herself in the mystical world of the Aen Elle, the Alder Folk, where she became a pawn in an ongoing political chess match between the powerful Sage Avallac'h and Eredin Bréacc Glas, the leader of the riders known to our world as the Wild Hunt. The Aen Elle, she discovered, had also staked a claim to her blood on the basis of her descent from Lara Dorren, who they felt owed an eternal debt for her betrayal of Ithlinne's prophecy. In order to return home, Ciri would have to give their leader what Lara had not all those centuries ago—a child with power over the Gate of the Worlds.

Different motives drove these two influential elves. Avallac'h claimed he wanted to use the Gate to save the inhabitants of our world—most importantly his cousins, the Aen Seidhe elves, but humans as well—from the threat of the White Frost. Eredin did not reveal his plans, but as one could clearly surmise, they had more to do with conquering other worlds than saving them. As Ciri accidentally discovered during her time in their strange realm, the Alder Folk had possessed mastery over the Gate of the Worlds once before, and had used it to capture the world in

> "Vysogota of Corvo—Alchemist, medic, surgeon, historian, scholar, philosopher, and ethicist. Professor extraordinarius at Oxenfurt Academy, estranged from said academy after publishing works in the discipline of philosophy considered blasphemous at the time. Forced to emigrate, he traveled to the Nilfgaardian Empire, where he took a position as lecturer in ethics at the Imperial Academy in Castel Graupian. Exiled once more after his publication of the treatise On Totalitarian Power and the Criminal Nature of Wars of Territorial Aggrandizement. He was accused of having contact with dissidents and betraying the state, for which crimes he was sentenced to life in prison. His sentence was waived in favor of lifetime banishment, with any encroachment on Nilfgaardian soil to be punishable by death. He then emigrated to Ebbing. When this kingdom was annexed by the Nilfgaardian Empire and brought under imperial jurisdiction, he was most probably forced to emigrate once more, or else found another way to hide from imperial justice."
>
> —Effenberg and Talbot, Encyclopaedia Maxima Mundi, Tome XV

which they currently dwelled, killing or enslaving its primordial inhabitants: humans.

Ciri decided to flee. In her time with the Aen Elle, she had already begun to develop more control over her newfound powers, and she now called on her growing ability to move between worlds and departed. Eredin gathered his Wild Hunt to give chase, but Ciri managed to elude them. Unfortunately, she also became lost herself, wandering through unknown times and places, unable to find her way back to her own. When at last she did so, she found destiny had deposited her right at the gates of the foreboding Stygga Citadel—which happened to be where Vilgefortz was hiding.

The Last Days of the Witcher's Band

Every self-respecting tale of heroic deeds has a culminating moment, a point when all the heroes must face their archnemeses in a final, glorious battle. So it is with this tale as well, for when Ciri strode forth to challenge the renegade Vilgefortz, Geralt and his companions rushed to her aid and Yennefer freed herself from captivity to join them. Lest the reader become confused by the sorceress's sudden appearance in our tale, I must pause to mention here that the witcher's beloved had not, contrary to rumor, taken part in the coup on Thanedd. Instead, Yennefer had

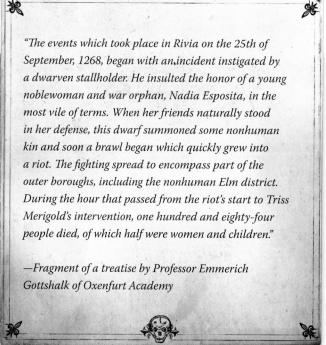

> "The events which took place in Rivia on the 25th of September, 1268, began with an incident instigated by a dwarven stallholder. He insulted the honor of a young noblewoman and war orphan, Nadia Esposita, in the most vile of terms. When her friends naturally stood in her defense, this dwarf summoned some nonhuman kin and soon a brawl began which quickly grew into a riot. The fighting spread to encompass part of the outer boroughs, including the nonhuman Elm district. During the hour that passed from the riot's start to Triss Merigold's intervention, one hundred and eighty-four people died, of which half were women and children."
>
> —Fragment of a treatise by Professor Emmerich Gottshalk of Oxenfurt Academy

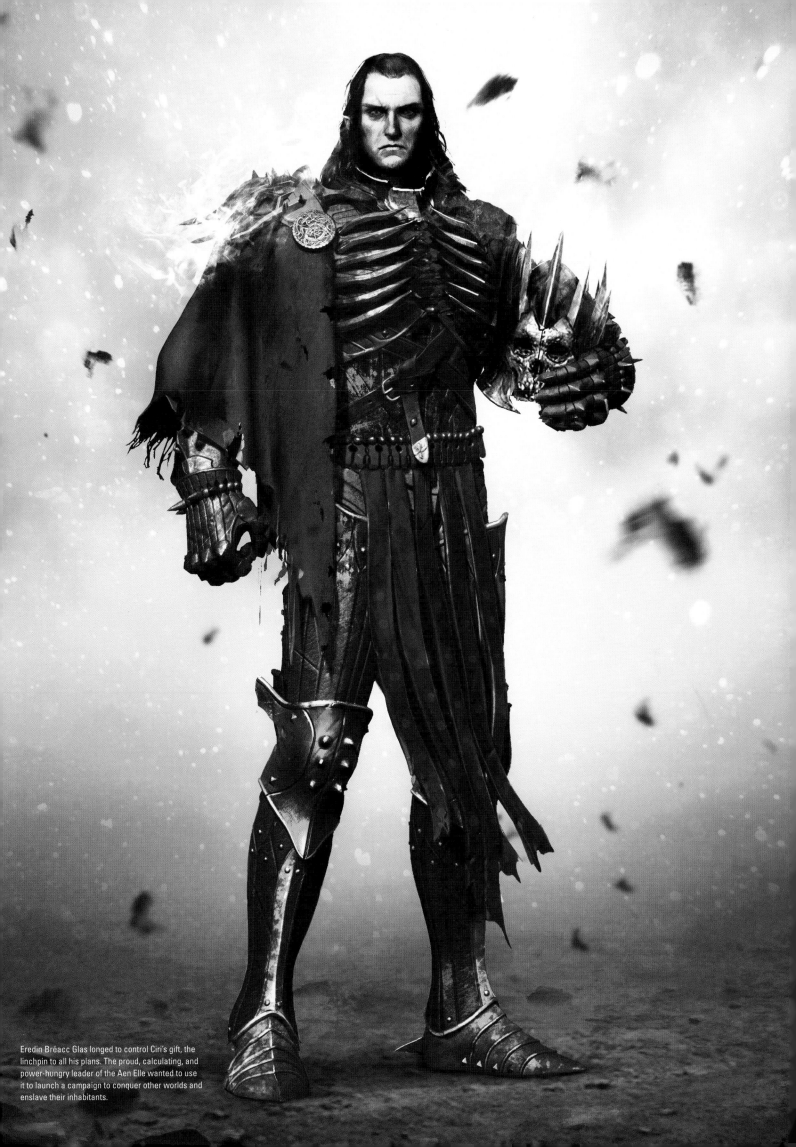

Eredin Bréacc Glas longed to control Ciri's gift, the linchpin to all his plans. The proud, calculating, and power-hungry leader of the Aen Elle wanted to use it to launch a campaign to conquer other worlds and enslave their inhabitants.

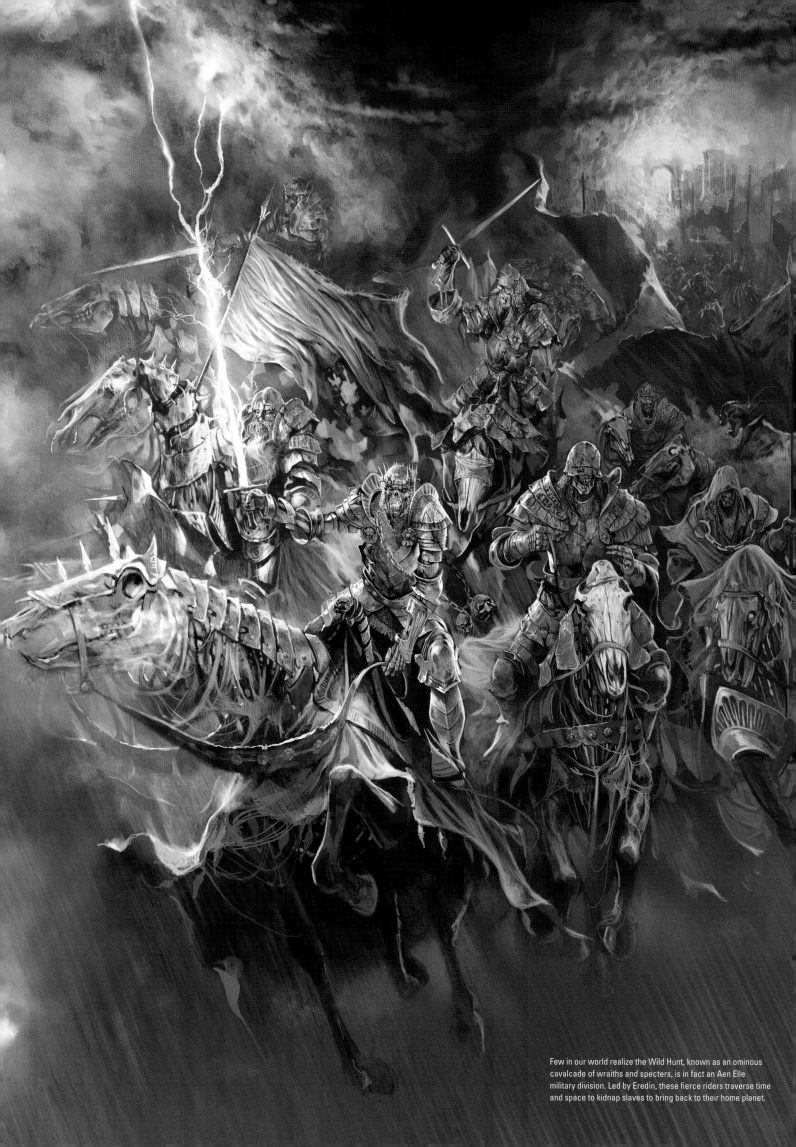

Few in our world realize the Wild Hunt, known as an ominous cavalcade of wraiths and specters, is in fact an Aen Elle military division. Led by Eredin, these fierce riders traverse time and space to kidnap slaves to bring back to their home planet.

been searching for a way to find Ciri from the moment she disappeared, and during this search had unfortunately fallen into the hands of her traitorous former companions.

Thus the great battle of Stygga Citadel began, a horrific and bloody affair that ended in defeat for Vilgefortz and his lackeys but exacted a terrible price from our heroes as well. For while Vilgefortz would die by Geralt's own hand, many of the witcher's companions also fell. Milva. Cahir. Regis. Angoulême. Before Geralt even had a chance to mourn them and rejoice at finding Ciri and Yennefer, the reunited trio was surrounded by imperial soldiers unexpectedly bursting on the scene. Within moments they found themselves face to face with the emperor of Nilfgaard himself, Emhyr var Emreis. Having learned of Vilgefortz's planned treachery and his collusion with the double agent Stefan Skellen, the emperor had come to Stygga Citadel to personally punish both the

"There exists considerable evidence to suggest that the Rivia Pogrom was a planned provocation. The ringleaders had entered the city two days before, smuggling in a transport of weapons with them. Mere minutes after the quarrel at the market, these weapons had already been distributed to the crowd of human onlookers, who were directed to the districts of the city predominantly inhabited by dwarves and elves. Furthermore, for the entire first hour of the incident the city guard was slow to react—when it chose to intervene at all."

—Boethius of Lyria, "The True Story of the Rivia Pogrom"

oath-breaking mage and his duplicitous ally.

It appeared Geralt had lost Ciri once more—not to mention his own life as well, for he knew far too much about her ties to the emperor to be allowed to live. Yet after Emhyr took a long look at his daughter's face, he surprised everyone by deciding not to take her with him. Not only this, but he, the White Flame Dancing on the Graves of His Enemies, showed mercy to his captives and let all three walk away unharmed. I do not know exactly why he did this, but the poet in me likes to believe that it was his paternal love for Ciri shining through, a love that gave him some understanding of the bond tying together Geralt and his ward.

Geralt, Yennefer, and Ciri embarked on the road back north, but their good fortune, as so often seems the case when one is with Geralt, did not last long. It took a turn most foul in—where else?—the town from which Geralt had taken his assumed name, Rivia. Soon after their

The Rivia Pogrom took the lives of almost two hundred individuals, mostly nonhumans. Geralt was injured while trying to hold back the enraged mob and died from his wounds—or so it was long thought.

arrival, a pogrom against nonhumans erupted. As a witcher, Geralt had endured hostile stares and muted whispers of "freak" and "mutant" for most of his life, and so was not about to stand aside and allow the slaughter of innocents whose only crime, it seemed, was to have been born as anything other than human. As Geralt struggled in vain to end the pogrom, a young man whose life he had spared just moments before stuck a pitchfork in his chest, mortally wounding him. The sorceress tried futilely to save her beloved with magic, nearly killing herself with exhaustion in the process. Finally Ciri, in a last desperate bid to save them both, transported Geralt and Yennefer somewhere outside of our time and space, then disappeared herself from this world.

> *"And that is why—and here I must beg to differ with my esteemed senior colleague Professor Gottshalk, as well as with the venerable Boethius and other adherents of his conspiracy theories—I firmly maintain that at the heart of those tragic events lay a combination of unfortunately common and all-too-human traits: ignorance, xenophobia, a brutal lack of regard for others, and deeply rooted, animalistic urges."*
>
> —*Master Casper Dubhen on the causes of the Rivia Pogrom*

Return of the White Wolf

Several years passed. None of us thought we would ever see Geralt again, and his friends and former companions, the current author of these words included, had time to mourn his passing and return to the normal cycle of days and nights, happiness and sadness, drunkenness and sobriety. You can thus imagine our surprise when rumors cropped up that the famous White Wolf was alive—and had returned from places unknown.

Geralt reappeared somewhere near Kaer Morhen, barely alive and wearing nothing but his undershirt and knickers. Moreover, he had partial amnesia and was unable to clearly remember where he had been or how he had suddenly arrived at the witchers' fortress. Had the Wild Hunt not clearly been nipping at his heels, one might have thought he had just returned from one blasted good party. The truth, of course, was something else altogether, though we learned the whole of it only a long time later.

The events leading to his return began soon after Ciri helped Geralt and Yennefer escape from the pogrom at Rivia. The Wild Hunt, led by Eredin, was still searching for the heiress to the Elder Blood, but she had remained elusive. Geralt and Yennefer, however, were found on the Isle of Avalon, where Ciri had prepared a refuge for them to rest and recover. Wanting to lure Ciri out of hiding, the Hunt kidnapped the sorceress, prompting Geralt to immediately set out after them.

He crossed many worlds as he followed the Hunt's trail, but Eredin and his riders always remained a step ahead. During his chase, Geralt gained several unexpected allies. These included three witchers from the School of the Viper, who decided to help Geralt in his quest to find the Wild Hunt after he saved the life of one of their company. The rescued witcher, whose name was Letho of Gulet, had been wounded in battle with a deadly monster, and only Geralt's timely intervention allowed the monster hunters to triumph. Little did Geralt know that saving Letho would turn out to be of tremendous significance in the future.

In the end, the witchers caught up with the Wild Hunt and plunged into yet another bloody battle. Despite their combined skills, however, they were not able to defeat Eredin himself or free Yennefer from the clutches of the Hunt. Seeing his chance to save his beloved slipping away, Geralt settled on a desperate gambit—he offered himself up in Yennefer's stead. The leader of the Hunt agreed to the exchange without a moment's hesitation, hoping that the capture of her surrogate father might finally draw out Ciri. Geralt was taken prisoner and dragged away with the ghostly cavalcade.

If Eredin thought that all this would cause Ciri to simply hand herself over, he had wildly misjudged her. Once again, she showed her tendency to play only according to her own rules. Instead of making a deal with her pursuers, she hatched a daring plan to rescue Geralt. With her help, Geralt was able to escape, give the Hunt the slip, and land back in his own world, half-naked and deprived of his memory, but free. He found shelter in the friendly confines of Kaer Morhen, cared for and protected by his old companions from the Wolf School. Yet neither their efforts nor the magic of the sorceress Triss Merigold, who was called upon to help the still-disoriented Geralt, were able to return his lost memory.

The Attack on Kaer Morhen

Geralt quickly returned to full strength, at least physically, and it was a lucky thing he did. For just as Geralt recovered, a band of hired thugs led by a renegade mage, Azar Javed, and a paid assassin known only as the Professor launched a surprise attack on Kaer Morhen. Though the witchers gave these assailants a thoroughly bloody thrashing, the attackers nevertheless achieved their goal, stealing the secrets of witcher mutations from the keep's laboratory.

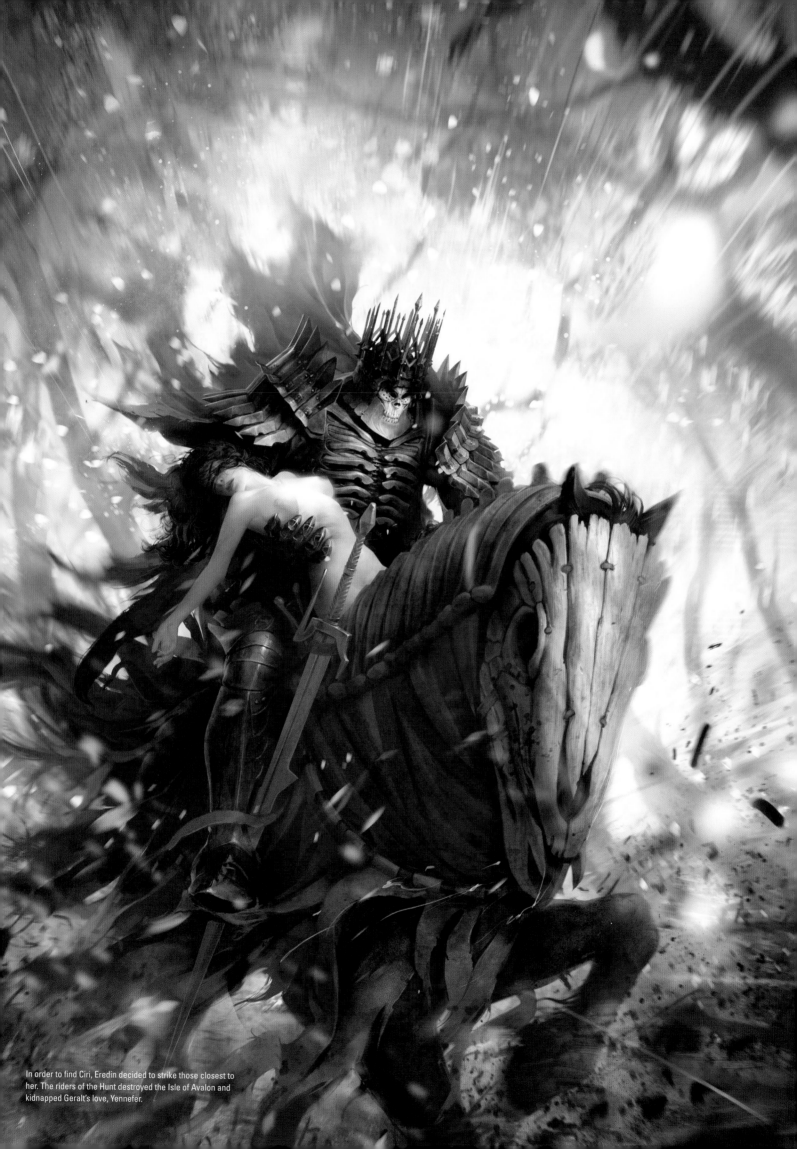

In order to find Ciri, Eredin decided to strike those closest to her. The riders of the Hunt destroyed the Isle of Avalon and kidnapped Geralt's love, Yennefer.

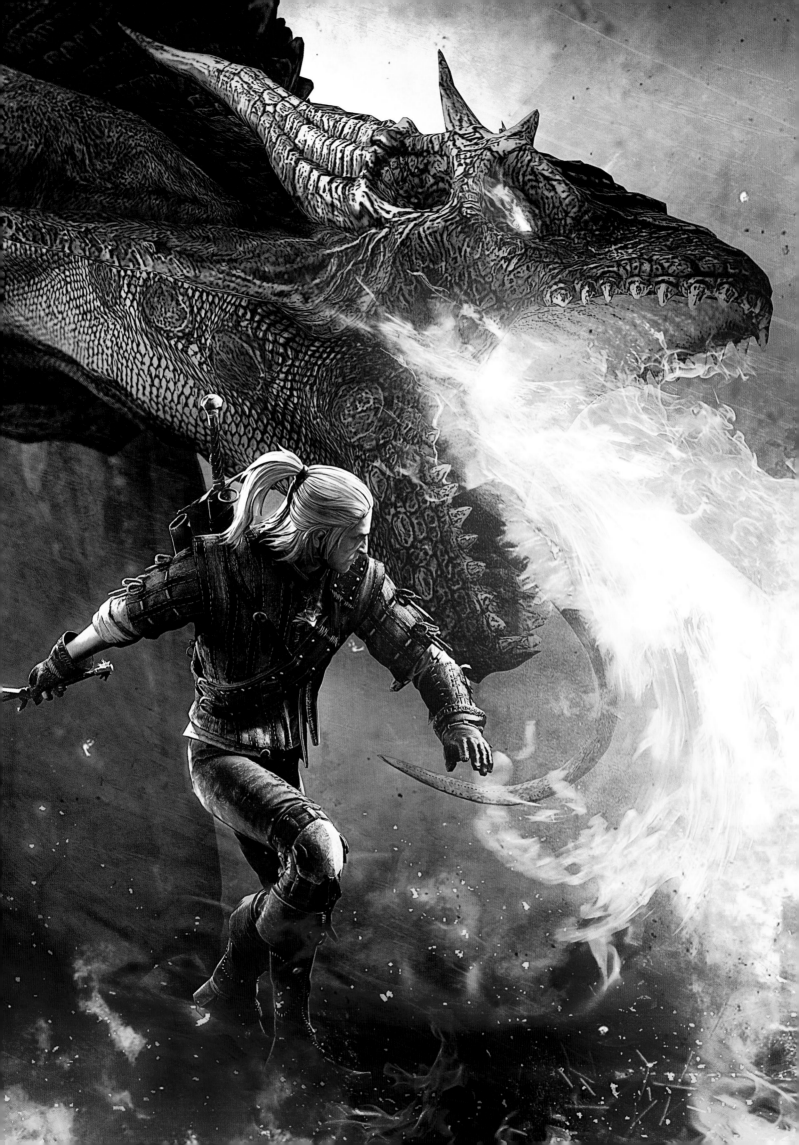

The motivations for this brazen and costly attack remained unknown. Geralt and his companions were determined to change this, particularly as one of their own order had perished in the fighting. They rode off to the four corners of the world to search for the guilty parties and recover their stolen property.

The White Wolf headed south to Vizima, the capital of Temeria, hoping to utilize his contacts in the royal court there. King Foltest, however, was not in residence, and overall conditions in the city were rather grim. During Foltest's absence, the leader of the Order of the Flaming Rose, Jacques de Aldersberg, had been slowly turning up the heat on human-nonhuman relations. The increased persecution of nonhumans had in turn led elves and dwarves to flock to the ranks of local Scoia'tael bands.

"Fisstech's a city drug. Vizima's full of it. So's anywhere else on the Continent big enough to have an alley or even a gutter. It's a white powder—fissties snort it, rub it in their gums . . . or find more creative ways of getting it in their system. Stuff's been around for years. It wakes you up, numbs the pain. Medics used it first on soldiers, then the soldiers started taking it on their own. Students were next—for kicks, or for a kick in the ass come exam season. They say, 'It does fucking wonders, makes you live long, clears your mind and your complexion.' Ha! That shit they sell on the streets rots your face almost as fast as it rots your brain. I've seen too many dope heads with stupid smiles smeared across their pockmarked leather pusses to believe that garbage. Long life—now that's a joke, too. Just ask the two lunks we took in last night. So high on the fiss they couldn't tell day from night, or their own cocks from overcooked noodles. Instead of cooperating like good little boys, one of them charges the arbalest aiming straight at him, screaming something along the lines of 'blades and bolts'll never hurt me.' Wrong. Though, to be fair, he was so fucked up it took three direct hits to take him down. Next thing I know, his pal pulls a sword on me, but he's done a line moments before and starts to sneeze so hard he damn near shoots his brain, or whatever's left of it, straight out his nose. So he's standing there, snot covering him head to toe, with this kind of dopey look on his face—right before one of the guards' maces smashes into it. Must have tapped him a bit too hard, 'cause the poor bugger didn't live to see the dungeons or the noose. We got a funny story out of it, at least, and hopefully some of his cohort learned a lesson. Example like that's far more effective than placards with slogans like 'Use, you lose,' 'Just say no,' or some other bullshit."

—Vincent Meiss, captain of the City Guard, Vizima Temple District

The Salamandra War

It takes a great deal to deter a wolf with the scent of prey in its nostrils, and likewise Gwynbleidd, the White Wolf, was not about to be put off the trail by a minor setback like this. He exploited all the contacts and acquaintances he had made during his weeks in the capital to the hilt and struck at the Salamandra where it hurt the most. He destroyed the secret labs where they produced fisstech, and one by one tracked down and killed the members of their guild, working his way up to the leadership. First to go was the Professor, who was repaid in full for the witcher he had slain at Kaer Morhen. Then Geralt cleared accounts with Azar Javed, who as it turned out was only a puppet. Before he died, he revealed to Geralt the identity of the man who had been pulling the strings from the very beginning.

Despite the delicate and extremely volatile situation in Vizima, Geralt was able to draw on the help of our old friend Zoltan Chivay, among others, and discover those responsible for the attack on the witchers' keep. They turned out to be members of the Salamandra, a criminal syndicate well known among the city's underworld. This organization dealt in all sorts of vile business, from extortion to fisstech dealing to contract killings. Geralt's investigation into this criminal guild, however, landed him right in the middle of the race conflict that had boiled over in the region of Vizima. While the members of the Order of the Flaming Rose and the Scoia'tael locked horns in deadly combat all around him, Geralt confronted the rogue mage Azar. Their battle, however, ended inconclusively, and Azar took advantage of the surrounding chaos to flee.

Javed's patron was none other than the grandmaster of the Order of the Flaming Rose, Jacques de Aldersberg. His aim in stealing the witchers' secrets soon became all too clear: He was breeding mutants to put down the non-human riot he had cynically incited by spreading terror and persecution in Vizima. Dropping all pretenses, de Aldersberg now made his ambitions to seize power clear as crystal. This, of course, was something King Foltest could not allow, particularly after he returned to his capital to find it red with fire and blood. On Foltest's orders, Geralt set out after the grandmaster and cornered him for a final confrontation. To Geralt's surprise, Jacques de Aldersberg had incredible magical power at his disposal—for it turned out he was a source. He bound Geralt in a lifelike illusion of the frozen world after the coming apocalypse. Trapped within this illusion, the witcher had

to face all-too-real monsters and mutants created by the grandmaster, driven by his twisted and fanatical belief that they were working for the good of mankind. The grandmaster's ultimate goal, it seems, was to breed a new race of übermen able to survive the White Frost prophesied by Ithlinne. Geralt wasn't buying any of it, however. He rejected de Aldersberg's final offer to join him and put an end to the Source's mad dreams with a witcher's blade. Thus perished the monster in human skin, the grandmaster of the Order of the Flaming Rose, Jacques de Aldersberg.

Assassins of Kings

Yet to think the overzealous grandmaster's death meant the end of Geralt's problems would be to commit a grave error—for life is no ballad, and every story's end is another's beginning. When the grateful Temerian king went to hand Geralt his well-deserved reward, he was suddenly set upon by a mysterious assailant. Geralt, naturally, did not allow the king to be slaughtered right before his very eyes and foiled the assassination attempt, for which he earned even more of Foltest's gratitude. Yet, when Geralt turned over the lifeless corpse of the would-be king slayer to search for clues to his identity, he discovered something most unsettling: the unknown assassin was, based off the characteristic signs of mutation visible in his eyes, a member of the witcher's own trade . . .

As no one could explain this mysterious incident, the king decided to keep Geralt on as his personal bodyguard, fearing more assassins might succeed where the first had failed. Though the whole affair stank worse than dwarven foot wrappings, the witcher, to everyone's surprise, agreed to accept Foltest's offer.

As any reader who has been paying the slightest attention to our story so far can guess, accepting this position would only lead to more trouble—but here I really must offer a few words in my friend's defense. Weighing heavily on his decision was the fact that Geralt needed more time to regain his lost memory; tipping the scales conclusively was the fact that the saying "one does not refuse a king" has a great deal of unfortunate truth to it, even for a witcher. Geralt thus agreed, but under one

The mage Azar Javed's powers allowed him to escape the witcher several times, but in the end Geralt caught him and was able to pay him back for all the harm he had done.

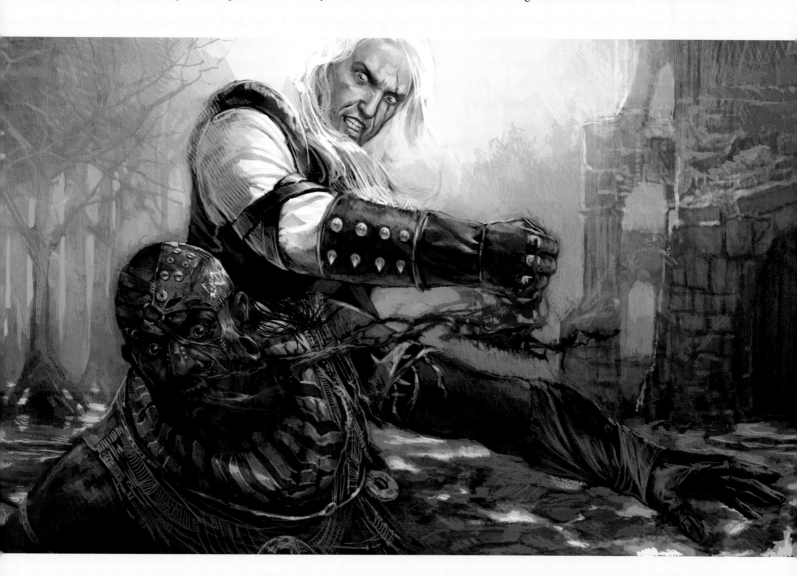

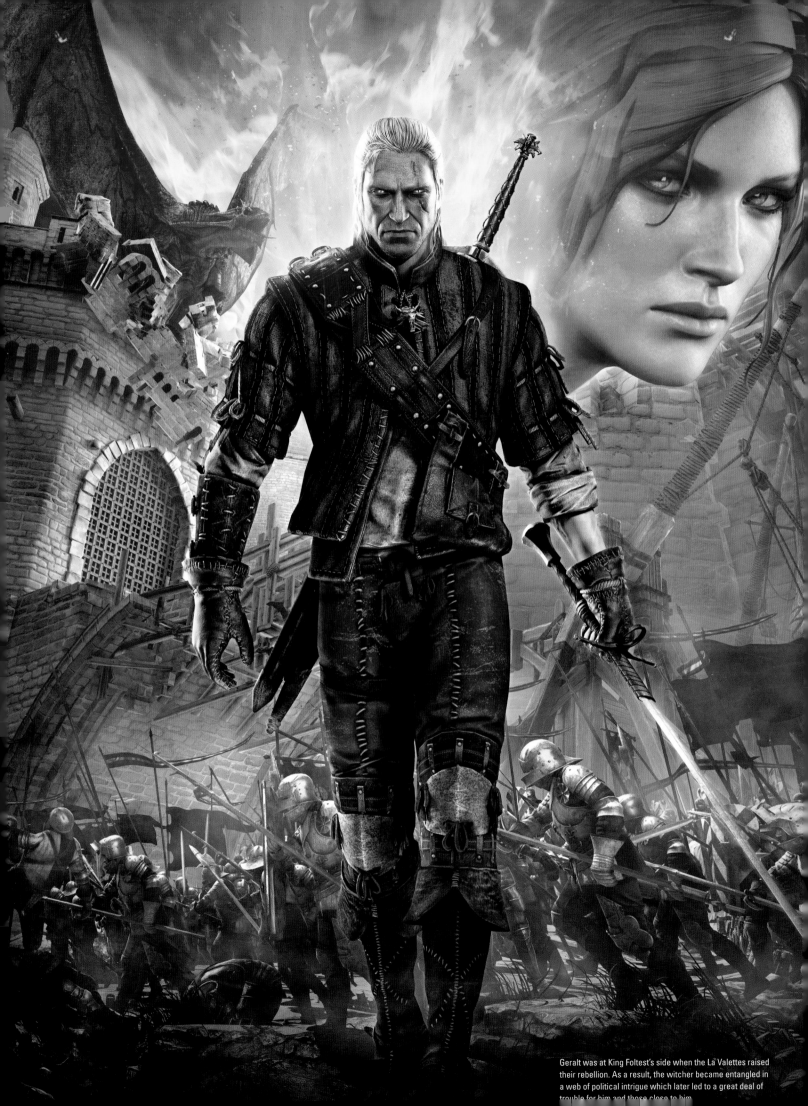

Geralt was at King Foltest's side when the La Valettes raised their rebellion. As a result, the witcher became entangled in a web of political intrigue which later led to a great deal of trouble for him and those close to him.

condition: he would be free to go his own way once the danger was nullified. Our naive hero did not know, however, how difficult a task he had signed up for. Dark times were ahead for the rulers of the North, times in which many would lose their lives to an assassin's blade. First King Demavend of Aedirn was struck down, and then barely a month passed before Foltest met the same fate. Despite his best efforts, Geralt was not only unable to save the Temerian monarch, but was himself accused of the murder and thrown in the royal dungeons.

His prospects of getting out alive were slim, as regicide is usually punished in an exceptionally creative and cruel manner. The witcher thus acted surprisingly reasonably—rather than submit to the dubious justice of a magistrate looking for a convenient scapegoat, he escaped and sought out the real assassin himself, hoping that locating Foltest's killer would clear his name.

Following the assassin's quickly fading trail, Geralt traveled to the border trading post of Flotsam, where as usual he quickly embroiled himself in a tangled web of trouble. This time it involved the Scoia'tael, the local militia and its corrupt leader, and the Temerian special forces. With a great deal of invaluable assistance from Zoltan Chivay and Triss Merigold, not to mention myself, Geralt managed to find the mysterious king slayer. He was surprised to learn that the assassin was in fact a witcher named Letho of Gulet. He would have been even more surprised if he'd known that the man had once been his companion and comrade. Unfortunately, Geralt had no memories of their previous adventure together, and at any rate Letho's priorities had changed considerably since that time. Their reunion thus led not to raised glasses and fond reminiscences of old times, but to a fierce duel. Geralt escaped with an aching head and not a few bruises on his body (and ego), while Letho fled Flotsam by forcing Triss to teleport them both away to the Kingdom of Aedirn.

"Your question: Explain what is meant by 'the Summit at Loc Muinne' and briefly describe its most important outcomes.

A summit of the leaders of the North in the ancient ruins of Loc Muinne. Taking part in the discussions were delegates from Kaedwen, Aedirn, Temeria, and Redania, as well as envoys from the Nilfgaardian Empire in the role of impartial observers. The goal of the summit was, among others, to address the situation in Temeria (which had been occupied following the death of its ruler, Foltest) and resolve the matter of the Temerian succession. Also raised was the question of reactivating the Conclave and Supreme Council of Sorcerers, dissolved previously as a result of the events on Thanedd. When the Nilfgaardian delegation intervened, the discussions were suspended, and then called off indefinitely when a dragon attacked shortly thereafter. Nevertheless, a few key questions were resolved at the summit, the most important being those regarding the future of the Kingdom of Temeria."

—Exam question in contemporary history at the Oxenfurt Academy

Politics and Hunts

Never one to give up in the face of adversity, Geralt set off without delay to find Letho and Triss. His pursuit took him to the Aedirn-Kaedweni borderlands, which were locked in armed conflict. The opportunistic King Henselt of Kaedwen had used the chaos which erupted after Demavend's death to grab a sizable hunk of his southern neighbor's lands. Standing in his way was a coordinated uprising of knights, princes, and peasants led by the renowned heroine Saskia, the Virgin of Aedirn. Geralt found himself having to navigate a convoluted mess of intrigue involving knights, priests, sorceresses, and even Nilfgaard, lift a deadly curse, and soak the earth with the blood of monsters and human enemies along the way, all the while keeping his eye on his true quarry: the king slayers. In the end his determined efforts finally bore fruit when he discovered that two of Letho's confederates from the Viper School (the same witchers who had once aided Geralt in his pursuit of the Hunt, though he did not remember this) were also active in the region. By this time, it was too late to come to any sort of understanding, and the three witchers ended up settling their differences with blades rather than words. Before the two monster hunters turned assassins met their ends, however, Geralt uncovered the name of their employer. This was the same person who had hired them to kill King Demavend, and whom Geralt himself had recently met in Flotsam: Síle de Tansarville, a member of the Lodge of Sorceresses.

Why would the Lodge seek to kill the kings of the North? No answers were readily available to this question, but both Síle's and Letho's trails led up the Pontar to the ancient ruins at Loc Muinne. These crumbling walls were to host a gathering of the loftiest sort—a summit of kings and sorceresses. The witcher raced to beat the coconspirators there, determined to bring this intrigue to a final end.

The events in the ruins of Loc Muinne came to a conclusion when the Nilfgaardian delegate's machinations managed to incite enough fear, uncertainty, and suspicion among the various representatives that any

The Story of Geralt of Rivia

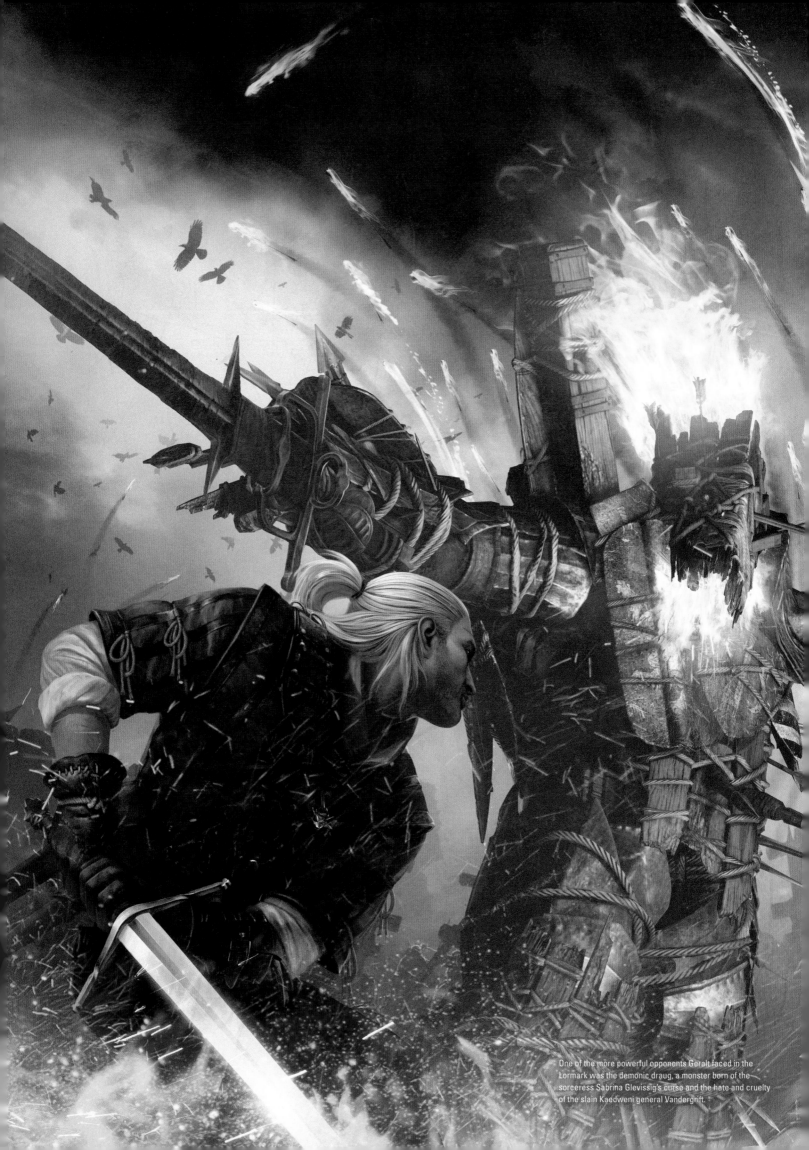

One of the more powerful opponents Geralt faced in the Lormark was the demonic draug, a monster born of the sorceress Sabrina Glevissig's curse and the hate and cruelty of the slain Kaedweni general Vandergrift.

negotiations effectively collapsed. While the gathered leaders each tried to grab as much for themselves as possible in the ensuing political free-for-all, Geralt and Letho faced off once again. It was then Geralt at last learned the inside story of the intrigue in which he had (quite unintentionally) become embroiled.

The whole plot had been concocted by Emperor Emhyr var Emreis, with some help from a few unwitting pawns. He gained the assistance of the witchers from the Viper School by promising to help rebuild their home keep, and then dispatched them on a mission to assassinate the North's rulers and spread turmoil throughout the Northern Realms. The role of the Lodge in the plot to murder King Demavend was a bit of private maneuvering on the sorceresses' part that landed as an unexpected gift in the emperor's lap. He was more than happy to benefit from the chaos of Demavend's death, before revealing at just the right moment the role the sorceresses had played in the assassination. He was

thus able to kill two birds with the proverbial one stone. He got rid of the Northern monarchs and simultaneously discredited the Northern mages—and weakened both the forces which might have stood in the way of his renewed march north.

It was also during this fateful conversation that the witcher learned Yennefer, whom he had saved from the Hunt's clutches, was most likely alive and well somewhere in the Nilfgaardian Empire.

The Long Search

Given the distance separating Geralt from the City of Golden Towers, and the dangerous chaos erupting everywhere as the Nilfgaardians once again invaded the North, Yennefer might as well have been in the mythical land of Hann. The witcher, stubborn as ever, decided to go after her anyway. He set off south, but some time

The summit of rulers held in the ruins of the ancient city of Loc Muinne had weighty consequences which shaped the fate of the entire North.

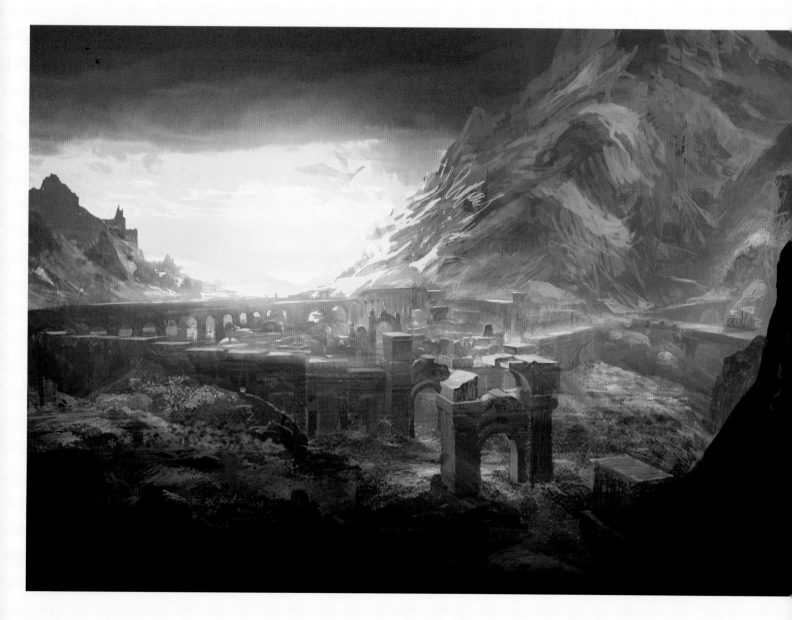

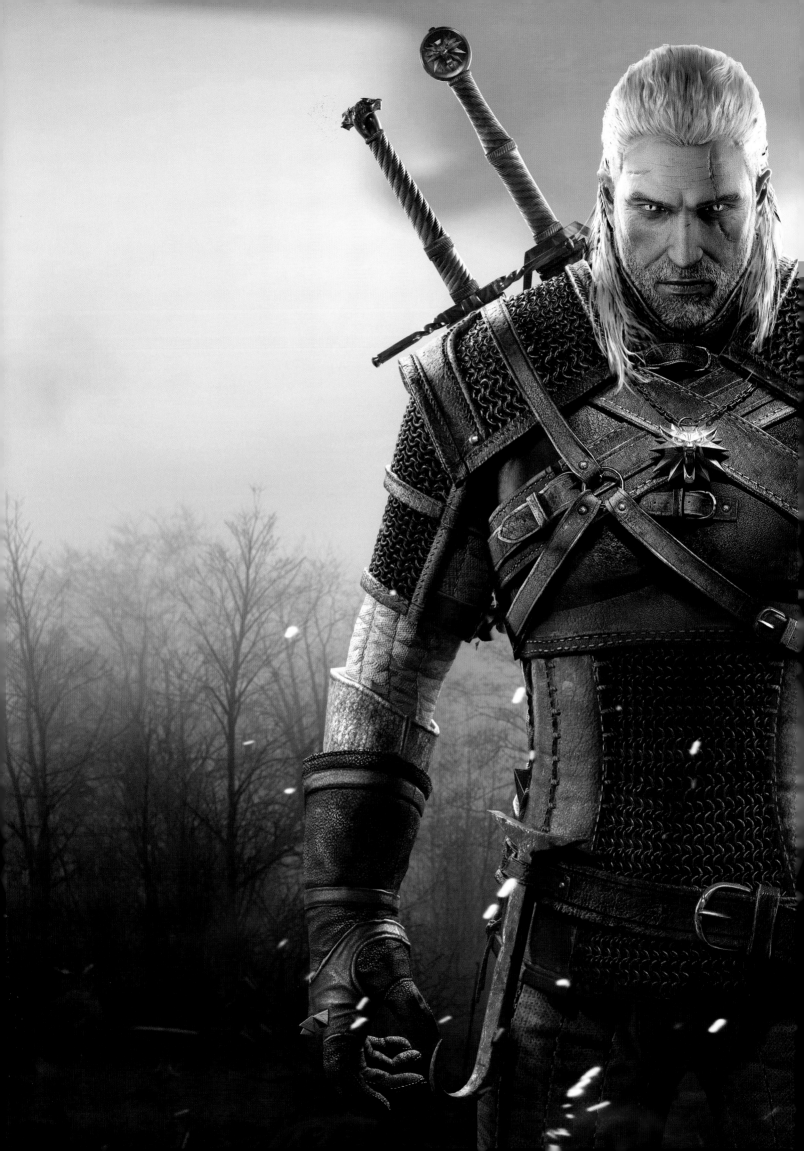

later received a letter from Yennefer urgently requesting a meeting with him in the former Temerian town of Willoughby. Geralt thus turned back north and journeyed through occupied Temeria, stopping for the occasional witcher contract to pay his way. To his surprise and great joy, en route he came across his mentor and close friend Vesemir, who had come to Temeria to slay some of the innumerable monsters that sprouted in this time of conflict like mushrooms after a heavy rainstorm. Reunited, they made their way to Willoughby together, only to discover the city had been leveled in a devastating clash between the Northern armies and Nilfgaard, with Yennefer nowhere to be found. They were able to follow her trail to the village of White Orchard, where, after taking care of a griffin menacing both the locals and the Nilfgaardian troops stationed nearby, Geralt at last came face to face again with his beloved Yennefer.

Less pleasant than their tender reunion was the fact that she was accompanied by a unit of Nilfgaardian guards and, without time to explain anything, informed Geralt that the emperor needed to see them both at once. Leaving Vesemir to return on his own to Kaer Morhen, they set off for Vizima, where the emperor

had set up a temporary court to oversee his Northern campaign. Before reaching the city, however, they had to escape another ambush by the Wild Hunt—an ominous portent of what dangers might be involved in the emperor's urgent summons.

As Geralt suspected, the emperor had not called upon him to play a hand of gwent and reminisce about old times. The vast network of imperial spies had discovered that Ciri had returned to this world. Moreover, the emperor and Yennefer had been searching for her for some time before they contacted Geralt, but without success. In fact, their efforts had proven too dangerous to continue, for they had attracted the attention of the forces pursuing Ciri, Geralt's old nemeses and the most powerful foes he had ever crossed: the Wild Hunt. They needed Geralt to track down Ciri using more conventional methods and bring her to safety. The emperor, clearly underestimating the power of the bond linking Geralt to Ciri, offered him a mountain of gold in return for completing the quest. Geralt, however, needed no additional incentive, having decided on his course of action as soon as he heard Ciri was in trouble. Finding Ciri and helping her fight off her otherworldly pursuers became his all-consuming task. He

Taking advantage of the Temerian interregnum and the chaos and discord sown between Aedirn, Kaedwen, and Redania, the Nilfgaardian army crossed the Yaruga—the first step in the next stage of the empire's expansion.

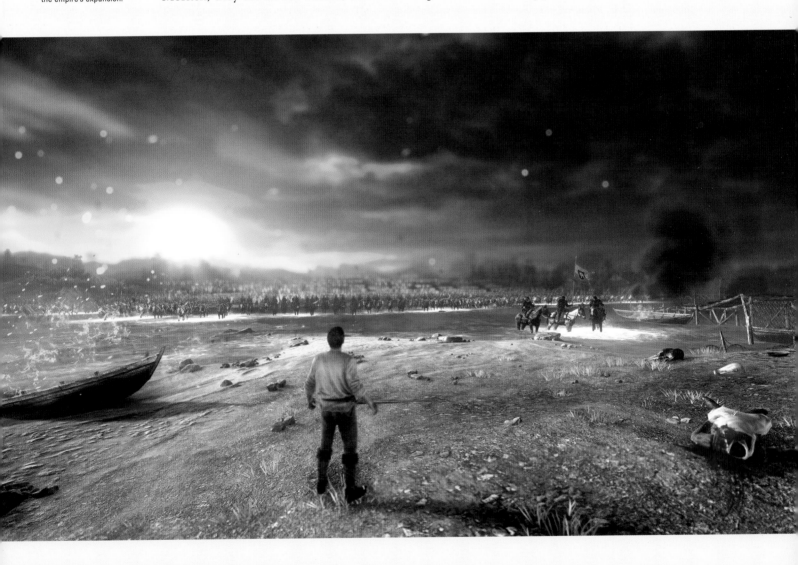

accepted the help of the emperor's spies as a means to this end, and after consulting with Yennefer, ventured forth to crisscross the land in the most far-reaching and desperate hunt of his life.

The emperor's spies had caught wind of Ciri in several places, ranging from the war-ravaged lands of Velen on the Temerian-Redanian border to the Free City of Novigrad and ending on the farthest edge of known civilization, the Skellige Islands. Geralt valiantly trekked back and forth through all these regions and beyond, braving treacherous swamps, untamed wilderness, haunted ruins, cutthroat city streets, grimy alleys, and elegant banquet halls. He came across many signs of Ciri's presence, but constructing a coherent trail from them proved nearly impossible, for Ciri was capable of moving from one place to another in the blink of an eye, and tended to leave little beyond confusion and chaos in her wake.

The general picture of her activities which he eventually pieced together was as follows: Ciri first touched down in this world in Skellige, where, with the Hunt at her heels, she somehow provoked a magic explosion that decimated one section of the islands, after which she fled via teleport. She then landed in Velen, where she had the misfortune to encounter three demonic sisters known as the Crones. After barely escaping capture, she sought refuge to recover from her injuries and found shelter with a local bandit leader known as the Bloody Baron. He recommended she try her luck in Novigrad, and so that is where she next appeared. There she sought help in lifting some curse—and turned to none other than me, Dandelion, for assistance. Alas, dear reader, I have no time to recount my many adventures, amorous and otherwise, in the great city of Novigrad, for the next thing I knew we were both up to our eyebrows in trouble, hunting ill-gotten lucre with underworld thugs breathing down our necks. Through an unfortunate series of events that ended with me covering Ciri's escape (quite valiantly, I might add), I was captured by guards working for the Church of the Eternal Fire and thrown in a dank dungeon. Living on a meager diet of bread, water, and rat droppings, I awaited my imminent execution. (I must note here that my arrest was a matter of pure banditry and had nothing whatsoever to do with religion. These were uneasy times in Novigrad, and the whims of corrupt officials were enough to deprive a man of his life, even a man of such fame and talent as myself.)

While a man made of weaker stuff would surely have broken, scared witless by imagining the cruel torture that would undoubtedly precede his death, I did not. I never lost hope, knowing my friends would not abandon me in my hour of need. And indeed, soon enough Geralt and Zoltan devised an ingenious plan to pluck me out of the guardsmen's hands, proving not for the first time that true friends always reveal their best faces in times of adversity.

The Mysterious Curse and the Isle of Mists

The witcher retraced Ciri's most important steps in Novigrad during his investigation, but at the time he was fumbling blindly, holding only a few pieces of the puzzle and trying somehow to force them together. Later on, however, with some key assistance from Yennefer, Triss, Zoltan, and myself, he managed to establish a full chronicle of what she did there—and more importantly, why she did it.

It became clear that Ciri had a crucial ally in her flight from the Wild Hunt: Avallac'h, now in open conflict with the commander of the Hunt, Eredin. As a powerful mage—an Aen Saevherne, as the elves call them—he was able to protect her for some time from the evil designs of his former comrade. Unfortunately, during one of their clashes with the Hunt, a powerful curse was cast upon him which deformed his body and mind, transforming the once-mighty Sage into a twisted wreck of a man incapable of uttering a sensible word or even caring for his own hygiene. With the help of Yennefer and some particularly invasive operations, Geralt managed to lift this curse. The grateful elf at once revealed Ciri's location, causing Geralt's heart to skip a beat at the thought of what would have happened had the curse continued. With sickening clarity, Geralt realized that as Avallac'h's body and mind slowly decayed into nothing, Ciri's chances of ever being found would have diminished into the same—for the elven mage had tucked her away outside of time and space itself, in a place where neither Eredin nor anyone else could ever find her.

What was this place? The mystical and long-forgotten Isle of Mists. Ciri lay there in a deep, magically induced slumber, waiting for the danger to pass or the witcher to arrive and bring her back to this world.

I won't recount here Geralt's heroic exploits while journeying to the Isle of Mists, what enemies he slew, and what allies he gained. It is sufficient to say his road was long, and that when he reached its end and stood on the threshold of the room in which Cirilla slept, no magical kiss was needed—his very presence broke the spell and she awoke. Was this part of the protection left by Avallac'h? Did he foresee the witcher's coming? Or was it simply the unstoppable power of Destiny, the thunderclap of fate being fulfilled, that awoke Ciri from her slumber? Whatever the case, now, after years

of separation and ardent searching, the witcher had at last found his adopted daughter, and the joy he felt in this moment neither voice nor quill can ever express.

The Hour of Truth and the Last Battle

Unfortunately, the precious reunion fate had granted them would soon be taken away. As soon as Geralt and Ciri returned to our world, Eredin could sense that the one he sought was at last again within reach. Gathering his spectral riders, he set off for Kaer Morhen, where his long-sought prey had found temporary refuge. Thanks to Avallac'h's warning, Geralt had managed to gather his allies at the fortress, and led them in a bloody and desperate struggle against the Hunt. Despite the bravery and dedication of the defenders, the battle soon took a disastrous turn, for the riders of the Hunt were many and personally led by the fearsome Imlerith, one of Eredin's right-hand commanders. Imlerith threw himself directly into the fray and during the horrific combat that ensued slew Vesemir, depriving the world of one of the greatest men to ever walk its surface. Ciri, shattered by the loss of her former guardian and mentor, unwittingly unleashed the Power lying dormant within her, devastating the remaining attackers and forcing the Hunt to fall back.

Everyone who took part in this fight was aware that this victory was only momentary, making the losses

The rumors about Cirilla's return proved to be true. In her flight from the Wild Hunt, she narrowly escaped death time after time, evading one danger only to find herself confronted with another—one of which was the hideous crones dwelling in Velen's swamps.

with which it had been purchased all the more painful. The Hunt would surely strike again, and the defenders of Kaer Morhen knew the same tactics would not work to fend off another assault on that fortress. Anyone familiar with Geralt and Ciri, however, knows that neither of them is the kind to give in to despair. They decided that, if they acted quickly and with precision, they could further weaken Eredin's band and then strike while the iron was hot, catching the Hunt in a time and place of their choosing, before they had a chance to regroup and replenish their ranks.

Determined to disable the evil's nerve center, they found and killed Imlerith, depriving the Hunt of one of their best officers. Next, Avallac'h took Geralt to convince another top general, Ge'els, to refrain from joining the conflict. They went to a great deal of trouble to round up the surviving members of the Lodge of Sorceresses and convince them to help in the coming battle. With the combined magic of the Lodge at their disposal, they planned to summon and then imprison the *Naglfar*, the vessel Eredin used to travel between worlds. They would then face the Aen Elle on their turf and on their terms.

The final battle took place off the shores of Skellige. Using a magic elven artifact, Geralt called forth the *Naglfar* from the mists of time and space to a rocky Skellige bay—and into a trap. The sorceresses' power kept it from fleeing this world, and the imperial fleet cut off its escape route to the high seas. Geralt boarded the ghostly ship and, amid the screams of men and

the clashing of steel, at last stood face to face with Eredin. In a long, drawn-out duel, the witcher and the leader of the Aen Elle fought to the very limits of their considerable abilities. Yet when it was all over, it was Geralt who stood victorious, having broken the power of the Wild Hunt for good.

The End?

Alas, only in fairy tales does the story end with the death of the hated villain and everyone living happily ever after. The time had now arrived for Ciri to face her own destiny. According to Avallac'h, only she possessed the power to stop the White Frost—the near-mythical force that threatened to destroy not just this world, but all worlds. That was why Cirilla decided to enter the ancient portal on the Isle of Undvik, leaving behind the adoptive father who had tried so desperately and for so long to find her. How did her expedition end? Based on the fact that, as I write these words, I look out my window and behold a glorious summer's day, I believe I can say she succeeded.

"Tedd Deireadh is nigh, the Final Age, the Time of the White Frost and the Wolf's Blizzard. In that time the cockerel Cambi will crow, heralding the coming of the Naglfar, the longship made of dead men's claws, carrying an army of demons from Mörhogg. Its crowing will awake the hero Hemdall, who will stand on the Rainbow Bridge and blow his horn, sounding the time to seize weapons and close ranks for the Last Battle, for Ragh nar Roog. For its outcome will decide whether the world will be overcome with Darkness and Cold, or whether dawn will break, a harbinger of New Days."

—Skellige mythology

And so, dear reader, we have reached the end of our story. With my inner eye I can see you exclaim in anger, "The end? Already? Like that? But there are still so many questions I want you to answer! What happened to Ciri afterward? Did Geralt of Rivia live to see her return from her journey through time and space? And did he find true love? Was it Yennefer, or someone else? What happened to Zoltan Chivay, that incorrigible dwarven altruist? And most intriguingly, how did the further career of the author of the present work unfold? The one who painted for us with words such a marvelous tapestry of long-past moments?"

Sadly, I must leave you like this, dear reader, full of suspense and speculation. Perhaps you will find answers to some of these questions yourself. Others I myself may answer—but at another time. Now, if you will permit me, I will paraphrase the words of a certain famous philosopher: a good tale should be like a feast, in that it should end at the moment when you can stand up and leave, being neither thirsty nor drunk.

—Dandelion

Eredin was determined to capture Ciri and did not hesitate to descend on Kaer Morhen with his second in command, Imlerith, and the riders of the Wild Hunt. Only a miraculous stroke of luck allowed the keep's defenders to stave off this assault.

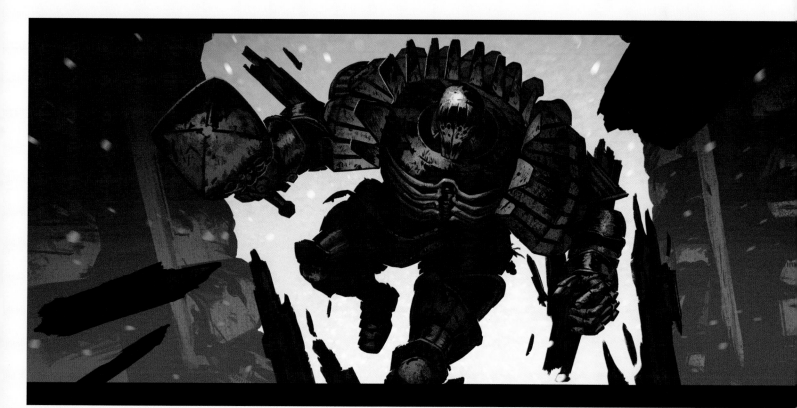

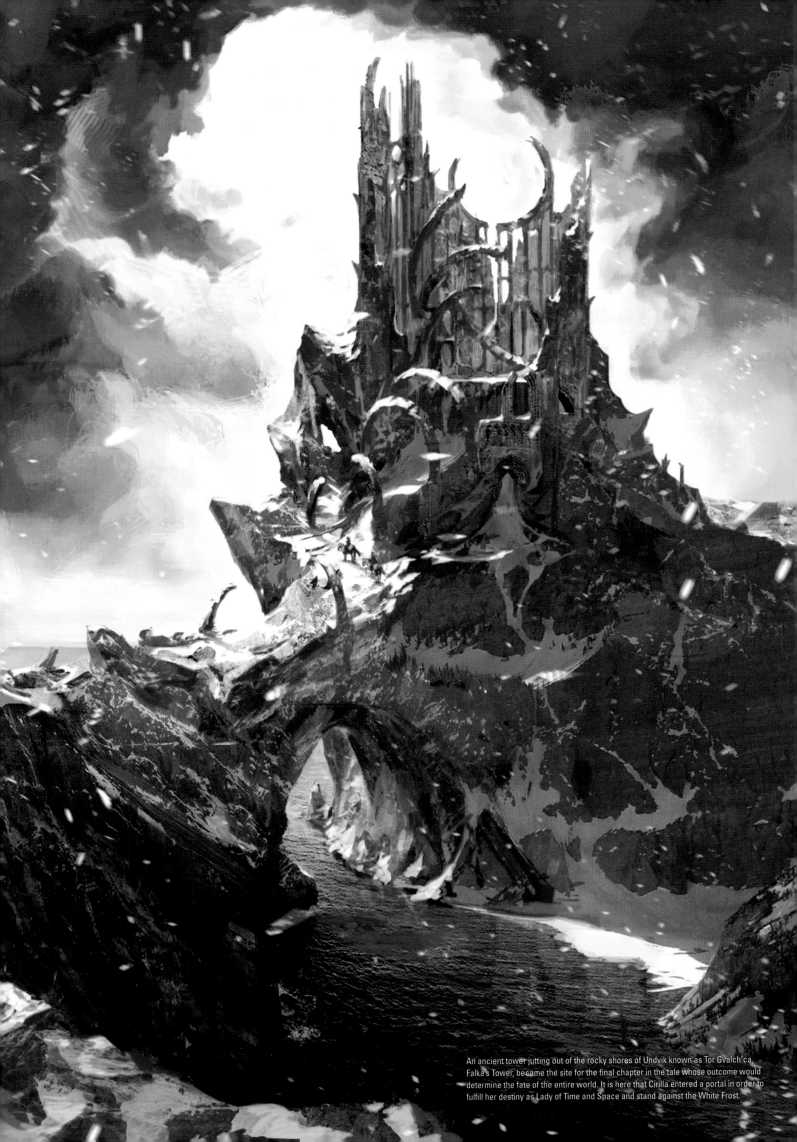

An ancient tower jutting out of the rocky shores of Undvik known as Tor Gvalch'ca, Falka's Tower, became the site for the final chapter in the tale whose outcome would determine the fate of the entire world. It is here that Cirilla entered a portal in order to fulfill her destiny as Lady of Time and Space and stand against the White Frost.

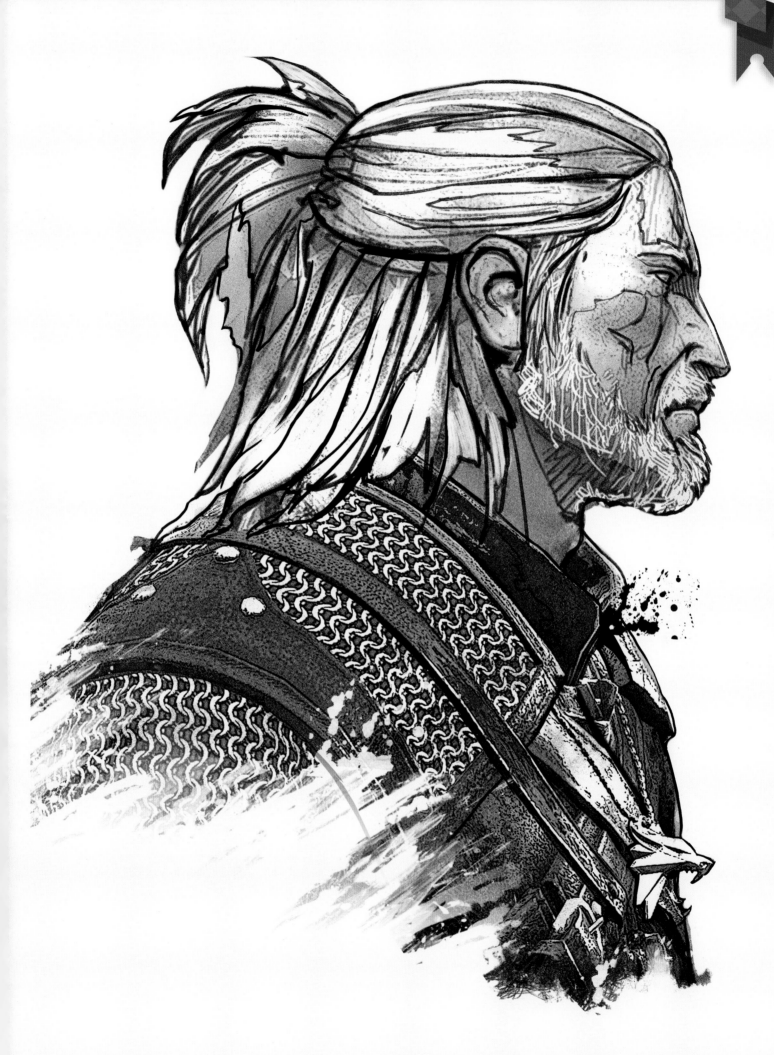

The Story of Geralt of Rivia

ARTWORK

Bartłomiej Gaweł • Paweł Dobosz • Adam Kozłowski • Adrian Madej • Dominik Redmer •

Przemek Truściński • Sławomir Maniak • Jan Marek • Jakub Rebelka • Monika Zawistowska

• Grzegorz Krysiński • Damian Bajowski • Marek Madej • Lea Leonowicz • Marta Dettlaff

• Andrzej Dybowski • Grzegorz Rutkowski • Victor Titov • Michał Buczkowski • Marian

Chomiak • Kamil Kozłowski • Paweł Mielniczuk • Piotr Żyła

DARK HORSE COMICS

THE WITCHER ADVENTURE GAME

Featuring the characters you know and love from the critically acclaimed video games, and the unparalleled quality of a Fantasy Flight Games board game, *The Witcher Adventure Game* will immerse you and your friends in the world of *The Witcher*. Complete quests, slay fearsome monsters, and adventure throughout the land.

VISIT **THEWITCHER.COM/ADVENTUREGAME** FOR MORE INFORMATION.